Speaking
of Objects

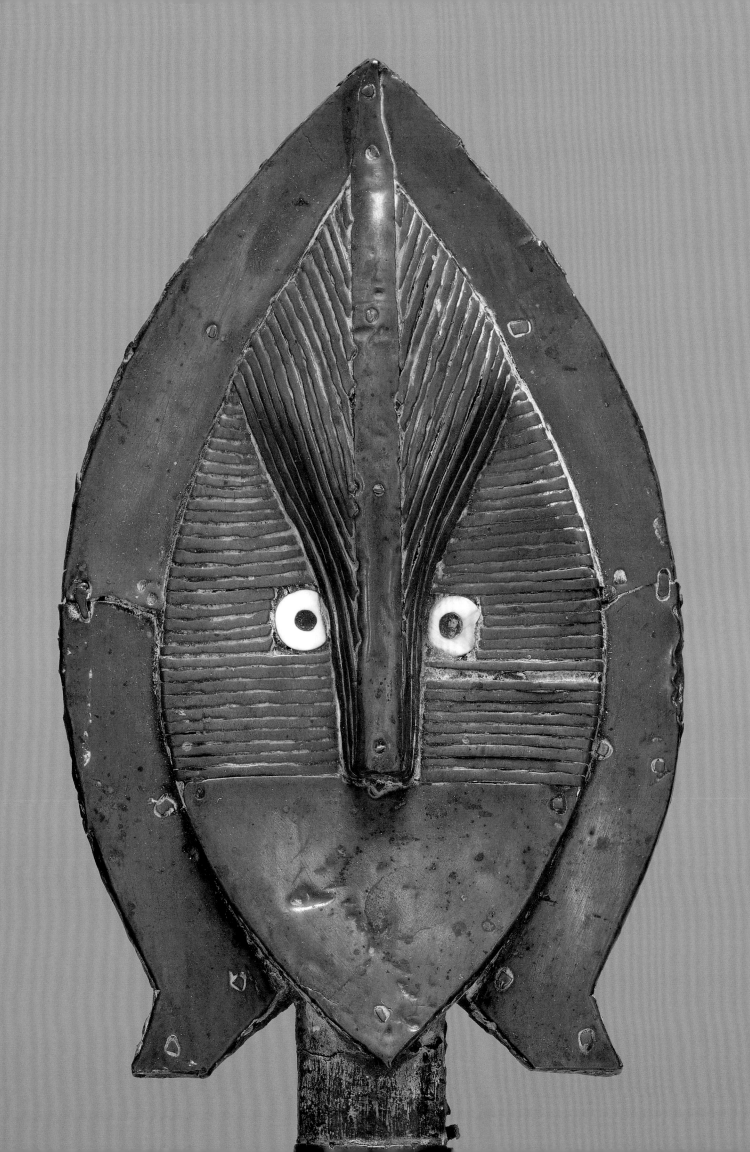

Speaking
of Objects

African Art
at the Art Institute
of Chicago

Edited by Constantine Petridis

With contributions by
Martha G. Anderson, Kathleen Bickford Berzock,
Pascal James Imperato, Manuel Jordán,
Babatunde Lawal, Anitra Nettleton,
Constantine Petridis, and Janet M. Purdy

The Art Institute of Chicago

Distributed by
Yale University Press, New Haven and London

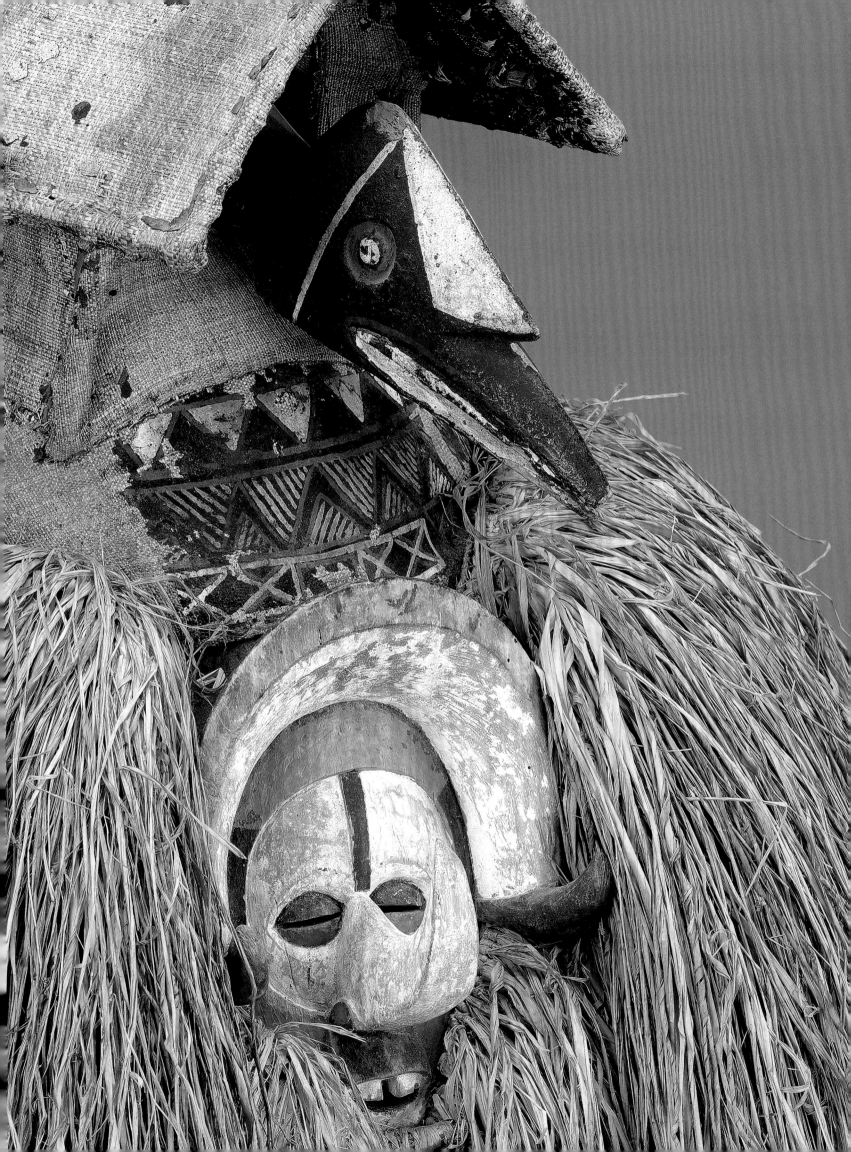

Contents

Foreword

Speaking of Objects sheds new light on the Art Institute of Chicago's collection of the traditional arts of Africa by focusing on works that exemplify significant styles, display a high degree of artistic achievement, and also prompt stories from and about their makers. Indeed, this catalogue seeks to inspire a new generation of scholars by featuring contributions from a select group of art historians and anthropologists—specialists who have gained their expertise in part through personal experience with the communities and artists they discuss. Each of them draws on extensive field research to contextualize museum objects that were extracted from their original sociocultural environments without any firsthand documentation. Their investigations illuminate the types of works that predominate in galleries dedicated to the arts of Africa not just at the Art Institute but in museums throughout the world. It is our hope that such in-depth analyses will reinvigorate the study and appreciation of these historical forms and encourage further research by and among members of the communities that created them.

This book also celebrates the recently refreshed display in our galleries. That reinstallation, like this publication, features the museum's first acquisitions of African art as well as works from northern Africa and Ethiopia, Tanzania, and elsewhere in eastern Africa that came into our collection more recently. Kathleen Bickford Berzock was the Art Institute's curator of African art from 1995 to 2013, when many of these objects were acquired; she edited the last survey of our holdings, published in 1997 as a special issue of our scholarly journal, *Museum Studies*, and we are grateful that she has also contributed to this volume. It dramatically expands upon that earlier endeavor, illustrating the collection's growing strengths and affirming the museum's ongoing commitment to studying, preserving, and exhibiting such works.

We eagerly anticipate future developments within this field as the art historical canon grows and evolves. The Art Institute is continuing to enhance the presentation of traditional African arts throughout our museum and to feature them more prominently in our exhibition programming. Our curatorial staff, especially in Modern and Contemporary Art, also strive to represent the inspiring work being undertaken by African artists and creative communities today. Those efforts emerging from the specific context of the studio can be juxtaposed with the traditional arts of the continent in complementary ways. The development of our museum's collecting mission also brings with it the exciting prospect of more collaboration between departments within the Art Institute as well as with other museums and universities in North America, Europe, and, above all, Africa.

It is my sincere pleasure to thank Constantine Petridis, Chair and Curator, Arts of Africa, for his initiative in supervising this publication, carefully selecting seventy-five highlights of the collection, and securing the richly varied contributions of his esteemed colleagues. I am also grateful to The Andrew W. Mellon Foundation, which has long championed deep collection research at our institution, for funding both the production of this catalogue and a postdoctoral curatorial fellowship in African art, the latter of which is also supported by the Daniel F. and Ada L. Rice Foundation. I hope that *Speaking of Objects* will not only immerse you in pathbreaking scholarship but also inspire you to visit our galleries and return to the museum as we continue to deepen our engagement with the diverse arts of Africa.

James Rondeau
President and Eloise W. Martin Director

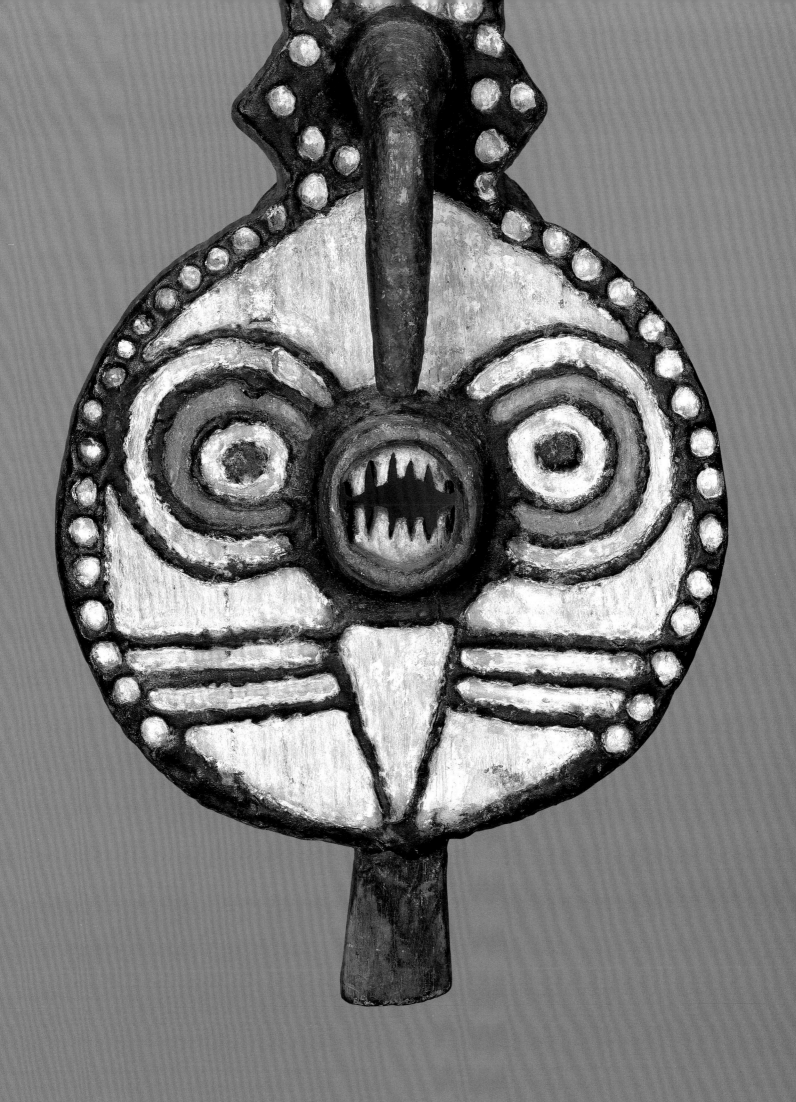

Acknowledgments

This book was made possible by a grant from The Andrew W. Mellon Foundation, whose enduring support is gratefully acknowledged. It reflects the dedicated and enthusiastic efforts of many people. First and foremost, James Rondeau, President and Eloise W. Martin Director of the Art Institute of Chicago, together with Sarah Guernsey, Deputy Director and Senior Vice President for Curatorial Affairs, encouraged my colleagues and me to envisage this publication as more than just a collection catalogue. I thank them both for their endorsement.

I am greatly indebted to the scholars who authored the essays and entries in this catalogue: Martha G. Anderson, Kathleen Bickford Berzock, Pascal James Imperato, Manuel Jordán, Babatunde Lawal, Anitra Nettleton, and Janet M. Purdy. It has been an honor and a privilege to benefit from their expertise. Susan Elizabeth Gagliardi at Emory University, Atlanta, and Wilfried van Damme at Leiden University contributed constructive comments on earlier versions of the introduction.

I owe a special debt to Greg Nosan for his role in shaping the project with his team in Publishing, including Ben Bertin, Kylie Escudero, Robin Hoffman, Lauren Makholm, Lisa Meyerowitz, and Joseph Mohan. Robin's rigorous and tireless editorial work did justice to the wide range of contributions. Lauren efficiently handled every aspect of its production, not least the coordination of new photography for this purpose. In Imaging, Aidan Fitzpatrick, Jonathan Mathias, Shelby Silvernell, Craig Stilwell, Joe Tallarico, and P. D. Young worked together and in collaboration with Jamie Stukenberg of Professional Graphics to capture beautifully the often unusual angles and shiny surfaces of the sculptures showcased here. In Conservation and Science, I thank Suzie Schnepp and especially Rachel Sabino, who kindly assisted with the art movement required for the new photography in addition to crucial conservation treatments. Much of this work happened in tandem with that of my departmental colleagues at the time. I sincerely thank both Simone Chagoya and Raymond Ramirez for their invaluable assistance. Elizabeth Pope, above all, merits my deepest gratitude for her critical contributions at every step.

This book also benefited from feedback offered by colleagues throughout the museum, especially as we reinstalled the Art Institute's African art gallery from late 2018 into 2019: in Learning and Public Engagement, Emily Fry and Jacqueline Terrassa; in Experience Design, Kristin Best, Mark Dascoli, Bronwyn Kuehler, Andrew Meriwether, Michael Neault, and Jeffrey Wonderland; in Collections and Loans, current and former colleagues including Matthew Alicea, Kerri Callahan, Sally-Ann Felgenhauer, Andrew Gordon Haller, Deanna K. Tyler, and Lindsay Washburn; in Design, Samantha Grassi, Juneer Kibria, and Andrew Talley; in Communications, Paul N. Jones and Lauren Schultz; in Marketing and Public Affairs, Katie Rahn; in Legal, (formerly) Julie Getzels and Jennifer Sostaric; in Museum Facilities, (formerly) Mark Adkins, Leslie Carlson, Craig Cox, Christine Estelle Huck, Tim Porter, Esther Ramirez, Patrick P. Smith, and Christina Warzecha; and in Auxiliary Operations, Kirstie Lytwynec. In Textiles, Katherine Andereck, Isaac Facio, Sarah A. Gordon, Kathleen Kiefer, Erica Warren, and Melinda Watt are appreciated for facilitating the textile rotations that enliven our gallery.

Thanks to the generosity of the Field Museum and its president and chief executive officer, Richard Lariviere, the Art Institute was able to integrate seven stellar works from that museum's historic African collection into our refreshed permanent installation. Several individuals on their staff were instrumental to this collaboration: Lauren Hancock, Stephanie Hornbeck, H. Thorsten Lumbsch, William A. Parkinson, and Christopher Philipp.

The following colleagues provided or helped secure illustrations that appear in conjunction with the essays and entries: Thomas Bassett; Anna Bennett; Brunhilde Biebuyck; David A. Binkley;

Huib Blom; Samir and Mina Borro; Alexander Bortolot;
Herbert M. Cole; Dominique and Roland Colin; Henry
John Drewal; Susan Elizabeth Gagliardi; Eric Ghysels
of 5 Continents Editions, Milan; Cory K. Gundlach;
Sandra Klopper; Frederick John Lamp; Pierre Loos;
Laurence Mattet of the Barbier-Mueller Museum,
Geneva; Steven Morris of the Donald Morris Gallery,
New York, and Birmingham, Michigan; Dori Rootenberg
of Jacaranda Tribal, New York; Holly W. Ross; Nora
Leonard Roy; and Susan Mullin Vogel. Bart Ryckbosch
assisted with locating images in the Art Institute's
Ryerson and Burnham Archives.

 The following institutions provided compar-
ative images or permission to reproduce them: Agence
Hoa-Qui, Paris; American Museum of Natural History,
New York; Archives Nationales d'Outre-Mer, Aix-en-
Provence, France; Basel Mission Archives, Switzerland;
British Museum, London; Cleveland Museum of Art;
Visual Resource Archive, Metropolitan Museum of Art,
New York; Musée du quai Branly–Jacques Chirac,
Paris; Melville J. Herskovits Library of African Studies,
Northwestern University, Evanston, Illinois; Royal
Anthropological Institute, London; National Museum
of African Art and Eliot Elisofon Photographic Archives,
Smithsonian Institution, Washington, DC; University
of Iowa Stanley Museum of Art, Iowa City; and
University of KwaZulu-Natal, Durban, South Africa.

 For their continued support of the arts of
Africa at the museum, I am grateful to the members of
our advisory committee and its chair, Rita Knox. Finally,
I dedicate this publication to my predecessors, who
have helped build the Art Institute's African art collec-
tion since the foundation of a dedicated department
in 1957 and made it what it is today: Alan R. Sawyer,
Allen Wardwell, Evan M. Maurer, Richard F. Townsend,
Ramona Austin, and Kathleen Bickford Berzock.

Constantine Petridis
Chair and Curator, Arts of Africa

Note to the Reader
For organizational purposes, the conti-
nent of Africa has been divided into four
geographic regions (see map, pp. 196–97);
their boundaries do not correspond with
national borders or other official
demarcations.

For objects that cannot be assigned spe-
cific dates due to a lack of empirical or
documentary evidence, date ranges have
been provided on the basis of collection
information and scholarly assumptions.
The qualifier "probably" indicates greater
confidence than "possibly."

Measurements are given in centimeters
(cm), followed by inches (in.); height pre-
cedes width precedes depth. For variable,
nonlinear, or ambiguously oriented
structures, the measurement is clarified
with the following abbreviations:

 Diam. = diameter
 H. = height
 L. = length

A brief provenance history accompa-
nies each object; complete information
is available at artic.edu/collection.

Diacritics have been used in translitera-
tions of Yòrùbá and other languages at
the discretion of the author of each essay
or catalogue entry.

All translations are by the authors unless
otherwise noted.

Constantine Petridis

From the Object to the Field (and Back Again)

Complementary Perspectives on African Art

Although scholarly investigations of the arts of Africa began more than a century ago, occupying a space between the disciplines of anthropology and art history, African artworks typically were not integrated into general, world, or encyclopedic art museums in North America until the late 1950s. In 1957 the Art Institute of Chicago, along with a number of other institutions, decided to establish a department dedicated to so-called "primitive art." The term typically also encompassed the arts of the Americas (both Ancient and Native) and Oceania. Museums have subsequently not only adopted more neutral geographic descriptors for the names of curatorial departments stewarding African art collections, but some—the Art Institute among them—have also chosen to dissolve historical divisions and create autonomous departments for such works.[1] Enthusiasts had great reason for optimism during the latter half of the twentieth century, as the scope of the field expanded and the number of specialized participants increased accordingly.

In the twenty-first century, however, we have witnessed declining interest in the scholarly study of traditional African art. I prefer this term to the also commonly used descriptor "historical," which may evoke some sense of antiquity and even extinction. Moreover, in my mind the adjective "historical" might be erroneously understood to imply that there is also some kind of ahistorical African art. Scholars continue to debate the most appropriate label for the kinds of objects presented in this volume.[2] While I choose to use the adjectives "traditional" and, less eagerly, "tradition-based," I also wish to reiterate that in some parts of the continent, traditional or tradition-based arts are in fact contemporary (see figs. 1–2). But while the categories of contemporary and, to a lesser extent, modern African art are gaining more attention in both universities and museums, and some other art museums in the United States are making concerted efforts to enhance their collections, the traditional arts of the African continent are generally losing ground. The diminishing academic interest in both this country and Europe prompts reasonable worry about the long-term future of the field.

The purported shortcomings of African art studies are often blamed on tensions that arise between art history and anthropology as well as a fluctuating relationship between the two disciplines and their respective practitioners.[3] The opposition between them is paralleled by the sometimes enduring and arbitrary divide between the

categories of "art" and "artifact." Despite repeated attempts to bridge the gap, including the introduction of visual culture as a new term and focus of study, this separation of art history and anthropology continues to impact research on the arts of Africa. In Chicago the distinction is institutionally embodied by the Art Institute on one hand and the Field Museum on the other. Some new initiatives are in place for collaboration and exchange, however, as exemplified by the recent loan of seven works from the Field's extensive African collection to the Art Institute's refreshed African art gallery (see figs. 3–4).

By presenting a selection of highlights from the Art Institute of Chicago's undervalued collection, this book seeks to revive interest in the subject of traditional African art. Individual objects, specifically discussed in dedicated essays and catalogue entries by a range of expert contributors, are at the heart of this book and its effort to attract scholars and museumgoers alike. This essay provides an introduction to those discussions by sketching some important moments in the history of African art studies and reviewing some methodological approaches, with an eye toward highlighting past accomplishments and

encouraging future explorations. Advocating for object-focused art historical research grounded in the analysis of materials and forms as well as the contextual study of styles, I conclude with a call for field-based investigations by scholars who are members of the African communities that created the objects now primarily in collections in the United States and Europe.

Object-Based Research

African art is best understood when anthropological, *in situ* research (that is, research "in the field") yields insights into objects similar to those preserved in private collections and museums in the West. Such "art-anthropological" research was initiated in the 1930s by pioneers including the Belgian art historian Pieter Jan Vandenhoute and the German ethnologist Hans Himmelheber. Writings by researchers with extensive experience in the field as well as the appropriate scholarly training and language skills are usually the most valuable. But since a single scholar obviously cannot conduct fieldwork on every culture's arts, they must rely on the existing professional literature as well as nonprofessional writings comprising observations by travelers or residents without specific training. As in any field of scholarly research, available sources must be carefully assessed and critically evaluated to determine whether and to what extent they are reliable. The archival sources that complement the published literature—such as collection inventories and travel diaries—sometimes also contain pertinent data but can be difficult to access due to limitations imposed by the repositories where they are held or because of the language used or even the handwriting.[4] The records accompanying objects in many of the early ethnology museums throughout Europe are especially tantalizing, despite caveats about the sociopolitical context of these museums' origins and development. The acquisition documents held in American art museums, even though those institutions were founded more recently, are of special interest as well because they hold scattered documentation on the African dealers who sold many works to art collectors in the United States—works that were later transferred to museums through gift, bequest, or sale. In my estimation, much could be uncovered by a systematic and comprehensive investigation of this largely neglected facet of African art collections in museums across the country.[5]

Despite the potential and merits of field, library, and archival research, there are many

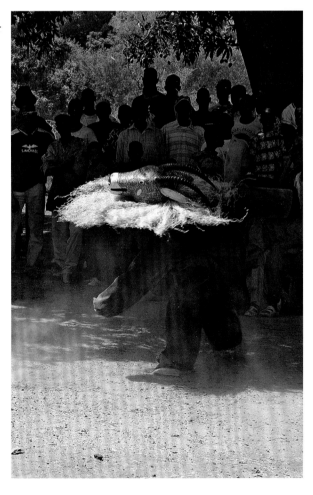

1 Senufo roan antelope masquerader of the Noumoussoba hunters' association, wearing a helmet mask sculpted by Ouattara Konomba and prepared by Ouattara Souleymane Sanga'an, dancing in front of local community members and foreign donors in the village of Kankalaba, Burkina Faso, February 25, 2007. Photo by Susan Elizabeth Gagliardi.

cases where the only source at our disposal is the object itself. Thus Roy Sieber, a foundational scholar in the study of African art, offered the dictum "Begin and end with the object."[6] I share his belief that an art historical investigation should depart from and conclude with the work of art in itself. Even though this approach is not novel, reinvigorated interest in the object might open another avenue toward "renewed study of the age-old arts of Africa," to echo the influential scholar and curator Susan Mullin Vogel.[7] This emphasis upon materiality and form is the cornerstone of the object-focused or object-based art historical research that has been promoted for decades by both academics and museum professionals. It is precisely this kind of analysis that allows even "outsiders"—that is, observers who are not members of the cultures represented by the works and who therefore cannot speak with firsthand authority—to contribute knowledge and enhance the interpretation of works that have resided in collections for half a century or longer or were exported from their African places of origin without any kind of primary documentation or record. Furthermore, the modest number of African scholars who have been contributing

to the field since its inception reflects only a small portion of the cultures and regions represented by African art collections around the world (an issue I will return to below). To this one should add that while there are still parts of Africa where one can see continuities between past and present, there are at least as many parts where a historical disconnect limits the potential of contemporary *in situ* research.[8]

The material study of African art by conservators and conservation scientists is still in its infancy, notwithstanding some noteworthy efforts over the past few decades.[9] Further technological advancements should be explored and applied to the arts of Africa with the aim of refining and improving our understanding and descriptions of the material infrastructure of the works in our museums and collections. Aside from obtaining specific dates and arriving at a better sense of chronology through application of the most sophisticated dating methods, we should also aim at establishing a basic inventory of the wood species used for the carvings that still constitute the majority of African art collections around the world. In recent years, computerized tomography (CT) scanning and X-ray photography

2 Three Bwa masqueraders, all wearing plank masks sculpted by Yacouba Bondé or members of his workshop, waiting to perform in the village of Boni, Burkina Faso, May 3, 2007. Photo by Christopher D. Roy.

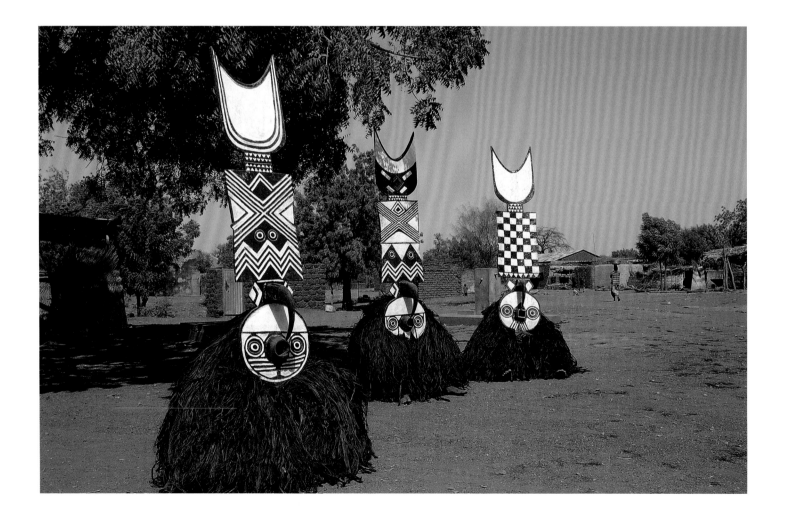

have increasingly been used in both the African art market and the museum field, and have proven to be invaluable means of comprehending how specific works were made as well as detecting forgeries and reconstructions. At the Art Institute these techniques were adopted to examine a magnificent set of five archaeological ceramic figures in the Bankoni style from Mali (cat. 3), confirming the objects' creation dates and attesting to their physical integrity. Another noteworthy project at the museum is an ongoing effort, carried out in collaboration with researchers at Emory University, to determine the composition of the encrusted surfaces that distinguish many of the sculptures created within various modern cultures at the borders of present-day Mali, Côte d'Ivoire, and Burkina Faso (see cat. 10 and p. 37, fig. 1).[10]

Style, Ethnicity, and the Artist
In African art, as in many other arts traditions throughout the world, "style" refers to the visual appearance of an object—or, more accurately, a set of related objects. In the African context, style is more specifically understood as the collective visual expression of a culture or an ethnic group, even though in practice many cultures are known for their multiple different styles. Following a method implemented by connoisseur Frans M. Olbrechts and his students Albert Maesen and Pieter Jan Vandenhoute at Ghent University in Belgium, after earlier examples by Carl Kjersmeier and especially Eckart von Sydow, these ethnic styles are described and ideally presented as part of regional styles or style zones that recognize the existence of broader cultural groupings. This division of the arts of Africa was subsequently updated by American scholars such as Paul Wingert and, later, Roy Sieber, Arnold Rubin, and others.[11] It has also been interrogated continually. Long before 1984, when Sidney Littlefield Kasfir's classic article critiquing the rigid concept of "one tribe, one style" appeared, the issue of ethnic styles had been complicated by scholars such as Vandenhoute, who discussed "internal and external peripheries" in 1948, and René Bravmann, who wrote of "open frontiers" in 1973.[12] In the late 1960s William Bascom, inspired by his extensive research among the Yòrùbá of Nigeria, also pointed out the diversity of styles within a single group, recognizing substyles and individual styles as well as the

3 Installation view of Gallery 137, Art Institute of Chicago, featuring the Baga/Nalu *banda* or *kumbaruba* helmet mask (cat. 19), 2019.

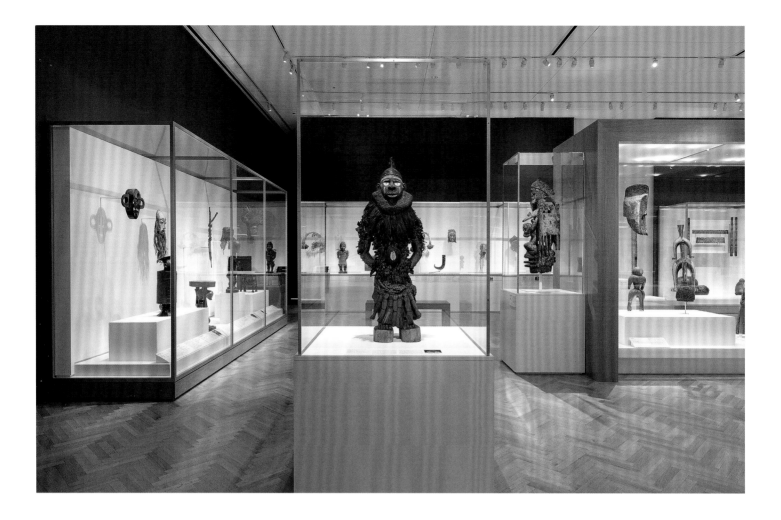

existence of suprastyles, including regional styles that transcend peoples or ethnic groups, and so-called "blurred" or mixed styles (figs. 5–6).[13] But despite these exceptions to the rule, and the fact that there are indeed areas where the ethnic definition of styles does not hold, style as an indicator of both locale and epoch still serves as the key to attributing objects to a particular space and, ideally, a time period. Even if the names of the regions differ slightly from place to place and their composition varies between museums, the map of ethnic and regional styles in Africa has been quite stable and remains a useful tool for organizing the arts of Africa and establishing artistic and, by extension, cultural relationships. To this day, regional styles inform the organizational principles of permanent gallery installations including those of the Metropolitan Museum of Art, New York, as well as the Art Institute.

In my opinion the utility of formal analysis as an investigative technique cannot be over-estimated. I do not deny the fact that the study of style, like connoisseurship, is inherently a Eurocentric concept because it is inextricably linked with the European origins of the discipline

of art history.[14] Nonetheless, the terms and methods it subsumes should remain at the heart of any art historical project and especially of any object-focused study that encompasses questions of attribution and authenticity. No matter how complicated such determinations can be, attribution and authenticity remain central to the museum profession. Curators are constantly asked to assess these qualities when considering acquisitions through purchase or gift and when making selections from external museum and private collections for permanent displays or temporary exhibitions.[15] Formal analysis, whether carried out plainly through visual observation or with the aid of verbal descriptions, drawn or sketched renderings, or photographic records, is the primary technique used to understand an object's appearance and define its style.

Starting in 1929, Olbrechts was one of the first scholars of African art to focus on individual styles—meaning styles that are the expression of an artist, or at least of a workshop or atelier, rather than of a culture—by using the Morellian method, named after Giovanni Morelli, a scholar of Italian Renaissance art.[16] Because the biographical data specifying historical African artists

4 Installation view of Gallery 137, Art Institute of Chicago, featuring the Central Africa section, 2019. The central figure is a Kongo *mangaaka*, which belongs to the Field Museum, Chicago, 91300.

5 Dance Staff (*Oshe* Sàngó), early 20th century. Yòrùbá; Egbado (now Yewa), Nigeria. Wood and pigment; н. 38.7 cm (15 ¼ in.). The Art Institute of Chicago, gift of Richard Faletti, the Faletti Family Collection, 2003.177.

were not recorded, the first exponents of this search for individual styles or hands used conventional or invented names—*Notnamen* in German—to identify recognized artists. Occasionally, actual personal names would be recovered and assigned.[17] But the individuality of the artists in these traditional, even conservative, societies has sometimes been overrated. Indeed, as Vogel and Olbrechts before her have confessed, their intense search for artists' names had much to do with their ambition to be taken seriously by their peers at, respectively, the Metropolitan Museum of Art in the early 1980s and Ghent University half a century earlier.[18]

More recently, Vogel and Mary Nooter Roberts, among others, have convincingly demonstrated that the absence of so many artists' names from the record cannot be attributed solely to a mere lack of interest on the part of European and American scholars. The conventional explanation has been that those in the field did not consider the objects they encountered during their research to be art and therefore neglected to ask the names of their makers.[19] In fact, artists' names were apparently often omitted from field reports as part of a purposeful silence maintained by the patrons and users of the works who, today as they did then, assign more importance to what the objects *do* and can accomplish than to their makers. As a rule, the works that populate Western art collections and publications are perceived locally as more than just human-made sculptures and instead are viewed as powerfully charged implements with identities that rest on their supernatural, spiritual endowment. Of course none of this means that local artists were not known and recognized as such. On the contrary, the most successful ones were likely quite famous and received commissions from far away or traveled long distances to work for foreign patrons. But once the work was completed and put into use, it transcended its material nature and became a spirit-invested device whose earthly, human origins were deliberately suppressed.

Ultimately, stylistic analysis remains the predominate mode of attribution for the arts of Africa. If we can bear in mind that style is informed by both meaning and aesthetics, and that there is no such thing as "pure form," then morphology—the study of form in service of style-based attribution—should go hand in hand with iconography and the study of aesthetics. It is precisely because of this union of form with

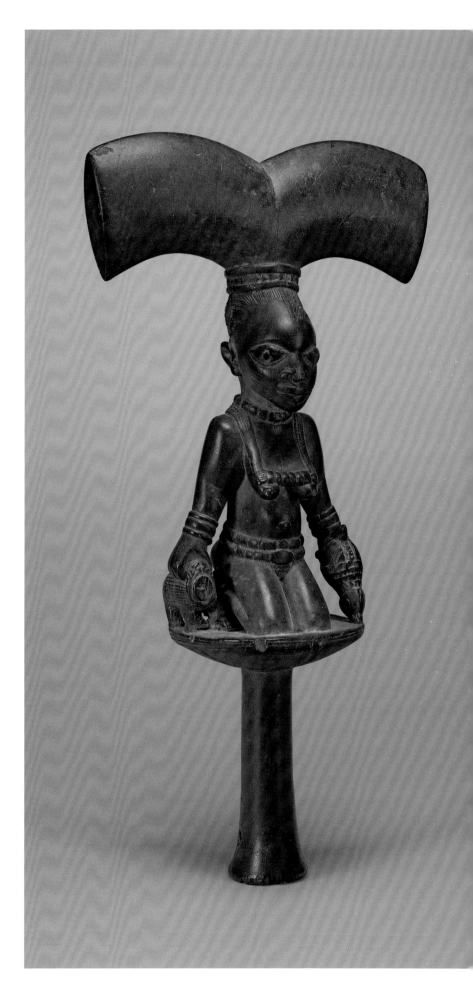

meaning and aesthetics that ethnic styles are what they are and that the arts of the Bamana differ from those of the Yòrùbá and those of the Lega from those of Chokwe, and so on.[20]

History, Tradition, and Provenance

Despite the pioneering recommendations made by Olbrechts in the late 1930s and some serious attempts undertaken since then, complemented by the recent advent of more sophisticated (albeit not unanimously accepted) technological means of dating artworks, our sense of the history of most African art traditions remains extremely limited.[21] In some cases the gap between contemporary *in situ* research and the age of the artworks in collections has made it difficult, if not impossible, to apply newly acquired knowledge to historical objects. The risks of anachronism inherent in this kind of retroactive research are great and are compounded by the fragmented nature of the historical record.

We can simultaneously resist the false assumption that the arts of Africa—as well as the cultures they relate to—are timeless and somehow developed outside of history, unaffected by time, while also reevaluating American and European intellectuals' insistence that the continent's dynamic and ever-changing indigenous arts follow the trajectory of modern European art. Indeed, in an effort to promote the acceptance of Africa's arts as equal to those of other parts of the world—and thus similarly worthy of study— the sometimes conservative nature of the continent's arts has routinely been minimized and occasionally ignored. Although it is difficult, of course, to generalize across the vast continent, there are many instances in which our limited record suggests historical consistency in formal terms. It is remarkable, for instance, that masks and figures of particular genres exported from Africa before 1915 are basically similar to examples of the same genres that were acquired in Africa in the 1980s.[22] It seems highly unlikely that the latter had been created a century or so ago and kept as heirlooms until their acquisition in the late twentieth century. But we have little information on the long history of the arts whose modern and contemporary expressions have been the focus of analysis since the first decades of the past century.

6 Attributed to Areogun of Òsì-Ìlorin (Nigerian, c. 1880–1954). Container (*Opón* Igede), early 20th century. Yòrùbá; Odò-Owà, Òsì-Ìlorin, Kwara State, Nigeria. Wood and pigment; 49.5 × 52 cm (19 ½ × 20 ½ in.). The Art Institute of Chicago, restricted gift of Marshall Field, 1999.288. Compare this *opón* Igede container with the *opón* Ifá divination tray discussed in the concluding essay of this volume (p. 191, fig. 3).

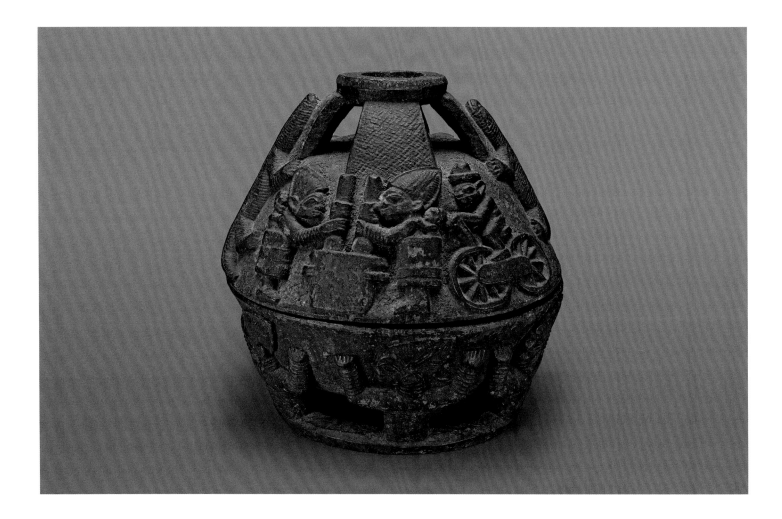

Some Africanist art historians have argued that because of the uncertainty of our chronological data, we should abstain from any form of speculation and merely offer the accession, publication, or exhibition date as a *terminus ante quem*.[23] But I believe this practice may unnecessarily imply the modernity of the works in question and thereby deny their potential age. Perhaps future dating methods will allow us to revisit our assumptions and will reveal that some of the works preserved in collections and reproduced in the literature are in fact much older than we now believe. For the time being we should accept the limitations of our historical understanding and the tentative nature of most of our suggested dates.

Scholars' recent efforts to assign more objective dates to the arts of the continent have freighted provenance research with more significance. This interest in reconstructing collection histories has helped to enhance an evidence-based diachronic framework for the arts of Africa, and it has also been stimulated by the restitution debate, as such research is expected to provide information necessary to determine the legality of ownership. A Western collection history is usually the only primary information associated with an African work of art. But such records rarely reveal the name of the original patron or owner. At its best, provenance research provides the name of the person believed to be a work's first Western owner. It typically does not even confirm an object's place of origin in Africa and consequentially has extremely limited potential to help determine an artwork's rightful owner, whether individual or collective, to whom it can be returned in accordance with restitution concerns.[24]

African Art Scholarship by African Scholars

In 2020 African art occupies a more prominent position on the global stage than ever before. One cause of this special attention is a widely publicized and much discussed report by Bénédicte Savoy and Felwine Sarr, commissioned by French president Emmanuel Macron and released in November 2018, that reignited a long-standing debate about the restitution of looted art to the African continent. It is not my intention here to examine this report in any detail, but I would like to spend some time on the key concern underlying Savoy and Sarr's recommendation to return some African artworks in French and other European museums to the African nations where they originated—to paraphrase the cultural theorist Kwame Anthony Appiah, "Whose art is it, anyway?"[25] Embedded in this question is the notion that not everybody has the same right to lay claim to Africa's "cultural heritage"—which, in the minds of the French president's advisors, seems to include the art category without being limited to it—and that consequently, not everybody can speak with authority about the continent's art. This assumed opposition between "us" and "them" can be traced back to the colonial context within which most of the works from Africa we now commonly label as "art" were first acquired and studied.[26] We must view the foundation of the antecedents for today's European and, to a lesser extent, American ethnology or ethnography museums against the background of imperialism and exploitation. These museums formed the earliest collections of objects from Africa that would, over time, be "transformed" into art in a Western sense. Moreover, despite some modest changes in recent years or even decades, the discipline largely remains dominated by European and American art historians and anthropologists.[27]

The past decades have brought a welcome shift in African art scholarship, with the emergence of students from the continent who have conducted research on and written about their own culture and heritage. In the field of art history, Yòrùbá scholars of Yòrùbá art and, to a lesser extent, Igbo and Akan scholars of Igbo and Akan arts have forged professional careers for themselves and achieved prominence in museums and universities in the United States and beyond. Many of these experts earned their degrees in American or European universities after their initial education in their home countries. And even though their intellectual frameworks are epistemologically and methodologically rooted in those of America or Europe, these researchers have brought significant changes to the discipline thanks to their cultural sensitivities and their linguistic fluencies. Our knowledge of Yòrùbá arts in particular has grown exponentially due to the contributions of Yòrùbá scholars. We have come to appreciate the relationship between sub-Saharan verbal and visual arts and the pertinent role that language plays in the meanings and symbolism of the different African art forms populating museums and private collections in the West.[28] Even though important strides have been made in recent years, many more African scholars of African art are needed and their investigations from within should be further encouraged.

Despite the shortcomings of our general understanding of the arts of Africa, the various contributors to this book offer original interpretations of works pertaining to their respective specialty. The seventy-five color plates in the following pages illustrate a selection of the most important works from the African collection at the Art Institute of Chicago, including objects that were acquired in 1928 alongside others that were added to the collection as recently as 2019. They are organized into four sections reflecting broad geographic regions, in accordance with the arrangement of the Art Institute's newly refreshed gallery of African art; within each section their ordering reflects the map of ethnic (that is, cultural) styles (see pp. 196–97) and their multiple internal relationships. The texts accompanying these images discuss the contextual framework in which the illustrated objects were conceived and used, and the meanings they held for their original audiences. The concluding essay by Babatunde Lawal further demonstrates the benefits of studying an art tradition from within, as he is a member of the Yòrùbá culture and a speaker of the Yòrùbá language. It is to be hoped that the volume as a whole advocates for more research by members of the African communities that have produced these works as well as the potential for achieving a high level of insight into the arts of a particular culture through a combination of object study, archival and library research, and, most importantly, art-focused, participatory fieldwork.

1 At the Art Institute of Chicago, the arts of Africa were originally housed within the department of Primitive Art (founded in 1957); it was subsequently reorganized and renamed several times — most recently in December 2016, as "Arts of Africa and the Americas." As of July 2020, an autonomous department for the arts of Africa was established, which included the arts of ancient Egypt as well as associated curatorial staff.

2 For insightful comments on the problem of how to describe "the kind of African art at the core of our discipline," see also Vogel 2005, 15.

3 For a discussion of how the double heritage of African art studies has contributed to its problematic status within the discipline of art history, see Adams 1989, 55–63; Blier 1990, 91–92 and 100–103; and Phillips 1994, 39–44.

4 On the availability of recently digitized archives and their potential impact on our understanding of African art, see Vogel 2005, 16.

5 A volume on the role of Africa in the art market—set against the background of the Amrad African Art Collection—edited by Silvia Forni and Christopher B. Steiner is an important exception to this trend; see Forni and Steiner 2015. I hinted at the necessity of research on this same issue in an essay on the Central African art collection at the Indianapolis Museum of Art; see Petridis and Gotway 2018, 46.

6 See Kreamer 2003a, 11. For Sieber, the emphasis on the object was a key component of his interest in connoisseurship; Kreamer 2003a, 12–22. See also Cole 2003.

7 Vogel 2005, 13.

8 One case in point is the contrast between the masking traditions of the Pende that were flourishing in the late 1980s and the figurative power sculptures of the neighboring Luluwa, which were extinct by the early 1990s, both in what is today the Democratic Republic of the Congo; compare Strother 1998 and Petridis 2018. Of course, as Susan Mullin Vogel has argued, any of the new visual arts that were developed in rural areas where the traditional arts have been abandoned or extracted from the continent also merit study and are as interesting as their historical antecedents (Vogel 2005, 17); see also M. Roberts 2005, 6.

9 For instance, as announced in a press release on July 5, 2016, the Andrew W. Mellon Foundation awarded the Virginia Museum of Fine Arts, Richmond, a grant of $1.5 million to support in-

depth technical examination, conservation, and art historical studies focused on the museum's African art collection. For a broader discussion of the materialist approach to cultural artifacts, see also a recent special issue of *The Art Bulletin* edited by Nina Athanassoglou-Kallmyer (vol. 101, no. 4 [2019]), especially Fowler 2019.

10 This ongoing project is spearheaded by Susan Elizabeth Gagliardi, associate professor of art history at Emory University, Atlanta, and Brittany Dolph Dinneen, assistant conservator at Emory's Michael C. Carlos Museum. For an earlier collaborative study on two power association helmet masks in the Fowler Museum at the University of California, Los Angeles, see O'Hern, Pearlstein, and Gagliardi 2016.

11 Wingert 1962; and Sieber and Rubin 1968.

12 Vandenhoute 1948; Bravmann 1973; and Kasfir 1984.

13 Bascom 1969a.

14 In his essay on style in Robert Nelson and Richard Shiff's *Critical Terms for Art History*, Jaś Elsner states: "For nearly the whole of the twentieth century, style has been the indisputable king of the discipline, but since the revolution of the seventies and eighties the king has been dead" (Elsner 2003, 98). In his concluding paragraph, however, Elsner warns: "Yet style remains a crucial reminder of our discipline's depths . . . If we abandon it entirely, we do so at our peril" (Elsner 2003, 108).

15 For an interesting discussion of authenticity and its role in the art market, see Forni 2010, 155–57. And as Susan Vogel rightly notes: "A field that might base scholarship upon forgeries is a field in trouble" (Vogel 2005, 15).

16 Even though Olbrechts's first publication dedicated to the "Long Face Style of Buli" did not appear until 1940, in his 1951 follow-up article he tells us that the subject had first captured his attention in 1929. See Olbrechts 1940; and Olbrechts 1951, 131.

17 Neither *Masterhands*, held March 22–June 24, 2001, at the BBL Cultuurcentrum in Brussels (see de Grunne 2001) nor *Afrikanische Meister* (African Masters), which opened at the Museum Rietberg, Zurich, and traveled to multiple venues in 2014 and 2015 (Fischer and Homberger 2014), revealed many names of artists or significant biographical data behind the stylistically identified hands.

18 Vogel 1999, 44; and Olbrechts 1940.

19 Vogel 1999, 44–48; and M. Roberts 1998, 57–58.

20 There is no doubt in my mind that the hundreds or even thousands of ethnic styles as we know them long predate the recent history of colonialism on the African continent, regardless of the actual names of the ethnic groups that are attached to them. For instance, the various styles and substyles associated with the label "Luluwa" surely had been developed well before Chokwe immigrants and invaders applied the ethnonym in the late 1800s to the varied groups that had been using other names to denote themselves, and thus well before the establishment of European hegemony in the region.

21 Olbrechts 1943; this article is an English translation of Olbrechts 1941.

22 In a conversation on February 6, 2018, Anita J. Glaze noted that a Senufo face mask of the *kodoliye'e* (*kodal*) type she documented in the village of Poundia in Côte d'Ivoire in the late 1960s was remarkably consistent with Senufo masks that could be found in European collections at the end of the nineteenth century and in the beginning of the twentieth.

23 Thus, in the didactic labels for the Cleveland Museum of Art's 2015 exhibition *Senufo: Art and Identity in West Africa*, for which she served as consultant and authored the companion book, my colleague Susan Elizabeth Gagliardi initially wanted me to date the works on view on the basis of the earliest temporal reference in their acquisition, exhibition, or publication history. But in the end we refrained from doing so because the provenance information at our disposal was insufficient; Gagliardi 2014, esp. Petridis in Gagliardi, 12–14.

24 Interest in provenances has especially benefited the art market, where the name or names of reputed or "famous" previous owners add significantly to the value and recognition of a work. Silvia Forni commented on the issue of provenance in her essay on the canon and the art market, as did I in my essay on the seminal Antwerp Congo art exhibition of 1937–38; Forni 2010, 154–55; and Petridis 2017a, 117–19. The relationship between provenance and the art market was also addressed by John Warne Monroe and others in a special edition of the journal *Critical Interventions*; Forni and Steiner 2018.

25 Although this formulation is indebted to Kwame Anthony Appiah's essay "Whose Culture Is It, Anyway?" in his acclaimed 2006 book *Cosmopolitanism: Ethics in a World of Strangers*, the universalist argument made in Appiah's book is ultimately aimed at transcending the opposition between "us" and "them," and advocates for a sharing of culture and by exten-

sion of art. I suspect that Appiah's essay also inspired Bénédicte Savoy's 2016–17 lecture series "À qui appartient la beauté? Arts et cultures du monde dans nos musées" for the Collège de France in Paris.

26 Let us also recall, as Susan Mullin Vogel does, that in the United States, "scholarship in African art has always been conducted under the shadow of the politics of race in America and the legacy of colonialism in Africa" (Vogel 2005, 16).

27 Aside from European pioneers who were active from the 1930s onward, including William Buller Fagg, Marcel Griaule, Hans Himmelheber, Frans M. Olbrechts, and Pieter Jan Vandenhoute, the beginnings of the study of African art in the United States can be traced to the anthropology students of Melville Herskovits at Northwestern University in Evanston, Illinois; see also Blier 1988. For further information on the historiography of the discipline, and on Olbrechts and Belgium, see Petridis 2001b; on Sieber and the United States, see Kreamer 2003a–b. For a comprehensive overview of the twentieth-century history of African art studies, see Adams 1989 and the essays in *African Art Studies: The State of the Discipline* (African Art Studies 1990).

28 See Abiodun 2014 for an important contribution to this conversation. Outside of the Yorùbá realm, Senufo scholar Boureima T. Diamitani offered valuable insights on the topic in his essay "The Insider and the Ethnography of Secrecy: Challenges of Collecting Data on Fearful Komo of the Tagwa-Senufo" (Diamitani 2011). Obviously, the presumed dichotomy between "native" and "foreign" anthropologists and art historians cannot ignore the heterogeneity of culture and the subjectivity of the researcher. For some commentary on "multiplex identity" and "situated knowledge," especially in the postcolonial context, see Narayan 1993. My thanks to Susan Elizabeth Gagliardi for bringing this essay and Diamitani's to my attention.

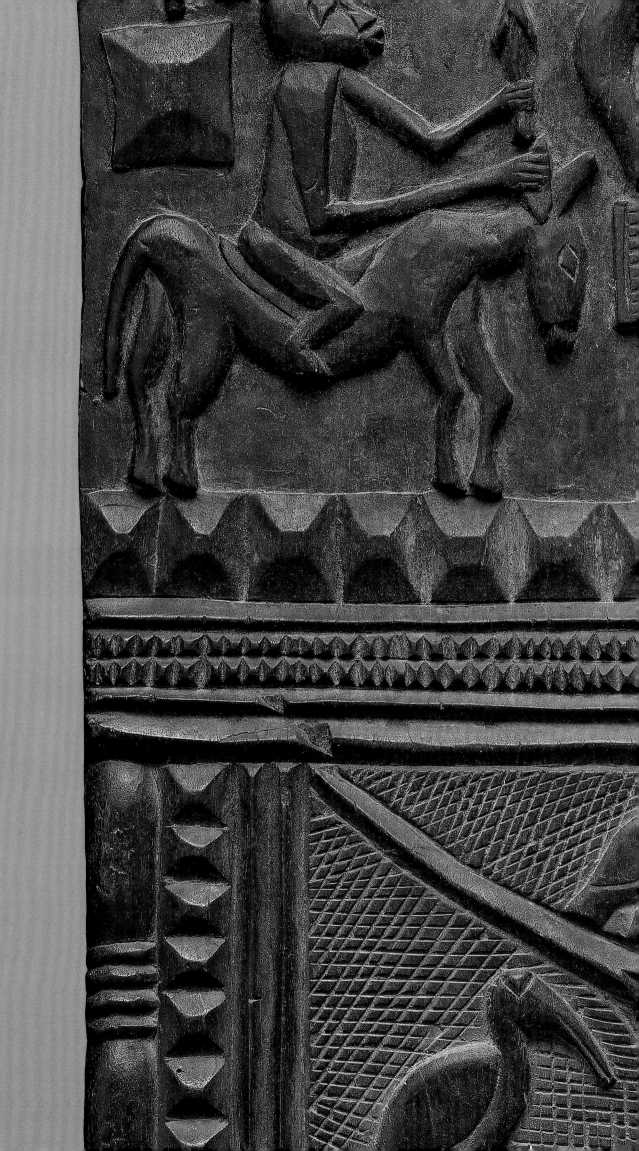

Northern Africa
and the Sahel

1 Pair of Headdresses (*Tyi Wara Kunw*)

Bamana
Baninko region, Mali
Mid-19th to early 20th century
Wood, metal, brass tacks, and grasses
Left: 98.4 × 40.9 × 10.8 cm
(38¾ × 16⅛ × 4¼ in.); right: 79.4 ×
31.8 × 7.6 cm (31¼ × 12½ × 3 in.)

Ada Turnbull Hertle Endowment,
1965.6–7

Provenance: Henri Kamer (died 1992)
and Hélène Kamer (later Hélène Leloup),
Henri A. Kamer Gallery, Paris, by 1965;
sold to the Art Institute, 1965.

Pascal James Imperato

Of Crests, Farmers, and Antelopes

Clearly the work of a master sculptor-blacksmith, the *Tyi Wara kunw* (sing. *kun*) at the Art Institute are a trio of figures—a male and female adult and a male child—that derive their meaning primarily from an association with the myth and mask of Tyi Wara. Once a widely distributed power association (*dyo*) among the Bamana, with a village sanctuary within which power objects (*boliw*; sing. *boli*) were housed, Tyi Wara focused on supporting agriculture and preventing or treating snakebites. This dichotomous purpose reflects the fact that the greatest risk to Bamana farmers while tilling the soil with a hand hoe or removing weeds from their fields is an encounter with a poisonous snake. Thus, from one perspective, Tyi Wara was—and, in a few places, still is—a snake cult. The *dyo* aspect of the Tyi Wara has also persisted in remnant form in a few places, such as the Baninko and Miniankala regions.

The black-necked spitting cobra (*Naja nigricollis*) is one of the snakes most commonly encountered by farmers. The Bamana greatly fear it because its venom is considered inevitably fatal. Yet this snake species figures prominently in the Bamana myth of creation. The deity Mouso Koroni coupled with a cobra and gave birth to Tyi Wara, a half-man and half-animal who tilled

the earth with his claws and a stick from the *sunsun* tree. He also fertilized the soil with his venom. The name *Tyi Wara*, also rendered as *Tyiwara*, *Ci Wara*, *Ciwara*, *Chi Wara*, and *Chiwara*, derives from *tyi* (to cultivate or farm) and *wara* (wild animal).[1] The sculpted headdresses of the Tyi Wara society, such as those discussed here, were generally called *Tyi Wara kun* (Tyi Wara head) in the eastern Bamana area. However, in the western area and among the Malinké, they were often referred to as *Wara kun* (wild animal head), *Wara ba kun* (large wild animal head), *Sogoni kun* (small antelope head), and *N'gonzon kun* (possibly "pangolin head"). These terms were fluid and often used interchangeably.

Tyi Wara taught men how to become excellent farmers. While the literal meaning of "Tyi Wara" is "farming wild animal," it is actually a name that translates as "excellent farmer," "champion farmer," or, by extension, an "excellent worker." This latter sense has been extended in modern Malian society to mean "outstanding performance."[2] But Tyi Wara was disheartened when men eventually became wasteful and less conscientious with their harvests when grain was plentiful. In despair over men's reprehensible actions, he buried himself in the earth.[3]

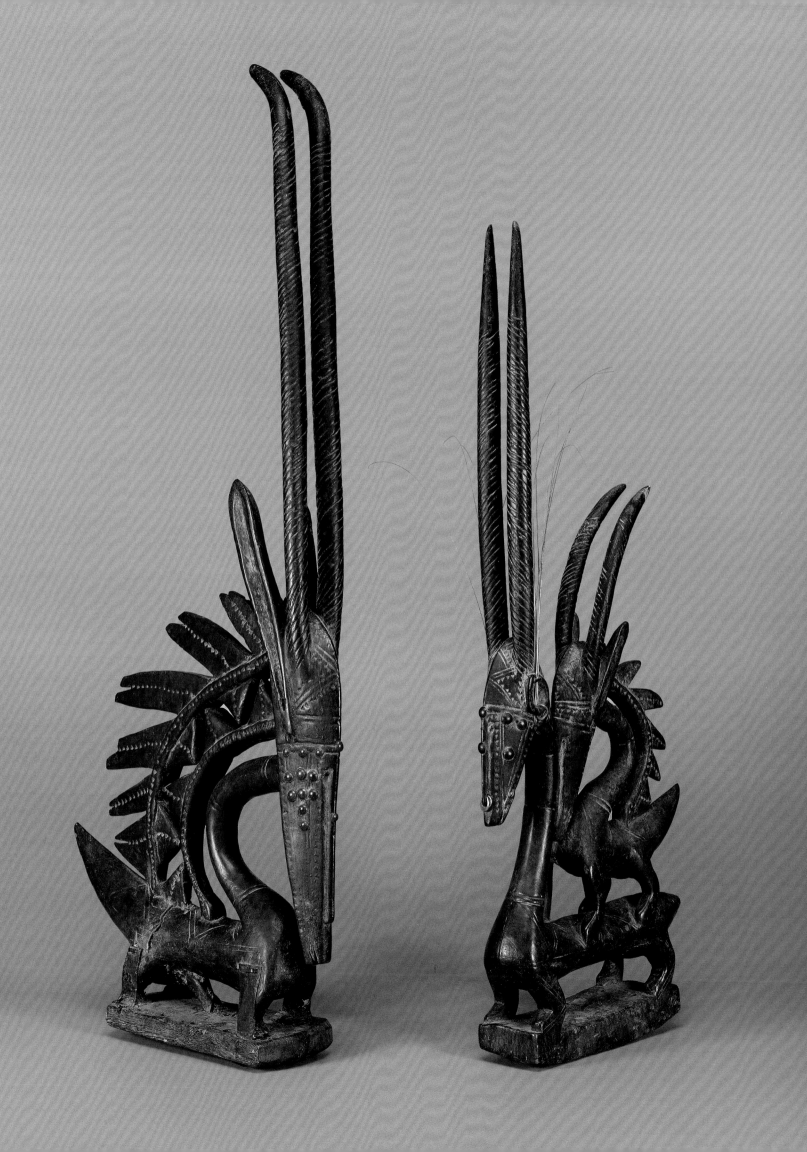

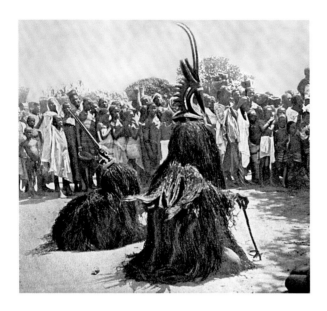

1 Joseph Dubernet (French, early 20th century). "Procession of the Tyi Wara," c. 1910. From Henry 1910, facing page 144.

Historical Documentation of Tyi Wara Headdresses

European interest in Tyi Wara headdresses, or dance crests, began in the late nineteenth century. In 1882 Captain (later General) Louis Archinard shipped an example of a Tyi Wara headdress to the Musée d'Ethnographie du Trocadéro.[4] Several decades later a French missionary named Joseph Henry published a book that provided details about the Tyi Wara *dyo*.[5] Henry also discussed the wooden headdresses and included photographs of them being used in a village ceremony. Taken by Reverend Joseph Dubernet, these images are of great historical importance due to the early period in which they were created. The one shown in figure 1 documents Tyi Wara performers next to a field of maturing millet, accompanied by villagers, some of whom are carrying hoes (*dabaw*; sing. *daba*). Scholars assume that the performers were there to encourage people in their agricultural work. It is also possible that what is depicted is Tyi Wara when it was still a *dyo*—that is, an age-group–based initiation society. Henry reported that by very early in the twentieth century, colonial officials had begun to express interest in acquiring sculpted Tyi Wara crests. This desire may have been catalyzed by French art dealers such as Paul Guillaume, who were prepared to purchase such objects from officials on their return trips to France. Tyi Wara headdresses also became well known to Europeans thanks to Dakar-based photographer François-Edmond Fortier. In 1905 and 1906 Fortier undertook a trip through the French Sudan (then officially the colony of Haut Sénégal et Niger) and photographed a pair of Tyi Wara dancers in a field (fig. 2). They are positioned in the center of the photograph, facing

2 François-Edmond Fortier (French, 1862–1928). "Afrique Occidentale.–Danseurs'Miniankas.'– Fétiches des Cultures," 1905/6. Postcard; 13.3 × 8.3 cm (5 ¼ × 3 ¼ in.). Visual Resource Archive, Department of the Arts of Africa, Oceania, and the Americas, The Metropolitan Museum of Art, New York, VRA.PC.AF.017.

several men who are bent over hoeing. Behind the dancers are an ensemble of drummers and several women who appear to be clapping. Fortier soon published this photograph as a postcard that sold widely in French West Africa and beyond.

The Tyi Wara society was briefly and repeatedly described over the ensuing decades, but no in-depth information was provided until 1960, when Dominique Zahan discussed the Tyi Wara in a volume on the N'Tomo and Kore societies; he eventually followed this with his monumental 1980 work on the Tyi Wara, *Antilopes du soleil*. It reflects a decade of field research (between 1948 and 1959) and laid the groundwork for art historical investigations and museum exhibitions during the twenty-first century.[6] At present, it is apparent that the Tyi Wara tradition survives primarily as a public entertainment among village youth associations (*tonw*; sing. *ton*).[7] In addition, some communities close to Mali's capital, Bamako, have attracted visiting tourists by organizing public performances not only of Tyi Wara, but also of other masking traditions. In one of these communities, modern paints have been used to decorate sculpted vertical headdresses in green, gold, and red, the Malian national colors. Indeed, the vertical Tyi Wara headdress form has become a potent international symbol, widely reproduced in both traditional and digital media, including on postage stamps and currency.

Styles of Tyi Wara Headdresses

Tonw often engage in communal work (*tyi*). In some western and southern Bamana areas, *tonw* involved in these efforts were called *gonzon*, which may derive from the word for pangolin (*n'gonzon-kassan*). A type of scaly anteater,

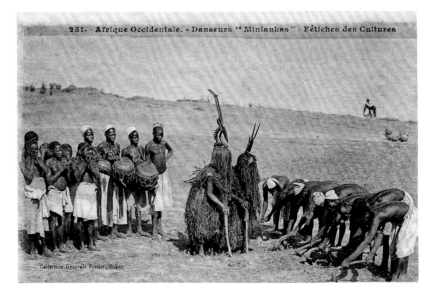

pangolins are found in forested areas of West Africa, including southern Mali, as well as other parts of the continent such as Zambia (fig. 3). The aardvark and other related species are known in Bamanankan as *timba*; like terrestrial pangolins, they are anteaters and proficient at digging into termite mounds with their claws. These two animals are often depicted on Tyi Wara headdresses, sometimes in a blended manner. French anthropologist Solange de Ganay has proposed that sculptors may have placed the prominent ears of the aardvark on the scaly body of the pangolin to demonstrate their shared ancestry in the spirit of farmers.[8]

The majority of the headdresses used in the Tyi Wara performance are carved in either a seminaturalistic or abstract manner with flowing lines, angles, and spaces. All take one of two principal forms—vertical or horizontal—and within these groups there are several substyles. The vertical forms are found in the eastern and southern Bamana areas, and the horizontal in the western ones. Each example possesses the general attributes of the regional substyle, but every one is also a unique creation. The vertical crests are usually extremely abstract, but the dominant animal form in these male Tyi Wara headdresses is recognizably that of the roan antelope with its long, curving horns. The long, straight horns of the vertical female Tyi Wara, on the other hand, represent those of the oryx.[9] The series of triangular forms on the convex backs of these figures—characteristics that are present in the Art Institute's pair—are said to represent the fur mane on the neck and back of roans. This antelope is admired for its beauty, strength, and endurance. Among the Bamana it is comparable to the sun, which is beautiful, strong, and dependable as it pursues its daily path across the sky.[10] Hence the term "solar antelopes" is used to describe sculpted vertical male Tyi Wara headdresses.

The figures' large ears naturally connote a strong sense of hearing; the *dyo* was affiliated with this sense because it was the means by which one was encouraged during farm work. Some of the vertical male Tyi Wara headdresses feature flared bases on the ear structures, which some informants describe as representing the hood of the spitting cobra. They also see the body of the cobra in the sinuous neck that terminates at this "hood." Zahan also described these serpentine elements in some vertical male Tyi Wara headdresses, specifically those from the eastern Bamana area.[11] He proposed that the curving neck might represent the wooden handle of the farming hoe (*daba*) that terminates in

a metal blade, which is in turn represented by the sculpture's long, tapered face. Many informants, however, indicate that the tapered face represents the anteater, the symbol of durability, strength, and resistance. In the Banimounitie area around the town of Bougouni, human figures are often also incorporated into elaborately carved vertical and horizontal Tyi Wara headdresses. Whatever additional forms are present, these sculptures are still referred to as *Tyi Wara kunw* (Tyi Wara heads).

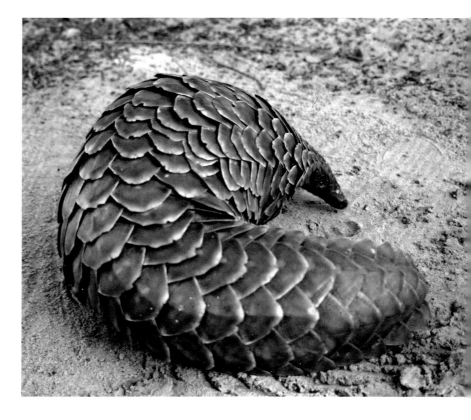

3 A Cape pangolin (*Smutsia temminckii*), Zambia, 1992. Photo by Manuel Jordán.

The Art Institute's Tyi Wara pair reflects a vertical style unique to a small area in the eastern Bamana country, the Baninko (land beyond the Bani River). The Baninko straddles the territories traversed by the north-flowing Banifing, Bagoé, and Baule Rivers, which form the great Bani River that joins the Niger at Mopti. The overwhelming majority of people living in the Baninko are Bamana. The Minianka and Senufo peoples, who also perform with vertical Tyi Wara headdresses, live to the east and south, respectively. Thus, this antelope pair can confidently be identified as Bamana.

By contrast, horizontal headdresses are found in the western Bamana country and among the Malinké. They are more naturalistic in their design than the vertical ones (see, for example, fig. 4). In the northern sector of the western Bamana country, they are patterned after two animals in nature, the hornbill (*dyougo*) and the roan antelope.

The head and mouth are very realistic representations of the head and beak of the hornbill, while the horns and body represent the roan. In some sculptures, a human head protrudes from the body, often facing downward. The surfaces of these headdresses are often decorated with cut-out triangular markings that represent the skin of the pangolin.

The Sculpting of Tyi Wara Headdresses

Traditionally, *Tyi Wara kunw* in the eastern Bamana country were made from the hard wood of the *toro* tree because it was resistant to invasion by wood beetles and termites. Occasionally, the wood of the *bembé* tree was used. Headdresses made more recently tend to be fashioned from the light wood of the *kapok*, which is easy to carve. Blacksmiths (*numuw*, sing. *numu*) have always been the sculptors in Bamana society, so they still carve all of the *Tyi Wara kunw*. When the *dyo* existed, carvers did their work without remuneration. But in recent years they have been paid by the members of the age-group association (*ton*) that commissions them. The choice of style is generally left up to the blacksmith. Occasionally, some members of the *ton* request a reproduction of a headdress they have seen danced in a distant village. In these instances, the blacksmith must travel to the village and observe the headdress, and then model his own creation after it. For this additional effort, the blacksmith is paid a higher

4 Antelope Headdress, early to mid-20th century. Bamana; Mali. Wood, beads, shell, and metal; 44.5 × 66 cm (17 ½ × 26 in.). The Cleveland Museum of Art, gift of Mrs. Ralph M. Coe in memory of Ralph M. Coe, 1965.325.

fee. It takes a skilled blacksmith about ten days of continuous work to produce a headdress of high artistic quality from a hard wood. Headdresses intended for sale on the commercial market can be carved from soft woods in about three days.

Once the figure is carved, the blacksmith decorates its surface with designs before he chars the wood to a patchy black and brown. The headdresses are then further decorated with pieces of red cloth and hammered metal, and given to the buyers. Upon receiving the carvings they have ordered, the members of the *ton* smear them with shea butter and attach them to a basket cap by using cords made from the *da* plant. *Tyi Wara kunw* made for commercial sale are blackened in the same way but are also then suspended from the roof of a smokehouse where, after several weeks, they are thoroughly imbedded with soot. They are then burnished, which makes them a color ranging from deep black to maroon, overlaid with a shining patina. The headdresses used for actual dances are often stored in the rafters of a kitchen in order to protect them from wood beetles and termites, and over the years they develop the same kind of patina imparted by the commercial smokehouses. But signs of wear immediately distinguish ritual headdresses from ones made for the wider market: they become worn by being washed with water after use as well as through being handled.

Tyi Wara Kun and *Sogoni Kun*

Any discussion of *Tyi Wara kun* must acknowledge its possible confusion with *Sogoni kun*, which is the name applied to a headdress, the dancer who wears it, and the dance context in which it is used. Literally translated, the term means "antelope" (*sogo*) "small" (*ni*) "head" (*kun*). Contemporary informants claim that *Sogoni kun* originated in the Wasalu (variously spelled "Wassalou," "Wassoulou," and "Wasulu"), a hilly, wooded region around the Sankarani River where the borders of modern Guinea and Mali meet. The Wasalunké, among whom *Sogoni kun* is said to have originated, are a relatively small ethnic group thought to be of mixed Malinké and Peul origins. *Sogoni kun* diffused through villages primarily among the western Bamana and some of the Malinké as a tradition governed by age-sets. It was one of several masked performances of the *wara denw* (children of the wild animal; sing. *wara den*), organized for public entertainment.[12] According to contemporary

5 Renée Colin-Noguès (French, 1928–2000). *Gwomba*, dance of the agrarian cults, Zégéudougou [Zégédou], Mali, 1952–54.

informants, the diffusion of *Sogoni kun* continued until the immediate post–World War II era; thereafter, the tradition gradually faltered. During the time that *Sogoni kun* was undergoing rural decline as a village-based *ton* tradition, it became popular as a dance performed by skilled itinerant performers and among the Wasalunké and Bamana diasporas living in Mali's capital, Bamako. It had been introduced into Bamako by the 1950s by seasonal workers (*barani*) from the Wasalu.[13]

Sogoni kun falls under the general rubric of *wara* performances.[14] The heterogeneity of *Sogoni kun* performances from one area to another in terms of choreography, costuming, number of dancers, and accompanying music and lyrics makes it challenging to clearly distinguish it from *Tyi Wara kun*, which is performed by an initiation society.[15] There are also similarities between *Sogoni kun* and *Tyi Wara kun* in some areas with regard to female participation. For instance, a female vocalist plays a prominent role in *Sogoni kun* performances, first by singing songs that comfort and assure the dancer, and later by extolling him as well as famous historical figures. In Tyi Wara performances, female *ton* members encourage the dancers through clapping, and one woman often follows them fairly closely carrying a fan. Both performances had become *ton*-sponsored many decades before, but very talented *Sogoni kun* performers sometimes opted to become itinerant artists. Creating small troupes comprising musicians and a female singer along with themselves, they began to perform outside of their village and region, and in metropolitan centers such as Bamako. As independent artists separated from close association with a village *ton*, they were able to be creative with their choreography and thereby infused their work with new and unique features. This process moved *Sogoni kun* further away from the Tyi Wara performance tradition from which it may have emerged or at least have been associated.

Even when context is known, it is a challenge to issue a definitive identification. Some village performances incorporate choreographic or costuming elements of both. To complicate matters, they may refer to the performance not as *Tyi Wara* or *Sogoni kun*, but by some other name such as *Gwomba*, as recorded by Renée Colin-Noguès.[16] The four performers she photographed in the Sikasso region wore wooden sculptures that are stylistically Tyi Wara (fig. 5). Their heads were also camouflaged with a covering of black *da* fibers, and they blew whistles. During the dance, they bent over and carried wooden canes. All of these features align with a Tyi Wara performance, albeit modified. However, their tight

body costumes were decorated with cowrie shells and small clusters of bells were tied around their legs; both elements are characteristic of *Sogoni kun* performances. In other performances I have observed in the western and southern Bamana areas, the predominance of one tradition over the other is not as apparent; in the western and southern regions where the Bamana, Senufo, Malinké, and Wasalunké interface, performance hybridization is common and continues to prompt efforts at clarification.[17]

Differentiating the sculpted headdresses of *Sogoni kun* from those of Tyi Wara is challenging in the absence of contextual information. Some villages possessed both *Sogoni kunw* and *Tyi Wara kunw*; often, the latter were of the horizontal type. The inevitable consequence is that these sculptures are referred to as either *Tyi Wara kun* or as *Sogoni kun* by different writers. What is classified in one publication as a *Tyi Wara kun* may be referred to as a *Sogoni kun* in another. In his classic volume on the Tyi Wara, Zahan classified all of these sculpted headdresses as *Tyi Wara kunw*.[18] Some, however, appear to be *Sogoni kunw* given their small size and white goat-hair attachments. Others have classified headdresses as *Sogoni kunw* that actually seem to be *Tyi Wara kunw*. Accurately classifying some headdresses is virtually impossible. But in the eastern Bamana areas of Baninko, Massigi, and Beleco, the *Tyi Wara kunw* were consistently vertical, like the Art Institute's pair. Additional features confirm its attribution: the long horns; the curving ribs, sculpted mane, and pointed head on the male figure; and the small sculpted "baby" figure on the back of the female figure.

Decline in the Tyi Wara over Time

Bamana *dyow* (sing. *dyo*) and masked performances have been declining steadily for many years. Mitigating factors include the rural-to-urban exodus of young people (who would otherwise sustain village *tonw*), the adoption of more orthodox forms of iconoclastic Islam, and the expansion of electronic forms of entertainment. Two field-based studies provide quantitative data that elucidate this issue with respect to the Tyi Wara in particular. In 1955–59, French anthropologist Dominique Zahan surveyed 637 villages inhabited by the Bamana and Malinké.[19] The Tyi Wara was then extant in 133 (20.9%) of them. Zahan additionally found that the Tyi Wara was present in 77 villages in the subdivision of Kolokani.[20]

This was a high frequency compared to other nearby subdivisions.

A decade later, in 1969–70, I conducted a survey of 132 Bamana villages in the eastern region and attempted to identify the proportion of villages that once possessed the *dyo* of the Tyi Wara; those that then currently possessed headdresses; the types of wood used to sculpt them; the names used; and the ultimate fate of these carvings.[21] I found that of the 132 villages surveyed, 33 of them (25%) possessed the *dyo* of the Tyi Wara at one time or another. By 1970 only four (12.1%) of those villages still had headdresses and danced with them. Among the remaining 29 villages, the headdresses had been stolen in all but one instance (96.5%), when it was thrown away (3.5%). A response of "stolen" may have been given, however, to avoid acknowledging that the sculptures had been sold.[22]

While the above data were published in 1970, additional information obtained during this survey was not included. The fact that people were able to recall detailed facts about the headdresses and how they were stored and treated indicates retained memory based on recent practices. Villages that had Tyi Wara headdresses—at that time or previously—were asked if they knew the wood from which they were made. Most replied that their headdresses were carved from wood of the *kapok* tree. *Bembé* was next in frequency, followed by the hard wood of the *toro* tree and that of the *dyum* tree. Village residents were also asked where the headdresses were or are stored. Some stated that they were stored attached to the ceiling of the *blo* (vestibule) of the head of the *ton*. Two villages kept them in the Tyi Wara sanctuary, and others at the home of the wearer of the male headdress. In recent years, Tyi Wara performances have reappeared in some areas where they had been absent for many years. Much modified, these performances represent a response to tourist demand in some villages, while in other communities they reflect a national effort to revalorize important aspects of Mali's cultural heritage.

1 But the word *wara* has a number of meanings, including "lion," "animal," "wild animal," and "leopard."

2 In recent years, for example, a Ciwara (Tyi Wara) prize has been awarded to students for exceptional academic performance; see Hirschoff 2002.

3 Imperato 1970, 8.

4 Imperato and Imperato 2008, 18.

5 Henry 1910, 143–45.

6 Zahan 1960; Zahan, 1980, especially 20–21; and Imperato 1970, 8–13, 71–80. See also Imperato 1981, 12, 14–15. Zahan later made an important contribution to our understanding of Tyi Wara in an essay posthumously published in *African Arts*; see Zahan 2000, 35–45, 90. In the same issue of that journal, Stephen R. Wooten greatly contributed to our understanding of Tyi Wara based on his extensive field studies in several villages on the Mande Plateau during the 1990s; see Wooten 2000, 19–33, 89–90. Wooten's later studies also extended to broader issues such as rural Malian communities striving to maintain centuries-old farming goals while adopting newer ones; see Wooten 2009.

7 See Colleyn and Homberger 2006.

8 Personal communication, Solange de Ganay, Paris, Jan. 17, 1976.

9 Zahan 1980, 64.

10 Zahan 1980, 89–92.

11 Zahan 1980, 66.

12 Imperato 1970; Imperato 1981; and Prouteaux 1929.

13 Meillassoux 1968, 96–100.

14 Prouteaux 1929.

15 Imperato 1981, 42–46.

16 Colin-Noguès 2006, 56–57.

17 I had previously attempted to partially resolve this dilemma by classifying some headdresses in a hybrid *Sogoni kun/Tyi Wara kun* headdress category defined by uncertainty about their taxonomy and function; see Imperato 1981, 43.

18 Zahan 1980, plates 1–101.

19 Zahan 1980, 166–69.

20 Zahan 1980, 166.

21 Imperato 1970, 73–74.

22 Imperato 1970, 73–74.

2 Headband, Earrings, and Pair of Clasps

Imazighen: Ida Ou Nadif
Souss-Massa region, Morocco
Late 19th or early 20th century
Headband: silver, enamel, niello, glass,
leather, and fabric; earrings: silver,
enamel, niello, glass, leather, and fabric;
clasps: silver, enamel, and glass

Headband: 11.4 × 39.4 cm (4½ × 15½ in.);
earrings: 27.9 × 12.1 cm (11 × 4¾ in.);
clasps: 132.1 × 15.2 cm (52 × 6 in.)

Edward E. Ayer Endowment in memory of
Charles L. Hutchinson, 2002.272–73

Provenance: Fatma ben Houssein ben
Ali, Souss-Massa region, Morocco, by early
or mid-1990s; by descent to her grandson,
El Houssein, Souss-Massa region,
Morocco, from early or mid-1990s; sold to
Ivo Grammet, Essaouira, Morocco, 1997;
sold to the Art Institute, 2002.

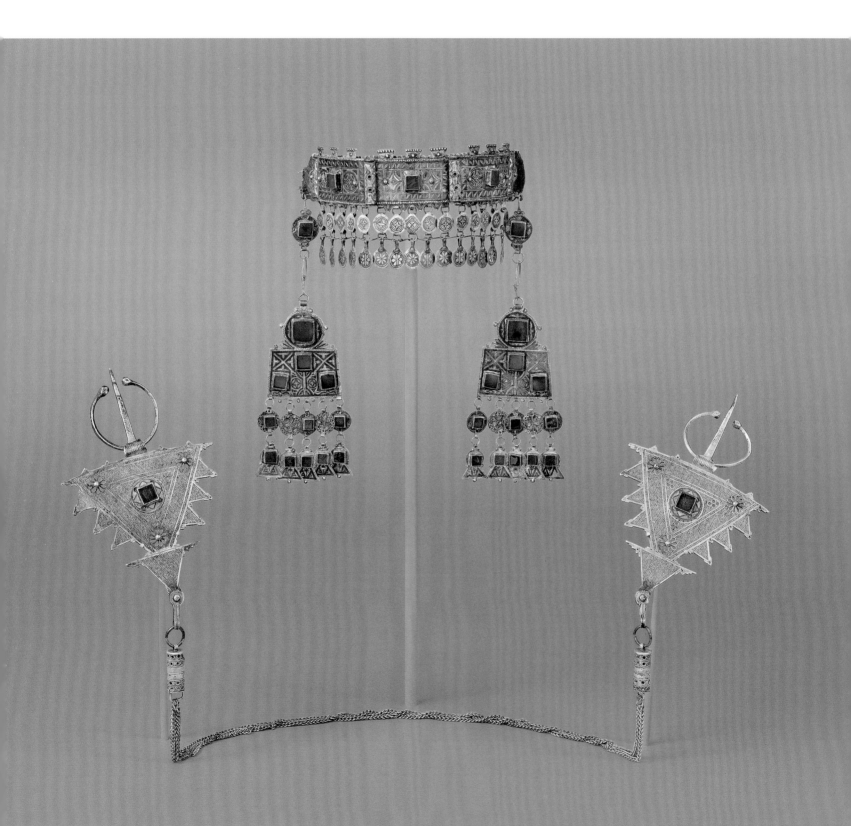

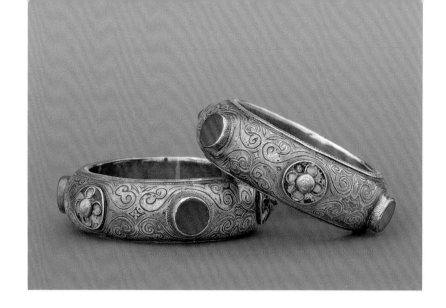

Jewelry is an important form of personal expression for the Imazighen (Berber) peoples of North Africa. These pieces of silver jewelry reportedly belonged to a woman named Fatma ben Houssein ben Ali, and include items inherited from her grandmother and great-grandmother.[1] In the late nineteenth to mid-twentieth century, when these pieces were made, Imazighen peoples lived side by side with Arab and Jewish neighbors and their lives were connected through relationships of exchange and patronage.[2] Jewish silversmiths, some based in towns and others working itinerantly, made items of jewelry including anklets, bracelets, clasps, head ornaments, necklaces, and pendants for diverse clients, blending forms and styles across religious and cultural traditions (see, e.g., fig. 1).[3] The style of this group of jewelry is most closely associated with the Ida Ou Nadif peoples, who live in the Souss-Massa region of the Anti-Atlas Mountains of southern Morocco.

Historically, jewelry was collected by Imazighen women as a way of consolidating

1 Bracelets, late 19th or early 20th century. Ida Ou Nadif; Morocco. Silver, enamel, niello, and glass; 11.4 × 2.7 cm (4 ½ × 1 ⅛ in.). The Art Institute of Chicago, Edward E. Ayer Endowment in memory of Charles L. Hutchinson, 2002.274.1–2.

wealth. A woman added to her collection of jewelry in times of prosperity and sold pieces in times of need. She was also given jewelry by her parents and husband, and these pieces remained in her possession as a form of financial security even in the case of divorce.[4] Elaborate and valuable pieces like these were often worn selectively, and a woman wore her full trousseau only on very special occasions.[5]

Traditional silversmiths crafted Imazighen jewelry of silver or copper alloy overlaid with silver—a Qur'an box pendant also in the Art Institute's collection offers an example of this (fig. 2)—and embellished these pieces with a variety of materials including glass stones, enamel, and niello, a form of metallic inlay. They often combined geometric shapes and patterns derived from indigenous Imazighen designs with curved shapes and stylized floral motifs that were adapted from Arab or Andalusian influences (see fig. 2). This large pair of clasps (cat. 2), for instance, was made using an unusual and demanding technique in which thin tubes of silver are aligned in parallel and soldered together to create a lacy openwork surface. Like many historic Imazighen jewelry forms, their triangular shape can be dated back to antiquity; similarly shaped small gold clasps were excavated at the Roman site of Volubilis in Morocco. Archaeologists also unearthed several medieval clasps among a group of North African scrap goldwork, including broken jewelry, coins, and ingots, at the site of a seventeenth-century shipwreck off the coast of Devon, England.[6]

Kathleen Bickford Berzock

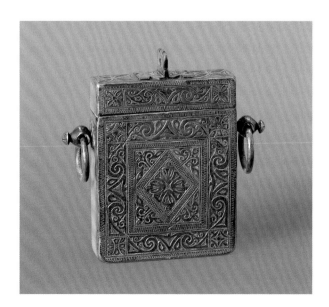

2 Qur'an Box Pendant, late 19th or early 20th century. Ida Ou Nadif; Morocco. Brass with silver overlay; 8.9 × 8.9 × 1.6 cm (3 ½ × 3 ½ × ⅝ in.). The Art Institute of Chicago, Edward E. Ayer Endowment in memory of Charles L. Hutchinson, 2002.275.

1 Ivo Grammet, May 24, 2002, correspondence in the Art Institute of Chicago curatorial object file. **2** Becker 2010, 203. **3** Becker 2010, 203. **4** Grammet 1998, 212. **5** Grammet 1998, 215. **6** These are illustrated in Silverman 2019, 264.

3 Equestrian and Four Figures

Bankoni
Bougouni region, Mali
Probably late 12th–15th century
Terracotta
**Horse and rider: 70 × 21 × 48.5 cm
(27½ × 8¼ × 19 in.); figures: 28.5 ×
14.6 × 19.3 cm (11¼ × 5¾ × 7⅝ in.);
46 × 14.7 × 19 cm (18 × 5¾ ×
7½ in.); 44 × 10.2 × 18.5 cm (17⅜ ×
4 × 7¼ in.); 28.5 × 12.7 × 18.4 cm
(11¼ × 5 × 7¼ in.)**

Ada Turnbull Hertle Endowment,
1987.314.1–5

Provenance: Acquired in Mali by
Sarah Brett-Smith, New Brunswick, NJ,
Jan. 1987; sold to the Art Institute, 1987.

The five Bankoni-style terracotta statues from Mali in the Art Institute of Chicago's collection are an exceptional grouping because of the number of figures and their stylistic characteristics, and also because the set features statues of humans in various positions including standing, seated, and astride a horse. They belong to a sculptural style from Mali named for the village of Bankoni, which is situated on the left side of the Upper Niger River to the east of Mali's capital, Bamako. Terracotta figures of this type were first excavated there in the late 1950s.[1] Since the discovery of the first Bankoni statue in a pseudo-tumulus (an apparent burial mound), similar figures have been excavated in the area to the south known as Bougouni; these are assigned their own regional name. Scholars further differentiate the Bankoni style from the now more familiar Jenné-Jeno style on the basis of formal characteristics: spherical or flattened heads, a long linear torso, abdominal scarifications, and rudimentary facial features.[2] The corpus of Bankoni- and/or Bougouni-style ancient terracotta statues is small relative to the number of Jenné-Jeno figures.[3]

The predominant figure in this group is the mounted horseman, as befits the high leadership position or warrior status of such a person. Beginning in the fifteenth century, horses imported from North Africa were greatly desired in the Sahel and savanna of West Africa. They were previously procured as part of the trans-Saharan slave trade: slaves were exchanged for horses that were valued for height and speed. The animals greatly enhanced the prowess of warriors, especially during warfare or when raiding villages for slaves.[4]

All of the statues with arms are adorned with impressive three-dimensional bracelets that signal the wearer's high social status. In some Bankoni statues, they are also present on the upper arms.[5] These prominent bracelets rarely appear on terracotta statues of the Jenné-Jeno style, however; they are usually represented on these figures by a series of incised lines on their wrists.[6]

The ancient cultural use-contexts of these figures are not fully understood. Like the Jenné-Jeno statues, most have not been unearthed under controlled conditions. Professional excavations have uncovered both these and Jenné-Jeno statues, however, in physical locations that may infer a funerary or ancestral worship cultural use.

The mounted horseman and a similarly bearded seated male figure may have been made by the same artist or in the same workshop. But there is no firm evidence as to the types of individuals who produced ancient terracotta figures in Mali. Bernard de Grunne has recently proposed that the wives of blacksmiths may have been responsible for crafting these objects.[7] He has based this hypothesis on the fact that blacksmiths in this part of Africa have long been associated with the creation of ritual objects in wood and metal. The wives of blacksmiths have been and still are the creators of a variety of terracotta objects.[8] Thus, de Grunne extends this practice into the past and in so doing, he challenges a long-held assumption that these figures were fashioned by men.

Pascal James Imperato

1 Szumowski 1957. **2** de Grunne 1980, 123–35. **3** Bernard de Grunne published photographs of six statues of this style that collectively provide an excellent overview of their unique stylistic features; see de Grunne 1980, 123–35. **4** Webb 1995, 68–69. **5** de Grunne 1981, 27. **6** de Grunne 2014, 144. **7** de Grunne 2014, 51. **8** Frank 1998, 16–18.

4 Fragment of a Kneeling Figure

Jenné-Jeno
Inland Niger Delta region, Mali
11th–14th century
Terracotta
47.6 × 23.5 × 30.5 cm (18 ¾ × 9 ¼ × 12 in.)

Maurice D. Galleher, Ada Turnbull
Hertle, and Laura R. Magnuson funds,
1983.917

Provenance: Probably Adama
Ouologuem, Bamako, Mali, by about
1976; sold to Philippe Guimiot,
Brussels, probably from about 1976;
sold to the Art Institute, 1983.

Terracotta figures in a variety of styles, including this example, were made throughout the region of the Lower and Middle Niger River during the medieval period, which extended from the eighth to the sixteenth century. During this time the area was occupied by three successive powerful states, Ghāna, Māli, and Songhai, which were significant actors in interregional trade networks that reached down the Niger River into the West African forest and traversed the Sahara, connecting with active Mediterranean Sea routes. At the heart of the region, the Niger's vast and fertile inland delta supported hundreds of towns and hamlets with its arable land, perfect for agriculture and the grazing of livestock.

While a small number of figures dating to this period of West African empires have been excavated under controlled circumstances, hundreds more have been illicitly dug up at multiple sites across the region.[1] Like the majority of such figures in museum collections outside of Mali, there is no record of when, where, how, or by whom the Art Institute's figure was removed from the ground, thereby compromising what we can know about it.

This elegant male figure kneels with his long-fingered hands resting on his thighs. He wears a fringed garment at his waist and stacks of rings on each arm, likely representing bracelets cast from copper alloy. The figure's pose and style are similar to several others that have been excavated by archaeologists at and near the site of Jenné-Jeno, which was an important center of trade and learning from the ninth to the fourteenth century.[2] Those figures were excavated from the foundations and walls of several buildings, leading archaeologists to speculate that they were protective objects and possibly associated with ancestors. The snakes that wrap around this man's neck and arms likewise appear on a vessel excavated at Jenné-Jeno and on numerous looted and undocumented terracotta figures and vessels from the region. Close symbolic associations between snakes and the earth align these creatures to ideas about agricultural and human fertility.

Nothing in the archaeological record provides evidence about the artists who made such figures. But a number of craft professions are hereditary and gender-specific among the Mande peoples of the region. In this system pottery is the domain of women, and it is plausible that terracotta sculptures were also made by women centuries ago.[3]

Kathleen Bickford Berzock

1 The Malian "Projet d'inventaire des sites archéologiques dans le Delta" has identified 834 sites in the region, although not all of these have been excavated; see Dembélé 2019, 153. 2 McIntosh and McIntosh 1979. 3 LaViolette 2000, 58; and Frank 2002.

5 Male Figure

Dogon
Bandiagara region, Mali
Possibly 18th century
Wood, pigment, and sacrificial material
98.5 × 15.5 × 13.9 cm (39¼ × 6⅛ × 5½ in.)

Janie Brill Memorial Fund; Major Acquisitions Centennial Endowment, 1996.41

Provenance: Schanté Collection, Paris, by the 1960s. Gaston T. de Havenon (died 1993), New York, by 1971; sold to Marc Ginzberg (died 2012) and Denyse Ginzberg, Rye, NY, 1975; consigned to Lance Entwistle and Roberta Entwistle, Entwistle Gallery, London, 1996; sold to the Art Institute, 1996.

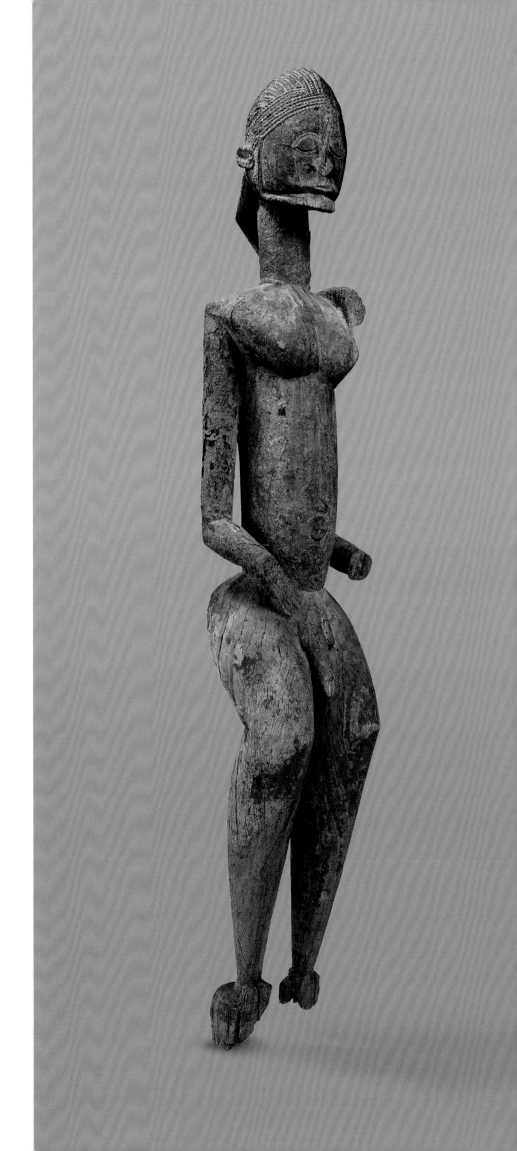

Scholars believe that Dogon sculptures were made for altars honoring the ancestors, in exchange for their protection and support. This particular figure's surface seems to confirm that idea: it shows remains of what, based on comparative research in the field, we understand to be the application of sacrificial materials including animal blood, millet, plant juice, and oil. All of these offerings infused it with a vital energy known as *nyama*. The figure itself probably represents an ancestor, specifically a high-ranking man whose prominence during his lifetime would have been transferred to his posthumous status. His rank is denoted by his finely braided hairstyle, his thin beard, and the amulet-pendant on his chest. A staff called *yo domolo,* hooked over the man's left shoulder, was used as a weapon or tool, or indicated that the person portrayed was a member of a ritual association called Yona, where such a staff would have served as a ritual emblem.[1] The figure's style belongs to the N'duleri category, which refers to a region on the north-central portion of the Bandiagara Plateau.[2]

The Dogon people and their arts have been extensively studied in the field since the 1930s, so we are relatively well-informed about their art-related beliefs and practices even though some early research by anthropologist Marcel Griaule and his team members has been questioned and criticized by subsequent scholars.[3] The provenance of the Art Institute's figure situates it in Paris by 1930, suggesting that it arrived there before the first expedition by the Griaule team in the early part of that decade. Before the museum purchased the work in 1996, it was published a number of times with what appeared to be its male figure counterpart. The assumption that the two figures represent twins cannot be substantiated, however.

A female figure also in the Art Institute's collection (fig. 1) displays the hallmarks of the so-called Tellem style: raised arms, which are interpreted as a plea for rain, along with a heavy, crusty patina and a pared-down form. The name Tellem refers to a population thought to precede the Dogon people and established in the Bandiagara Escarpment in Mali from the eleventh to the sixteenth century.[4] The cultural and artistic affinity between the Tellem and the Dogon is strong, however, and it is impossible to attribute the sculpture to one of the two groups on the basis of style alone. Carbon-14 tests are also needed to confirm this work's actual age. This female figure features a thick patina on its surface, suggesting that it had been placed on an altar where it received repeated offerings of sacrifices—probably animal or plant material—and had thus been supernaturally imbued.[5]

Constantine Petridis

1 Leloup 1994, 488–500; and A. Roberts 1988. See also van Beek 1988; and Bouju 1994. 2 For a description of the various Dogon styles, see especially Leloup 1994, 105–75. The assigned age of this figure is derived from historical knowledge of the region's migration and population history, and has not yet been confirmed by carbon-14 dating. 3 Of Griaule's many publications, his *Masques dogons* (Paris: Institut d'ethnologie, 1938) has received the harshest criticism; see van Beek 1991. 4 Leloup 1994, 135–42; and Bedaux 1988. 5 Leloup 1994, 488–500. See also Ezra 2011, 32.

6 Female Figure (*Bateba Phuwe*)

Lobi
Burkina Faso
Late 19th or early 20th century
Wood and sacrificial material
78.1 × 20.3 × 15.2 cm (30¾ × 8 × 6 in.)

Gift of Richard Faletti, the Faletti Family Collection, 2002.533

Provenance: Eric Robertson, Robertson African Arts, New York, by 1982; sold to Richard J. Faletti (died 2006) and Barbara Faletti (died 2000), Chicago then Phoenix, AZ, Oct. 1982; given to the Art Institute, 2002.

7 Bird Figure (*Lumbr*)

Lobi
Burkina Faso
Late 19th or early 20th century
Wood and sacrificial material
H. 62 cm (24⅜ in.)

Arts of Africa and the Americas Curatorial Discretionary Fund, 2019.716

Provenance: Reportedly acquired in Burkina Faso by Franz Burkhard, Germany, between 1960 and 1979; sold to Thomas G. B. Wheelock (died 2017), New York, 1981; sold Sotheby's, Paris, June 15, 2011, lot 55, to Patrick Girard, Lyon, France; sold to Olivier Castellano, Paris, Sept. 2018; sold to the Art Institute, 2019.

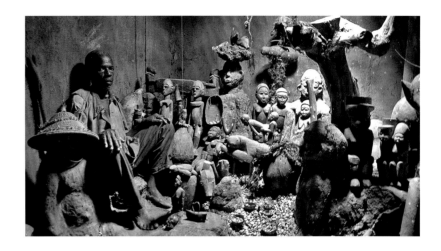

Although they are rarely displayed in art museums in North America, Lobi sculptures are extremely popular among private collectors in Europe. The Art Institute's female Lobi figure (cat. 6) displays an unusually naturalistic style that cannot be situated geographically within the culture's territory. A simian face and four-fingered hands indicate her spiritual nature.[1] Animal Lobi figures are much less common than human ones, which have hairstyles, scarification marks, and other distinguishing features that are said to mimic those of the figures' owners. This figure's flat breasts reflect the carvers' preference for depicting older women.

In their original context in Burkina Faso, such wooden figures are placed in shrines or used in divination to serve as intermediaries between humans and nature spirits (*thila*; sing. *thil*).[2] These invisible *thila* were created by God with supernatural powers and manifest themselves through animals as well as natural objects or human-made sculptures in order to assist people grappling with illness and other misfortune. They also mourn on behalf of the living and help out with more pleasant tasks. The shrines (*thildu*) that serve as dwellings for the spirit-beings are located at the entrances to homes or in the inner courtyard within a cluster of houses. These sites can contain dozens or even hundreds of sculptures in addition to various other types of objects, including clay pots, bottles, and iron staffs (see fig. 1).

The anthropomorphic figure sculptures are called *bateba* and sometimes referred to as *bateba thil*, meaning "child of a *thil*," reflecting how they help the *thil* as a child helps his father. The *thila* also dictate the appearance of the figures, which are typically created in pairs. Offerings of a mixture of earth or clay, animal blood, millet, and plant extracts contribute to the figures' efficiency and efficacy. Over time a thick,

1 Sib Tadjalté, a diviner and healer, in his shrine room, village of Kouekouera, Burkina Faso, 1999. Photo by Huib Blom.

crusty patina forms, testifying to the respect a resident *thil* has earned from the communities that benefited from their supernatural powers.

Among Lobi animal figures, bird images—generically called *lumbr*—are the most common. They are typically much smaller than the Art Institute's example, whose encrustations reveal its repeated usage and old age.[3] Sometimes the sculptures' features are detailed enough to recognize the specific bird species represented. One interpretation states that the birds captured in the figures are sent out by the *thila* to alert the figures' owners whenever they face danger while traveling or working in the fields.[4] The *thil*'s bird representative can then advise the owner to seek the help of a diviner who will identify the cause of the risk and offer a remedy.

Constantine Petridis

1 Roberts and Roberts 1997, 62. **2** Meyer 1981, 52–109. **3** Meyer 1981, 113–16. For a closely related bird figure, most likely by the same hand or at least workshop, see Meyer 1981, 116, fig. 142. **4** In her essay in the exhibition catalogue *Animal*, for a show organized by the Dapper Museum (now closed) in Paris, Daniela Bognolo offers different contextual data about the meaning and purpose of bird sculptures among the Lobi; see Bognolo 2007, 182–86.

8 Plank Mask (*Luruya*)

Bwa
Burkina Faso
Late 19th or early 20th century
Wood and pigment
63.5 × 22.9 × 14 cm (25 × 9 × 5½ in.)

Gift of Joan Faletti Scottberg, Faletti Family Collection, 2000.313

Provenance: William Wright, Wright Gallery, New York, by 1983; sold to Jeffrey S. Hammer (died 2016) and Deborah Hammer (born and later Deborah Stokes), Chicago, by 1983; sold to Richard J. Faletti (died 2006) and Barbara Faletti (died 2000), Chicago, May 14, 1983; given to Joan Faletti Scottberg, Chicago; given to the Art Institute, 2000.

Wooden plank masks are among the best-known arts associated with the various peoples living around the tributaries of the Volta River in Burkina Faso. These are typically incised with geometric motifs that evoke practices of scarification and boldly painted in white, red, and black. The diminutive one shown here exemplifies the Bwa variation of the genre (see fig. 1). Among the Bwa such masks represent characters in family myths and their use is limited to only a few communities, within which their design, production, and performance are controlled by specific lineages.

The Art Institute's mask, generically called *luruya*, is believed to stem from the village of Boni in the southernmost part of Burkina Faso, where the Bondé family has explained that it was created to perform in honor of a historic ancestor. They also asserted that the mask type continues to be used to that end.[1] A man of short stature, this ancestor was a masterful hunter who was able to communicate with animals. On his deathbed he asked his family to commission this relatively small mask to be danced in his memory. It features deep incisions that suggest considerable age, but dating estimates lack scientific support.

Different viewers with varying levels of knowledge have offered interpretations of the abstract patterns of the surface, which rely on a symbolic vocabulary of the spirit world with references to the passage of time, the phases of the moon, and relationships between humans and ancestors.[2] The checkerboard pattern is often understood as a representation of the black-and-white animal hides that elders and initiates sit on during masked performances, and the color contrast in turn symbolizes the distinction between knowledgeable insiders and ignorant outsiders. Incised concentric patterns serve as the eyes while the parallel horizontal lines under

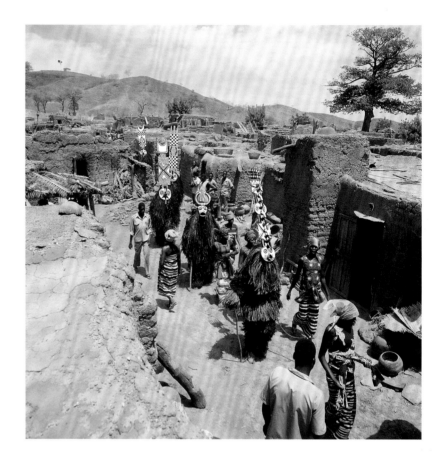

1 Michel Huet (French, 1917–1996). Masqueraders and musicians parading through a village, Burkina Faso, 1970s. Agence Hoa-Qui, Paris.

the eyes and the cross on the plank both represent scarifications. The crescent shape above the plank stands for the moon that shines when the masks are performed, and the hooked protuberance in the section between the plank and the face represents either the circumcised penis of an initiated adolescent or the beak of a hornbill, a bird with magical and divinatory powers.

Constantine Petridis

1 This entry is based largely on oral information provided in 1997 by the late Christopher Roy to Mary Nooter Roberts and Allen Roberts; see Roberts and Roberts 1997, 58. A similar mask is in the University of Iowa Stanley Museum of Art, Iowa City; see Roy 1992, 200–1. 2 See Roy 1987, 276, 290.

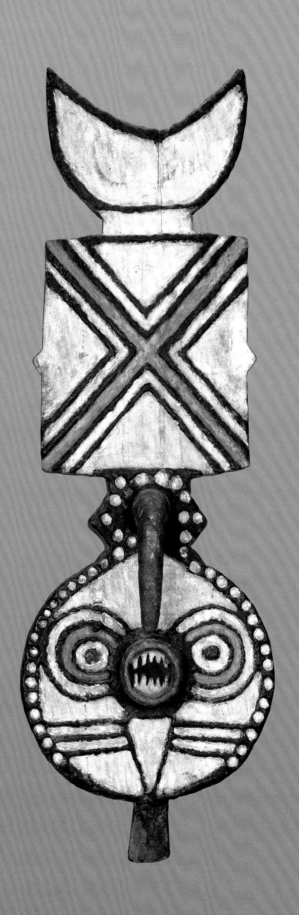

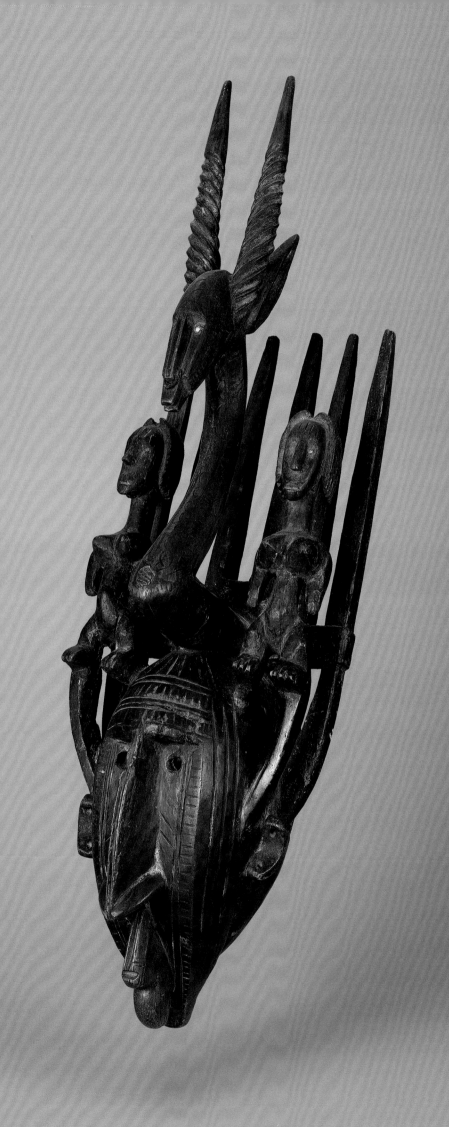

9 Male Face Mask (*N'Tomo*)

Bamana
Segou region, Mali
Late 19th or early 20th century
Wood and metal
79.4 × 22.9 × 22.2 cm (31¼ × 9 × 8¾ in.)

African and Amerindian Art Purchase
Fund, 1961.555

Provenance: Henri Kamer (died 1992)
and Hélène Kamer (later Hélène Leloup),
Henri A. Kamer Gallery, New York,
by 1960; sold to the Art Institute, 1961.

This N'Tomo mask belongs to a Bamana substyle of N'Tomo masks from the Segou region of Mali that are generally characterized by rear vertical horns. Some are embellished with cowrie shells and red *n'de'* seeds (abrus seeds). The Bamana N'Tomo society is an initiatory group, once composed of five classes, for boys who are not yet circumcised.[1] But in recent decades the society's masks have been presented for secular entertainments by village age-set associations known as *tonw*.[2] These entertainments, known in the western Bamana areas as *wara* (animal) and in the eastern areas as *sogo* (antelope), are usually held in the pre-planting and post-harvest seasons.

Allen Wardwell extensively described the Segou substyle that includes not only N'Tomo masks but also Tyi Wara antelope headdresses, sitting and standing statues, horse-and-rider figures, and marionettes.[3] More than sixty sculptures in this substyle have now been identified in private and museum collections. Bamana N'Tomo masks frequently have standing figures, antelope busts, or inverted crocodiles or lizards incorporated into their superstructures. The Art Institute's mask is unique among the known N'Tomo masks because it has twin female figures on either side of an antelope bust; solitary ones are typical. However, it is also noteworthy that these figures, including the ones found in the superstructures, are not rendered in the usual form of Segou-substyle statues. Wardwell attributed such modification to artistic license and noted that the style of these figures more closely resembles that of Bamana figures found to the south of Segou.[4] N'Tomo masks of this substyle are characterized by elongated faces, large vertical noses with flared nostrils, pursed lips, incisions along the sides of the face, small arc-shaped ears, round eyes, and a small stylized beard beneath the mouth.[5]

The precise origins of objects of this more southern substyle and its proponents have been debated since at least 1927.[6] It seems probable that the substyle began in the Segou–Sarro area in the late nineteenth century, initiated by a master blacksmith-sculptor of great virtuosity, and continued until the early twentieth century. In 1964 Henri Kamer, a Paris-based art dealer, informed Wardwell that the seated figures in this particular substyle originated in Sarakolé villages in the Bafoulabé district of western Mali.[7] This assertion was based on scant evidence, however; Wardwell was rightly skeptical, not least because the Sarakolé have been adherents of Islam for many centuries. The prevailing opinion among scholars at the time was that these sculptures originated in the Segou area.

The writer Ezio Bassani raised the possibility that the sculpture's origins lay between Segou and Koutiala to the southeast.[8] However, the evidence he presented to support this opinion is not convincing; in recent years, Jean-Paul Colleyn and I have independently concluded, on the basis of on-site field studies, that these sculptures came from the area of Segou-Sarro in the eastern Bamana area.[9]

Pascal James Imperato

1 Henry 1910, 109–12; Zahan 1960, 52–73; and Zahan 1974, 17.
2 Zahan 1960, 52 –73; and Imperato 1980, 82. **3** Wardwell 1966, 112–28; and Bassani 1978. **4** Wardwell 1966, 122. **5** Wardwell 1966, 118. **6** Bassani 1978, 198–99. **7** Wardwell 1966, 126. **8** Bassani 1978, 199. **9** Colleyn 2001, 158–60.

10 Helmet Mask (*Kono Kun*)

Bamana
Mali
Early to mid-20th century
Wood, horn, quills, and sacrificial material
22.9 × 103.5 × 28.6 cm (9 × 40¾ × 11¼ in.)

Through prior gifts of Mr. and Mrs. Herbert Baker, Mr. and Mrs. Dave Chapman, Dr. H. Van de Waal; through prior acquisitions of the Robert A. Waller Fund, 1997.62

Provenance: Private collection, Belgium, from late 1960s; sold to Philippe Leloup and Hélène Leloup (previously Hélène Kamer), Arts Primitifs, Paris, by 1996; sold to the Art Institute, 1997.

This large and impressive wooden mask once belonged to a chapter of the Kono initiation society. This secret power association was once common in the eastern Bamana area, especially in the cercles of Segou and San, and among the Bamana's southeastern neighbors, the Minianka.

This mask's large ears and long snout are stylized representations of an elephant's ears and trunk.[1] This symbolism relates to the aims of the Kono society, which are directed toward maximizing an individual's intelligence and understanding. The ears' size expresses the power of Kono to hear and know everything. A heightened sense of hearing allows the spirit residing in the mask—and, by extension, the masquerader who appears wearing it—to acquire information for the society and to then impart it to initiates. As the anthropologist Jean-Paul Colleyn notes, however, this society is also concerned with fostering human and agricultural fertility.[2] Kono is further responsible for neutralizing sorcerers and exercising social control.

While working in French colonies in the early twentieth century, Joseph Henry and Louis Tauxier documented much about the Kono society, its shrines, and its material culture.[3] In particular, Henry published a photograph of an elongated *Kono kun* (Kono head) similar in its overall form to the one at the Art Institute.[4] He also published a remarkable photograph of another Kono mask along with a *boli* in the shape of a zebu (a type of oxen; see also p. 47, fig. 1).[5] Henry and Tauxier reported that the *Kono kun* is worn by a masquerader who is camouflaged in a costume covered with feathers (see fig. 1). Although the mask represents the elephant and the *boli* represents a zebu cow, the feathered costume of the masquerader reminds initiates of Kono's relationship to birds, which symbolize the human internal spirit. The purpose of the mask and its rituals is to encourage young initiates to strive to develop a keen sense of thinking and an ability to discern good from evil. Abstract thought is emphasized so

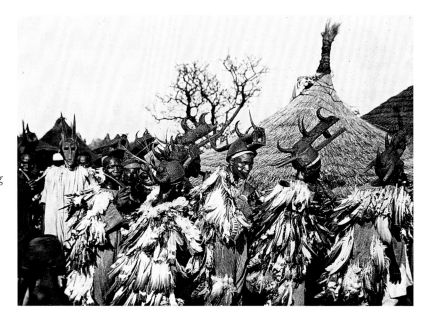

1 A Kono performance among the Senufo, Bobo-Dioulasso, Burkina Faso, 1950. Photo by Germain Nadal. Archives Nationales d'Outre Mer, Aix-en-Provence, France, CAIN 30FI5/14.

that initiates can, as Dominique Zahan puts it, think of "a bird capable of lifting an elephant and carrying it away."[6] The performer generates a whistling sound that is both unique and terrifying to non-initiates. This masquerader is accompanied by the leaders of the society and by singers who softly perform their ritual songs.

The top surfaces of Kono masks are often covered with talismans of various sizes sewn into leather or cloth sacs. These are tied with cord to the upper plank of the long snout. Some masks are also embellished with antelope horns and porcupine quills. Sacrifices of animal blood and millet porridge are poured over them, forming a thick gray encrustation over time. Evidence of such treatment can clearly be seen in this example, and the surface accretions attest to its great age.

Pascal James Imperato

1 Zahan 1974, 19. **2** Colleyn 2001, 188. **3** Henry 1910; and Tauxier 1927, 327–28. **4** Henry 1910, 152. **5** Henry 1910, 152. For another example of a *boli*, see cat. 11. **6** Zahan 1974, 19.

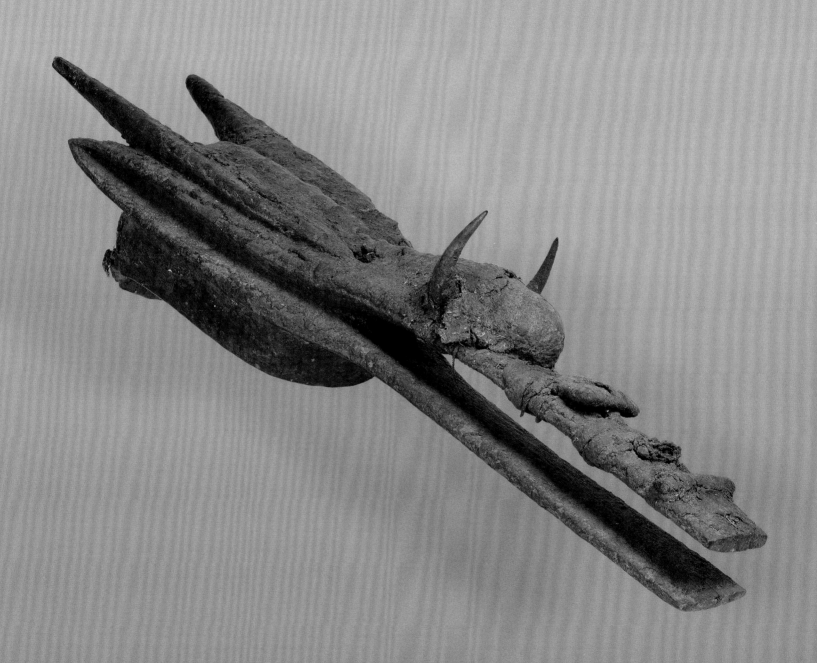

11 Zoomorphic Figure (*Boli*)

Bamana
Mali
Mid-19th to early 20th century
Wood, cloth, mud, and
sacrificial material
H. 43.8 cm (17¼ in.)

Gift of Mr. and Mrs. Harold X.
Weinstein, 1961.1177

Provenance: Mary and Harold X.
Weinstein, Chicago, by 1961; given to the
Art Institute, 1961.

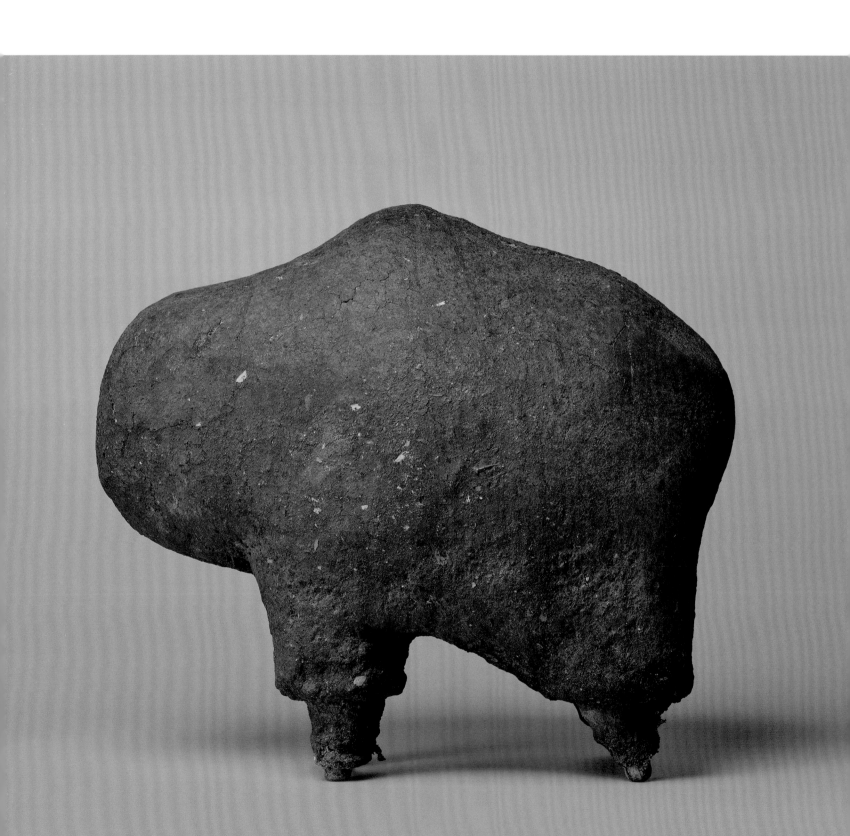

1 A Kono mask and a zoomorphic *boli* power object, Mali, before 1910. From Henry, 1910, facing p. 152.

Boliw (sing. *boli*) are magical power objects that the Bamana use to assess accusations, divine guilt, and punish wrongdoers, especially sorcerers. They are created in a variety of forms, such as round balls, sticks and branches, human-like figures, and cows.

This impressive *boli,* in the form of a zebu (a type of oxen) with a hump on its back, was a principal power object of a village chapter of the Kono initiation society.[1] It would have been stored in a substantial mud brick shrine.[2] Joseph Henry, a French missionary, published the first known photograph of this type of *boli* at the entrance to such a shrine, where it was placed next to a Kono helmet mask, or *Kono kun* (fig. 1; see also cat. 10).[3] A 2009 catalogue by Jean-Paul Colleyn included a number of computerized axial tomography (CAT) scans of *boliw* and their interior construction, with a particular focus on these large zebu-shaped examples. The contents thus identified included cloth dolls, antelope horns, wooden frames, clusters of medicines, bone fragments, and knotted cords (*tafow*)—that is, verbalized talismans.[4] The cow-like forms of Kono-society *boliw* symbolize a chapter's material and spiritual wealth, as literal cattle do among the Bamana. One of the aims of the Kono society is to promote female and agricultural fertility.[5]

The encrustations found on the surfaces of *boliw* consist of a heterogeneous mixture of sacrificial elements that might include millet porridge, alcoholic liquids, chewed kola nuts, saliva, the blood of sacrificial animals (such as chickens, goats, sheep, dogs, monkeys, and cattle), and animal or human excrement. Over time, sacrificial materials build up to create a hard layered exterior. All of these encrusted surfaces are understood to possess enormous amounts of *nyama*, a vital life force or energy. The use of blood in such practices has been particularly well documented. Henry published a photograph taken by his colleague, Reverend Joseph Dubernet, of a Bamana elder sacrificing a chicken over a round

boli.[6] Evidence of blood sacrifices on the surfaces of *boliw* has also been scientifically confirmed.[7] New research undertaken by scientists at the Art Institute using advanced protein analysis methods allowed them to confirm the specific presence of chicken, goat, and dog blood on the museum's *boli*.[8]

The purpose of periodic sacrifices over *boliw* of this type is to nourish them. In so doing, Kono society leaders hope to make them responsive to individual and communal requests. Some *boliw*, usually from the cercle of San, are fashioned in the shape of a zebu and constructed with an interior hollow bamboo tube running along the length. These tubes represent an intestinal tract into which sacrificial materials are introduced.[9] This *boli* has a residual small opening in the rear behind the back legs. It probably once had a front opening that became obscured over time by liquid sacrificial materials dripping and then hardening over it. The thick patina of the Art Institute's example speaks to its former use as a major power object as well as its great age.

Pascal James Imperato

1 For more recent studies of these *boliw*, see Brett-Smith 1983; Cissé 1996; and Colleyn 2009, 37–173. **2** Tauxier 1927, 327–28. **3** Henry 1910, 152. **4** Colleyn 2009, 154–55. Regarding the talismans, see Imperato 1977, 64. **5** Colleyn 2001, 188. **6** Henry 1910, 137. **7** The authors confirmed the presence of blood in the patinas of seven of eight Dogon and Bamana objects tested, including a Kono society *boli* in the collection of the Musée du quai Branly–Jacques Chirac. See Mazel et al. 2007, 9255–60. **8** Granzotto et al., 2020. The research was undertaken in collaboration with staff at the Northwestern University Proteomics Core Facility, Evanston, IL. **9** Leiris 1934, 87.

12 Helmet (*Sigi Kun*)

Bamana
Mali
Mid-19th to mid-20th century
Wood and pigment
H. 70 cm (29 %₆ in.)

African and Amerindian Curator's
Discretionary Fund; through prior
restricted gift of the Alsdorf Fund;
through prior gift of Mrs. Ernest B.
Zeisler; through prior restricted gift of
the American Hospital Supply Corp.;
through prior gift of the Britt Family
Collection, Gwendolyn Miller and
Herbert Baker; through prior restricted
gift of the Alsdorf Foundation; African and
Amerindian Art Purchase Fund; through
prior gift of Deborah Stokes and Jeffrey
Hammer in honor of Milton Gross; through
prior gift of Muriel Kallis Newman; through
prior bequest of Florene May Schoenborn,
2018.362

Provenance: Simon Escarré (died 1999)
and Miche Escarré (died 2007), Korhogo,
Côte d'Ivoire, and La Baule, France, from
early 1950s; Miche Escarré (died 2007),
La Baule, France, by 2002; sold to Patrick
Girard, Lyon, France, Apr. 26, 2002; sold
to the Art Institute, 2018.

West African forest buffalo (*Syncerus caffer nanus*) are commonly depicted in public entertainments among the Bamana and Senufo peoples. These performances are usually presented by Bamana village youth associations (*tonw*) as part of pre-sowing or post-harvest celebrations. The helmet form of this mask is found among the Senufo of northern Côte d'Ivoire and southern Mali. It is also present among the Bamana of southern Mali. In the north, however, the Bamana use either a face mask with similar horns or a basket-based headdress with long straight horns tipped with small bird figures. In both of these latter forms, a female figure may be present on the top of the headdress or mask.

One of the earliest descriptions of the buffalo pantomime and other, related performances was published by M. Prouteaux, a chief administrator in the French colonies; he based it on observations made in the northern part of present-day Côte d'Ivoire in 1913.[1] There, the person representing the buffalo performed along with hunters who were eventually unsuccessful in their hunt. Prouteaux included in his article a description of Bamana *tonw* performances provided to him by Satigui Sangaré, a schoolteacher from the cercle of Bougouni in what is now Mali.[2] These performances, known as *wara* or *ouara* (wild animal), included a number of masks and masquerades. In the eastern Bamana areas, they are called *sogo* (antelope), and often include performances with marionettes. Sangaré provided a thorough description of the animals presented in village *wara* performances; these included the buffalo, to which he gave the name *Misi kun*.[3] Sangaré describes the mask as having horns, and indicates that the performance featured the wearer of the *Misi kun* chasing off masqueraders representing monkeys.

The Art Institute's headdress, a work of great virtuosity by a master blacksmith-sculptor, clearly represents a buffalo. But other such headdresses represent a cow (*Misi kun*). It is noteworthy that Sangaré called the buffalo mask he documented in the cercle of Bougouni *Misi kun* (cow head) and not *Sigi kun* (buffalo head).[4] Among the Bamana of western Mali, the *Misi kun* (cow head) is similar to the *Sigi kun* in its overall form; also, the choreography of the two is similar.[5] It is sometimes difficult to distinguish one from the other. Nonetheless, the imposing wooden helmets with large, curved horns found among the southern Bamana are invariably termed *Sigi kun*.

Pascal James Imperato

1 Prouteaux 1929, 449–75. 2 Prouteaux 1929, 469–75.
3 Prouteaux 1929, 470, 473–74. 4 Prouteaux 1929, 470–73.
5 The *wara* performances of villages in the western Bamana area, including the cercle of Bougouni, have been described in detail; see Imperato 1972; Imperato 1975, 62–70; and Imperato 1980, 47–55, 82–85, 87. The *Sigi kun* mask and performance have also been discussed in detail based on field observations. See Imperato 1972, 23; and Imperato 1980, 83.

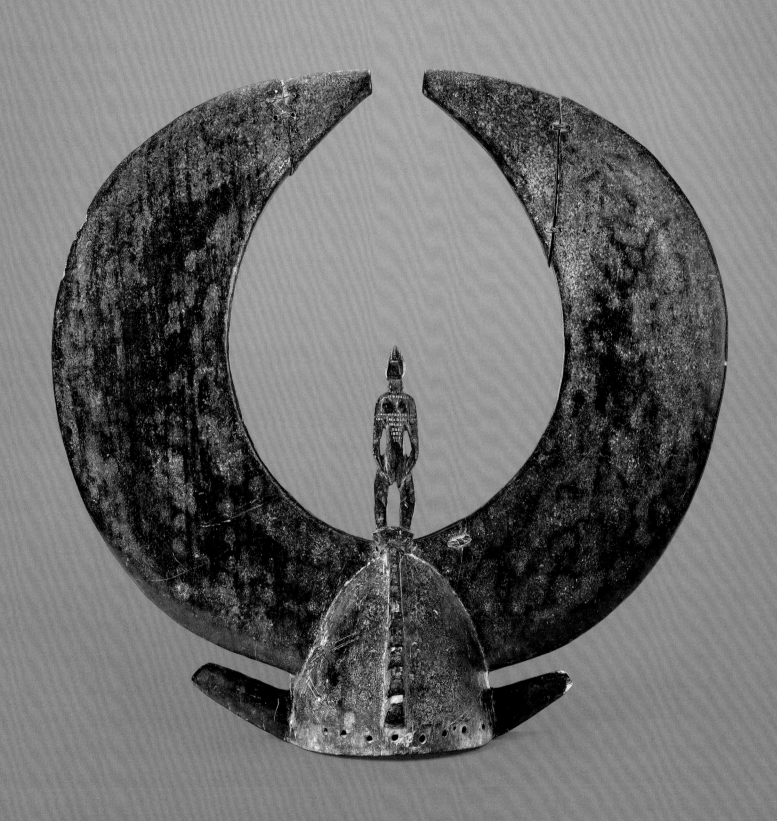

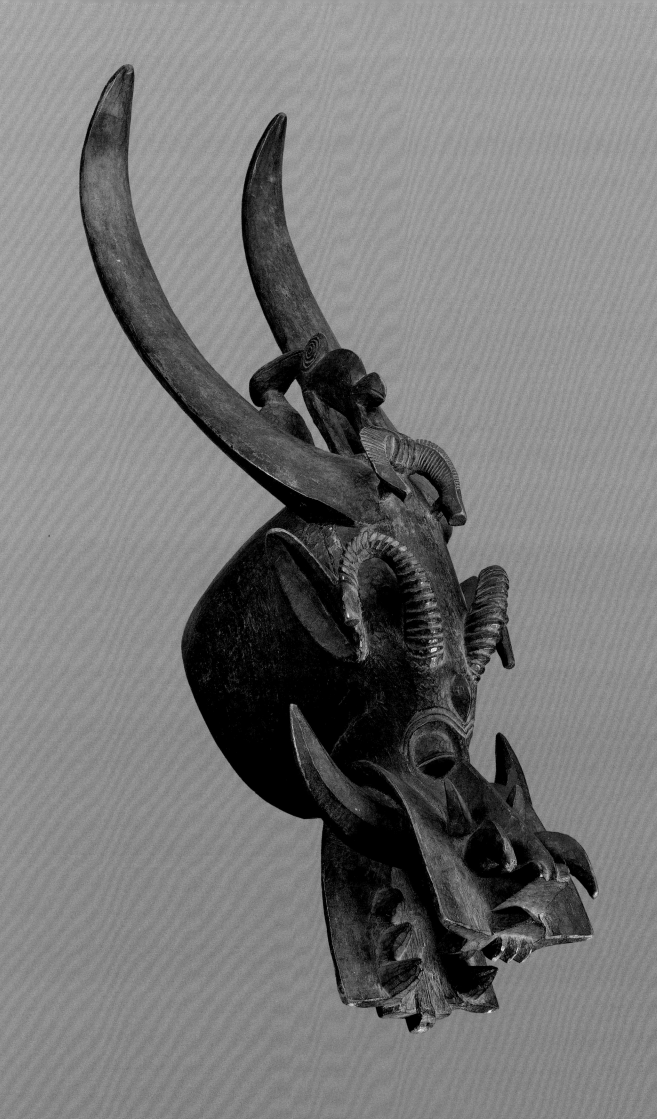

13 Helmet Mask (*Kponyungo*)

Senufo
Côte d'Ivoire
Mid-19th to mid-20th century
Wood and pigment
27.9 × 27.3 × 102.9 cm
(11 × 10¾ × 40½ in.)

African and Amerindian Art Purchase Fund, 1963.842

Provenance: Henri Kamer (died 1992) and Hélène Kamer (later Hélène Leloup), Henri A. Kamer Gallery, New York, by 1963; sold to the Art Institute, Nov. 1963.

This genre of composite Senufo helmet mask is called *kponyungo* (also spelled *ponyugu*), meaning "head of the Poro." The name points to its connection with a village's Poro association, an organization responsible for interacting with supernatural forces, honoring the ancestors, educating young people, and patronizing the art that plays a role primarily in initiations and funerals. *Kponyungo*'s main task is to appear at the burial and funeral of a deceased member of the association in order to escort him to the otherworld while simultaneously protecting the community from supernatural threats (see fig. 1).[1] The Art Institute's *kponyungo* was most likely carved by a *kuleo* (woodcarver) from the central Senufo area around Korhogo.

Despite local variations in both form and style, the features of all the masks in the genre refer to multiple animals in order to express their otherworldly potency. These elements might include the long horns of an antelope (sometimes they are rendered flat and interpreted as those of a buffalo), the jaws of a crocodile or a hyena, the horns of a ram or a warthog, and the ears of a hyena. Combined, these animal traits evoke terror and danger. The eyes and nose, however, are anthropomorphic. This example also includes a rendering of a chameleon holding an abstract wing-shaped motif, called *mangele*, between its feet. Both the chameleon and its burden refer to the Senufo cosmogony.[2]

The specific iconographic characteristics of such sculptures are dictated to the carver by the commissioning organization, so every sculpture is unique and interpretation is difficult outside its performance context in Senufoland. There, the mask character typically is worn in combination with a painted cotton bodysuit and a thick collar of raffia fibers. The performer carries a small double-membrane drum that plays a key role in separating the "shadow" or life force of the

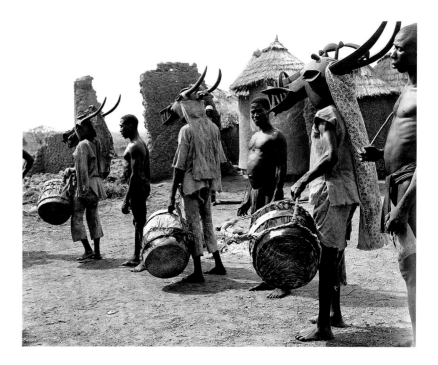

1 Michel Huet (French, 1917–1996). A *kponyungo* performance at a funeral in Korhogo, Côte d'Ivoire, probably 1970s. Agence Hoa-Qui, Paris.

deceased from his body during the burial ritual. Either the masked man or an assistant rings a small iron bell to announce his arrival in the village and ensure that only Poro association members and the closest relatives of the deceased are present; everyone else seeks refuge in their homes. Although these funerary appearances in the context of a Poro death continue to this day, in recent times *kponyungo* also features in public performances where he may pay his respects to a national politician at a rally.[3]

Constantine Petridis

1 See Glaze 1981b; Bochet 1993b, 2: 19–20; and Förster 2004, 200–201. 2 It should be noted, however, that the name, function, and nomenclature of these composite helmet masks varies among the different Senufo (sub)groups, and that the same genre is also used by the non-Poro association called Wa(m)bele. See Richter 1981. 3 Förster 2004, 201.

14 Door (*Korugo*)

**Carved by Nyaamadyo Koné
(active early to mid-20th century)**
Senufo
Côte d'Ivoire
Early to mid-20th century
Wood and pigment
136.5 × 64.7 × 3.8 cm (53¾ × 25½ ×
1½ in.)

Restricted gift of Anita Glaze,
Marshall Field, and Robert J. Hall;
through prior gifts and acquisitions
of various donors, 1992.732.

Provenance: Acquired in Côte d'Ivoire
by Anita J. Glaze, Champaign, IL, by 1991;
sold to the Art Institute, 1992.

Senufo carvers have made massive doors since at least the early twentieth century. But their use had been in decline for many years by the time that scholars began to show interest in them, so our knowledge about these sculptural works is limited. Their production seems to have been confined to the northern region of the Senufo territory. The doors most praised locally were carved in the first third of the twentieth century by a small number of master sculptors from western *kulebele* (woodcarvers; sing. *kuleo*) workshops such as those of Dabakaha, Kolia, and Ouazumon. They were signs of status and prestige, both costly and time-consuming to make.

Some of these doors served to close off the homes of chiefs, notables, and wealthy individuals. Others likely belonged to sacred spaces such as the small buildings that served as altars and consultation rooms for ritual experts including the *kacenefolo*, who possesses magic and supernatural knowledge. These latter spaces were all oriented toward combating threats to a village's well-being; accordingly, the spiritual knowledge embodied by these shrines is symbolically evoked by the carved motifs that appear all over the doors' surfaces. The doors may have been part of mud-brick buildings whose walls bore modeled images in low relief similar to those rendered on the doors. Indeed, the tradition of carving doors may have grown out of the practice of adorning mud walls.

The Art Institute's door is the work of the artist Nyaamadyo Koné, who had his atelier in the important regional woodcarving center of Kolia and was renowned for his low-relief doors of this size and complexity.[1] Its surface is divided into three registers separated by ornately carved friezes. The lower section features mythological subjects and primordial animals, such as crocodiles and pythons similar to those depicted on the Art Institute's caryatid drum (cat. 15), while the upper section highlights an image of a *kpeli-yehe* mask flanked by mounted warriors and radiating geometric designs that imitate scarification marks. The door is dominated by the central zone, known as *kulo* (the cosmos), which features an umbilical point from which diagonal lines emanate toward each of the four corners. Generally speaking, these motifs are related to divination, forest spirits, and other sources of powers. However, carvings on both doors and drums are "saturated with multiple references and allusions" according to Anita J. Glaze, who points out the close association in Senufo culture between oral ritual and the visual arts.[2] These images cannot be interpreted in simple one-to-one terms.

Constantine Petridis

1 The more specific information about this door's collection history and origin derives from a personal communication by Anita J. Glaze to Ramona Austin, then Art Institute assistant curator of African art; see Glaze 1991. See also Glaze 1981a, 50–51; and Bochet 1993a, 2: 37–38. 2 Glaze 1993, 125.

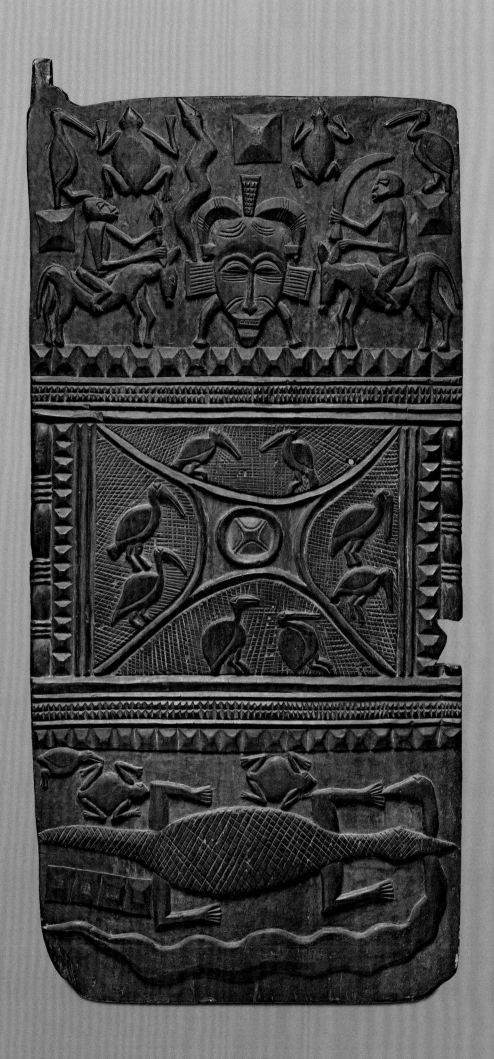

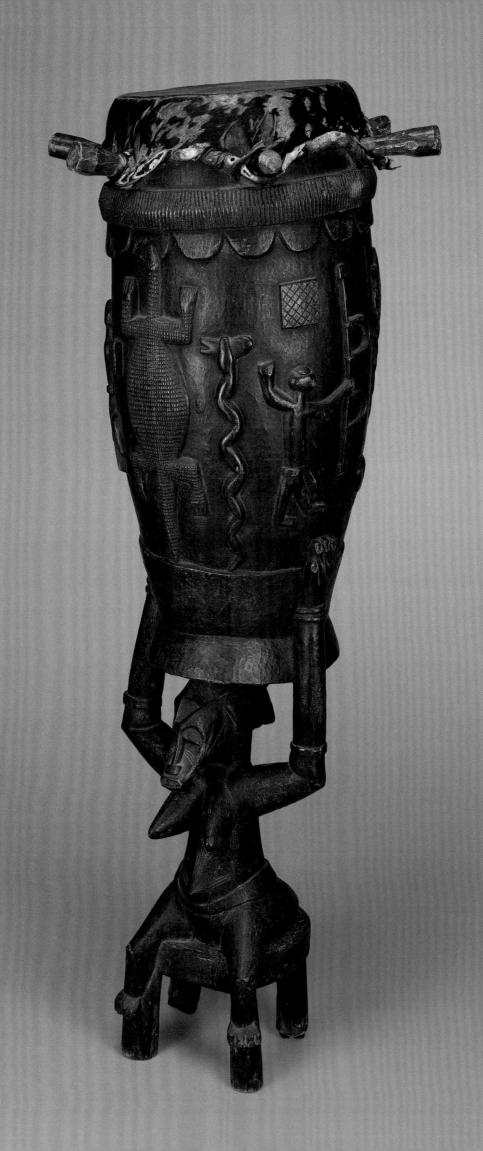

15 Female Caryatid Drum (*Pinge*)

Senufo
Côte d'Ivoire
c. 1930–c. 1950
Wood, hide, and pigment
122.9 × 49.2 cm (48⅜ × 19⅜ in.)

Robert J. Hall, Herbert R. Molner Discretionary, Curator's Discretionary, and African and Amerindian Art Purchase funds; Arnold Crane, Mrs. Leonard Florsheim, O. Renard Goltra, Holly and David Ross, Departmental Acquisitions, Ada Turnbull Hertle, and Marian and Samuel Klasstorner endowments; through prior gifts of various donors, 1990.137

Provenance: Charles Ratton (died 1986), Paris, by 1957; sold to Harry A. Franklin (died 1983), Beverly Hills, CA, early 1960s; by descent to his daughter, Valérie Franklin-Nordin, to 1990; sold Sotheby's, New York, Apr. 21, 1990, lot 47, to the Art Institute, 1990.

This tall cylindrical membrane drum has been decorated with motifs in low relief that depict people, objects, and various animals with spiritual meaning for the Senufo people's most powerful village associations: Poro, Tyekpa, and Sandogo.[1] Similar images appear on a wooden door in the Art Institute's collection (cat. 14). Such ornately carved four-legged caryatid drums, commonly called *pinge*, are rarely found in collections and seldom reproduced in the scholarly literature. Their production originally seems to have been limited to two groups of Central Senufo farmers called Kasembele and Tagbanbele. The drums were formerly used in connection with the military activities of the Poro association, but today they are sounded primarily in relation to initiations or funerals for associations, depending on the region. While men act as drummers in the context of Poro, women take on the role among the Tyekpa and Sandogo. Female drummers are rare in Africa south of the Sahara. With the weakening of the Poro association's power over time, however, the sacred character of these drums has diminished considerably (see fig. 1).

The Art Institute's example has been tentatively dated to the 1930s or '40s and is believed to have been created in one of the eastern settlements of *kulebele* (woodcarvers; sing. *kuleo*) in the M'bengué region. It is comparatively large and may have been inherited within a family of considerable rank and wealth. Its iconography combines the stately, female, load-bearing caryatid with complex bas-relief motifs that feature both humans in war scenes and animals, an indication that it probably served in funerary ceremonies of the Tyekpa or Sandogo associations. An ideological matrix of competition and conflict in the cosmic, spiritual, ethical, and social arenas underlies the Senufo culture's religious beliefs and philosophy as they are expressed in the initiations and activities of both Tyekpa and Sandogo. The latter organization

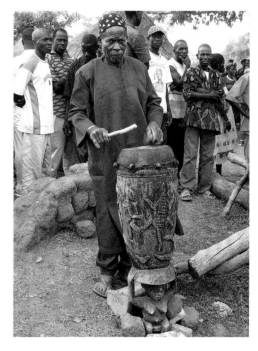

1 Caryatid drum and drummer at a funeral in the village of Katiali, Côte d'Ivoire, March 2008. Photo by Thomas Bassett.

comprises women who act as diviners and mediate between humans and spirits, while the former is the female equivalent of the male Poro, and is charged with maintaining social order and cohesion.

Many of the songs sung in the context of Tyekpa performances that include the beating of drums deal with gender conflict. Using a secret language exclusive to Tyekpa initiates, their lyrics often insult men's sexual parts and behavior. The imagery of a woman seated on a four-legged stool and balancing a heavy load on her head symbolizes the key role of Senufo women as family founders and spirit intermediaries—or as Anita J. Glaze put it, this caryatid is "a female Atlas who balances with composure the world on her head."[2]

Constantine Petridis

1 For an in-depth analysis of this work, see Glaze 1993.
2 Glaze 1993, 133.

16 Lidded Box

Senufo, Jula, or Lorhon
Côte d'Ivoire, possibly Kong
Possibly late 18th or early 19th century
Tin alloy
H. 21 cm (8¼ in.)

African Decorative Arts Fund, 2018.361

Provenance: Simon Escarré (died 1999) and Miche Escarré (died 2007), Korhogo, Côte d'Ivoire, and La Baule, France, from early 1950s; sold to Loed Van Bussel (died 2018) and Mia Van Bussel, Amsterdam, in 1958 or 1959; sold to Patrick Girard, Lyon, France, late May or early June 1996; sold to the Art Institute, 2018.

The elaborate design of this lidded box, which most likely served as a Qur'an container, illustrates dynamic communication networks—particularly those that facilitated the diffusion of metallurgical expertise throughout West Africa. Originally identified as Senufo, these boxes have more recently been associated with the Jula people (also spelled "Dyula"), an ethnic group of itinerant Muslim merchants who are currently established in Côte d'Ivoire, Mali, Burkina Faso, and Ghana. From the thirteenth century onward, Jula traders carried valuable metal objects over this vast area, and simultaneously participated in spreading Islamic culture throughout West Africa by the fourteenth century, when the Māli Empire reached its apogee. Begho in Ghana and Bondoukou in Côte d'Ivoire were among the many trading posts they established.

The Art Institute's box probably stems specifically from Kong in northeastern Côte d'Ivoire, which developed into a city before becoming an empire in 1710.[1] Skillfully crafted metal objects like this box have tentatively been situated in the context of the Kong Empire in the early nineteenth or even late eighteenth century—its heyday—where they served as status symbols for the nobility in the hierarchical Jula society. The Kong Empire fell when Samori Ture (also known as Samory Touré; c. 1830–1900) burned down its capital in 1881. Many works made of relatively fragile alloys likely did not survive, and this box is one of only two extant examples (see also fig. 1).

Curved knives or daggers are another type of metal prestige object with a similar manufacture and related decorative designs that are tentatively situated in these Muslim Jula communities in Kong. Many of these works feature a small head with an elaborate hairstyle of braided "horns." This coiffure is also seen on a rare

1 Lidded Box, possibly late 18th or early 19th century. Senufo, Jula, or Lorhon; Côte d'Ivoire. Copper alloy; H. 22.5 cm (8⅞ in.). Private collection, Brussels.

category of face masks made of brass or pewter. These continue to be used in performances organized by the Do association in the context of funerals for titleholders and to mark important Islamic holidays such as the end of Ramadan.

Interviews conducted in Kong in the late 1980s have revealed that such Jula masks and other metal objects may in fact be the work of the Lorhon, a group of casters who worked for the Jula as well as for the Senufo, Kulango, and other ethnic groups in northern Côte d'Ivoire. As the commercial center of the Muslim Jula, Kong would have offered the necessary supplies—including brass rods, pewter, and metal objects—for the Lorhon to execute their work. Moreover, the inclusion on all these prestige objects of a decorative motif that resembles a typical Senufo mask of the genre known as *kpeli-yehe* or *kodal* suggests a relationship between Lorhon-made metalwork and elite Senufo patrons.
Constantine Petridis

1 See Garrard 1993, 396–400; Förster 1997, 93–110; and Aloudat and Boghanim 2017, 14–15.

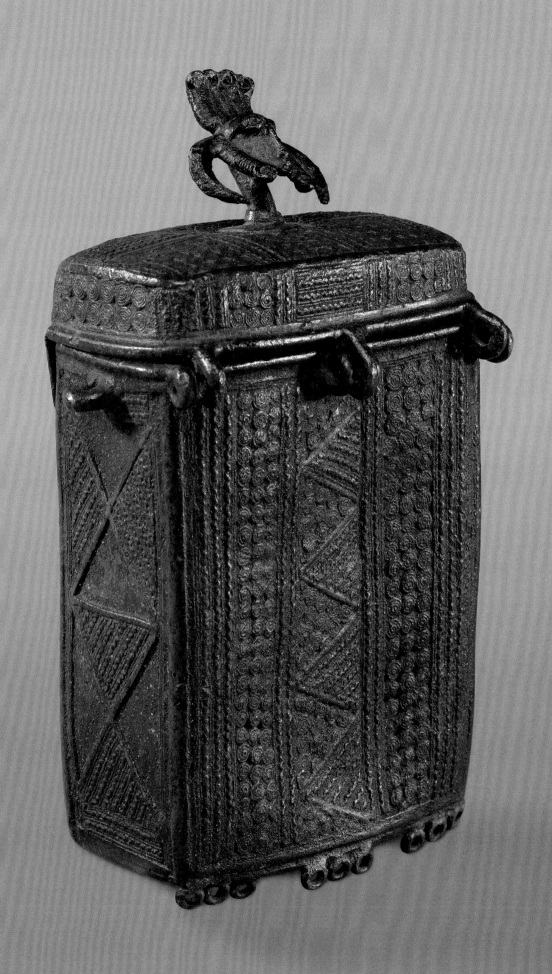

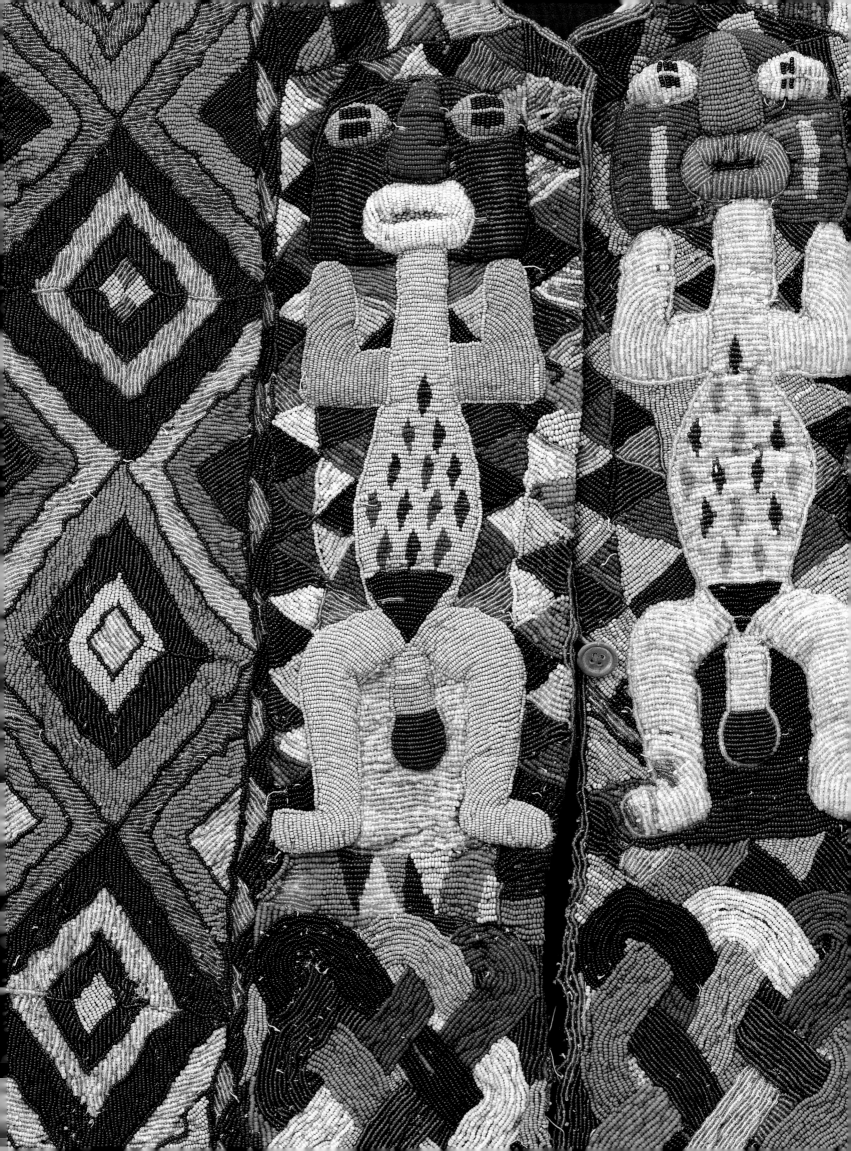

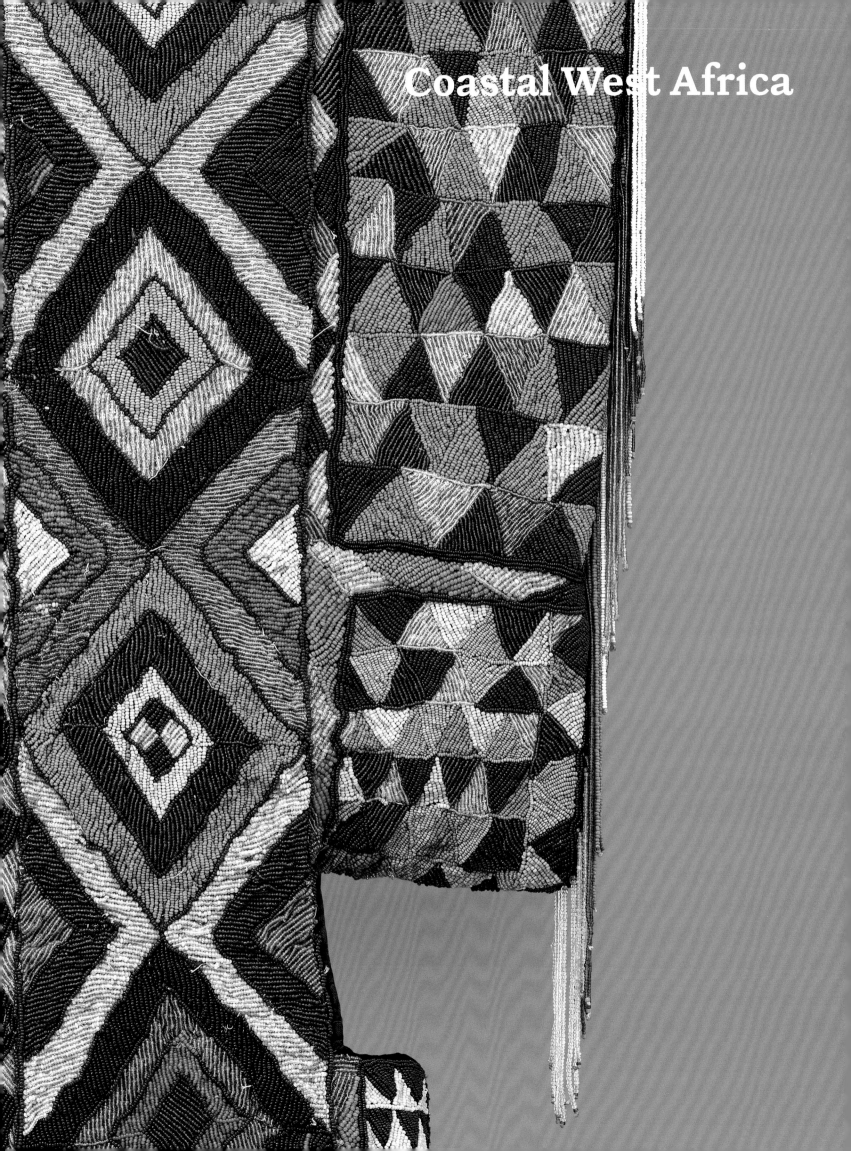

17 Male Figure

Ijo: Western or Central
Possibly Ndoro region, Nigeria
Early to mid-20th century
Wood, chalk, and pigment
153.7 × 24.1 × 19.1 cm (60½ × 9½ × 7½ in.)

Gift of Richard Faletti, the Faletti Family
Collection, 2000.321

Provenance: Eric Robertson,
Robertson African Arts, New York, by
1990; sold to Richard J. Faletti (died
2006) and Barbara Faletti (died 2000),
Chicago then Phoenix, AZ, Mar. 11, 1990;
given to the Art Institute, 2000.

Martha G. Anderson

Of Figures, Spirits, and Shrines

In the absence of collection data, figures like the one that Richard Faletti donated to the Art Institute of Chicago can generate a seemingly endless series of questions alongside some admittedly speculative conclusions. This so-called "forest spirit figure" lacks documentation connecting it to a particular locale, but its projecting eyes and mouth place its origin quite firmly in the area of the Niger Delta occupied by the Central and Western Ijo. Its vertical forehead keloid—a mark that formerly distinguished the Ijo from their neighbors—reinforces that attribution. Almost all figure carvings from the region west of the Nun River represent forest spirits, and it seems reasonable to assume that the Art Institute's figure conforms to this pattern. But linking it to a particular locale or a specific spirit proves more problematic. In order to properly contextualize the object, I begin with a review of Ijo beliefs about nature spirits. The descriptions of Central Ijo forest spirit shrines and images that follow offer further insights into the way people may have viewed the Art Institute's figure *in situ*. Finally, I conclude by comparing it to a similar object and thereby point to a possible provenience.

Beliefs about Nature Spirits

The Ijo (or Ijaw), or Izon-speaking peoples, share beliefs in a female creator, nature spirits (*oru*), and war gods.[1] Although views about nature spirits vary from one part of the Niger Delta region to another, most of the Ijo who described the spirits (*orumo*) to me consider them to be much like human beings and even insist that they *are* people. *Orumo* live in their own communities but sometimes approach human family members and friends in visions and dreams or take control of their bodies through possession. They can also inflict illness or misfortune as a means of alerting people to their need for attention. Some spirits simply want food, drinks, music, and companionship—the same kind of hospitality that people offer their earthly guests; others demand shrines and costly rituals. Declining the spirits' wishes can cause trouble or even death, whereas complying can ensure (or restore) health and prosperity. People credit nature spirits with protecting them against everything from smallpox epidemics to invasion by hostile enemies. They invoke the most potent ones to punish criminals and settle disputes.

The Central and Western Ijo differentiate two types of nature spirits: forest spirits (*bou oru*)

or forest people (*bouyou*) roam the bush—the land that surrounds Ijo communities—and have claimed certain areas for their exclusive use, while water spirits (*bini oru*) or water people (*biniyou*) reside in rivers and lakes and sometimes invite humans to visit their fabulous underwater towns. Although the forest and water spirits share certain characteristics and can even intermarry, shrines and rituals reinforce the idea that they contrast in both appearance and temperament.[2] According to Ijo lore, the spirits materialize in ways appropriate to their habitats. Forest spirits often reside in trees and other natural objects or appear as land animals; water spirits can materialize as reptiles and aquatic animals or take the shape of natural or manufactured objects discovered in the water. Alternatively, both can assume human form. People who claim to have seen water spirits typically describe them as beautiful, fair-skinned beings with long, flowing hair. In contrast, people who have encountered forest spirits portray them as uncouth and grotesquely ugly, with very dark skin and messy hair. They say that many are deformed, blind, deaf, or enslaved—conditions that help to account for their bad tempers.

The behavioral traits that people ascribe to nature spirits reflect differences in the way they regard the two realms. The Ijo generally characterize water spirits as playful and beneficent. Followers often credit their shrines with bringing them children and success in financial endeavors. Although water spirits can be troublesome and occasionally even deadly, forest spirits have a reputation for being so ill-tempered and malicious that people who work in the forest fear that even a chance meeting with one could result in death. A song sung in Olodiama clan warns, "Beware of the bush; the bush is a difficult place." Forest spirits are so easily annoyed and vengeful that priests complain about the dangers of serving them. Stories about the spirits' vindictiveness, however, only enhance their reputations for efficacy; as a song for one enshrined spirit observes, "Dirimobou is a bad spirit, therefore he is very good."

Descriptions of forest spirits recall stories about great Ijo war heroes of the past, men whose drum titles, like Aguda (Twist Someone), convey their indomitable strength and brutality. To accomplish their miraculous feats, these legendary warriors called on magical knowledge (*atamga*) to transform themselves into animals, trees, and even footprints; armed themselves with charms and herbal medicines; and employed magical speech (*aunbibi*).[3] They visited shrines to petition forest spirits for support and sprinkled themselves with medicines from their medicine pots (*osain*), both to fortify themselves for battle and to cool down on their return.[4]

The epic tale of Ozidi graphically illustrates how warlike and intimidating forest spirits can be. It originated when a Western Ijo priest woke from a trance to orchestrate an elaborate seven-day performance that told the story of the hero through narration, song, dance, and mime. Versions were once performed throughout the Central and Western Ijo region, and the noted author J. P. Clark-Bekederemo published one in 1977.[5] The "warlords" Ozidi confronts in this tale—including Egebesibeowei (Scrotum Carrier) and Azezabife (Skeleton Man)—are clearly forest spirits. One of the scariest, Oguaran (He of the Twenty Fingers and Twenty Toes) has a head the size of a house and the strength to topple towering cottonwood trees. When he wields his enormous sword—so heavy that four men could not lift it—he stirs up tornados. As gigantic as he is, Oguaran augments his physical powers with magical ones: like other Ijo warriors, he visits his shrine to strap on charms before setting off to fight. Shrines for Oguaran, Kemepara (Half Man), Tebesonoma (Seven Heads), and some of the other fearsome characters who feature in the tale could once be found around the region, but the spirits they honor could well predate the performance.

Shrines for Nature Spirits

The spirits' preferences with respect to matters ranging from offerings to shrine furnishings also contrast markedly. Because forest spirits live on land, like people do, they resemble them more closely. They prefer local produce and palm wine. Water spirits, who live in an environment more foreign to humans, have a taste for imported food and beverages such as corned beef, white rice, and orange soda. Forest spirits display dark-colored textiles to signify their strength and invincibility; water spirits typically prefer cloth that is white, a color that connotes purity and spirituality. The songs sung for forest spirits are war songs, and the rites diviners perform to alleviate problems attributed to them incorporate gestures intended to beat them back and medicines aimed at rendering them powerless. With rare exceptions, the songs sung for water spirits are not war songs, and the rituals performed for them are more gently persuasive than combative.

The types of earthly receptacles provided for the spirits who require them are also dictated by their respective realms.[6] Water spirits commonly

choose to be represented either by masquerades or by objects that have obvious links to water and/or trade, such as paddles, glass tumblers, and plastic dolls. Things that people find in the water while bathing may likewise be enshrined when diviners determine that they are water spirits. In contrast, forest spirits typically choose to be represented by figure carvings like the one at the Art Institute. Indeed, the vast majority of Ijo figure carvings represent forest spirits. Despite these spirits' renowned ugliness, shrines depict them as bold warriors with no apparent physical abnormalities except multi-headedness, which—aside from being monstrous— can indicate superhuman powers, clairvoyance, and vigilance. They wear war paint and "bulletproof-ing" medicines, and many brandish weapons, recalling Ijo war heroes of the past.[7]

Identifying undocumented carvings with particular spirits proves to be highly speculative; reconstructing their contexts is even more problematic. Few such shrines survived the 1970s, and those that still stood in the 1990s were probably abandoned by the beginning of this century. The available shrine histories confirm that diviners played an important role in establishing them. Many, if not all, clairvoyant diviners are women. Their ability to "see things" in the spirit world and to understand the language of birds makes them powerful and influential members of the community. Speaking through diviners, the spirits issue highly idiosyncratic instructions that dictate everything from the type and number of images they want in their shrines to the medicines, food, and songs they require for worship. Layers of complexity may accumulate over the years through further consultations with clairvoyant diviners and revelations the spirits impart to spirit mediums through possession and dreams. The spirits can also communicate their wishes through ladderlike devices known as *obebe*. When raised horizontally by male bearers, the *obebe* would tilt forward or back to indicate the spirits' responses to queries posed by their priests.

The layered histories of shrines result in a great deal of diversity, and other factors complicate the situation even further. Many shrines are unique and are also associated with a specific community or, more often, a lineage. They may honor a relationship between the shrine's founder and a spirit (or spirits) associated with a particular area of the forest. For example, Dirimobou—the "bad-therefore-good" spirit mentioned above—roams the forest outside the town of Ikebiri, which houses the only shrine devoted to him. But even in instances where shrines located in different towns honor spirits who bear the same name—as in the case of Oguaran, Osuo-owei, and Tebesonoma— the relationship between them is ambiguous. Priests often claim to know only the spirits they serve in their own shrines, although some describe similarly named shrines as branches of the same spirit. In either case, shrine histories, contents, and associated rituals vary widely from one "branch" to another. Diviners tend to confirm the differences between branches; they may instruct a client to travel to a distant shrine for Adumu, for example, rather than advise them to join a local one.

Ijo Shrines for Forest Spirits

Well into the twentieth century, the Ijo frequently fought each other as well as neighboring groups. They granted titles to men who had killed human beings, whether by engaging in battles or staging attacks on unwary travelers. Although endemic warfare gradually faded during the colonial era, shrines and rituals performed to appease forest spirits continue to draw on imagery that refers to combat. As noted above, the songs that followers sing for these spirits are war songs, and the lyrics sometimes echo the insults that people once hurled at warriors to incite them to fight. One sung for a spirit named Benaaghe at Azama in Apoi clan cautions him against being lazy when war threatens. Another for Odewei (or Edewei) at Korokorosei in Olodiama clan calls on the shrine's medicine pot to come out of the forest "to crush the dead and the spirits."

Although shrines for forest spirits can differ substantially even within a single community, they tend to share certain features. Unlike shrines for water spirits, most contain a medicine pot and *obebe* as well as carved images. Smaller figures representing family members, supporters, and animals often appear alongside the one that depicts the central spirit, in order to emphasize his power and authority. These ensembles may include a female figure because the Ijo do not consider a man to be an adult until he has married. Alternatively, spirits can designate shrine members as their spouses, children, and attendants. The shrines described below loosely fit the parameters described above, but they also illustrate how widely shrine complexes—including associated beliefs and practices—can vary.

Edisibowei has an unusually elaborate origin story. Members of his shrine in Ikebiri, a town in Olodiama clan, report that he lived in far-off Benin before his neighbors tricked him into carrying a miniature war canoe filled with sacrificial offerings (*ikiyan oru*) into the forest.[8] After losing

ness to support him. The name of his other companion, "Mashing Something to Cause It to Spoil," suggests what will happen to people who annoy him. Although the caretaker does not emphasize the shrine's association with warfare, that connection probably existed in the past. Some Ikebiri residents believe that Edisibowei left to fight in the Biafran conflict and never returned.[9]

Odewei, enshrined nearby at Korokorosei in Olodiama clan, provides a clearer example of military symbolism, although his seventh and last priest emphasized the help he offers in hunting, fishing, and bearing children.[10] According to oral history, the shrine began as a medicine pot and warriors anointed themselves with its contents before setting off to fight. Odewei, who originally appeared in the form of a small figure on the pot's lid, eventually became powerful enough to demand a larger carving (fig. 2). His image portrays him as a warrior without apparent physical abnormalities, but songs sung at the shrine suggest a different story. One inquires, "What sort of an awkward-looking man is he?" Another chants "*yangaba, yangaba*," meaning "rough" or "twisted body," an abuse that implies that Odewei suffers from yaws. The lyrics of a third scold him for calling on his family only in times of war. In the past, people

his way, he wandered around the Niger Delta until Dirimobou, the spirit that presides over a section of the forest near Ikebiri, defeated and enslaved him. According to the Ijo, slavery makes both people and spirits irritable and prone to violence, so the condition enhances Edisibowei's reputation as an irascible, merciless spirit ready to battle anyone who crosses him. Edisibowei's shrine emphasizes his bellicose nature (fig. 1). Like most forest spirits, he dresses for battle, with a medicine gourd (*atu*) hanging from his neck and bands (known variously as *egbe*, *gbinye*, and *ideri*) stuffed with additional medicines strapped around his arms. Such charms, commonly referred to as "bulletproofing," can be invoked to do things like render warriors invisible or seek out and destroy their enemies. In keeping with his origin story, Edisibowei carries a sacrificial war canoe atop his head. One of the figures inside it holds a gun. His name, which means "Black Magic Will Not Hurt Me," recalls the titles the Ijo bestowed on brave warriors and wrestlers. The other figure, "Diviner from Ufe," communicates with Edisibowei, who is deaf as well as enslaved, by drumming on the canoe. Edisibowei's wife stands by his right side; her name, "Not Marrying a Woman in Vain," indicates her readi-

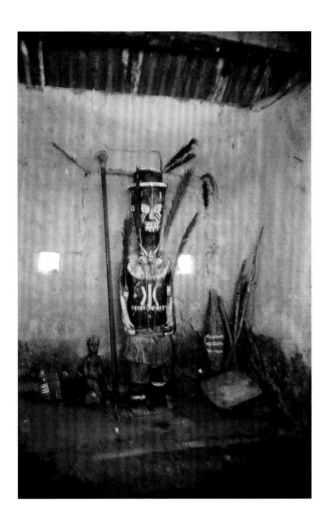

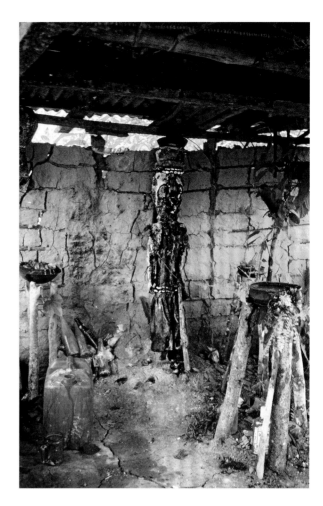

3 Isobowei
in his shrine,
Olugbobiri,
Olodiama clan,
Nigeria, 1978.
Photo by Martha G.
Anderson.

4 A shrine for
Benaaghe at
Azama, Apoi clan,
Nigeria, 1992.
Photo by Martha G.
Anderson.

hurled similar criticisms at warriors as they went off to battle to incite them to fight. The pervasive military symbolism surrounding Odewei extends to the name of the infant carved on his wife's back: "War Canoe Will Never Have Bad Luck."[11]

Other shrines in the area reinforce the connection between forest spirits and war, including one for Isobowei at another town in Olodiama clan, Olugbobiri. Isobowei may not have joined in the Biafran war as Edisibowei is said to have done, but after its conclusion, veterans reportedly came from distant towns to thank him for protecting them in battle. Like others of his kind, Isobowei resembles an Ijo warrior. His shrine reinforces his militant image by providing him with guns (fig. 3). He wears a gourd and belts packed with medicines to protect him against injury and ensure victory. The feathers sprouting from his image proclaim his status as a titled warrior, and followers claim that these accoutrements shake to warn them of approaching danger. Despite his titled status, however, Isobowei's name, "Man from the Isoko/Urhobo Area," identifies him as a slave. Like Odewei, he belongs to the shrine's medicine pot. In the days when the Ijo regularly feuded with their neighbors, slaves accompanied their owners to battle. Some people say that slaves

were the ones who did the fighting. Ijo women reportedly stood beside their husbands in battle and loaded their guns. The name of Isobowei's wife, "What Is in the Mind of a Small Woman," refers not only to the diminutive size of her image but also to the strong-mindedness and tenacity that the Ijo associate with short stature. These qualities would make her an asset to any warrior.

A shrine at Azama in Apoi clan originated when Ouaku, who is not a forest spirit but the "town founding destiny" (*amatemesuo*) of the community, requested a carving for his son, Benaaghe (fig. 4).[12] War medicines identify Benaaghe as a forest spirit/warrior. His priest credits him with calming malicious spirits who haunt the surrounding forests and also with protecting his followers from vengeful spirits who have been invoked to punish them. Although he claims that the medicines in the shrine's pot provide relief for people who are being tormented by forest spirits, they may have fortified warriors in the past.

Benaaghe reportedly maintains friendships with notable nature spirits whose shrines are scattered throughout the region, including Eleke of Korokorosei in Olodiama clan. Like Eleke and other formidable spirits, he holds the *peri* warrior title.

Although many Ijo had abandoned *peri* by the late twentieth century, it formerly provided the primary path for Ijo males to achieve status. Practices varied throughout the Ijo region, but clan war gods generally conferred the distinction on men who had killed either a human being or an animal considered to be equally formidable, like a leopard or a shark.[13] Recipients earned the right to wear eagle feathers, drink with their left hands, wear special costumes (which differed from clan to clan), and perform a special *peri* "play" at the funerals of other titleholders. His priest describes Benaaghe as a strong man who has killed many people. During rites, he performs the part of the play that English speakers refer to as the "fit confessing ceremony," in which a warrior proclaims his fitness for the title by issuing a distinctive cry at the waterside while raising his right arm.

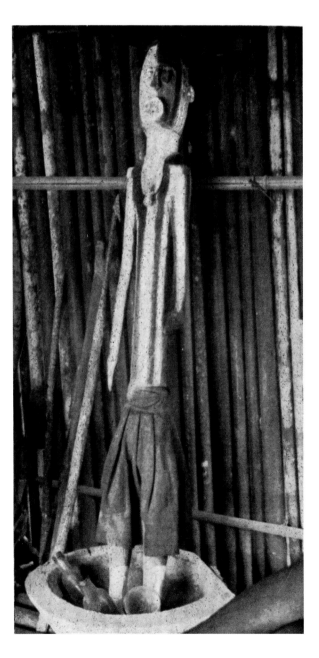

5 Carved figure, Western Ijo region, 1950s. Photo by Robin Horton. From Horton 1965.

The Art Institute's Figure

As noted at the beginning of this essay, the Art Institute's figure almost certainly depicts a Central or Western Ijo forest spirit, although its slender physique and attenuated torso depart from stylistic norms. Wide variations in the style of documented examples make it notoriously difficult to define Ijo substyles. As the anthropologist Robin Horton noted many years ago, stylistic differences appear to reflect the idiosyncrasies of individual artists rather than conforming to regional patterns.[14] This case may be an exception: a carving Horton photographed in the 1950s resembles the Chicago one so closely that it suggests a provenance in or near Ndoro, an Ekeremor (or Operemor) community (fig. 5). Although Ndoro is a Western Ijo town, its location near the border between Bayelsa and Delta States places it within a few miles of several Central Ijo communities.[15] The published example is about eighteen inches shorter, but the two figures share remarkably similar proportions, and both bend their left arms as if to hold something. Although the faces are similar, the more angular mouth and higher forehead of the museum's figure suggest that it was carved by a different artist. Unfortunately, the angle of the field photograph makes it impossible to determine whether the head of the Horton figure has similar protrusions. Comparable forms appear on a number of Ijo examples and represent either hairstyles or headdresses that people wore in the past. The Art Institute's figure lacks a wrapper, but undoubtedly would have had one when it was enshrined because spirits conform to social norms of dress. The notched rectangles below its shoulders do not appear on other known Ijo examples. They may represent medicine pouches.

The vertically striped markings on both figures merit further attention. They almost certainly represent the type of war paint warriors once applied to enhance their prowess, intimidate their opponents, and protect against injury. The black-and-white photograph confounds a comparison of colors, but those on the Art Institute's figure may connote certain qualities or conditions. Red can signify danger or a heightened spiritual state. The red pigment on the carving appears to be camwood powder, a substance derived from the African sandalwood tree. People living in the Niger Delta region consider camwood to have apotropaic properties and use it for both medicinal and cosmetic purposes. White refers to the spirit world in general; priests of various types of spirits wear white garments and hang white curtains in their

shrines. They and others who participate in rituals often apply white marks to their bodies using either kaolin or "native chalk," which is made by grinding shells. The Ijo believe that chalk, like camwood, has supernatural properties that can protect, purify, transform, and heal. Dark colors connote strength, as in the name for Dirimobou (Dark Bush) in Ikebiri. Most forest spirit shrines display deep blue or black textiles, as do a few of those dedicated to exceptionally powerful water spirits, such as Eleke. All three colors can connote *peri* warrior status: titleholders in Olodiama clan pair red jackets and caps with white wrappers. In other parts of the Central Ijo region they wear dark wrappers or dress entirely in white.

Horton identified the figure he photographed as a forest spirit named Kondou-bara-owei (Left-Handed One).[16] People living in the Niger Delta, like many others in and beyond Africa, consider use of the left hand to be antisocial, so left-handedness may reinforce the image of forest spirits as dirty and uncouth creatures. Alternatively, it could indicate membership in the *peri* warrior society. Part of the *peri* "play" performed in Olodiama clan, and perhaps others, required titleholders to cut through trunk-like stalks of plantain plants using their left hands. As noted above, their status also entitled them to drink with their left hands.

The bent left arm of the Art Institute's figure could indicate that it represents Kondou-bara-owei. If so, it was probably carved as a replacement for the one Horton photographed. It is unlikely that another spirit within the same community would have had a figure so similar. But Ijo carvers sometimes served multiple communities, so despite the striking resemblance, this figure may have been carved for another spirit and enshrined in another town. Therefore, as tempting as it may be to offer a specific provenience for the forest spirit in the Art Institute's collection, identifying any undocumented figure would be imprudent. There are simply too many unknowns.

1 Despite my use of the "ethnographic present" tense throughout this essay, it is important to note that most Ijo now embrace Christianity. Shrines had already begun to disappear when I first conducted fieldwork in the Central Ijo region in 1978–79, and more had fallen by the time I returned for further research in 1991–92. The conflicts that erupted in the mid-1990s have largely prevented research in the region since that time. In 2018 I learned that a church now sits on the site of a formerly powerful shrine that had functioned for many generations.

2 Some spirits, like Adumu, are considered amphibious, but shrines represent only one of their aspects.

3 *Aunbibi* means "unknown language," confirming that it is unintelligible to ordinary Ijo. Those who command it can supposedly accomplish astonishing feats simply by uttering a few words. See Anderson 2002a.

4 Anderson 2002a.

5 Clark-Bekederemo 1991.

6 The Ijo consider them to be emblems rather than actual embodiments; the spirits move about freely and only occupy them occasionally.

7 Carvings made for the water spirit Adumu look very much like those made for forest spirits, but lack war medicines. Adumu was the only water spirit I found to be represented by figure carvings, but that may not be true for the entire region to the west of the Nun River. Unlike most water spirits, he is said to have a very dark complexion. Carvings made for him are so similar to those for forest spirits that when asked about the difference between them, a carver explained that they eat different types of food. The shrine for a forest spirit named Apeghele at Olugbobiri in Olodiama clan contained contrasting emblems. A small bronze figure in the form of a Grecian caryatid stood at the feet of Apeghele's carved image. His former priest found it in the river. Diviners often advise people to acknowledge relationships with spirit friends or spouses; in this case, they determined that the figure was Apeghele's water spirit wife, supporting the idea that water and forest spirits can intermarry.

8 Anderson 2003.

9 In 1979 I was told that people still ran the other way whenever they heard a pounding noise or a kingfisher when working in Dirimobou, for either sound might announce Edisibowei's return.

10 Odewei's priest, Owei-koroghawei, claimed to be the seventh priest in a line going back to Igali, another of the town's founders. See Anderson 1987.

11 Although pangolins often carry symbolic significance in Africa, the one that stands at Odewei's feet was described simply as a protector. Dogs that appear in shrines are often said to serve as guides, and pangolins may serve a similar function.

12 *Amatemesuo* is an abstract force that accompanied the town's founder and is not represented by an emblem. Ouaku does not have a carved image; an *obebe* (divination ladder) kept in Benaaghe's shrine is used to consult him.

13 There are many exceptions. Some communities granted titles that were independent from clan war gods and/or acknowledged men who had inherited the title. Benaaghe received his title from his father, rather than a clan war god.

14 Horton 1965, fig. 61.

15 Horton 1965, fig. 62.

16 Horton n.d., 9, fig. 72. The Ijo word is unreadable on available copies of the manuscript, but Jeremiah Yabefa translated the English term for me; personal communication, March 13, 2019.

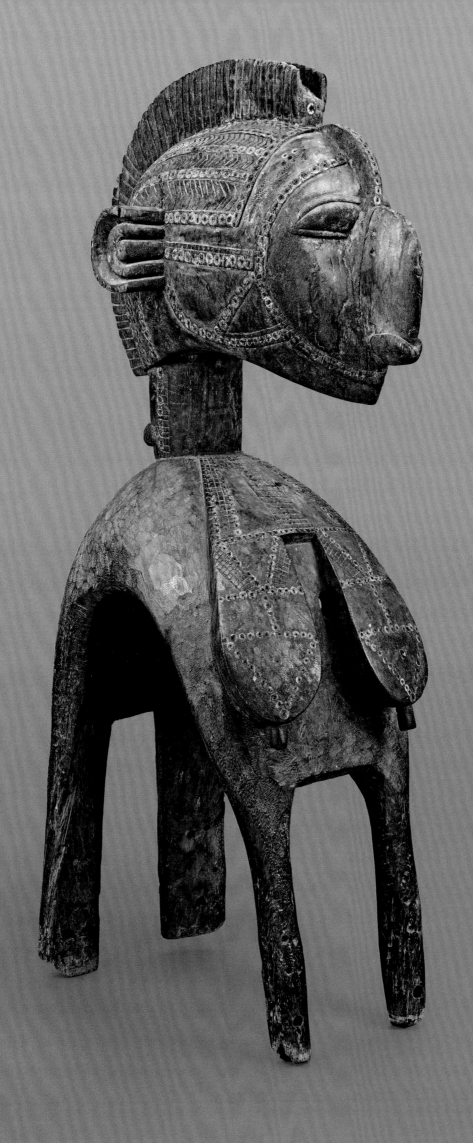

18 Female Headdress (*Nimba, D'mba,* or *Yamban*)

Baga
Guinea
Mid-19th to early 20th century
Wood and pigment
119.4 × 33 × 59.1 cm (47 × 13 × 23¼ in.)

W. G. Field Fund, Inc.; Edward E. Ayer
Endowment in memory of Charles L.
Hutchinson, 1957.160

Provenance: Reportedly acquired in
Guinea, about 1955. John J. Klejman
(died 1995), Klejman Gallery, New York,
by 1957; sold to the Art Institute, 1957.

One of the first acquisitions by the Art Institute's department of Primitive Art (now Arts of Africa), this majestic headdress was removed from the continent during the Islamic Revolution, which lasted from 1954 to 1957; the upheaval included a "demystification campaign" led by Ahmed Sékou Touré, who became Guinea's first president. Baga art traditions and related practices were temporarily abandoned as part of this effort to purge traditional religion of its essential mysticism. The national program led to religious persecution and the massive destruction of ritual art. Shortly before Guinea achieved independence from France in 1958, the Baga people were brutally forced to convert to Islam and to give up their indigenous religious practice. Muslim missionaries looted ritual art from the villages and French collectors and art dealers arrived in their wake. They transported objects to the Guinean capital and from there to Paris and beyond.

A Baga renaissance took place in the late 1980s, however, after a new political regime took control and foreign researchers demonstrated renewed interest in Baga art and culture. Indigenous rituals and associated art forms were reinvented—including this type of headdress, known locally as *nimba*, *d'mba*, or *yamban*. First recorded in 1886, it is the best-documented and most widely recognized genre of Baga art—often serving to represent Baga culture as a whole—and one of the most iconic forms of African sculpture.

Like other examples of the genre, the Art Institute's *nimba* was originally colored with pigments and once embellished with brass upholstery tacks. The horseshoe-shaped ears that are characteristic of *nimba* are sometimes decorated with separately carved, painted wooden ornaments. The incised lines covering its body mimic scarification and its profile shows sculpted braided hair and a high crest. With a prominent nose, jutting chin, strong neck, and pendulous breasts that

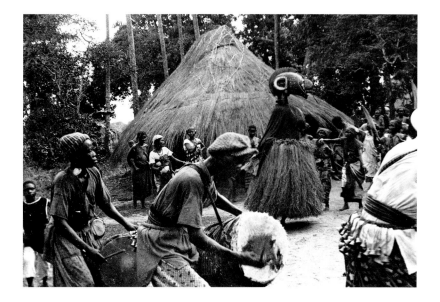

1 Béatrice Appia (French, 1899–1998). Baga Buluñits *d'mba* performance in the village of Monchon, Guinea, 1938. Photograph on barium paper; 22.5 × 29.5 cm (8 ⅞ × 11 ⅝ in.). Musée du quai Branly-Jacques Chirac, Paris, PP0070253.

connote childbearing and nurturing, the mask represents the Baga ideal of mature womanhood—the universal mother, who is at the zenith of beauty and goodness.

During performances, a dancer carries the headdress so that its two pairs of long legs fall over his shoulders, and he can see through the two holes between the flat breasts (see fig. 1). It is always worn by a male individual whose body is covered with a costume comprising a raffia-fiber skirt and pieces of colorful fabric. In the past *nimba* dancers appeared at weddings, births, wakes, ancestral rituals, harvest festivals, and welcoming ceremonies, but today these massive sculptures perform in entertainment masquerades that celebrate Baga ethnicity and involve audience participation.[1]

Constantine Petridis

1 This entry is primarily based on research by Frederick John Lamp; see especially Lamp 1996, 155–81 and 232–39; and Lamp 2004, 222–25. For complementary information on the same topic, see also Curtis and Sarró 1997; and Curtis 2018, esp. 31–35.

19 Helmet Mask (*Banda* or *Kumbaruba*)

Baga or Nalu
Guinea (Conakry) or Guinea-Bissau
Mid-20th century
Wood and pigment
L. 152.4 cm (60 in.)

Restricted gift of Marilynn B. Alsdorf and
the Alsdorf Foundation, 1997.360

Provenance: Reportedly acquired in
Guinea by Jacqueline Nicaud and
Maurice Nicaud (died 2004), Paris, by 1956
[see Lamp 1996, 147, fig. 129] to at least
1975; sold on commission through
Marceau Rivière, Galerie Sao, Paris, to
Merton Simpson, Merton D. Simpson
Gallery, New York, about 1980; Marc
Ginzberg (died 2012) and Denyse Ginzberg,
Rye, NY, by early 1980s; sold on commis-
sion through the Donald Morris Gallery,
New York and Birmingham, MI, to the Art
Institute, 1997.

Representing a powerful spiritual being, this hori-
zontal mask combines human and animal features
including a woman's face and hairstyle, a croco-
dile's jaw, an antelope's horns, a serpent's body, and
a chameleon's tail. It was originally used in a ritual
to protect against crocodile attacks and other
human and supernatural threats, especially at the
time of the male initiation.[1] The mask was also
performed on joyous occasions, such as weddings,
harvest and planting celebrations, and at the
appearance of a new moon. Some villages owned
two or three masks of this genre and they would
dance together in one performance, either sequen-
tially or simultaneously.

Today the mask is danced only for entertain-
ment, during special events such as the visit of a
dignitary or New Year's Day. These performances
take place after sundown in a circular dance arena
or plaza defined by a crowd of onlookers (see fig. 1).
The mask is always worn by a man, who is accompa-
nied by rhythms played on large wooden slit drums.
His vigorous dance includes dizzying spins and
twirls, and also imitates the movements of various
animals, including an undulating snake and a bull
scraping his feet backward before charging. Spectac-
ular and eye-dazzling despite the weight of the
massive headdress, the performance lasts several
hours and elicits an ecstatic response from the audi-
ence, who intermittently congratulate the dancer.
At times, his movements are so rapid and frenetic
that the sculptured headdress can barely be distin-
guished by the audience members. The mask's form
and painted ornamentation accommodate the per-
formance in the design: it lacks details or they are
rendered schematically, and the carving can appear
crude or generally unpolished when viewed up close.
Constantine Petridis

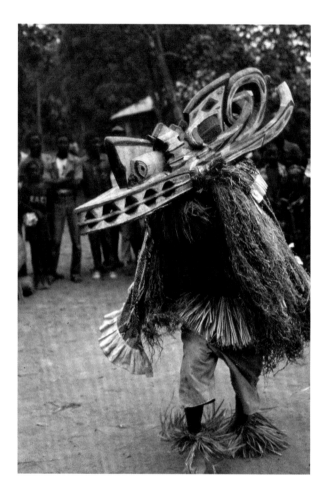

1 Performance
of the costumed
banda headdress
among the
Baga Mandori,
Guinea, 1987.
Photo by Frederick
John Lamp.

1 This information is drawn from Lamp 1996, esp. ch. 7
(144–53); see also Lamp 2004, 74–76.

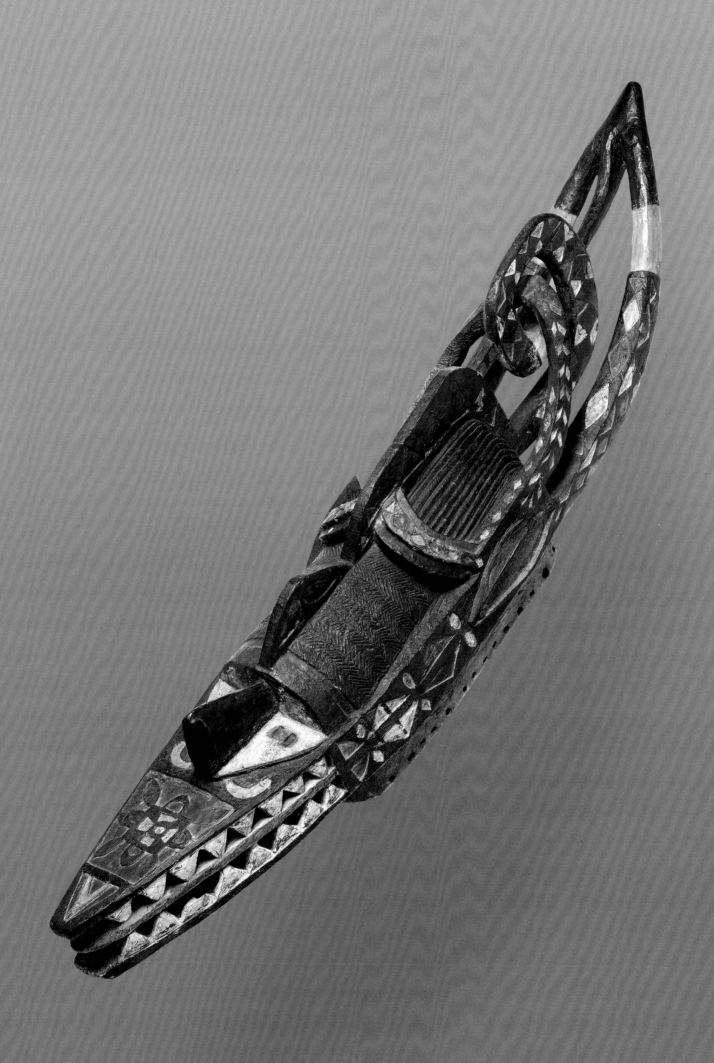

20 Shrine Figure (*a-Tshol* or *Mbëlëkët*)

Baga or Nalu
Guinea (Conakry) or Guinea-Bissau
Late 19th or early 20th century
Wood
58.7 × 26.7 × 80.1 cm (23⅛ × 10½ × 31¾ in.)

Restricted gift of Mrs. Chauncey Borland; through prior gift of Mr. Raymond J. Wielgus, 1962.474

Provenance: John J. Klejman (died 1995), Klejman Gallery, New York, by 1957; sold to Raymond Wielgus (died 2010) and Laura Wielgus (died 2003), 1957. Allan Frumkin Gallery, Chicago and New York, by 1962; sold to the Art Institute, 1962.

The culturally related Baga and Nalu peoples in Guinea and Guinea-Bissau, respectively, created sculptures like the example seen here that combine avian and human features: a long beak on an anthropomorphic face. These figures were the most revered objects in shrines dedicated to protecting the community and to healing the sick and injured.[1] Such a shrine would belong to a clan elder and could be either a miniature shed or a specially built house, within which the sculpture was placed on an altar and shielded from view (see fig. 1).

These figures vary considerably in terms of size, form, and decorations. Some are compact and abstract; the larger examples are usually carved in two separate pieces. Both the head and base often bear complex, pierced designs. Their surfaces may be covered with brass tacks. The finials carved at the end of the cranium can also be strikingly distinct; some are simple knobs while others are in the shape of a miniature head.

The name of this type of object varies according to who uses it, but it always means "medicine," a term that refers to materials, substances, or objects that have the potential to effect material or metaphysical transformation. The most common Baga name for this type of object is *a-tshol* (beaked head on a pedestal); the Nalu call it *mbëlëkët*. The figures were invested with supernatural powers and kept together with other protective medicines in the shrine, including a headdress called *töngköngba*. The sculptures also received offerings of substances including red kola-nut spittle and oils, which could build up into a crusty and shiny surface. The Art Institute's example has a hollowed-out interior within the hairstyle of the head, which likely would have contained a medicine-filled animal horn; that element has been preserved on pieces in other collections.[2]

On important occasions—such as the initiation of young men and women, at the death of an elder, or at the annual festivals at the beginning of

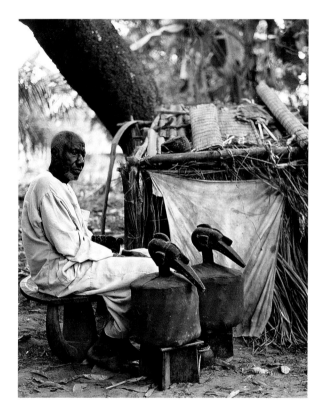

1 A clan elder with two of his *tshol* figures in front of his shrine in a village among the Baga Sitemu, Guinea, 1992. Photo by Frederick John Lamp.

the dry and rainy seasons—a man would perform with one of these bird-human sculptures by simply balancing it on his head and dancing, without a costume. This practice had been outlawed when Guinea achieved independence, but it was revived in the 1980s (see also cat. 19). During his fieldwork among the Baga in 1987, art historian Frederick John Lamp witnessed and photographed several *a-tshol* performances at which the wearer of the headdress occasionally entered into a state of spirit possession.

Constantine Petridis

1 This entry is based on Lamp 1996, ch. 5 (87–103). **2** See, e.g., Curtis 2018, plate 30.

21 Face Mask

Dan
Possibly Liberia
Late 19th or early 20th century
Wood, metal, and nails
H. 34.9 cm (14¾ in.)

Gift of Mr. and Mrs. James W.
Alsdorf, 1964.1101

Provenance: James Alsdorf (died 1990)
and Marilynn Alsdorf (died 2019), Chicago,
by 1960; given to the Art Institute, 1964.

The Dan peoples inhabit the region where
Liberia and Côte d'Ivoire meet, and scholars
have studied the rich and sometimes varied
masking traditions they have developed on both
sides of the border—Belgian art historian
Pieter Jan Vandenhoute on the Ivorian side, and
on the Liberian side, Hans Himmelheber and
Eberhard Fischer, a German-Swiss father-and-
son team who were anthropologists and art
historians.[1] Marked differences in language and
cultural practices have sometimes led several
of the most prominent Dan art scholars to differ-
ent insights and conclusions.

This mask exhibits a number of striking
features, including the vertical scarification vein
bisecting the forehead and the row of small ante-
lope horns that are carved above the forehead as
a high-relief frieze. But the toothed crocodile-
like mouth (or beak) is one of the most significant.
In Côte d'Ivoire, at least in the late 1930s, the beak
design would identify it as belonging to a type
known as *sagbwe*, which is proper to the Bafing
region in northern Dan territory. *Sagbwe* is a
highly sacred mask that serves as a guardian,
especially as a fire-watcher; the name refers to its
prime role during the dry harvest season, when
the Harmattan desert winds regularly cause dev-
astating wildfires.

Other considerations may, however, sup-
port an attribution to the Liberian Dan: its close
stylistic affinity with another smaller mask with a
more birdlike beak in the Art Institute's collection
(fig. 1). This latter sculpture was field-collected in
Liberia before 1950 by the medical missionary
George W. Harley; regrettably, he did not record
its function.[2] During their research in Liberia,
Fischer and Himmelheber described a category of
male mask called *gägon*, with beak-like features
with slit eyes, often with a movable lower jaw and
visible teeth. This mask character represented a
type of hornbill, and was a mythological reference

1 Face Mask,
late 19th or early
20th century. Dan;
Liberia or Côte
d'Ivoire. Wood;
H. 18.4 cm (7¼ in.).
The Art Institute
of Chicago, African
and Amerindian
Art Purchase
Fund, 1963.273.

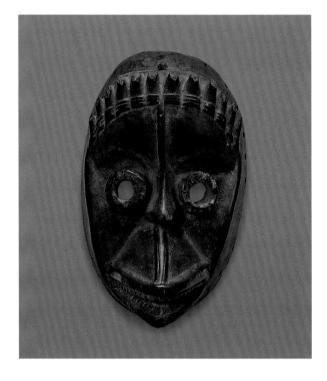

to a culture hero created by God before the earth
was shaped.[3]

Precisely because a mask's identity depends
on its costume and accessories as well as its cho-
reography and musical accompaniment, without
firsthand documentation it is impossible to deter-
mine the vernacular name of a particular example,
the character it would have portrayed, or the func-
tion it would have fulfilled.

Constantine Petridis

1 See Vandenhoute 1948; and Fischer and Himmelheber 1984.
2 This object was purchased through the Merton Simpson
Gallery, New York, in 1963. See Harley 1950, plate XI, fig. H; see
also Adams 2009; Petridis 2012; and Steiner 2018. **3** See Fischer
1978, 22–23; see also Fischer and Himmelheber 1984, 80–86.

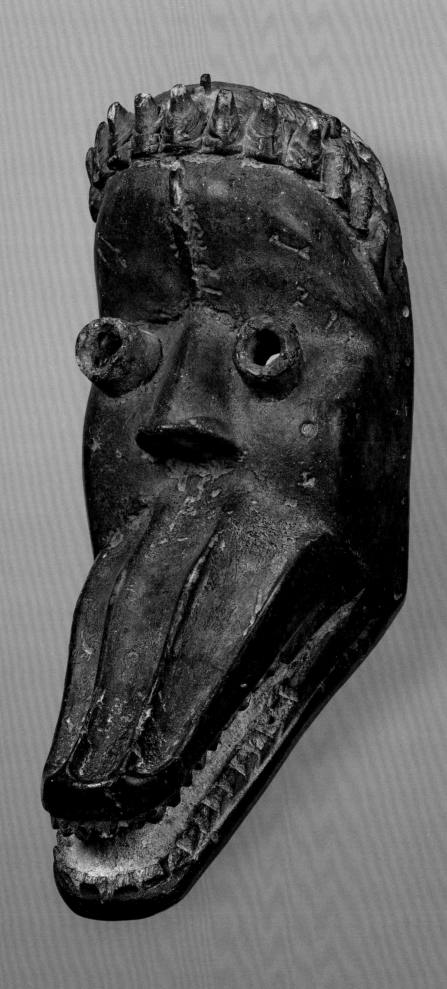

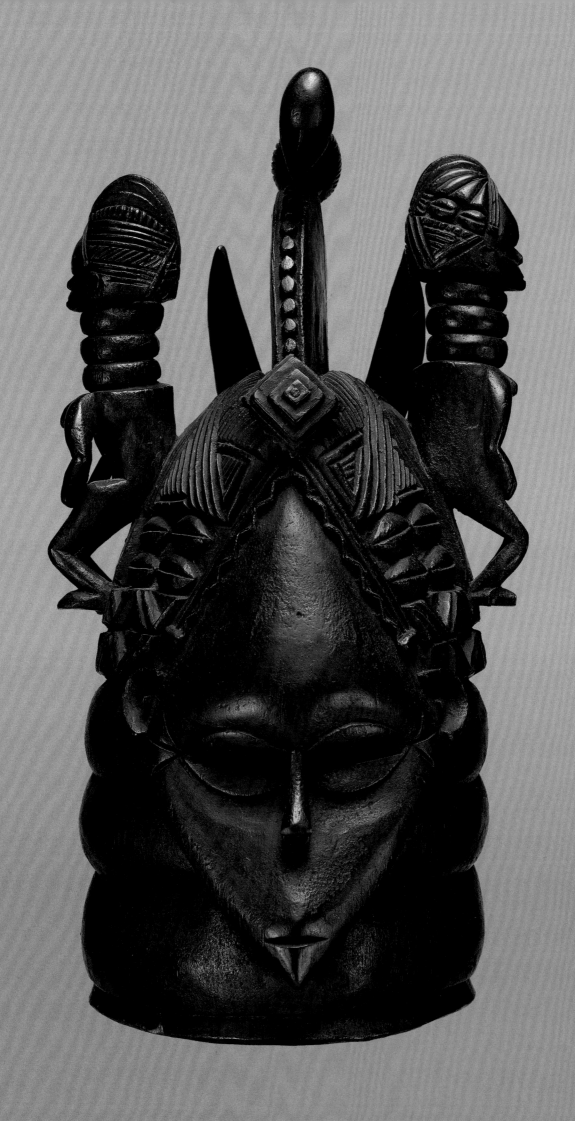

22 Female Helmet Mask (*Ndoli Jowei*)

Mende or Sherbro
Sierra Leone or Liberia
Early to mid-20th century
Wood
48.3 × 24.8 × 26.7 cm (19 × 9¾ × 10½ in.)

Through prior acquisitions of the George F. Harding Collection, Mr. and Mrs. Herbert R. Molner, and the Ada Turnbull Hertle Endowment, 1997.361

Provenance: Private collection, London, by 1946 [Art of Primitive Peoples 1946, no. 12b]. Ernst Anspach (died 2002) and Ruth Anspach, Greenwich, NY, by 1968 to at least 1983; sold to Tom Slater, Political Gallery, Indianapolis, IN, by 1997; sold to Robert Laff, Chicago, 1997; sold to Tom Slater, Political Gallery, Indianapolis, 1997; sold to the Art Institute, 1997.

Most field research pertinent to the Art Institute's mask dates from the 1970s or before, in part due to military conflict in the surrounding region that began in 1990.[1] In Sierra Leone and across the border in western Liberia, helmet masks like this example were governed by the all-female Sande association, also known as "Bundu."[2] This mask organization was present in every village among both the Mende and Sherbro to serve as the bridge between the community and the spirit world, a role carrying important political, religious, and educational responsibilities. In addition to acting primarily as patrons of the arts, association members oversaw a sanctuary and school for girls to be initiated into adulthood.

These masks expressed ideals of local Mende and Sherbro female beauty, which embodied moral perfection as well: a high forehead, slitted eyes, neck-fat rings (signs of a well-fed person), luminous skin, and an elaborate hairstyle. They were worn and performed by senior Sande officials at funerals, during visits from esteemed guests, at installations of chiefs and leaders, and during the initiation of young women into the association (see fig. 1).[3] This is one of the rare instances in Africa when women danced with carved masks. The name given to the helmet mask, *ndoli jowei*, means "dancing *sowei*"; the term *sowei* refers to the leader of the Sande. Representing the association at every major public occasion, the helmet mask acted as the lead dance teacher for the girls undergoing initiation. It also, and most importantly, embodied the guardian spirit of the organization, which was believed to have emerged from the world beneath the waters. In recognition of the helmet masks' spirit origin, the names of their carvers were never acknowledged.

Constantine Petridis

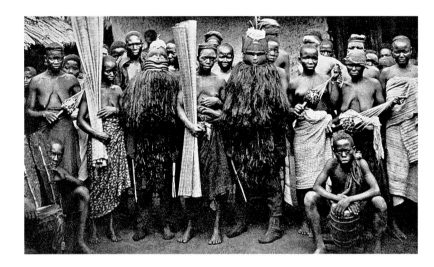

1 Alphonso Lisk-Carew (Sierra Leonean, 1887–1969). Masqueraders of the Bundu (or Sande) association in Freetown, Sierra Leone, 1905. From Kenneth J. Beatty, *Human Leopards* (London: Hugh Rees, 1915), facing p. 21.

1 The earliest description may be that of Thomas J. Alldridge; see Alldridge 1901, 141–43. **2** The classic monographs on the subject are Boone 1986; and Phillips 1995. See also Lamp 1985; and, among various entries by him on the subject, Siegmann 2009, 78–81. **3** The excision of the clitoris was the culmination of the girls' initiation, marking their physical transition into womanhood. In recent years, the practice of excision has been heavily criticized, and some scholars have argued that it is inappropriate to exhibit the helmet masks that relate to this form of body mutilation. See Kart 2020, 2–3, 6–7, and 11–12.

23 Male Face Mask (*Zauli*)

Guro
Côte d'Ivoire
Possibly early or
mid-20th century
Wood, kaolin, and
metal tacks
63 × 17.5 cm (24¾ × 6⅞ in.)

Restricted gift of Mr. and
Mrs. Eugene A. Davidson,
1976.21

Provenance: Mathias Komor
Gallery, New York, by 1975;
sold to the Art Institute, 1976.

24 Male Face Mask (*Zamble*)

Guro
Côte d'Ivoire
Possibly early or
mid-20th century
Wood and pigment
H. 46 cm (18⅛ in.)

Through prior bequest of
Florene May Schoenborn,
2017.107.

Provenance: Galerie Lucas
Ratton, Paris, by 2015; sold to
Galerie Jacques Germain,
Montreal, 2015; sold to the Art
Institute, 2017.

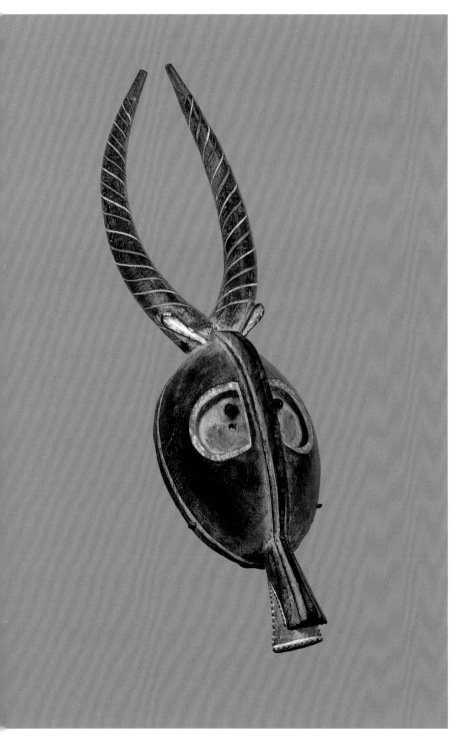

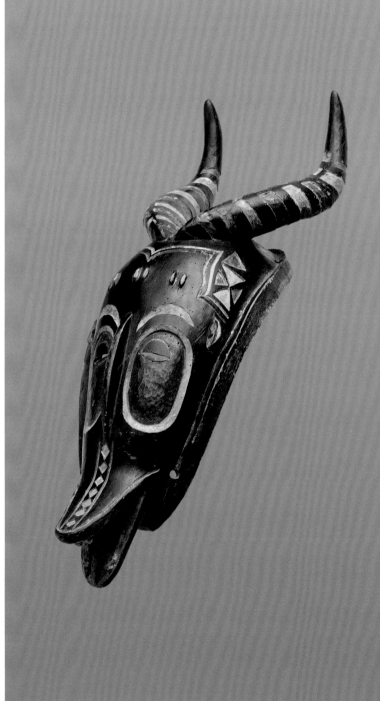

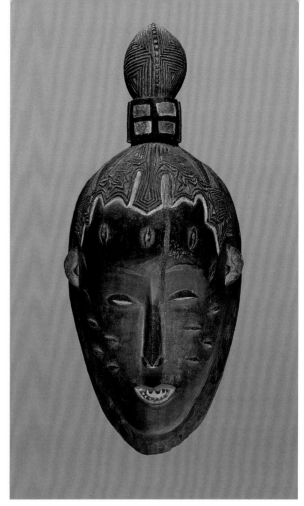

1 Female Face
Mask (*Gu*), early 20th
century. Guro; Côte
d'Ivoire. Wood and
pigment; 31.8 × 13 ×
9.8 cm (12 ½ × 5 ⅛ ×
3 ⅞ in.). The Art
Institute of Chicago,
bequest of Kate L.
Brewster, 1950.154.

Zamble is the name of a mask genre popular among the northern Guro people of central Côte d'Ivoire. It combines animal components, including carved antelope horns and the teeth-filled jaw of a dog or crocodile, with human ones such as a hairline and scarifications. In the past, *Zamble* usually appeared at an important man's second funeral, which would be organized months or even years after the actual burial to commemorate the significant accomplishments of the deceased during his lifetime.

Until recently, the Guro deployed *Zamble* exclusively for apotropaic ends. But today's performances are held primarily for entertainment, and contemporary masks are typically brightly colored with dazzling chemical paints. Nonetheless, even the most entertaining and secular of today's masquerades have retained spiritual connotations.[1] The *Zamble* mask wearer performs under the influence of the swift, capricious, and fearsome nature spirit it represents.[2] By offering the spirit an energetic body through which it can express its powers, the mask dancer allows it to purify its surrounding environment and to keep negative influences at bay. *Zamble*'s lightweight wood enables the dancer to be agile and daring as he carries out its physically demanding performance, which is distinguished by rapid footwork. The wearer holds the mask in place by clamping his teeth on a wooden bit inserted in two of the holes on its rim. The dancer's costume consists of a woven cloth wrap, preferably white, with a leopard or civet skin attached to the back so that it drapes over his shoulders.

Despite the difficulties of its performance, *Zamble* gives its wearer more freedom than others because he is permitted to reveal his identity during his performance. This openness allows some of the most beloved dancers to become quite famous. Mask performances are often organized in the form of competitions between dancers from two different families, one appearing after the other as they vie for coveted recognition.

In the past *Zamble* sometimes formed a trio with two other masks. One was the delicately beautiful female mask character known as *Gu*, often considered to be *Zamble*'s spouse (fig. 1). She is adorned with carved imitations of the leather protective amulets that are often incorporated into a woman's elegantly braided hairdo. The other was a different male character called *Zauli* ("the Ugly"), sometimes identified as *Zamble*'s elder brother or father.[3] Examples of the latter type are rather rare in collections in the West, and the Art Institute's is one of the best known even though it is atypical with its three clearly defined parts: mouth, head and horns. *Zauli* was everything that *Zamble* was not, both in its grotesque physical appearance and in its behavior: dirty, disorderly, brusque, rude, greedy, and somewhat funny. The mask was both admired and feared for its sudden mood swings and supernatural powers.

Constantine Petridis

1 See Bouttiaux 2016, 14–17; see also Fischer and Homberger 1985. **2** Bouttiaux 2016, 29–36. **3** Bouttiaux 2016, 36–38.

25 Face Mask

Bete or Guro
Côte d'Ivoire
Late 19th or early 20th century
Wood, pigment, chalk, monkey(?)
fur, leather, metal, and twine
H. 35.6 cm (14 in.)

Buckingham Fund, 1958.118

Provenance: Julius Carlebach
(died 1964), Carlebach Gallery,
New York, by 1958; sold to the Art
Institute, 1958.

The Guro and Bete routinely interact around the city of Gagnoa in south-central Côte d'Ivoire, and the resulting cross-cultural exchange—including stylistic borrowings in their art—make it impossible to attribute masks like this example to either population on formal grounds alone. Guro masks are better known and have also been collected on a broader scale during the twentieth century. But Bete masks have barely been studied in the field and some scholars have even questioned whether the Bete made masks of this type.[1]

The mask at the Art Institute features a median, vertical scarification mark in low relief on its high forehead as well as the striking addition of animal fur (possibly that of a monkey) to represent hair and a beard. Scholars have made a stylistic comparison to a famous mask of the same genre in the Musée du quai Branly–Jacques Chirac in Paris (fig. 1); that one once belonged to the avant-garde poet and artist Tristan Tzara, a proponent of the Dada movement during the first half of the twentieth century.[2] Some believe that a single artist carved Tzara's Bete/Guro mask, the one at the Art Institute, and a third example now in a private collection.[3]

The anthropologist and art historian Anne-Marie Bouttiaux has speculated that these masks either belonged to powerful and fearsome men or represented violent, male spirits or tutelary ancestors, given their ferocious appearance.[4] But without field research we cannot confirm either their vernacular meaning or their function.

Constantine Petridis

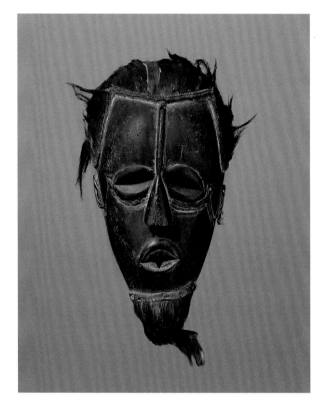

1 Face Mask,
early 20th century.
Bete or Guro; Côte
d'Ivoire. Wood, mon-
key fur, vegetable
fibers, metal, and
pigments; 42 × 28 ×
15.3 cm (16 9/16 × 11 ×
15 5/16 in.). Musée
du quai Branly–
Jacques Chirac,
Paris, 73.1988.2.1.

1 See Matthys 1996, 279–89; see also Fischer and Homberger 1985. **2** The Romanian-born exile was among the first dedicated private collectors of African art in the French capital before 1917; see Le Fur 2009, 66. **3** See Sotheby's 2012, lot 40. **4** Bouttiaux 2016, 50–51 and 131, plates 31–32.

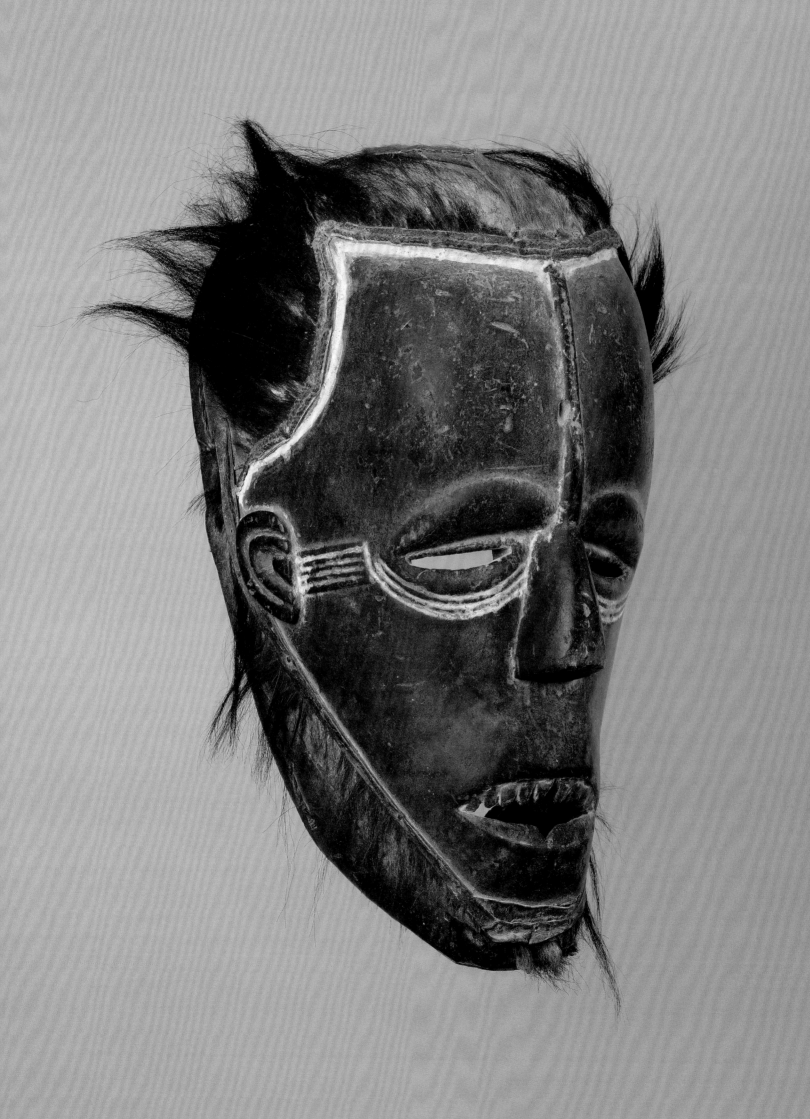

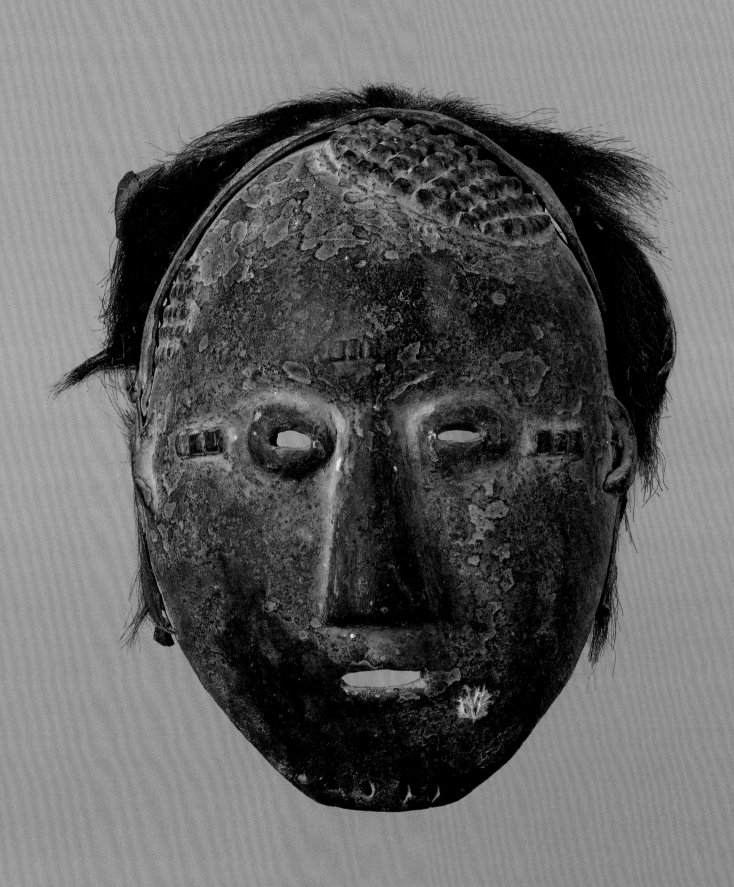

26 Face Mask

Unknown Lagoons people: possibly Attie/Atye/Akye or Adiukru
Lagoons region, Côte d'Ivoire
Late 19th or early 20th century
Wood, pigment, and fur
H. 26.4 cm (10 ⅜ in.)

African and Amerindian Art Purchase Fund; through prior acquisition from the Gaffron Collection, 1962.473

Provenance: Roger Bédiat (died 1958), Abidjan, Côte d'Ivoire, and Paris, by late 1930s; by descent to his stepson, Georges Stoecklin (died 1997), Nice and Cannes, 1958; sold to Henri Kamer (died 1992) and Hélène Kamer (later Hélène Leloup), Henri A. Kamer Gallery, New York; sold to the Art Institute, May 1962.

This small, flat mask is one of three or four stylistically related masks that have been variously associated with one or more of the twelve groups in southern Côte d'Ivoire collectively referred to as the Lagoons peoples. Two of these other masks are today in museum collections: one, formerly in the collection of Charles Ratton, is in the Musée du quai Branly–Jacques Chirac, Paris; the other, formerly in the collection of Paul and Ruth Tishman, is now in the Smithsonian Institution's National Museum of African Art, Washington, DC (fig. 1).[1] The Parisian example was acquired by Ratton in 1931 from a man named Roger Bédiat, a timber trader who would later become a collector and dealer of African art. From the late 1920s onward, he operated in the Ivorian region inhabited by the Attie (or Atye, or Akye), one of the above-mentioned Lagoons peoples belonging to the Akan language family. The Art Institute's mask was also once part of Bédiat's collection; he owned it until his death in 1958.

The first mention of such a mask appeared in an 1898 publication by the French explorer Camille Dreyfus, who had spent six months in Attie country.[2] The use of these masks came to an end soon after Dreyfus's visit, and the Art Institute's example is thus one of few survivals of a tradition that has long been extinct.[3] Originally, however, the Attie performed in the context of the Do association, with the aim of defending the community against all sorts of threats.[4] Their masks comprised several characters representing nature spirits in the guise of humans, animals, and composite beings. The extant masks do feature similar eyes, noses, and mouth forms, as well the facial designs that are both painted on and carved in low relief. Two of them (those at the Musée du quai Branly and the Smithsonian) also show a finely scalloped edge, and the ones at the Smithsonian and the Art Institute have animal fur—possibly from a monkey—attached to a

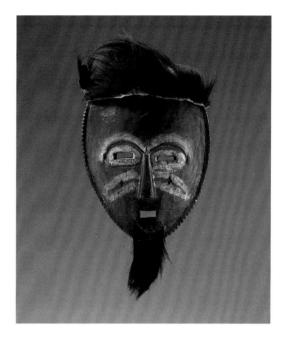

1 Face Mask, late 19th or early 20th century. Attie (or Atye, or Akye); Côte d'Ivoire. Wood, fur, and pigment; 35.6 × 20.3 × 12.1 cm (14 × 8 × 4 ¾ in.). National Museum of African Art, Smithsonian Institution, Washington, DC, gift of Walt Disney World Co., a subsidiary of The Walt Disney Company, 2005-6-63.

series of holes, representing hair and, in the former's case, a beard (fig. 1).

Both provenance information and stylistic markers have led us to deduce that the Art Institute's mask was created by an Attie artist; however, art historian Monica Blackmun Visonà believes that it might have been made by an Adiukru artist, basing her attribution primarily on forehead markings that imitate that group's practice of head-shaving.[5]

Constantine Petridis

1 Another example exhibited in a show titled *The Mask: All Peoples, All Times* at the Royal Museum of Fine Arts in Antwerp in 1956 is now in a private collection. See Olbrechts and Claerhout, 31, cat. 211; and Sotheby's 2017, lot 64. 2 Dreyfus 1898, 135. 3 Contemporary Attie people do not remember having danced any masks; see Féau 1989, 149. 4 See Visonà 1983, 127–28 and 132–34. 5 Monica Blackmun Visonà to Holly W. Ross, personal communication, Dec. 5, 1984, in Art Institute of Chicago curatorial object file. Visonà has also noted the Adiukru number among the twelve ethnic groups that are usually considered to form the "Lagoons Peoples"; Visonà 1993, 368.

27 Female Face Mask (*Ndoma*)

Baule
Côte d'Ivoire
Late 19th or mid-20th century
Wood, copper alloy,
and pigment
28.6 × 18.1 × 12.7 cm
(11¼ × 7⅛ × 5 in.)

Ada Turnbull Hertle Endowment
1988.309

Provenance: Paul Bedia, Abidjan,
Côte d'Ivoire. Henri Kamer (died 1992),
Paris, by Oct. 1958. Philippe Leloup
and Hélène Leloup (previously Hélène
Kamer), Hélène & Philippe Leloup,
African and Primitive Art, New York;
sold to the Art Institute, 1988.

Like many other Baule mask types, the portrait mask generically called *ndoma* (meaning "double," "copy," or "replica") is designed for a performance context.[1] Although danced by a man wearing a complementary costume (see fig. 1), each mask would be made to honor a specific (living) beautiful woman. The creator did not attempt to achieve physical likeness, however; rather, the honoree's portrait was idealized with fine facial traits and old scarification marks as well as an outmoded hairstyle. These attributes denote personal beauty and a desire to please others. The high forehead symbolizes great intelligence and downcast eyes, an introspective personality. The lustrous surface suggests clean, healthy, and well-fed skin. In the recorded opinions of Baule observers, these portrait masks—each one unique, like the individual honored—represent the apex of Baule sculpture.

Masks like this appeared during daytime festivals, entertainment masquerades open to all that used to punctuate village life at regular intervals. The portrayed woman, dressed in her best attire, danced beside the mask representing her. It would also be given the personal name of the individual it portrayed, although this information was rarely collected with sculptures that were brought to the West. The mask wearer did not attempt to conceal his identity, a practice unthinkable in sacred masquerades. Women were also allowed to honor the dancer by throwing money and other gifts to him, and were even permitted to touch the mask. The performance form or category in which these face masks appeared in skits was called *mblo*, a generic name that varied depending on the region. Today such masks are considered old-fashioned and have fallen out of use.

Constantine Petridis

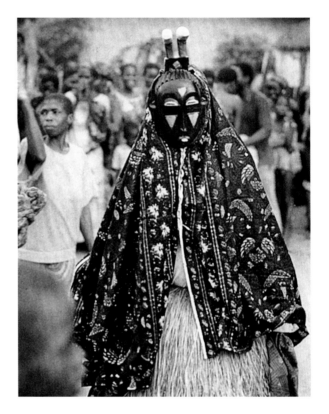

1 Masquerader in a Gbagba performance in the village of Kami, Côte d'Ivoire, 1972. The mask is a portrait of Kouame Oma commissioned by her brother and sculpted by Koffi Alany in 1934. Photo by Susan Mullin Vogel.

1 Susan Mullin Vogel has written extensively on the Baule and their art; see Vogel 1997, which served as the primary source for this entry.

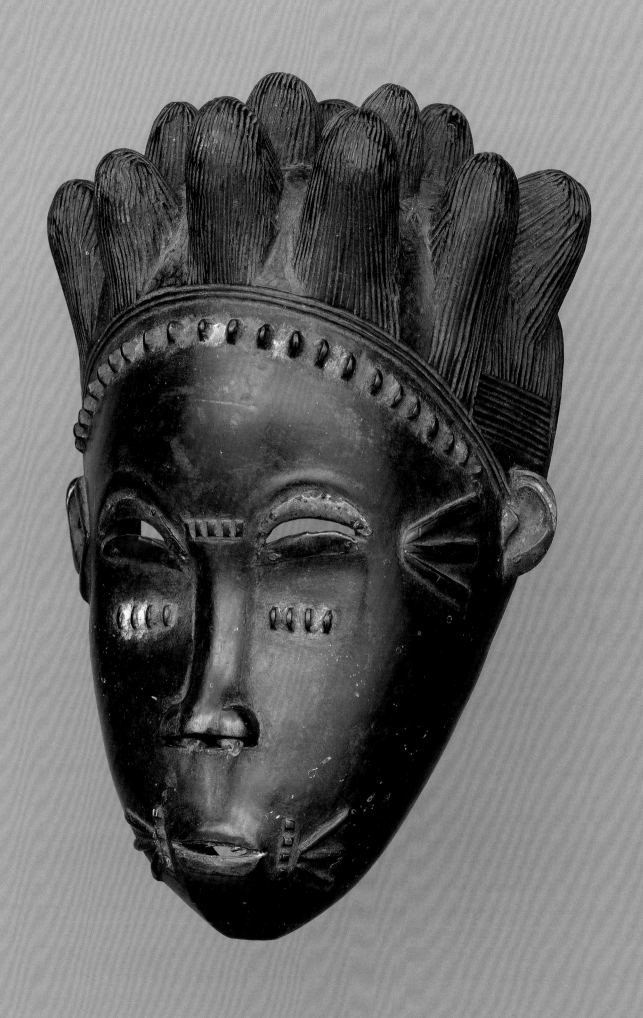

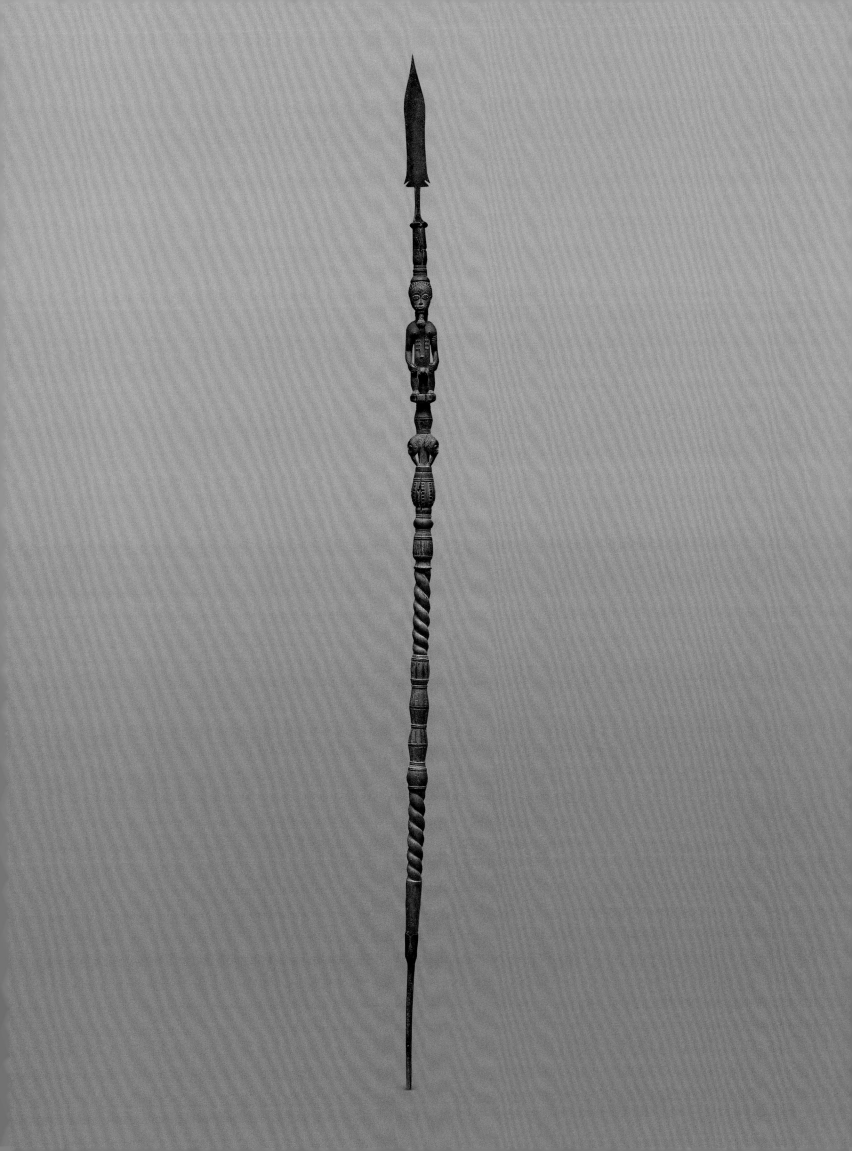

28 Figural Staff

Baule
Côte d'Ivoire
Probably late 19th century
Wood and iron
H. 160 cm (63 in.)

Restricted gift of Bernice Hirsch, William Hartmann, and Mr. and Mrs. Herbert R. Molner in memory of Milton Hirsch; African and Amerindian Art Purchase Fund, 1985.62

Provenance: Milton and Bernice Hirsch, Chicago, by 1970; consigned to Robert Barry, Chicago. Michael Wyman Gallery, Chicago, by 1985; sold to the Art Institute, 1985.

Along the eastern edge of Baule territory, figural commemorative staffs like this example were made until the 1950s as a means of honoring the ancestors.[1] Because these departed individuals were most often identified as the source of misfortune or death, they required regular sacrifices and invocations in order to be appeased. The staffs were placed in ancestral shrines, where they received periodic animal sacrifices, during which blood was sprinkled on them.

The staff at the Art Institute is wholly intact, which is unusual, and crowned with an iron spear-like blade. In most other parts of the Baule region, tribute is paid to the ancestors through stools and chairs, a tradition reflected here in the carving just below the blade: an idealized rendering of a male individual seated on a typical stool (fig. 1). The three faces carved in high relief under the seat may represent his wives and symbolize wealth. The drum carved beneath the faces likely alludes to success in warfare and in hunting.

Constantine Petridis

1 Detail of figural staff (cat. 28) showing the topmost figure.

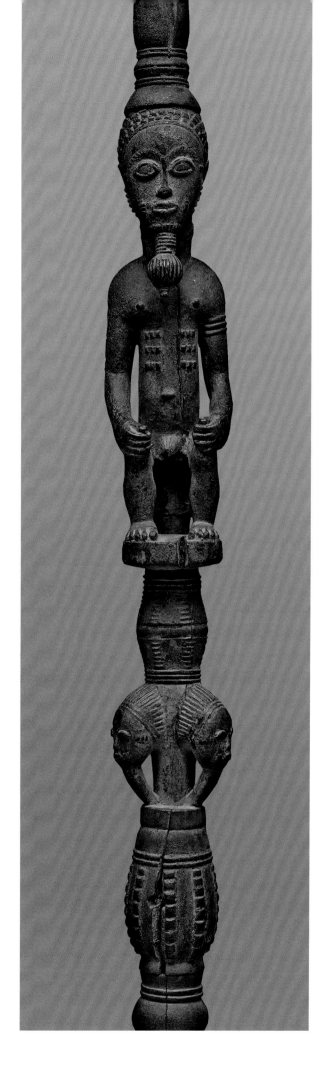

1 On a similar staff in the Newark Museum of Art, Newark, New Jersey, see Vogel 2018.

29 Female Figure (*Akua'ba*)

Fante
Ghana
Mid-19th or early 20th century
Wood, glass beads, shell,
copper alloy, and thread
36.8 × 6.9 × 6.9 cm (14½ × 2¾ × 2¾ in.)

O. Renard Goltra Fund, 1996.40

Provenance: Lucien Van de Velde and Mariette Van de Velde (born and later Mariette Henau; died 2012), Antwerp, Belgium, by 1977; sold to Alan Brandt (died 2002), New York, by 1995; sold to the Art Institute of Chicago, 1996.

Figures known as *akua'maa* (sing. *akua'ba*) have been made by artists among several related Akan-speaking cultures in Ghana (formerly Gold Coast) since at least the nineteenth century. Asante *akua'maa*, distinguished by their large disk-shaped heads and simplified bodies, are among the most recognizable forms of African sculpture. The figures are widely mimicked. Copies are produced for sale in curio and décor shops around the world, where they are marketed as "fertility dolls."[1] *Akua'maa* are also made by Fante sculptors, who adapt them slightly to feature rectangular heads, as in the example seen here. On this *akua'ba,* which was made in the nineteenth or early twentieth century, the shape of the head is defined by two tall ringed horns; these imitate a woman's coiffure that was popular in the period, in which the hair is separated into two equal clumps that are wrapped with string (see fig. 1). The sculpture is also remarkable because the artist has rendered the figure's torso and legs, as the majority of *akua'maa* are constructed with a simple rod standing in for the body.

 Akua'maa are associated with rituals that promote fertility and the safe delivery of healthy children. A woman of childbearing age would commission a figure from a sculptor. It would be consecrated by a priest, and then carried and cared for in the manner of a living infant.[2] Following a successful pregnancy, the figure might be placed on a shrine or the woman who had commissioned it might continue to care for it for many years.[3] The example seen here was probably kept on a shrine at one time, as evidenced by the shiny patina of the wood, the scattered resinous stains, and the encrusted surface of the figure's face and hairstyle. These encrustations

1 Unknown artist. "A Ga girl in Addah [Adda; now Ghana]," c. 1883–88. Albumen print; 8.9 × 5.3 cm (3½ × 2 1/16 in.). Basel Mission Archives, Basel, Switzerland.

were likely formed by offerings of drink or food that were poured over or rubbed on the figure. The care it was given is also reflected in the adornments, which include strands of glass, shell, and copper alloy beads around the neck, waist, and knees. These imitate similar beaded jewelry worn by Fante girls and women.

Kathleen Bickford Berzock

1 For a study on the marketing of Ghanaian "fertility dolls," see Wolff 2004. **2** Cole and Ross 1977, 104. **3** Cole and Ross 1977, 10.

30 **Pectoral Disk (*Akrafokonmu*)**

Asante
Ghana
Early to mid-20th century
Gold and red ochre
19.7 × 19.7 × 2.5 cm (7¾ × 7¾ × 1 in.)

Irving Dobkin and David Soltker estates; Jane Brill Memorial Fund; Mr. and Mrs. David B. Ross Endowment, 1999.287

Provenance: Odeefuo Boa Amponsem III, Denkyirahene (King) of Denkyira (reigned 1955–2016), town of Jukwaa, Denkyira State, Ghana, by 1991; given by subchief Nana Tuffuor on behalf of the Denkyirahene of Denkyira to Albert Nuamah, Abibiman Treasures: Fine African Arts and Artifacts, Detroit, 1991; sold to the Art Institute, 1999.

This large pectoral disk is an example of the sumptuous gold regalia that has been a highly visible indicator of status within the kingdom of Asante since its inception in the eighteenth century. Gold was central to the kingdom's economy before the colonial period, and this trade connected the kingdom to far-reaching networks of exchange across the Sahara Desert and the Atlantic Ocean. In 1870 the English traveler and writer Thomas Bowdich provided one of the earliest written accounts of Asante adornment when he described the abundant display he witnessed while in the presence of the ruler (*asantehene*) and his extensive entourage: "The sun was reflected, with a glare scarcely more supportable than the heat, from the massive gold ornaments, which glistened in every direction."[1] He also referred specifically to gold breastplates—probably pectoral disks like this one—worn by the *asantehene*'s messengers.[2]

In the nineteenth and twentieth centuries pectoral disks were part of the insignia of a wide array of court officials including royal linguists, messengers, subchiefs, and war-leaders (see fig. 1).[3] They were made to be worn on the upper chest, hung on a pineapple-fiber cord running through a channel extending across its full width. This pendant form may derive from circular gold pendants made in Africa's Western Sudan region, well north of Asante, in the medieval period.[4] A round pendant known as the Rao pectoral, which bears a central domed cabochon along with smaller ones that are surrounded by filigree patterns, was excavated from the twelfth-century burial of a young man in Senegal.[5] At that time, the region was prominent in the gold trade that extended across the Sahara Desert. As this trade shifted to the West African coast in the sixteenth century, forms of goldworking likely also traveled with it and evolved into the type of ornament seen here.

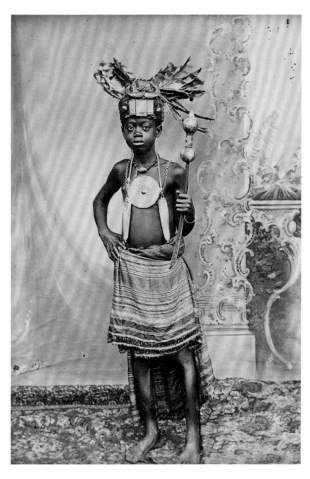

1 Unknown artist. "Attendant to Nana Kwasi Akuffo, the Akroponghene (King of Akropong)," 1907, from the series "Photographs of Ghana," 1910. Mounted photograph. Melville J. Herskovits Library of African Studies, Northwestern University, Evanston, IL, Folio 916.67043 P575.

The Art Institute's disk was made in the early twentieth century, a period of renaissance for Asante goldworking, which was severely curtailed in the late nineteenth century following the capture and forced exile of Asantehene Prempeh I by the British in 1896. In 1924 Prempeh I returned to his homeland and the event was widely celebrated, in part with the creation of lavish gold ornaments.[6] While based on traditional forms, regalia of the period featured innovative iconography that reflected the changing times. Fern leaves—symbols of defiance and durability—encircle the cone-shaped boss that marks the center of this disk.[7] According to Robert Rattray, the head of the British Anthropological Department of Ashanti in the 1920s, fern leaves communicated, "I am not afraid of you."[8] Images of cowrie shells, palm grubs, and cocoa pods are also featured on other disks of the period, when cocoa was a developing cash crop in the region.

Kathleen Bickford Berzock

1 Bowdich 1870, 35. 2 Bowdich 1870, 37. 3 Garrard 1989, 66.
4 Garrard 1989, 67. 5 Guérin 2019, 180. 6 Ehrlich 2018, 34.
7 Ehrlich 2018, 30. 8 Rattray 1927, 265.

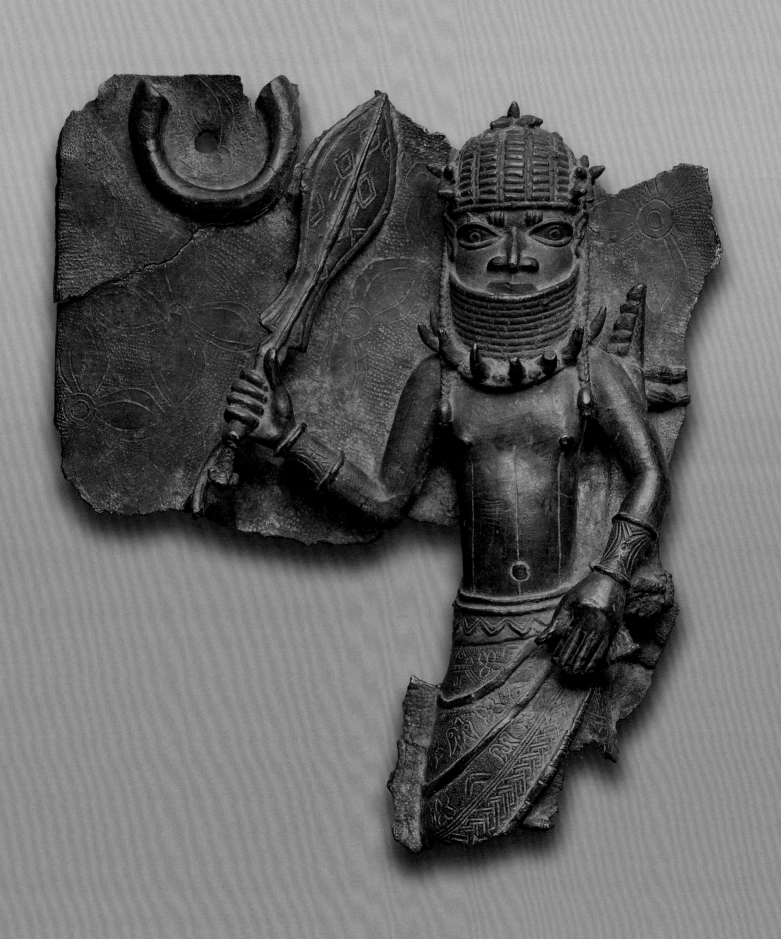

31 Figural Plaque

Edo, Kingdom of Benin
Nigeria
16th or 17th century
Brass
33.9 × 28.8 × 4.7 cm
(13⅜ × 11⅜ × 1⅞ in.)

Samuel P. Avery Fund, 1933.782

Provenance: Oba (King) Ovonramwen (reigned 1888–97; died 1914), Benin City, Kingdom of Benin, now Nigeria, before 1897; taken during the British military raid by George W. Neville (died 1929), Weybridge, England, 1897; by descent to his heirs, 1929; sold Foster's Auction House, London, May 1, 1930, lot 53, to Ernest Ascher (died early 1970s), Paris. Paul Vamos, Paris, Nov. 25, 1932. Ladislas Segy (Ladislas Szecsi; died 1988), Segy Art Gallery, New York, by Mar. 1933; sold to the Art Institute, 1933.

The origins of the Benin Kingdom in present-day Nigeria reach back to the thirteenth century; however, its role as a regional powerhouse in the forest region north of the vast Niger River Delta coalesced in the fifteenth century under the leadership of Oba (King) Ewuare (enthroned c. 1440).[1] Late in Ewuare's reign, the kingdom established trade with the Portuguese, newly arrived on the Atlantic Coast, and this added to the state's wealth and influence. Ewuare's grandson, Oba Esigie (enthroned c. 1504), built on the legacy of his ancestor, strategically leveraging Atlantic trade to increase the kingdom's wealth and expand its borders.

Esigie also expanded Benin's court hierarchy and defined aspects of its divine kingship rituals. Among other actions he increased patronage of the royal guilds, which worked under the exclusive command of the oba making objects of brass, coral beads, and ivory. These valuable materials were rich in the symbolism of divine kingship and as such were strictly controlled by the oba; they could not be owned or traded without his consent. Oba Esigie commissioned the creation of hundreds of elaborate brass plaques to decorate the royal palace.[2] The imagery on the plaques honors and commemorates royal ancestors and records ceremonies and hierarchies within the court. The plaque in the Art Institute's collection (cat. 31) depicts a war chief, identifiable by his prominent leopard-tooth necklace. The chief also wears a high collar and a headdress of coral beads, both bestowed upon him by the oba. The war chief raises aloft an *eben*, or ceremonial sword. During the yearly Ugie festival, which is celebrated to this day, chiefs dance before the oba, tossing and twirling their *eben* in his honor. The U-shaped object in the plaque's upper left corner is a *manilla*. Brass *manillas* were among the first goods that the Portuguese brought to the Atlantic Coast and

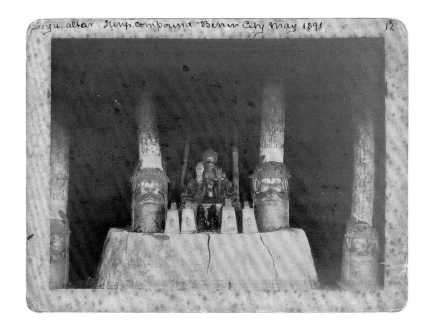

1 Cyril Punch (British, active late 19th century). "Niyu altar, Juny compound, Benin City, May 1891." Albumen print; 20.4 × 25.4 cm (8 ⅛ × 10 in.). Eliot Elisofon Photographic Archives, National Museum of African Art, Smithsonian Institution, Washington, DC, EEPA 1993-0014.

Benin's royal brasscasters used them as raw material when making objects for the court. The form of other complete plaques suggests that *manillas* originally were represented in each corner of this one.[3]

As a divine king, an oba's powers and influence continue after death. It is the responsibility of a new oba to establish an altar to his predecessor, including commissioning the ritual objects that will allow it to function. Among the most important objects on a royal altar are a matched pair of carved elephant tusks. The tusks are anchored on brass commemorative heads in the shape of the crowned head of an oba (see fig. 1). The color of ivory evokes spiritual harmony for the Benin Kingdom's Edo people; thus, its presence enhances the altar's sanctity. Ivory also served an important role as a commodity controlled by the oba, which made it suitable for use on royal altars. The tusk in the Art Institute's collection (cat. 32) was commissioned in the

32 Carved Tusk

**Edo, Kingdom of Benin
Nigeria
c. 1850–88
Ivory**
**150.5 × 195.6 × 12.7 cm
(59¼ × 77 × 5 in.)**

Gift of Mr. and Mrs. Edwin E. Hokin,
1976.523

Provenance: Reportedly commissioned
by Oba (King) Adolo (reigned 1848–88)
Benin City, Kingdom of Benin, now
Nigeria [see Blackmun 1997, 150]; by
descent to Oba Ovonramwen (reigned
1888–97; died 1914), Benin City, Kingdom
of Benin, now Nigeria, about 1888 to
1897; probably taken during the British
military raid, 1897. Edwin Hokin (died
1990) and Grace E. Hokin (born Grace
Cohen; died 2009), Chicago, by about
1970; given to the Art Institute, 1976.

mid-nineteenth century by Oba Adolo (reigned
1848–88) for the altar of his father, Osemwende
(enthroned c. 1816).[4] The iconography prominently
features the repeated image of an oba dressed in
coral regalia, with fish in place of his legs. In one
row the figure grasps a pair of crocodiles; in
another he grasps two mudfish; and in a third
he holds an *eben* (fig. 2). This imagery evokes
the supernatural powers of the oba and his close
associations with Olókun, the god of the sea,
who brings riches to the kingdom from afar. The
motif is closely associated with Oba Ewuare, the
fifteenth-century ruler mentioned above who
solidified the kingdom's regional dominance and
established trade with the Portuguese.[5]

In 1897 a British military force marched on
the Benin Kingdom with orders to invade and
conquer it. After a siege of several months they
captured the reigning oba, Oba Ovonramwen
(reigned 1888–97), and sent him into exile. During
their extended occupation of the city, the British
troops took thousands of artworks from the royal
palaces and shrines and shipped them to London,
where many were sold to defray the costs of the
military expedition.[6] Others were distributed to
members of the expeditionary force; among these
were the plaque in the Art Institute's collection
(cat. 31), which was in the possession of Captain
George Neville until his death in 1929. The royal
altar tusk in the Art Institute's collection likely
was also taken from the royal capital at this time.
During the long period of unrest that followed the
invasion of the Benin Kingdom, artworks contin-
ued to be removed from Benin City, either stolen or
coerced from their owners by European merchants
who acted as agents for museums and private
collectors across Europe and the United States.[7]

Kathleen Bickford Berzock

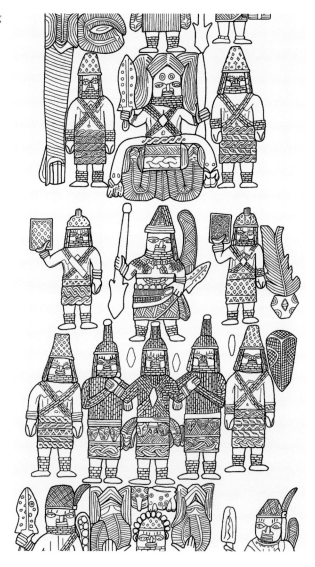

2 Detail of carving
on the tusk (cat. 32).
Drawing by Peggy
Sanders.

1 Plankensteiner 2007b, 23. **2** Art historian Kathryn Gunsch
proposes that the Art Institute's plaque was mounted on a pro-
cessional pillar in an audience hall of the oba's palace along
with other plaques with similar imagery of high-ranking courti-
ers; see Gunsch 2018, 151–53 and fig. 6.61, 1C. **3** According to
Gunsch, "corner motifs are de rigueur on single-figure plaques"
(Gunsch 2018, 77). **4** Blackmun 1997, 150. **5** Blackmun 1997, 153.
6 For more on the British invasion of the Benin Kingdom and
its impact on the kingdom's royal arts, see Plankensteiner
2007a. **7** Plankensteiner 2007b, 32–36.

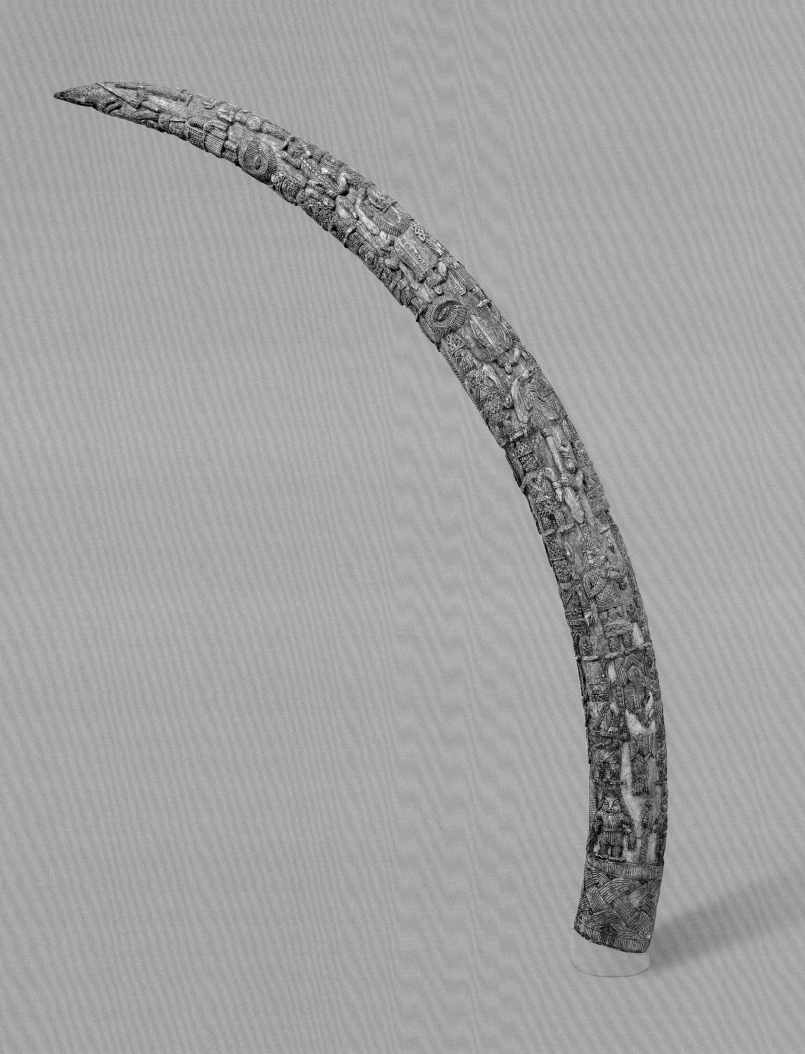

33 Figural Post
(Òpó Ògògá)

Olówè of Ìsè (c. 1869–1938)
Yòrùbá
Ìkéré, Èkìtì region, Nigeria
c. 1910–14
Wood and pigment
152.5 × 31.8 × 40.6 cm
(60 × 12 ½ × 16 in.)

Major Acquisitions Centennial Fund,
1984.550

Provenance: Reportedly commissioned
by Oníjàgbo Obásorò Alówólódù, Ògògá
(King) of Ìkéré (reigned 1890–1928),
Èkìtì State, now Nigeria, probably about
1910–14 [see Drewal and Pemberton
1989, 205]; by descent to his heirs, Ìkéré,
Èkìtì State, now Nigeria, until at least
1964. Gaston T. de Havenon (died 1993),
New York, by May 1981; sold to the Art
Institute, 1984.

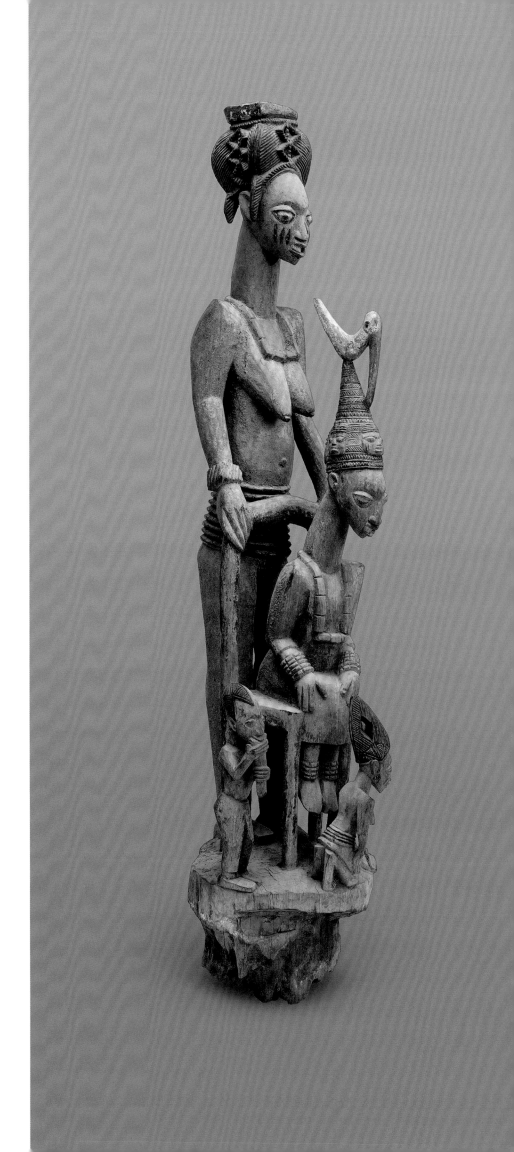

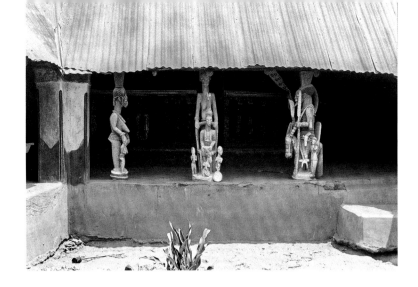

The veranda post (*òpó*) shown here was carved between 1910 and 1914, by the renowned artist Olówè of Ìsè, for an inner courtyard in the palace of Oníjàgbo Obásorò Alówólódù, the king (*ògògá*) of Ìkéré, Èkìtì, who reigned from 1890 to 1928 (see p. 113, fig. 1).[1] It features the king and his senior queen (*olorì*) apparently getting ready for a special ceremony or preparing to receive important guests in the courtyard. The primary figures are accompanied by two small ones: a man (on the left) playing a flute to announce the king's presence and a female kneeling to remind the public of the honor and respect due to his royal highness. A third small figure on the right is now missing, but clearly visible in a field photograph taken in 1959 by William Buller Fagg, then a curator at the British Museum (fig. 1). The man carries a fan that would be used to cool the king's body in hot weather.[2] The photograph shows that the Art Institute's veranda post was originally at the center of three sculptures. The mother of twins (*ìyà ìbejì*) on the left now belongs to the Memorial Art Gallery in Rochester, New York, while the armed equestrian figure (*jagúnjagún*) on the right is currently in the collection of the New Orleans Museum of Art.[3] All three posts reflect the Yòrùbá belief that a king has the metaphysical capacity to synthesize, for the benefit of the body politic, the attributes of men—as husbands, fathers, warriors, and protectors—with those of women—as mothers, wives, and homemakers.

The senior queen (*olorì*) towers protectively above the king (*ògògá*) in the post featured here and directs the viewer's attention to the bird on his crown (*adé*). As discussed elsewhere in this volume (see cat. 42), the bird motif has many implications in Yòrùbá culture, one of which identifies it with the hidden spiritual power of women. According to a myth, shortly after the creation of the physical world below the sky, the

1 William Buller Fagg (British, 1914–1992). Three figural posts in Ìkéré, Nigeria, 1959. Royal Anthropological Institute of Great Britain and Ireland, 400_WBF. 1959.080.10.

Supreme Being (Olódùmarè) sent down three deities—two male and one female—to administer it. To the goddess Odù, Olódùmarè gave a special power (*àse*) in the form of a closed calabash containing a bird, with which to "sustain the physical world" in her role as Mother of All, including the deities (*òrìsà*).[4]

As the myth goes, Odù later shared her power with certain women, called *àjé*, who now use it surreptitiously for negative purposes, such as turning into birds at night to suck the blood of innocent victims who will eventually die.[5] But there is a popular belief that, if appeased, the *àjé* can also do good, such as helping a given community fight epidemics or weaken enemies on the battlefield. Hence they are euphemistically called *Àwon-Ìyá-Wa* (Our Mothers) and *Eleye* (Wielders of Bird Power) in order to forge a mother-and-child relationship with them and encourage them to be more benevolent (see cat. 40).[6] Some towns require a powerful woman or priestess called Ìyá Oba (Royal Godmother) to place the *adé* on the head of a new king and thereby enable him to harness the procreative powers of Mother Earth and women in general for the well-being of his subjects. Since the *olorì* performs that role at Ìkéré, her image here is bigger than that of her husband, embodying the enormous spiritual power she wields in the palace, a phenomenon further reflected in her elaborate hairdo.

Babatunde Lawal

1 For Olówè of Ìsè's biography, see Pemberton 1989a; and Walker 1998, 13–33. 2 See Pemberton 1989a, fig. 9. 3 For more details, see Pemberton 1989a, 96–111; and 1989b, 206–11. 4 Verger 1965, 202. 5 Verger 1965, 200–19. 6 Prince 1961, 797; Lawal 1996b, 31–33, 40–41; and Abimbola 1997b, 403.

34 Kneeling Maternity Figure (*Ère Ojúbo*)

Abógundé of Ede (active late 19th century)
Yòrùbá
Nigeria
Late 19th century
Wood, beads, and traces of pigment
62.2 × 19 × 31.7 cm (24½ × 7½ × 12½ in.)

Gift of the Alsdorf Foundation, Mr. and Mrs. James W. Alsdorf, and Mr. and Mrs. Joseph P. Antonow; Samuel P. Avery Fund; gift of Herbert Baker and Gwendolyn Miller, the Britt Family Collection, and Gaston T. de Havenon; Ada Turnbull Hertle Fund; gift of Mr. and Mrs. Edwin E. Hokin, Robert Stolper, and Mr. and Mrs. Edward H. Weiss; through prior gift of Mr. and Mrs. Raymond J. Wielgus, 1988.21

Provenance: Milton M. Gross (died 1976), Brooklyn, NY; sold to Jeffrey S. Hammer (died 2016) and Deborah Hammer (born and later Deborah Stokes), Chicago, by 1976; sold to the Art Institute, 1988.

A maternity figure like the one shown here appears on many Yòrùbá altars because her kneeling pose (*ikúnlè*) implies greetings and communicates humility, respect, supplication, and the like. It is thus one of the most effective means of enlisting the support of the *òrìsà* who are collectively known as *àkúnlèbo* (literally, "beings to be worshipped with the kneeling pose"). The ritual power of the pose can also be traced to its association with motherhood. Because a woman risks her life during labor, Yòrùbá mothers often use their kneeling pose (*ikúnlè abiyamo*) to invoke the crucial moment of birth when begging for a rare favor. The invocation also carries with it a veiled threat of retributive justice should anyone disrespect the sanctity of motherhood. Even the *òrìsà* are expected to honor childbirth because, notwithstanding their suprahuman status, they have a symbolic mother themselves in the goddess Yemoja.

Women anxious to have children may be advised to donate a kneeling female or maternity figure to an altar to embody their wishes and then receive their weekly or monthly offerings.[1] Anthropologist William Bascom has also documented the case of a woman who donated a maternity sculpture to thank an *òrìsà* for enabling her to have a child, and to put herself and the child under the continuous protection of the deity.[2] To express their gratitude, some parents give their children names such as Fábùnmi (Ifá gave me this child) and Ògúnbíyi (Ògún brought this child to the world).[3]

Babatunde Lawal

1 Rear view of kneeling maternity figure (cat. 34).

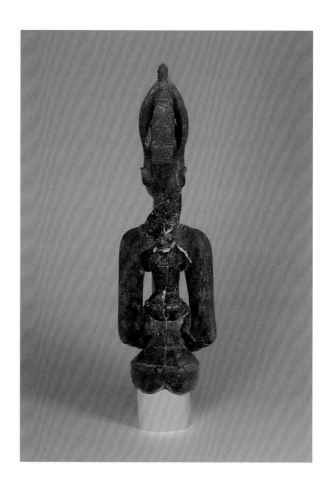

1 A priest of the creativity deity, Obàtálá, from the town of Ìséyìn once identified a maternity figure on his altar as a votive offering from a woman expecting another baby after her first pregnancy ended in a miscarriage. Personal communication with the author, 1983. **2** Bascom 1969c, 111. **3** See also Lawal 2012b, 33–34.

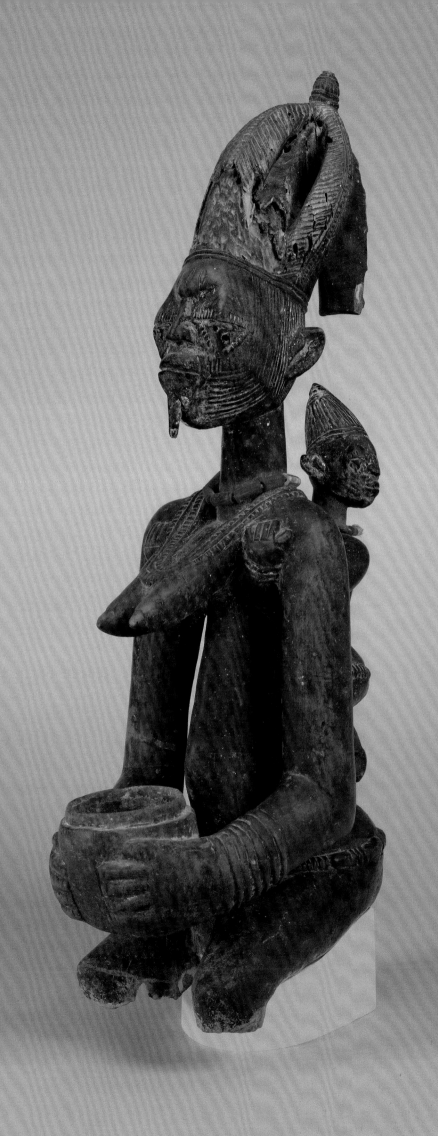

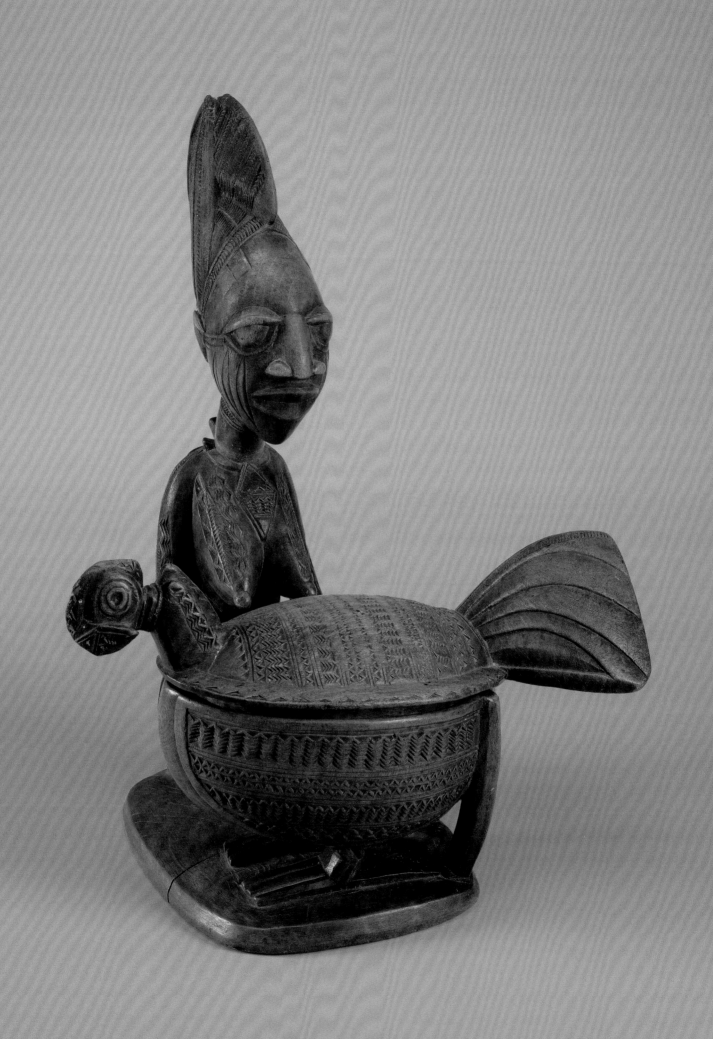

35 Kneeling Female Figure (*Olúmèye*)

Attributed to Òbémbé Alàyè (active late 19th to early 20th century) or Agbónbiofé (died 1945)
Yòrùbá
Nigeria
Late 19th or early 20th century
Wood, pigment, glass beads, fabric, and thread
40.1 × 31.1 × 22.8 cm
(16 × 12¼ × 9 in.)

Ada Turnbull Hertle Fund, 1977.493

Provenance: Alain de Monbrison, Galerie Monbrison, Paris, by 1977. Pace Primitive and Ancient Art (later Pace African and Oceanic Art), New York, 1977; sold to the Art Institute, 1977.

The kneeling female figure shown here, holding a rooster-shaped bowl, is called *olúmèye* (one who knows honor). This figural type abounds in some Yòrùbá palaces because it is used to hold kola nuts (*Cola acuminata*; *obì* in the Yòrùbá language), which the king hands out to important visitors during special events in any of the courtyards. The nut is popular in West Africa because of its rich taste and nutritional value.[1] Its association with good health is discernible in the Yòrùbá incantation *Obì ní íbi ikú*; *obì ní íbi àrùn* (It is the kola nut that averts death; it is the kola nut that prevents diseases).[2] The belief that it also promotes mutual respect, peace, and tranquility in a given community resonates in a popular proverb: *Òrò gbere ní í yo obì lápò*; *òrò líle ní í yo ofà l' apó yo* (Peaceful words bring a kola nut from the pocket; hard words bring an arrow from the quiver).[3] Consequently, as Yòrùbá scholar G. J. Afolabi Ojo puts it, "no ceremony or function, ancient or modern, is complete without it."[4]

Such is the sociopolitical value of the kola nut among the Yòrùbá that even the *òrìsà* are believed to be fond of it.[5] Hence the incantation: *Òrìsà kì í kohùn obì* (Deities will not turn down an appeal made with kola nuts).[6] Accordingly, an *olúmèye* containing kola nuts and other offerings may be placed on an altar for communicating with a deity. Many diviners (*babaláwo*) also use the rooster-shaped container of the *olúmèye* to store kola nuts, as well as divination palm nuts (*ikín*) and other sacred objects, in order to increase their ritual potency. Some Yòrùbá elders identify the *olúmèye* as a messenger shuttling between the human and the spirit worlds.[7] Many of these female figures also carry children on their backs, apparently to stress the urgency of humanity's need for protection, especially from the *ajogun*, the "negative left" of the Yòrùbá cosmos.[8]

The intricate hairdo (*agògo*) in this *olúmèye* identifies her as a priestess. Like that in cat. 34, her kneeling pose (*ikúnlè*) connotes greetings and respect. The triangular pendants (*tírà*) in the front and back of her necklace reflect Islamic influence and are believed to both attract goodness and ward off evil forces. Her waist beads and body patterns recall those worn by palace maidens who sing and dance to entertain the audience on special occasions; the design on the rooster's body echoes that allusion.

Babatunde Lawal

1 Odebunmi et al. 2009; and Gollmer 1885, 176. 2 See also Awolalu 2001, 168; and Ayelaagbe 1997, 7. 3 Delano 1979, 107. According to Geoffrey Parrinder, the kola nut also signifies "friendship, and, when split and partaken of by others, constitute[s] a pact of loyalty and communion" (Parrinder 1949, 81). 4 Ojo 1966a, 52. 5 Epega 1971, 27. The only exception is the thunder deity, Sàngó, who prefers bitter kola (*Garcinia kola*; or *orógbó* in the Yòrùbá language). 6 Opadotun 1986. See also Awolalu 2001, 168. 7 Carroll 1967, 32, plate 28; and Pemberton 1989b, 202. 8 For illustrations, see R. Thompson 1974, 71, fig. 93; and Siegmann 1980, 32.

36 Tapper with Supplicant and Hunter (*Ìróké* Ifá)

Yòrùbá
Owo region, Nigeria
17th or 18th century
Ivory
H. 47 cm (18⅛ in.)

Gift of Richard Faletti, the Faletti Family Collection, 2000.316

Provenance: William Wright, Wright Gallery, New York, by 1984; sold to Richard J. Faletti (died 2006) and Barbara Faletti (died 2000), Chicago then Phoenix, AZ, 1984; given to the Art Institute, 2000.

37 Tapper with Maternity Figure (*Ìróké* Ifá)

Yòrùbá
Kétu region, Republic of Benin
Mid-20th century
Wood, glass beads, and thread
H. 42.6 cm (16¾ in.)

Gift of Richard Faletti, the Faletti Family Collection, 2000.317

Provenance: William Wright, Wright Gallery, New York, by 1985; sold to Richard J. Faletti (died 2006) and Barbara Faletti (died 2000), Chicago then Phoenix, AZ, Feb. 19, 1985; given to the Art Institute, 2000.

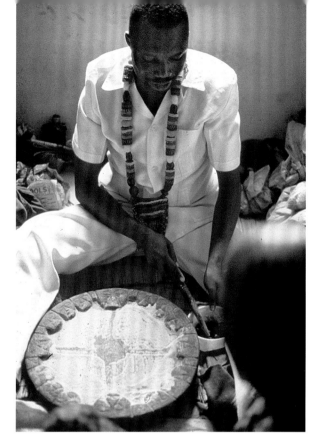

1 Babaláwo Kolawole Ositola beginning a divination session in the Porogun quarter of the town of Ìjèbú-Ode, Nigeria, 1982. Photo by John Pemberton III.

A typical tapper (*ìróké*), which a diviner uses to "knock on" the divination tray at the beginning of the process to greet the deity Ifá (see fig. 1 and pp. 190–91), has three sections: upper, middle and bottom. The upper part of the tapper shown here at far left (cat. 36) features a kneeling female figure with a horn projecting from her head. Beneath her, in the midsection, is a hunter (*olóde*), holding in his right hand a bow and arrow (*ofà*) with which he killed the crocodile (*awónríwón*) in his left hand. The bottom part of this *ìróké* doubles as a bell that the diviner shakes when praying for a client or acknowledging greetings from friends and neighbors.

The kneeling female motif is popularly associated with supplication (see also cats. 34–35). It performs a similar function here as when a diviner uses the tip of the cone on the woman's head to tap the divination tray and connect Ifá and the divine messenger, Èsù, also known as *Sónsó òbe* (Sharp Tip of the Knife). This paves the way into the hidden secrets of the cosmos, enabling Ifá to reveal the concealed. This apparently pregnant female touches her belly with her right hand, as if praying for safe delivery and reinforcing the prayer with the fan in her left hand. The Yòrùbá name for a fan is *abèbè* (literally, "that which begs heat 'to cool down' and not 'to hurt the body'"). It is used here metaphorically to plead the human cause.

The placatory significance of the fan also resonates in the image of the hunter in the midsection of the tapper. He has killed a dangerous crocodile to prevent it from hurting humans and seems to be offering the animal as a sacrifice to the divination deity (Ifá), the divine messenger (Èsù), the hunting deity (Òsóòsì), and the war deity (Ògún), pleading with them to protect the pregnant woman as well as humanity in general from negative forces.

The other tapper shown here (cat. 37) is atypical because most *ìróké* bear the horn-like projection (tapper) on the head. But in this example it is under the kneeling maternity figure. This tapper performs the same function even though the diviner will have to turn the figure upside down to use it. The security of both mother and child is assured as the diviner holds both of them, which explains why some beneficiaries of Ifá divination bear names such as Fágbèmí (Ifá supports me) and Fádáìró (Ifá sustains [this] family). The sash (*òjá*) that secures the baby on its mother's back recalls a popular Yòrùbá taboo: *Omo kìí jábó léhìn Ìyá rè* (A child must not fall off its mother's back).[1] This is a taboo that some Yòrùbá often use to remind the *òrìsà* of the maternal care they received from Yemoja, the Water Goddess and Mother of All. The female figure's red-and-white necklace (*kélé*) identifies her as a devotee of Sàngó, the thunderstorm deity whose bond with Yemoja was so tight that he is often addressed as *Baba wa òjò; omo olómi tí í jé Yemoja* (Bringer of Rain; the son of Yemoja, the Water Goddess and Mother of All).[2]

Babatunde Lawal

1 Lawal 1996a, 185–86. 2 Lawal 2008, 33.

38 Figural Staff (*Ògó*)

Attributed to an unidentified Kétu master
Yòrùbá
Republic of Benin
Mid- to late 19th century
Wood
25.4 × 12.7 × 12.7 cm (10 × 5 × 5 in.)

Gift of Anne R. Whipple and Jay Whipple in memory of Anne's son, W. Philip McNulty III, 1991.396

Provenance: Jay N. Whipple Jr. (died 2018) and Anne Reisse Whipple, Lake Forest, IL, by 1979; given to the Art Institute, 1991.

Probably collected from the kingdom of Kétu (now part of the Republic of Benin), this ritual staff (*ògó*) for Èsù features three figures: an armed warrior (center) flanked by a chained male captive (on his right) and a nursing mother (on his left). The staff is considered one of the most powerful symbols in Yòrùbá religion because it is used to plead with Èsù (the divine messenger) to unite all the positive forces of the cosmos for the human good. This expectation is evident in the deity's name, "Èsù," which derives from the root verb *sù* (to unite or gather into a mass). According to Yòrùbá cosmology, Èsù mediated the special power (*àse*) that enabled the sand poured by Odùduwà on the primordial waters to congeal and develop into habitable land. The laterite rock (*yangi*) is sacred to Èsù because of its identification as the first lump of earth to emerge from the primordial waters, like the head of a baby coming out of the womb.[1] This myth may account for the carved lump (*òsu*) on the head of some Èsù staffs, as if designed to butt off obstacles.[2] The image also brings to mind the Yòrùbá word for doggedness and perseverance, *iforíti* (literally, "using the head to push").[3] A similar metaphor is apparent in other *ògó* featuring human figures with sharp projections on their heads, recalling one of the deity's appellations: *Sónsó òbe* (Sharp Tip of the Knife; see also cat. 36).[4]

Although the projection on the warrior's dog-eared cap in this staff resembles a phallus, art historian Sarah Watson Parsons has noted a possible discrepancy between the common assertion that "Èsù's hairstyle is meant to convey his formidable power" and the fact that it is "almost always a representation of a flaccid penis." She wonders: "What other interpretations of Èsù iconography are being obscured by the focus on phallic sexuality?"[5] While a definitive explanation must await further field investigation, an Èsù priest in the city of Abéòkúta once assured me that many such projections signify the deity's virility and capacity to "cut through." According to this priest, other projections may, however, be serpents in disguise. He then showed me an *ògó* with a serpent motif on the head, which, in his words, "connects" Èsù with Òsùmàrè (the rainbow goddess, associated with wealth and prosperity). One of her most sacred symbols is a boa (*erè*).[6]

Èsù is the gatekeeper and guardian of frontiers as well as the crossroads, and thus is expected to collaborate with Ògún (the war deity) to ensure border security. Since this *ògó* is from the Kétu kingdom and was created in the nineteenth century, it probably commemorates the civil wars that engulfed much of southwestern Yòrùbáland during the period.[7] The Fon kingdom of Dahomey invaded Kétu in 1883.[8] So the warrior in the middle of the trio may embody the collaboration between Èsù and Ògún during the various conflicts—for while the projection on his head identifies him as Èsù, the gun in his right hand tags him as Ògún. This two-in-one imagery recalls the belief that Èsù is capable of assuming different guises to confuse an onlooker, a belief popularized by his cognomen, Elégbara (One Body with Two Hundred Aspects). The chained male captive (on the right) could signify an event during the wars when Kétu soldiers successfully ambushed a Fon regiment and liberated some Yòrùbá captives, here personified by the nursing mother on his left. Like those on the face of the warrior, the lineage marks (*ilà*) on the woman's forehead identify her as Yòrùbá.[9]

Babatunde Lawal

1 Personal communication with Yòrùbá diviner Babaláwo Fatoogun, Ilé-Ifè, Nigeria, 1973. See also dos Santos and dos Santos 1971, 29; and Adeoye 1989, 126. **2** For illustrations, see Drewal 1980, 27, figs. 9–10. **3** See Abraham 1958, 221; and Fakinlede 2003, 55. **4** Verger 1957, 139; see also Daramola and Jeje 1975, 298. For illustrations, see R. Thompson 1971, ch. 4, esp. fig. 17; and Poynor 1984, 31, fig. 26. **5** Parsons 1999, 37. **6** Personal communication with the author, Ilé-Ifè, Nigeria, 1973. For images of Èsù staffs with snake motifs on the heads, see Lawal 2008, 27, fig. 5; and Chemeche 2013, plates 200, 204, and 206. **7** See Okediji 1997, 177. **8** See Smith 1988, 134. **9** For more information on Yòrùbá lineage marks, see Johnson 1921, 106–9; and Daramola and Jeje 1975, 77–82.

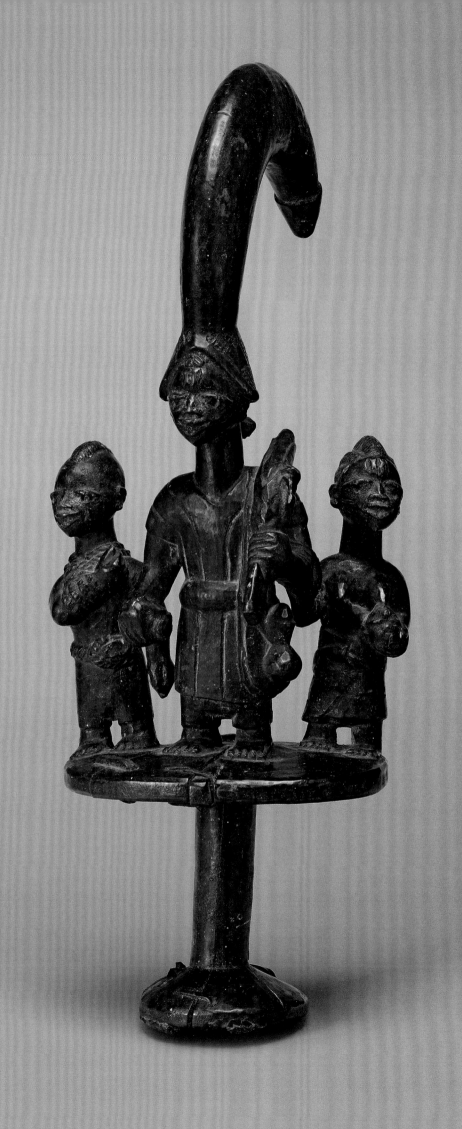

39 Headdress (*Àgó Ègúngún Ode*)

**Attributed to Adìgbòloge
(Òjérìndé; died c. 1914)
Yòrùbá
Ìtokò quarter, Abéòkúta, Nigeria
Mid- to late 19th century
Wood and pigment
29.8 × 24.1 × 20.3 cm (11¾ × 9½ × 8 in.)**

Edward E. Ayer Endowment
in memory of Charles L.
Hutchinson, 1969.240

Provenance: John J. Klejman
(died 1995), Klejman Gallery,
New York, by 1969; sold to the
Art Institute, 1969.

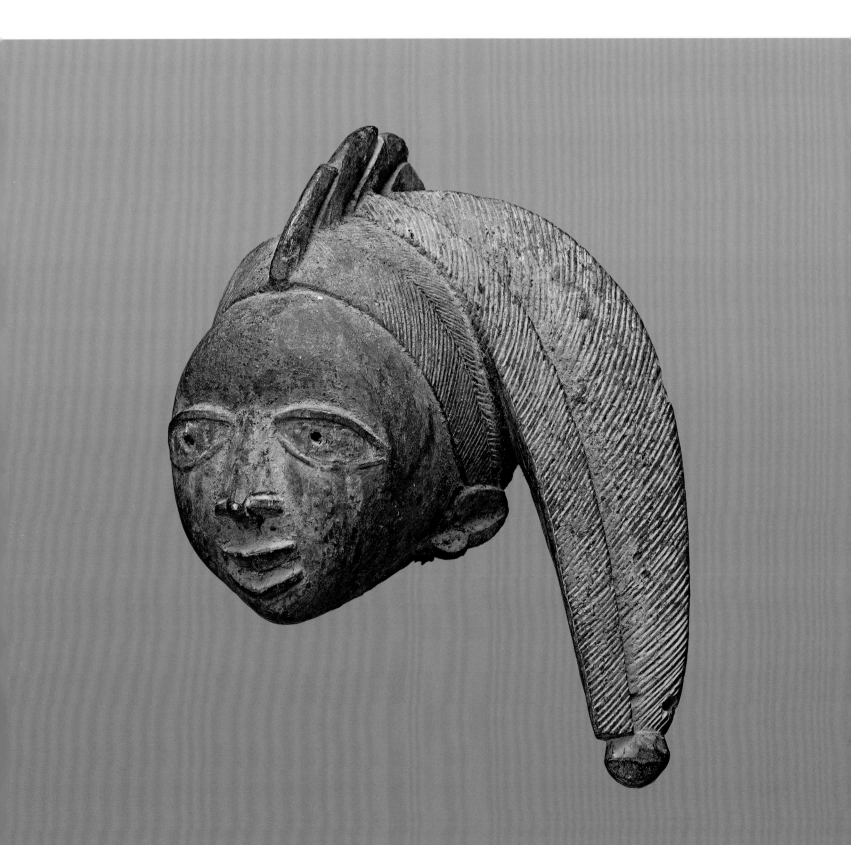

The Yòrùbá belief in life after death finds its most eloquent artistic expression in the *Egúngún* mask. Found mainly among the Òyó Yòrùbá (although other subgroups have different versions of it), a typical *Egúngún* represents the reincarnated soul of a deceased ancestor returning from the afterlife (*èhìn ìwà*) to interact briefly with living descendants. As a result, the annual *Egúngún* festival is a joyful occasion in a given community. Lasting between seven and twenty-one days, the festival gives many families an opportunity to renew old ties with long-departed ancestors who are now back among the living physically (although as masked figures), praying for their well-being and participating in rituals aimed at cleansing the community of disease and other harmful elements. Some masks serve as counselors and soothsayers and others as judges, helping to settle outstanding disputes and so on. There is a special category, *Egúngún onídán/Egúngún eléré*, whose primary function is to entertain the public with acrobatic dances and magical performances.[1] The masks appear in a variety of costumes fabricated from leaves, animal skins and raffia, leather, and colorful, multilayered fabrics that flare out during the dance, dazzling the audience with surreal, otherworldly spectacles (see fig. 1).

The masked presence of the living dead among mortals is like a dream come true for the general public—so much so that some *Egúngún* acolytes, thrilled at the prospect of immortality, sometimes work themselves into a frenzy, jumping and whipping one another. For the mask embodies and vivifies the Yòrùbá quest for eternal life.[2] As one community elder confided in me, the spectacle so moved him that he began to imagine the time in the future when his own *Egúngún* would be accorded a similar welcome. Although many spectators are aware of the human body under each costume, the general belief is that the rituals a masker underwent before donning it would have depersonalized

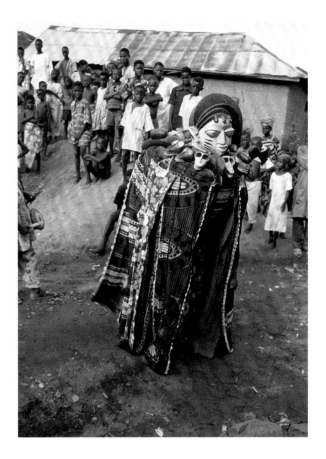

1 *Egúngún* masquerade, Abéòkúta, Nigeria, 1978. Photographic print. Henry John Drewal and Margaret Thompson Drewal Collection. Eliot Elisofon Photographic Archives, National Museum of African Art, Smithsonian Institution, Washington, DC, item no. EEPA D10105.

him, turning his body into a vessel for hosting a reincarnated soul. Hence the popular saying: *È kú l'erí, e è r'égún* (You see only the costume, not the spirit). To reinforce this belief, the masker speaks in tongues with a guttural or nasal voice to accord with the stylized human head on his costume.

This *Egúngún* headdress in the Art Institute's collection represents a deceased hunter. Its hairdo is called *aàso olúóde* (hunter's knot) and recalls the popular Yòrùbá hunter's long hat (*fìlà*) that doubles as a bag for keeping charms. As a result, the hat bends sideways when worn. While the head represents a specific ancestor or culture hero, it does not attempt to recapture his likeness because the latter, associated with the hunter's physical self (*ara*), was buried when his metaphysical "other" (*èmí*) left for the hereafter (*èhìn ìwà*). Only the special hairdo now recalls his past. The stylized face signifies his transformation from empirical to meta-empirical existence. The annual *Egúngún* festival thus celebrates the human spirit's triumph over death, which affects only the physical self, not its metaphysical other.

Babatunde Lawal

1 *Egúngún onídán* refers to masks that specialize in magical display, while *Egúngún eléré* refers to those that specialize in satirical performances. 2 See also Lawal 1977, 59.

40 Headddress (*Igi Gèlèdé*)

Fágbité Àsàmú (active late 20th to mid-20th century) or Fálolá Edun (active early to mid-20th century)
Yòrùbá
Idahin, Kétu region, Republic of Benin
Mid- to late 20th century
Wood and pigment
40 × 36.8 × 48.9 cm (15¾ × 14½ × 19¼ in.)

Gift of Neal Ball, 2008.176

Provenance: Herbert Baker (died 2001), Chicago and Los Angeles, about 1980; sold to Neal Ball, by 1983; given to the Art Institute, 2008.

Found mainly among the Kétu, Ègbádò, Òhòrí, and Àwóri Yòrùbá subgroups, the *Gèlèdé* mask consists of an elaborately carved wooden headddress (*igi Gèlèdé*) and a costume of assorted fabrics. A typical headddress takes the form of a human head, which in turn serves as a sort of stage for projecting—via sculptural metaphors—ideals intended to promote the spiritual and social well-being of humanity. The mask performs in a variety of social and religious contexts: to celebrate important events in the life cycle; to induce rain and increase plant, animal, and human lives; or to seek the support of the deities (*òrìsà*) and ancestral spirits in times of crisis.

One of the major goals of the Gèlèdé society is to facilitate good gender relations by advocating respect for motherhood within a patriarchal culture, where men dominate through kingship. To this end, the society institutionalizes the veneration of the Water Goddess (Yemoja/Olókun) as Ìyá Nlá (the Great Mother), equating her with Odù, the first female *òrìsà*, whom Olódùmarè allegedly gave the special power (*àse*) of motherhood with which to sustain life on Earth (see also cat. 33).[1] Odù later shared the power with some women, called *àjé*, who now use it secretly for both positive and negative purposes. The Gèlèdé society also popularizes the use of the term *Àwon-Ìyá-Wa* (Our Mothers) in order to establish a closer relationship with the *àjé* as well as to encourage all members of a given community to love and interact with one another like siblings, and thereby discourage the use of violence to resolve disagreements.

The representations on *Gèlèdé* headddresses range from those embodying prayers to Ìyá Nlá and other deities to ones that satirize antisocial community members in an effort to persuade them to change their behavior. The example in the Art Institute's collection features two hunters handling a pangolin (*arika*; see p. 25, fig. 3).[2] The animal appears frequently on *Gèlèdé* headddresses for three main reasons. First, it is a vital ingredient in herbal preparations for preventing and curing infertility. Second, since a pangolin uses its scaly body to protect its head and soft belly when it senses danger, the animal's scales are often used for military body armor and for charms to protect an individual from sorcery and witchcraft. And finally, because of the animal's tendency to curl up when threatened, Yòrùbá herbalists frequently add parts of its body (especially its scales) to amulets aimed at generating charisma or instilling awe in others, including the *àjé*. As a popular incantation puts it:

> *Ìpé arika kì í jé kí a rí arika ká rojú. Kí arika ká won lénu kò.*

> The pangolin scales will not allow anyone to frown at the pangolin. Like the pangolin, let everyone's mouth curl into silence.[3]

In other words, predators such as snakes should think twice before attempting to swallow a curled-up pangolin because its scales are difficult to digest and may kill them. For similar reasons turtle (*alábahun*) and porcupine (*oòrè*) motifs recur on *Gèlèdé* headddresses; their protective shells and quills are used to obliquely warn evildoers of possible retribution.

Babatunde Lawal

1 At this junction, it is important to note that this goddess has many aspects in Yòrùbá mythology. She is sometimes identified with the creator of the earth and divine ancestor Odùdúwà and sometimes as one of the wives of the divination deity Òrúnmìlà. See Olajubu 2003, 68–71; and Awolalu, 25–26. 2 This mask forms a pair with one in the collection of Yale University Art Gallery, New Haven, Connecticut (gift of Ellen and Stephen Susman, B. A. 1962, 2004.60.1.). 3 I am grateful to the late Lamidi Fakeye, a distinguished woodcarver, for bringing this incantation to my attention. See also Lawal 1996b, 250.

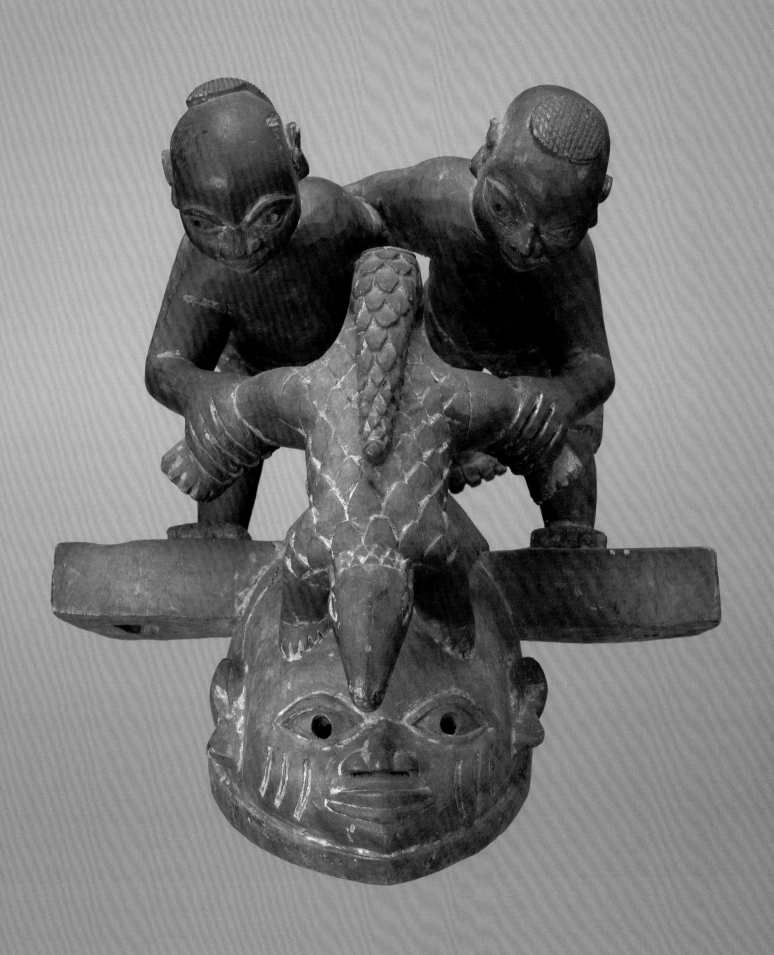

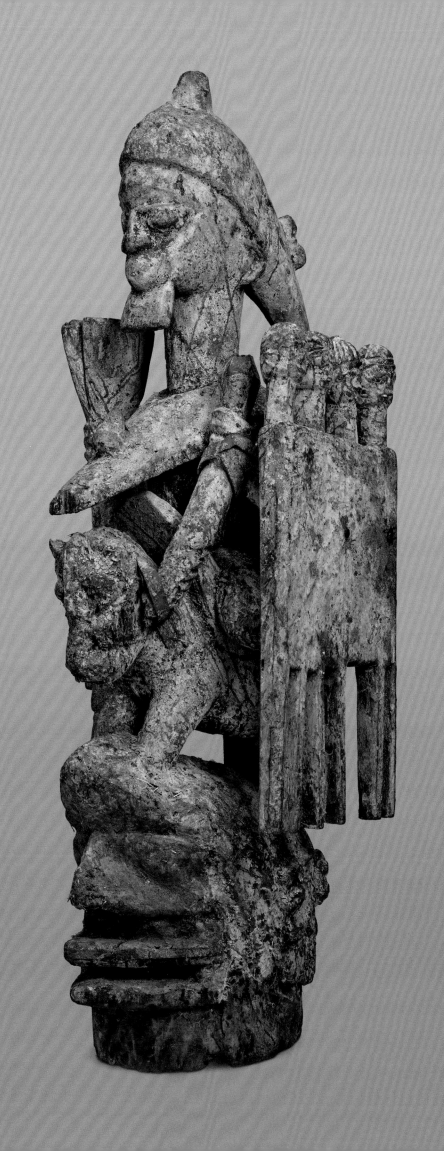

41 *Epa* Headdress (*Jagúnjagún*)

Yòrùbá
**Probably from Oyé-Èkìtì,
Èkìtì region, Nigeria
Mid- to late 19th century
Wood, iron, nails, fiber, and
sacrificial materials
H. 111.8 cm (44 in.)**

Gift of Richard Faletti, the Faletti Family
Collection, 2000.314

Provenance: Harry A. Franklin (died
1983), Beverly Hills, CA, from early
1960s; by descent to his daughter, Valérie
Franklin-Nordin, about 1983 to 1990;
sold Sotheby's, New York, Apr. 21, 1990,
lot 356, to Richard J. Faletti (died 2006)
and Barbara Faletti (died 2000), Chicago
then Phoenix, AZ; given to the Art
Institute, 2000.

Found mainly among the Èkìtì, Ìjèsà, and Ìgbómìnà Yòrùbá, the *Epa* mask is noted for its acrobatic performances. Its headdress is often used to embody prayers and celebrate the achievements of culture heroes as well as harness the powers of deities for the benefit of humanity.[1] A typical *Epa* consists of a carved headdress and a costume of palm fronds, dried raffia, or fabrics. The highly stylized and pot-like domed head (*ikòkò*) usually has protruding eyes, a short nose, and an open mouth. It provides a platform for displaying larger human or animal figures that are typically about three or four feet high and carved in a more naturalistic style. The equestrian warrior motif (*jagún-jagún*) on the Art Institute's *Epa* probably represents Ògún, the deity of iron, warfare, and technology, even though it may also be intended to celebrate the memory of deceased Èkìtì war heroes. When performed, it is expected to harness the powers of the subjects or role models, to ensure victory in an ongoing or future battle. It is also intended to inspire younger warriors to follow in the footsteps of their ancestors. The four human heads on the shield carried by this warrior probably represent those of slain enemies. While the flutist on the left of the warrior seems to be playing in his honor as well as in praise of Ògún, it may also signify Èsù, the divine messenger, whose support is often sought on the battlefield (see also cat. 38). The crusty patina on this headdress suggests that it had been kept in a shrine and received libations of blood and herbal preparations aimed at empowering it during performance.

Popular motifs on *Epa* headdresses include images of deities (to urge them to protect humans) as well as those of diviners (*babaláwo*), herbalists (*onísègùn*), hunters (*olóde*), and warriors (*jagúnjagún*) in order to wish them success in their endeavors. Others include pregnant women (*aboyún*), to wish all expectant mothers safe delivery, and maternity figures (*abiyamo*), to plead with various deities to allow the young to mature into adults and father their own children, thereby ensuring human survival. Each mask is expected to display exceptional athletic and choreographic skills during performance, which frequently includes jumping over mounds of earth in order to "activate" the messages and prayers embodied by the motifs on its heavy headdress. It is a bad omen if a masker should lose control, fall down, and break the headdress. On the other hand, a successful jump is a positive sign.[2]

Babatunde Lawal

1 *Epa* is a generic name for a variety of masks with related forms and functions but given different names (such as *Òkòtóróso, Eléfin, Egígún, Eriru,* and *Agúrù*) in different towns. See Carroll 1956, 3–15; Carroll 1967; and R. Thompson 1971. **2** In 1934 the British anthropologist J. D. Clarke observed an *Epa* festival at a venue outside Òmù village and jotted the following in his diary: "As the difficult feat of jumping on to the mound, carrying the heavy carved headdress [*sic*], had been effected without accident, everybody danced and sang: *Ebo wa nfìn*—Our sacrifice is accepted" (Clarke 1944, 91).

42 Crown
(*Adé Ilèkè*)

Yòrùbá
Ìdówá, Nigeria
Late 19th to mid-20th century
Glass beads, fabric, thread,
and copper alloy
102.8 × 27.6 cm (40⅖ × 10⅞ in.)

Cora Abramson Endowment, 1994.314

Provenance: Dagburewe (King) of
Ìdówá, Ìjèbú Kingdom, Ògùn State,
Nigeria, by early 1900s to at least
1950 [see Fagg 1980b, 19]. Milton D.
Ratner (died 1991) and Audrey Ratner,
Chicago, by 1980 until at least 1989.
Jeffrey S. Hammer (died 2016) and
Deborah Hammer (born and later
Deborah Stokes), Chicago then Sherman
Oaks, CA, by 1993; sold to the Art
Institute, 1994.

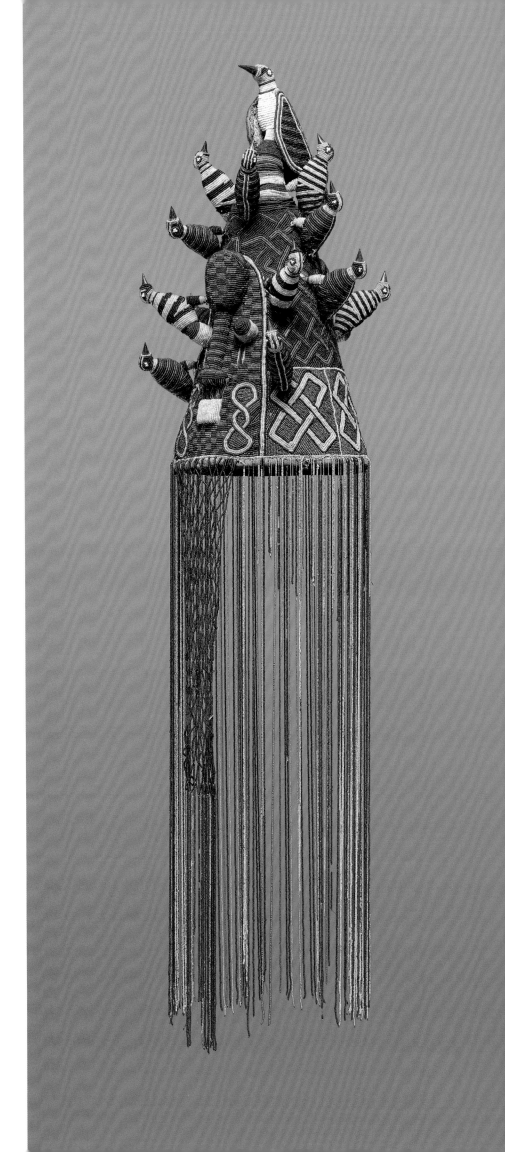

1 Charles Partridge (British, 1872–1955). The king (*̀ogòga*) of Ìkéré, Èkìtì, Oníjagbó Obasorò Alówólódù (reigned 1890–1928), and his son, 1909. Photographic print. Charles Partridge Collection, Trustees of the British Museum, London.

Before the twentieth century, a Yòrùbá king (oba) rarely left his palace without wearing a beaded crown (*adé ilèkè*) with a veil that concealed his identity from the general public (see fig. 1).[1] A typical crown is cone-shaped with a stylized face in the front and one or two birds on top. It signifies the importance of a monarch as the head of a kingdom whose special power (*àse*) is expected to guide his subjects through the ups and downs of life. This leadership role echoes in the following incantation often chanted by the Yòrùbá to bring good luck:

> *Orí, pèlé o, . . .*
> *Iwo ni mo sìn wálé ayé;*
> *Orí eja ni eja fi í la ibú já . . .*
> *Eye kì í fo kó f'orí s'ogi. . . .*
> *Orí mi wá gbére kò mí.*

> My head, greetings, . . .
> I followed you to the physical world;
> It is with the head that
> the fish cuts through the deep . . .
> A bird never collides
> with a tree in the sky. . . .
> My head, bring me good things.[2]

In other words, just as an individual's success in life depends on how well they make use of their head, that of a kingdom is determined by the administrative capacity of the king.

The bird motif on the crown reflects this capacity as well, although it has multiple meanings. First, it recalls the creation myth in which Odùdùwà used a bird to create habitable land at Ilé-Ifè. Second, since the motif is also associated with female power, it enables the kings to exercise some control over that power and harness its positive aspects for the benefit of the kingdom (see also cat. 33).[3] Lastly, the motif is popularly identified with the African egret (*òkín*), also known as "The King

of Birds" (*Òkín l'Oba Eye*) because of its beautiful tail feathers, which are often used to adorn crowns. In the past, this bird was considered so sacred that any hunter who caught it was required to present its white tail feather to the king, who would, in turn, give the hunter the robe he was wearing at the time.[4]

While the face (*ojú*) on a typical crown is routinely associated with the first divine king, Odùdùwà, the same face also identifies a new king with his predecessors and successors, signifying the continuity of the office.[5] Custom forbids a town crier to say in public that a king is dead. Instead he would euphemistically announce that his majesty has "climbed the roof" (*oba wàjà*), implying that he is on the way to the afterlife (*èhìn ìwà*). A coronation thus symbolically marks the reincarnation of the spirit of Odùdùwà in the body of a new king. Sometimes certain crowns called *adé nlá* (big crown), including this example, have two or more faces to hint at a monarch's visionary power and superhuman capacity to foresee and repel danger—that is, always protecting the kingdom.

Babatunde Lawal

1 Beier 1982, 24. **2** Ayelaagbe 1997, 74–76. For another version of this incantation, see Abiodun 2014, 43–44. **3** According to an oral tradition collected by Solomon Babayemi, the birds on top of the crown of the king of Òyó identify him as "the head of the witches in the sense that he is making use of *Ìyá ilé eye* [a priestess inside the palace] to make the power of witches beneficial to the society." The title of that priestess means "the mother in the compounds of the birds." See Babayemi 1986, 13. **4** Ojo 1966a, 38. For other meanings of the bird motif on the beaded crown, see R. Thompson 1972. **5** See R. Thompson 1970, 16. However, the face on other crowns may be identified with Obàlùfòn II, the fourteenth-century king of Ifè, because certain legends claim that he was the first monarch to wear a beaded crown. See Beier 1982, 24.

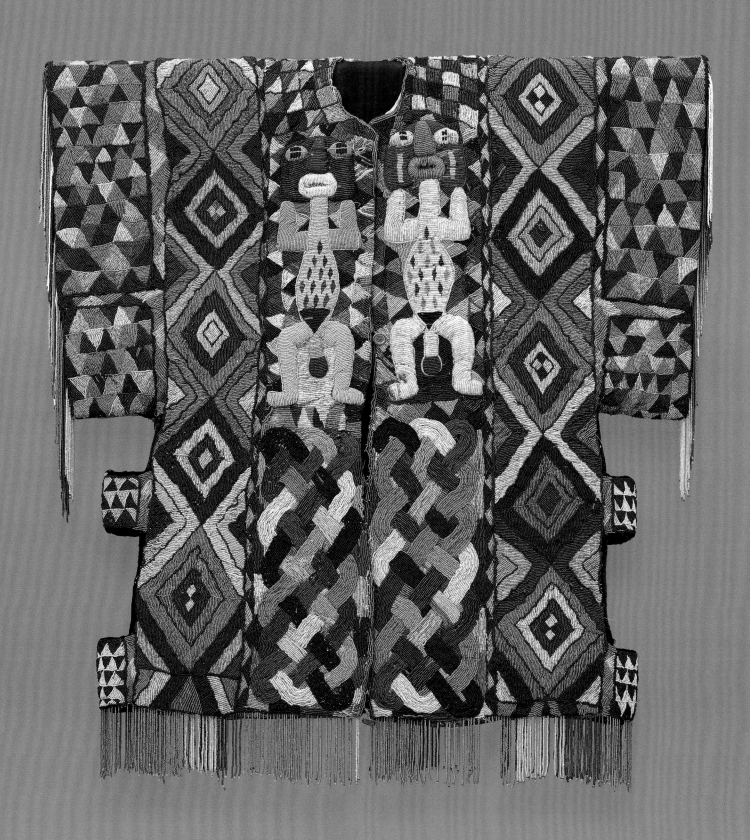

43–44 **Royal Tunic (*Èwù Ilèkè*) and Coronet (*Akoro*)**

Yòrùbá
Odò-Owá, Òsì-Ilorin, Nigeria
Early to mid-20th century
Glass beads, cloth, and string
Tunic: H. 102.8 cm (40 ½ in.),
diam. at bottom 27.6 cm (10 ⅞ in.);
coronet: 15.2 × 20.3 cm (6 × 8 in.)

Restricted gift of Cynthia and Terry
E. Perucca; African and Amerindian
Art Purchase Fund, 2009.580–81

Provenance: Oba (King) Délé
Adéshínà, Odò-Owá, Kwara State,
Nigeria, by 2009; sold to Garuba
Konte, Albuquerque, NM, 2009; sold to
Douglas Dawson Gallery, Chicago,
2009; sold to the Art Institute, 2009.

1 View of the back of the tunic (cat. 43).

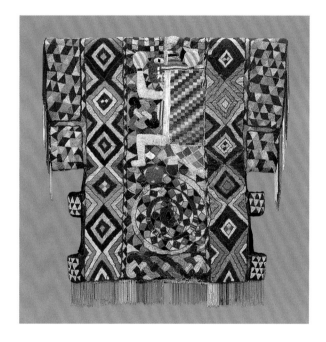

Tradition has long required a Yòrùbá king (oba) to wear an elaborate costume and beaded crown with a veil (see cat. 42). Since the beginning of the twentieth century (especially during the colonial period), however, the practice has been simplified because certain official duties or commercial engagements require some kings to spend more time outside the palace. Such garments are usually decorated with intricate motifs reminiscent of those found on carved doors and ritual implements such as Ifá divination trays (see p. 191, fig. 3).[1] While some Yòrùbá elders view the motifs as mere decoration, others regard them as symbols with the metaphysical capacity to link the human and superhuman realms. Similar motifs appear on the garments of priests and diviners to facilitate their interactions with deities.

The significance of the two male figures depicted on the front of this tunic is obscure, but their pronounced sex organs may be intended to increase the mettle of the monarch and, by extension, that of all his subjects. On the back of the robe is another male figure holding a shield as if to protect the king from danger (fig. 1). Although the coiled snake depicted beneath him connotes "surrender," it may also signify the rainbow deity Òsùmàrè, who connects heaven and earth and is associated by the Yòrùbá with wealth, prosperity, and human fertility.[2]

Many Yòrùbá tunic makers (*oníséonà*) combine colors for aesthetic purposes but they are also conscious of ritual implications. For example, white (*funfun*) is frequently associated with the celestial and sublime; various shades of blue (*èlú*, *aró*, and *ofefe*) with the waters; red (*pupa*) with blood, fire, and dynamism; black (*dúdú*) with the nocturnal and occult; and so on. At the same time, colors such as white, blue, red, and orange are also associated with the creativity deity, Obàtálá; the Water Goddess and Mother of All, Yemoja/Olókun; the thunderstorm deity, Sàngó; and the beauty and fertility goddess, Òsun, respectively. The *oníséonà* undertake their work with consideration for the contexts of use as well as a client's preferences.[3] On a royal costume, though, the main objective is to reinforce the king's charisma and ability to liaise with deities.

The king usually wears a coronet like this example inside the palace or in public on less formal occasions. It belongs to a category of casual royal headdresses called *oríkògbófo*, an abbreviation of the adage *Oríadé, kò ní gbófo* (The head destined to wear the crown will not remain unadorned). Most of the new designs were developed at the beginning of the twentieth century, when many monarchs converted to Islam and Christianity and began to make public appearances without a beaded crown with a veil.[4]

Babatunde Lawal

1 See R. Thompson 1971; and Drewal and Pemberton 1989. 2 See Lawal 2012a. 3 For more on color symbolism among the Yòrùbá, see Adejumo 2002, 27–39; Campbell 2008; and Lawal 2012b, 26–28. 4 For illustrations, see Drewal and Mason 1998, 70–77; and Beier 1982, 85–89.

45 Crest Masks

Niger Delta region, Nigeria
Late 19th or early 20th century
Wood, pigment, and string
Left: 25.4 × 20.3 × 38.7 cm (10 × 8 ×
15¼ in.); right: 26.4 × 21 × 42.2 cm
(10⅜ × 8¼ × 16⅝ in.)

Gift of Richard Faletti, the Faletti
Family Collection, 2000.320.1–2

Provenance: Richard Faletti (died 2006)
and Barbara Faletti (died 2000),
Chicago then Phoenix, AZ, by 1997;
given to the Art Institute, 2000.

People living in and around the Niger Delta honor water spirits by performing masquerades that incorporate masks, some of which feature a horizontal orientation like these.[1] They generally credit the Ijo with inventing this genre, but the Ijo say they copied their own performances from those of the water spirits themselves. Although these playful spirits occasionally threaten to kill people for failing to perform masquerades, maskers seldom incarnate powerful beings. Most simply come out of the water to play with their human friends.[2] Nevertheless, they often behave aggressively, and cautious spectators may choose to watch performances from canoes to avoid being cut by their knives.

Maskers transform themselves into otherworldly beings by donning costumes that incorporate fish tails, and their dances mimic the flickering movements of fish. Their wooden headpieces also refer to the spirits' watery realm. Most depict either animals—especially fish, reptiles, and amphibious mammals—or composite beings that mix aquatic features like fish fins with reptilian ones like crocodile jaws. Some include miniature masks and abstract—or at least unidentifiable—shapes. People explain the horizontal orientation that characterizes most of the carvings by saying that they look like spirits floating on the water.[3]

One of the exceptionally exuberant crests at the Art Institute pairs a fishtail at the back with a reptilian snout at the front (left); the flared nostrils on the other may refer to a hippopotamus (right). The assorted horns and tusks that sprout from both examples may represent species that frequent the water, like the aquatic antelope, but headpieces can depict or incorporate elements of all sorts of land animals, including goats, rams, and bush cows.[4] The birds that perch on both crests may or may not be associated with water, but because they travel between worlds, they often act as messengers from the spirit world.

The white markings that unify the diverse forms may further associate the carvings with the realm of the water spirits.

The crests' protruding eyes and horizontal orientation conform to Ijo style, but their formal complexity indicates an origin on the western fringes of the Niger Delta, where Ijo, Yòrùbá, and Edo-related subgroups live intermingled. They loosely resemble some Ìjèbú Yòrùbá headpieces, but the scarcity of comparable, well-documented examples confounds attribution.[5] The "Delta" designation suggested by anthropologist G. I. Jones is therefore preferable to a more specific one.[6]

Martha G. Anderson

1 G. I. Jones differentiates between the spread of masquerades and mask styles and concludes that Delta masquerades did not diffuse inland (apart from a few plays performed on the eastern margins of the Delta), but notes formal affinities that suggest that Delta style has "become dispersed or been recreated" as far afield as Nri-Awka, the Middle Benue, the Cameroon Grassfields, and even Liberia. See Jones 1984, 114, 162–63. **2** In the past, a few masks incarnated deadly spirits who could be invoked to punish criminals and settle disputes. But their shrines have now been abandoned. **3** See Anderson 2002b, 151–61. **4** When I asked why some headpieces depicted land animals, I was told that spirits living in the water have bush cows and other animals. **5** See de la Burde 1973, 28–33; Drewal 1986; and Drewal 2002. **6** Jones 1984, 133.

46 Figure Screen (*Duein Fubara*)

Ijo: Kalabari
Nigeria
Early 20th century
Wood, pigment, and fiber
101.6 × 69.9 × 20.3 cm
(40 × 27½ × 8 in.)

Joanne M. and Clarence E. Spanjer Fund; restricted gift of Cynthia and Terry E. Perucca, Marshall Field V, and Lynn and Allen Turner funds; Mr. and Mrs. David B. Ross Endowment; Alsdorf Foundation, 2005.154

Provenance: Private collection, Lomé, Togo, from early 1990s; sold to Charlie Davis, Davis Gallery, New Orleans, 1994; sold to the Art Institute, 2005.

When European vessels began plying Niger Delta ports in the fifteenth century, the Eastern Ijo started competing for control of the overseas trade. The most successful middlemen eventually presided over trading concerns called "war canoe houses."[1] By the early nineteenth century, the Kalabari—one of several Eastern Ijo groups—were constructing intricate artworks, such as this wooden screen, to commemorate these merchant princes.

According to Ijo beliefs, the *so*, which governs a person's fortunes, resides in his or her forehead. The Kalabari term for the screens, *duein fubara* (forehead of the dead), references their role as a similar, albeit posthumous, locus for the essence of an individual. By drawing attention to the ancestor's status and prosperity, these objects also recall the history of his canoe house and proclaim its prominence. The formal hybridity of *duein fubara* reflects the Kalabari's openness to new ideas. The figures bear the hallmarks of Ijo style, including prominent eyes and mouths, but their jointed bodies resemble those of Ogoni and Ibibio puppets. Benin plaques may have influenced the screens' hierarchical compositions. Their rectangular backdrops depart from African conventions and may have resulted from exposure to European images; the Kalabari artists who constructed them clearly employed Western joinery techniques. To complicate the situation further, the Kalabari credit Ghanaian furniture makers for introducing embellished frames.[2]

This example resembles a screen that was collected in the early twentieth century, although that one lacks the stylized cowrie-shell motifs that decorate this one.[3] Cowries, which formerly circulated as currency, allude to wealth, and their whiteness associates them with the spirit world. In both examples, rectangles flank the central figure's head. Although such details appear on most memorials, their meaning remains uncertain: the Kalabari identify them as either windows or mirrors, like those on masquerade headpieces.[4]

Most leaders wear masquerade headpieces to emphasize their role in the all-important Ekine masquerade society; this one sports a top hat but the eagle feather in its headband indicates membership in that group. In his left hand he carries a cane—a standard accoutrement of senior men—and he would originally have held a horn, fan, fishing spear, sword, or other status marker in his right. When enshrined, he and his attendants would have worn prestige textiles imported from India. Like his counterparts on other screens, the ancestor on the Art Institute's example sits between two "housepeople," who may represent children or other supporters. Their small scale emphasizes his importance. The inverted-T marks on their torsos indicate the figures' deceased state, and traces of white paint on their arms mark them as members of the *peri* warrior society (see p. 66 for additional discussion of *peri*). The heads resting on the ground on either side of the screen probably represent vanquished enemies.

Martha G. Anderson

1 Europeans had already begun trading for slaves when Duarte Pacheco Pereira visited the region at the end of the fifteenth century. By the eighteenth century, the Kalabari and Ibani Ijo exercised a monopoly over the overseas trade. See Jones 1963, 33–48; see also Pereira 1937. 2 For discussion of possible Benin influence on the screens, see Horton n.d., 53–56; Oelmann 1979, 38–40; and Barley 1988, 41–42. Barley goes on to explore how Western books and photographs may have affected their production (42–46). Horton (n.d.) mentions the Ghanaians, who were recruited to provide European-style furnishings for the chiefs, in regard to the "fancy" frames (12). A. G. Leonard and P. A. Talbot identify the main artists as Kalabari, members of the Pokia family of Ifoko; see Leonard 1906, 163; and Talbot 1967, 237. 3 British Museum, London, Af45.336. See Barley 1988, 57, plate 4. British colonial official and ethnographer P. A. Talbot collected a number of screens in 1916; see Talbot 1967, 80, 140–41. Most of these, including the screen similar to the Art Institute's, are now in the British Museum. 4 Barley 1988, 48.

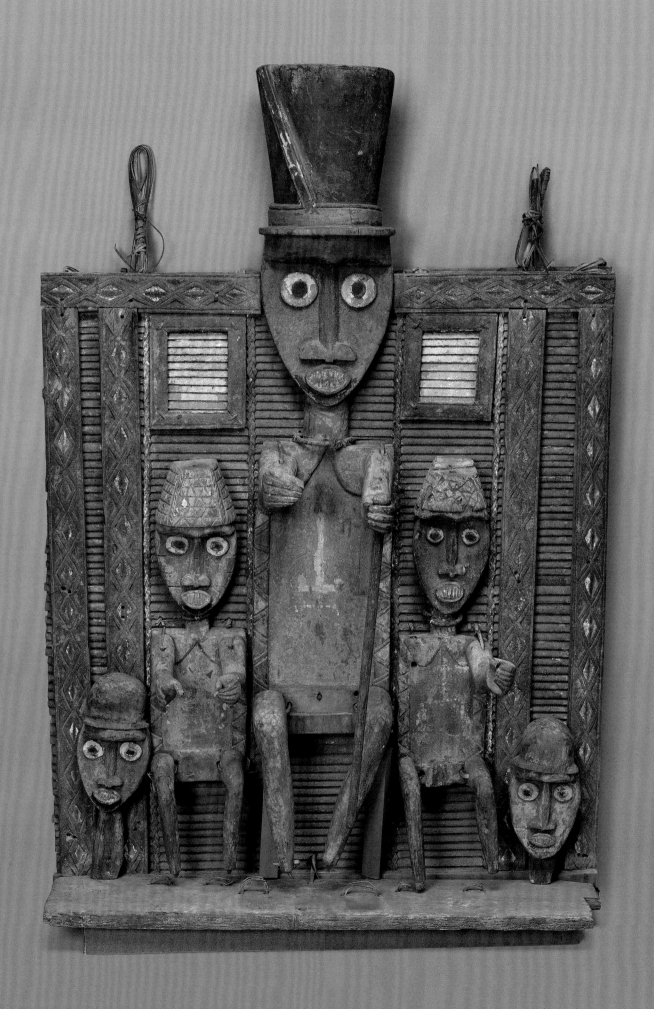

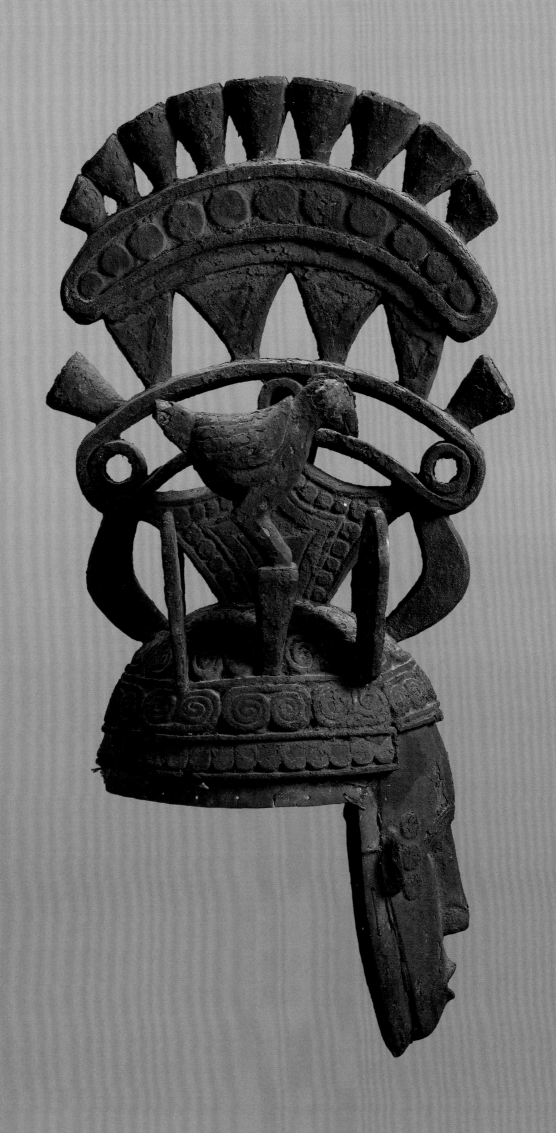

47 Face Mask (*Agbogho Mmuo*)

Igbo
Possibly Awka region, Nigeria
Late 19th or early 20th century
Wood
H. 71.2 cm (28 in.)

Cora Abrahamson, Gladys N. Anderson,
Harriet A. Fox, and Simeon B. Williams
endowments, 1994.315

Provenance: Jeffrey S. Hammer (died
2016) and Deborah Hammer (born and
later Deborah Stokes), Chicago then
Sherman Oaks, CA, by 1984; sold to the
Art Institute, 1994.

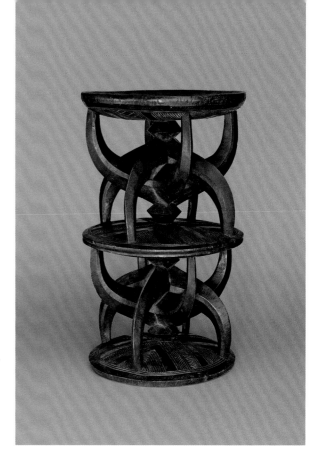

1 Stool, late 19th or early 20th century. Igbo; Awka region, Nigeria. Wood, iron nails, and traces of pigment; 57.2 × 34.9 cm (22 ½ × 13 ¾ in.). The Art Institute of Chicago, African Decorative Arts Fund, 2013.68.

The Igbo people, whose ancestors have occupied a broad region of Central Nigeria north of the Niger River Delta for over five thousand years, practice a form of governance that operates through age-grade societies, each of which is also connected to distinctive artistic forms and styles. Masquerades that honor, entertain, and commune with spirits and ancestors are an important part of age-grade responsibilities, and of these the Maiden Spirit masquerade, *Agbogho mmuo*, is among the most popular. Masks such as this one are performed by young men who wear them along with tightly fitting and brightly colored appliquéd costumes. The dancers move in an exaggeratedly feminine fashion, and the performance conveys an idealized and otherworldly beauty.[1]

In the tenth century, powerful and wealthy leaders from the city of Igbo-Ukwu asserted control over an extensive area of central and northern Igboland. Their unifying influence is apparent in Igbo title-taking practices that are widespread, coexisting with the more ancient local age-grade societies. To this day many Igbo men and women attain the first level of this title system, although ascending to higher levels within the hierarchy requires an ever-increasing investment of resources, social capital, and time. Titles come with restrictions and ritual and community responsibilities, as well as with privileges that include the right to regalia and status objects including a handsomely sculpted stool.

John Reilly, a Catholic missionary from Ireland who was stationed in Nigeria in the first decade of the twentieth century, purchased a tall and skillfully designed title stool during his time there (fig. 1).[2] Catholic missions were established around Onitsha, Nigeria, starting in 1885, and in 1908 they reached Awka, the town that is today best known for the manufacture of elaborate title stools.[3] The accounts of several early-twentieth-century British travelers to Nigeria reference title stools. The Anglican missionary George Basden noted in 1938 that "Awka stools" were generally made from the hard iroko wood and were sturdy and graceful, with beautiful ornamentation.[4] He went on to remark, "Formerly only one family appears to have held the right to manufacture stools of this pattern. Then there was not a great demand for them, because only chiefs and notable people were permitted to use them. Europeans, nowadays, buy most of the stools produced."[5]

The Art Institute's *Agbogho mmuo* mask likely comes from the same vicinity within the same time period. A similar mask, possibly by the same artist, is recorded as having been purchased in the town of Nibo, near Awka, in 1913; it was given to the Museum of Archaeology and Anthropology at the University of Cambridge.[6] This stool and Maiden Spirit mask showcase the tour-de-force skill of Igbo sculptors in the early twentieth century, particularly their capacity to playfully juxtapose positive and negative space within complex arrangements of interlocking and intertwining forms.

Kathleen Bickford Berzock

1 Cole and Aniakor 1984, 120–28. **2** Two similar stools purchased in the same period are in the collection of the Museum of Archaeology and Anthropology, University of Cambridge (UK). **3** Eli Bentor to Kathleen Bickford Berzock, May 3, 2013, correspondence in the Art Institute of Chicago curatorial object file. **4** Basden 1938, 322–23. **5** Basden 1938, 322–23. **6** The object bears accession number Z 13689; Eli Bentor to Kathleen Bickford Berzock, May 3, 2013, correspondence in the Art Institute of Chicago curatorial object file.

48 Crest Mask (*Ngambak*)

**Koro: probably Ache
Kafanchan Plateau, Nigeria
Early to mid-20th century
Wood, pigment, resin,
abrus seeds, and fiber
87 × 31.1 × 20.3 cm
(34½ × 12¼ × 8 in.)**

Through prior purchase
from Mr. and Mrs. Nathan
Cummings; through prior
bequest of Joseph R. Shapiro;
through prior gift of Deborah
Stokes and Jeffrey Hammer;
through prior purchase
from Mrs. Leigh B. Block;
and through prior gift of
Richard Faletti, the Faletti
Family Collection, 2018.6

Provenance: Private collec-
tion, by 1979; sold Sotheby's
Parke-Bernet, New York,
Mar. 24, 1979, lot 109, to Irwin
Smiley (died 2001) and
Cecilia S. Smiley (died 2013),
New York. Bruce Frank
Primitive Art Gallery, New
York, by 2014; sold to Steven
Morris Fine Art, Beverly
Hills, MI, May 2014; sold to the
Art Institute, 2018.

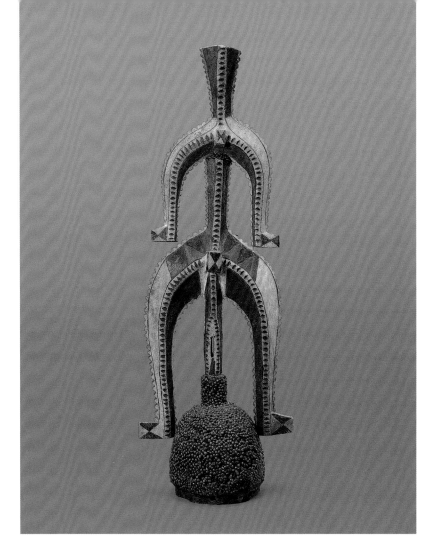

49 Female Figure

**Probably Kantana
Benue River region, Nigeria
Early to mid-20th century
Wood, pigment, resin, and
abrus seeds
H. 53 cm (20⅞ in.)**

Restricted gift of the Claire B.
Zeisler Foundation, 1972.173

Provenance: Philippe
Guimiot, Brussels, by 1971.
John J. Klejman (died 1995),
Klejman Gallery, New York,
from 1971 to 1972; sold to
the Art Institute, 1972.

The crest mask shown here (cat. 48), constructed in three parts (connected with pegs) and richly decorated with painted geometric patterns and poker work, belongs to a small corpus. The only comparable piece in the United States is the more modest two-part example at the Smithsonian's National Museum of African Art in Washington, DC.[1] The Art Institute's mask is the largest and most complex known example. It appeared on the cover of a catalogue authored by Anita J. Glaze and Alfred Scheinberg to accompany a traveling exhibition of the Smiley Collection at the Krannert Art Museum at the University of Illinois at Urbana-Champaign and the Smith College Museum of Art, Northampton, Massachusetts.[2] What we know about such headdresses stems from the limited field research conducted by late British Museum curator William Buller Fagg in 1949 and Indiana University art history professor Roy Sieber in 1958. According to Fagg, the Ache subgroup among the Koro invented this type of headdress and produced it for neighboring peoples, including the Ham, Jaba, Kagoro, and Kamantan.[3]

Sieber informs us that these crest masks, called *ngambak* (man with bowed legs), were worn with tentlike fabric robes and served as village guardians during agrarian festivals that marked the planting and harvesting seasons (see fig. 1).[4] The limited number of such headdresses in Western collections can be attributed to two factors: it is likely that few of them were produced in the first place, but also that they were discarded or even destroyed after being performed. The Art Institute's mask features red abrus seeds, which are used in local medicines and suggest both healing and danger.

Figures like the second, smaller carving shown here (cat. 49) were used by many peoples in the ethnically and linguistically complex Middle Benue region south of Nigeria's Jos Plateau. Without primary, field-based documentation, however, it is impossible to confirm the Kantana attribution that accompanies the Art Institute's small but expressive female figure.

1 William Buller Fagg (British, 1914–1992). An autumn celebration among the Ham people in the village of Nok, Nigeria, 1949. Royal Anthropological Institute of Great Britain and Ireland, 400_WBF. 49.50.12.04.

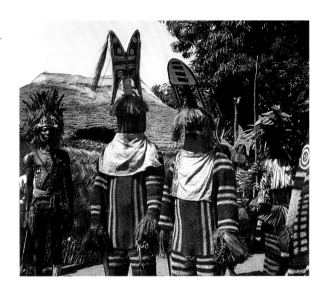

A very similar sculpture called *shagar*, dressed with a fiber ruff around its neck, was photographed in the Kulere village of Bargesh in the 1950s. They share similar anatomy: a "swelling treatment of the upper body with diminutive arms, short, bowed legs, round heads, and schematic features."[5]

The use and function of such figures are barely understood. Ochre has been rubbed onto the surface of this example—an act with spiritual connotations that imitates a real-life practice of coloring the human body—to produce its powdery patina. Abrus seeds (now mostly lost) were pressed into the resin patches on the figure's head and chest. Among the Montol and related Goemai as well as other peoples, figurative sculptures similar to this one were used in the context of men's associations called Komtin and Kwompten; these groups were also concerned with healing, whether that meant curing an illness or identifying its cause.[6]

Constantine Petridis

1 See Puccinelli 1999. 2 See Scheinberg and Glaze 1989, esp. cat. 32 (Scheinberg 1989). 3 Fagg 1980a. 4 Sieber 1969, 12 and 29, fig. 36. 5 Frank 2011, 404, fig. 12.20. 6 Frank 2011, 405.

50 Portrait Figure of Metang, the 10th King of Batufam

Carved by Mbeudjang
(Eastern Bangwa, active
early 20th century)
Bamileke
Kingdom of Batufam, Cameroon
c. 1912–14
Wood and pigment with traces of
chalk and camwood
130.5 × 43.2 × 31 cm (51⅓ × 17 × 12⅛ in.)

Major Acquisitions Centennial
Endowment, 1997.555

Provenance: Reportedly Fon (King)
Metang, Kingdom of Batufam, now
Cameroon, from about 1913. Private
collection, Belgium, by 1997; sold
Christie's, New York, Nov. 20, 1997, lot 110,
to the Art Institute.

This stylized portrait was commissioned and carved between 1912 and 1914, after Metang was initiated into kingship. His status is clearly conveyed with accessories: the royal stool he sits upon and the miter-like royal cap that he wears. Originally portrayed with his penis erect (now broken off), he holds a buffalo-horn drinking vessel and a gourd container, two of the most important regalia in the various Bamileke kingdoms across the Cameroon Grassfields. The gourd container likely represents the typical bead-covered calabash used for palm wine.

This figure was purchased by the Art Institute at an auction in New York in 1997, but its earlier provenance is unclear. As revealed by several photographs taken in Batufam between 1925 and 1961, it was displayed under the veranda of the richly decorated palace residence there, on one side of the entrance to the king's palace, along with several other kings' portrait figures (see fig. 1).[1] A complementary depiction of his spouse, Queen Nana, was displayed on the other side of the entrance with other queens' portrait figures. These displays of Metang and Nana with their predecessors and successors may represent a total of six generations.[2]

Rather than lifelike renderings, these sculptures are idealized images of kingship. Their identification with historical rulers is not based on resemblance, but on oral testimonials of the people of Batufam recorded by European scholars.[3] The name of the artist responsible for these sculptures, Mbeudjang, was passed along the same channels. We know little of his biography other than that he was a member of the Eastern Bangwa culture, a neighboring Bamileke group whose highly regarded master carvers received commissions from far and wide.

The figures and the kings and queens they portray were jointly responsible for the well-being and prosperity of the kingdom's inhabitants. Traces on the figure as well as photographic documentation

1 Frank Christol
(French, 1884–1979).
Commemorative
figures of kings and
queens in front of
the royal palace in
Batufam, Cameroon,
1925. Archives
du Musée du quai
Branly–Jacques
Chirac, Paris.

reveal that the royal sculptures were regularly refurbished with red camwood powder, imitating the real-life practice of applying it to the skin to signal authority and allure. Dots of white chalk allude to the spots of the leopard, the most powerful royal symbol in the Cameroon Grassfields. After a royal death, it was customary to color the skin of the deceased with both red camwood and white chalk spots.

Constantine Petridis

1 See the four volumes on arts of the Grassfields kingdoms authored by Jean-Paul Notué and Bianca Triaca and published by 5 Continents Editions in Milan: Notué and Triaca 2005a; Notué and Triaca 2005b; Notué and Triaca 2005c; and Notué and Triaca 2006. See also Jones 2016. **2** The portrait figure of Queen Nana is now in the collection of the Art Gallery of Ontario (accession no. 2004/68). The displays were observed by Frank Christol in 1925, by Raymond Lecoq in 1947, by Pierre Harter in 1957, and by Paul Gebauer in 1961; see Lecoq 1953, 121–22, figs. 92–93; Gebauer 1979, 45; and Harter 1986, 54, 55, and 57. See also Christie's 1997, lot 110. **3** According to Pierre Harter, Metang succeeded his father, Tchatchuang, in 1912; see Harter 1986, 298. But Lecoq claims that the Metang figure was identified as Pokam, who died in 1924 and was the father of Fotoo David; see Lecoq 1953, figs. 92–93.

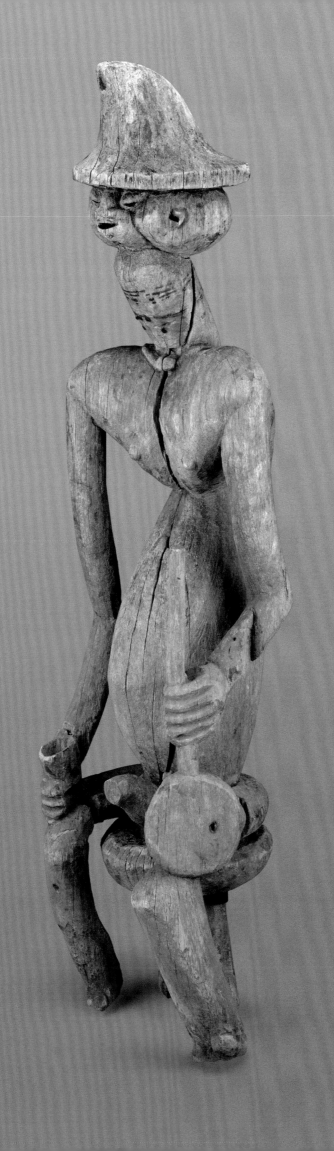

51 **Male
Face Mask
(Chihongo)**

Chokwe
**Angola or Democratic
Republic of the Congo
Mid- to late 19th century
Wood, raffia, burlap, turaco
feathers, guinea fowl feathers,
and pigment
73.7 × 48.3 cm (29 × 19 in.)**

Restricted gift of Mrs. James W.
Alsdorf, 2003.174

Provenance: Private collection, Berlin,
from about 1914; Wolfgang Nerlich
(died 2012), Munich, by early 1990s; sold
to Pace Primitive (later Pace African
and Oceanic Art), New York, early 1990s;
sold to John A. Buxton and Barbara
Buxton, Shango Galleries, Dallas, Oct.
1997; sold to the Art Institute, 2003.

Manuel Jordán

Of Masks, Men, and Women

In the Chokwe language, *akishi* (sing. *mukishi*) are mask characters, treated as the embodiments of memorable deceased individuals (*áfu*, sing. *múfu*) and as protective ancestors (*hamba*). The name *mukishi* derives from the term *kishi* (or *kisi*), which denotes the manifestation or representation of a spirit.[1] Hundreds of *akishi* mask characters with distinct physical features, performance (dance) behaviors, and symbolic attributes are made and performed by Chokwe and related groups in the Democratic Republic of the Congo, Angola, and Zambia.[2] *Akishi* may be human or animal, hybrid, or even abstract in appearance, yet they are all treated as ancestral in nature.[3]

The *mukanda* initiation of boys into adulthood is the prime context for *akishi*, although they are also performed during other sociopolitical events.[4] Embodying ancestors through a masquerade serves to engage the deceased—as active ancestor spirits—in matters of the living, in order to provide a propitious outcome to human endeavors.[5] As an initiation, *mukanda* marks the ritual or symbolic death of initiates (*tundanji*) as boys and their "rebirth" into the world of adults after months of training and education within the camp.[6] *Akishi* are

present throughout the *mukanda* initiation process and assist camp leaders in teaching *tundanji* about matters pertinent to male adulthood: sexuality, hunting skills, ancestry, spirituality, and knowledge of the supernatural. *Akishi* serve as tutelary guardian and protective spirits; by virtue of their behavioral and symbolic attributes, they also act as role models imparting concepts of culture, tradition, and morals to the *tundanji* within the privacy of the camps. These principles are witnessed and shared by all through multiple public mask performances, which conclude in lavish graduation ceremonies where *akishi* dance and engage audiences to celebrate the initiates' achievements and change in social status (childhood to adulthood).[7]

Chihongo Materials and Their Meanings

The Art Institute's Chihongo mask represents an exclusively Chokwe *mukishi* and one of their most iconic role-model types.[8] Chihongo is the embodiment of a male spirit of wealth and power. It may appear in initiations for the sons of chiefs, at royal confirmatory ceremonies, or during other court-sponsored events. Marie-Louise Bastin, an expert on Chokwe art, described Chihongo as follows:

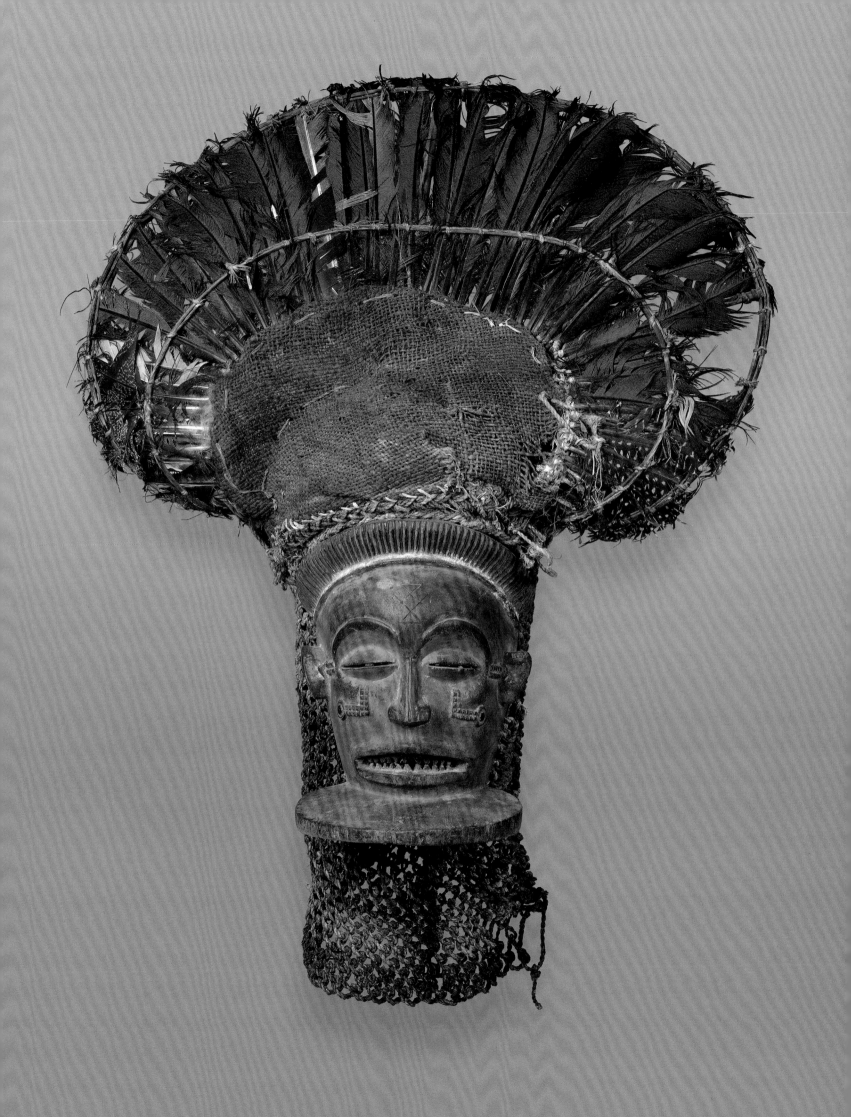

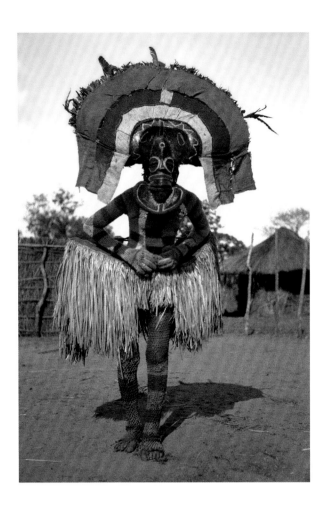

1 Émile Muller (Belgian, 1891–1976). "Full Chihongo character wearing a knitted fiber costume and characteristic broad skirt made from fibers," 1923–38. Photographic print. Private collection. This Chihongo's face mask is constructed from ephemeral materials rather than carved in wood.

their teeth. This mask also features a distinctive beard carved as a protruding disk-shaped element below the mouth. The beard style is reminiscent of those worn by some Chokwe chiefs.

Facial scarification marks are often incised or carved in low relief on Chihongo masks as symbols of cultural identity that are bound up in concepts of maturity and character. This example includes representations of keloid marks below the mask's eyes that are called *masoji* (tears). The angular *masoji* terminate in circular elements representing the sun (*tangwa*), which connote the passage of time and stress the theme of human and/or natural transition. Tears indicate endurance or sacrifice toward accomplishment and success. In combination with the "transitional" sun, the scarified symbols evoke concepts that are defined through initiation. The cross-shaped motif incised in the mask's forehead is a quintessential Chokwe identity symbol: *chingelyengelye* signifies the cardinal directions, movements of the sun, and cyclical nature of life.[10]

Like other wooden masks, Chihongo are colored to represent varying skin tones. In this case red ochre has been applied to the mask's surface, resulting in a relatively light color. Masks range from very dark (brown or black) to light tones of red or yellow-orange, and color choice is simply a matter of preference for the mask maker; the owner may repaint a mask to his liking.

Chihongo's most prominent feature is the head superstructure attached to the wooden mask. As described by Bastin, the characteristic fan-shaped crown of feathers is carefully arranged in an arched frame constructed from bent and tied twigs. The feathers carry symbolic connotations that are attributes of chiefly character. During the mid-twentieth century Portuguese captain Ivo de Cerqueira documented a Chokwe Chihongo mask in Angola and provided an account of the qualities associated with its feathers.[11] According to his informants, hawk feathers are associated with strength and dexterity; guinea fowl with lightness and agility; and those of other, smaller birds with patience and other attributes. He added that some of the feathers adorning a mask were acquired by initiates during *mukanda*-sponsored (educational) hunting excursions.

Such a crown of feathers is evident on the Art Institute's Chihongo mask; rather than stork or hawk feathers, it wears those of the great blue turaco and guinea fowl. Like storks, blue turacos are distinguished as regal birds because of their coloration.[12] This quality of the bird and its feathers supports Chihongo's chiefly attributes as an

The mask, whether made of resin or wood, is surmounted by a coiffure of feathers, usually those of a stork, *khumbi*. The feathers are attached to a basketry frame in the shape of a fan, furbished with European cloth, which itself indicated amongst other things the symbolic wealth of *C[h]ihongo*. The dancer wears a mesh shirt and a wickerwork waistband, which supports a grass skirt [see fig. 1]. He also has jingles attached to the legs. In his hands he holds a bell, a staff, and sometimes the chief's ceremonial axe, *c[h]imbuya*. Occasionally a leopard skin tied to the belt emphasizes the dancer's high rank.[9]

I would like to draw attention to additional details evident in the Art Institute's wooden Chihongo mask, particularly stylized facial elements including convex and well-defined slit eyes set within concave orbits or eye sockets. These are conventions of a Chokwe style of carving for masks, which also include broad mouths with sharp, triangular teeth clearly showing. Pointed teeth mirror the (traditional) Chokwe practice of filing

ancestral spirit of wealth and power. Yet the turaco and guinea fowl feathers introduce additional, more direct symbolic connotations. Turacos are particularly active at dawn and dusk, and as such they are within a category of animals that receive the sun (morning) and also put it to sleep (evening). They are thus guardians of time and cyclical transitions.[13] Furthermore, the calls of turacos have a distinctive repetitive and percussive quality that is associated with setting off an alarm at times of impending danger. The raucous calls of guinea fowl throughout the daytime carry the same connotations of awareness and alertness. These attributes are symbolically associated with chiefs, who can anticipate threats and protect their people and territories.

For most Chokwe masks, it is indeed the prominent crowns or headdresses that reveal the most about the characters' ascribed supernatural powers and qualities. Chihongo's feathered crown or head superstructure is also interpreted as the "energizing" element for the character. The feathers act as receptacles for universal forces that reach the spirit/performer through the head. Through symbolic allusions to cyclical (solar and other) regenerative power, Chihongo is imbued as an extraordinary chiefly character, meant to represent chiefly values while also ensuring human transitions (e.g., initiations and the community's well-being).

The symbolic attributes carried by Chihongo (the sun, time, and the cyclical nature of life) are concepts reinforced through *mukanda* initiation. The experience includes many private—that is, within the camp—practices where initiates may be in proximity to *akishi*, to perform or engage in aspects of this cosmology. One such event is their daily playing of *kukuwa* (bones of the ancestors) sticks, percussion beaters that are sounded by the *tundanji* at sunrise and sunset. *Kukuwa* sticks reference the nature of *akishi* and the spiritual underpinnings of *mukanda*. During *mukanda*, initiates "awaken" the sun each day by playing the sticks; at sunset they "help the sun go to sleep" in the same way. The explanation obviously echoes the behavior-based symbolism attributed to the turaco and then evoked in the Chihongo headdress through its blue feathers.

We should bear in mind that besides the symbolism and powers associated with Chihongo as an ancestral spirit and chiefly character, an actual individual is dressed as a *mukishi*—and that degree of ownership bears additional implications. The success of a performance is directly related to the performer's ability to embody the character, and only particularly talented and capable individuals (experts) are assigned to perform/ dance specific masks.[14] Because Chihongo represents aspects or values associated with the ruling class, its performer literally holds a court's reputation at stake every time he engages in character representation during rituals or ceremonies.

An important related detail on the Art Institute's Chihongo is a small packet attached behind the feathered frame. The tied-up bundle, called *yimpelo* or *impelo*, reveals something about the mask's use and history, particularly who may have worn it. A bundle or bundles may be added to a mask as medicines to address or balance out its perceived powers if it is deemed too powerful to be worn. One explanation, shared with me in relation to a different mask, is that one individual may have danced it for years or even decades. Upon that individual's death—and in the case of renowned performers—before a new person could inherit the mask, he would have to undergo rituals to recognize and appease the spirit of the original owner, to prove his worth in inheriting the mask and secure the rights to perform it.[15] To inherit the *mukishi*, medicines need to be applied, some of which may include elements and/or materials owned by the original dancer (for example, strips of cloth) along with mixed substances such as roots or herbs from medicines consumed by the inheritor during the rituals.[16] If these rituals fail, the mask itself may be buried with the original dancer or incorporated into an ancestral shrine where it would continue to receive the respect of members of the community.

Akishi such as the Art Institute's Chihongo thus prompt reflections on the exponential power(s) that may be ascribed to a specific mask. At a fundamental level, it is the embodiment of a powerful chiefly ancestral spirit, compounded by the essence of the spirit of a second ancestor, the deceased performer who may have worn it proudly and effectively for many years before it was inherited by another. A full understanding of this spirit of wealth and power rests within the reach of ritual experts who may maintain such masks within a Chokwe chief's court. For most people, such as those who may enjoy Chihongo public performances in the context of a *mukanda* held for a chief's sons, the *mukishi* is perceived as a prominent, fulfilled, and proud male spirit. It educates by example (behavior, demeanor, beauty of the dance) and appearance (regal, elegant, mature, with scarifications) and brings forth goodwill and protection to all. But to fully grasp what Chihongo stands for, it must be understood as one of many

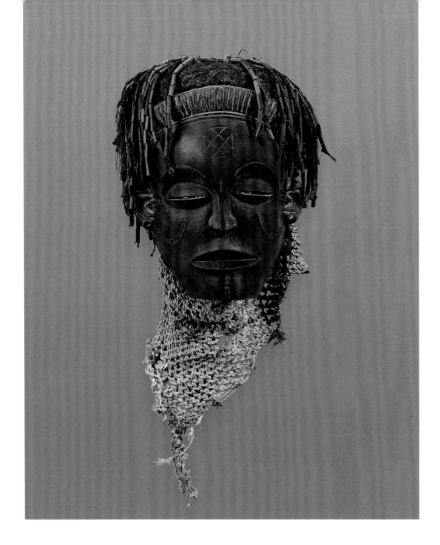

akishi characters with complementary or contrasting behaviors and attributes that people also experience through public performances.

Paired with Pwo

The most celebrated and popular counterpart to Chihongo is Pwo, "the woman," a primordial female ancestor for the Chokwe and one of their best-known mask types in museum collections worldwide. The Art Institute's Pwo (fig. 2) visually complements the collection's Chihongo. Like the male mask, the carved wooden Pwo includes scarification details such as the forehead cross motif (*chingelyengelye*) and curved *masoji*, as well as additional marks called *kangongo* (tail of the mouse) on the temples and down the nose and chin. As previously discussed, these are marks that reflect Chokwe identity and maturity as they replicate scarifications obtained by men and women through different initiations.[17]

Like the featured Chihongo, the Pwo mask has dark, burnished eyebrows, but its mouth (also burnished black) is closed rather than showing pointed teeth. The lips are sumptuous, broad and well-defined. This was the carver's choice, perhaps inspired by the beautiful facial features of a woman

2 Female Face Mask (Mwana Pwo), late 19th or early 20th century. Chokwe; Angola or Democratic Republic of the Congo. Wood, fiber, beads, and pigment, 44.5 × 19.3 × 18.7 cm (17 ½ × 7 ⅝ × 7 ⅜ in.). The Art Institute of Chicago, Major Acquisitions Centennial Endowment, 1992.731.

he knows. Quoting a fellow researcher named José Redinha, Bastin adds the following: "The artist is inspired by the looks of a woman much admired by her beauty. Since he must carry out his work far from the gaze of women, he observes his model at length, often for several days, long enough for him to be able to memorize her features. He also finds inspiration in her hairstyle and scarifications."[18] Pwo, the female ancestor, is then a literal representation of an admired and beautiful woman.

Further details on the Art Institute's Pwo confirm that this is a depiction of a young woman. These include the diadem carved above the forehead: an arch of small, consecutive, vertically incised lines (the same detail appears on the Chihongo). Remnants of blue powder or pigment applied to the diadem are still evident. This reflects the same color symbolism already discussed in relation to Chihongo, in which the character's attributes are framed as "regal" and elegant. Additionally, the mask's original coiffure remains attached. Fiber coiffures imitate different hairstyles favored by women, and in this case, beads (imported or made from modified cane) have been added in imitation of a hairstyle fashionable among mature—but still young—Chokwe women in the 1920s and '30s. The facial features and hairstyle thus unite to identify

this character as Mwana Pwo, "the young woman." This is one of multiple versions of Pwo, each of which is meant to honor women of different ages and degrees of maturity.[19]

In performances, Pwo wears an overall costume of knitted fiber (usually cotton) together with imported textiles as a wraparound skirt. A large dance bustle made from bundled lengths of cloth with hanging rattling elements is worn by the *mukishi* with ankle rattles to emphasize dance movements. Pwo remains very active during *mukanda* as a distinctly accessible mask type that performs for the enjoyment and pride of the community and the village hosting *mukanda*. Although it is danced/performed by men, it serves as a symbolic emissary for women, particularly the mothers of initiates, who are honored by it.[20] Pwo represents the beauty, morality, and abilities of women through a performance that imitates dance steps associated with them.

Whereas Chihongo only appears in the context of chief-sponsored events, Pwo is a female ancestral character accessible to all. It is present in most (if not all) initiations practiced by Chokwe in their vast territories, many of which are far from where chiefs may reside. Thus, Pwo masks and

their performances are numerous. In villages outside the direct influence of chiefs and their courts, Pwo generally enjoys a diverse array of male counterparts, with Chisaluke—a *mukanda* guardian and initiates' tutelary spirit—as perhaps the most prominent one.[21] Nonetheless, Chihongo and Pwo are Chokwe's quintessential male and female *akishi*, reflecting gender complementarity; the two are admired for their maturity, demeanor, beauty, and exemplary talents.

Chihongo's dance is unique, accented by the characteristic broad, fiber, skirtlike frame that enhances male initiates' graduation dances. Pwo's dance bustle is different and emphasizes the rhythmic hip movements taught through female initiation and associated with women's fertility and sense of style. Pwo and Chihongo may participate in the same ceremonial contexts but they are not meant to dance together, or at least not at the same time. Bastin notes the same in her field experience while also mentioning another report of the two *akishi* actually being together. She attributes this to potential variation in practices between Angola, where she conducted her fieldwork, and other areas, such as the Democratic Republic of the Congo.[22] Her statements were quoted by Tony Jorissen in 2010 when he published archival photos taken by Franciscan missionaries in 1948; they show a Chihongo dancing with a number of Pwo masks, and Jorissen also frames Chihongo and Pwo as a dance pair.[23] Such interpretation is problematic, however. In missionary stations, colonial museums, cultural centers, and other places with significant outsider influence, masks, mask groupings, and performances follow standards outside traditionally prescribed norms. A lot can be learned from such archival photos and videos, but they should be properly presented so that new or alternative contexts for masquerades are better understood.[24]

My own research supports Bastin's assertions that the characters complement each other: Chihongo and Pwo may share an arena yet their performances are independent, danced in short skits with male or female members of the audience who may approach to give a small monetary contribution to the masquerader.[25] This is an opportunity for women to test the skills of a performer, particularly in the case of Pwo, wherein men are impersonating women and imitating their dances. The whole strategy of *akishi* is precisely to facilitate engagement with the audience and generate commentary on skills and qualities as compared to human values and standards. The ancestral spirits Chihongo and Pwo continue to

3 Émile Muller (Belgian, 1891–1976). Portrait of a young Chokwe woman. Photographic print. Private collection. The young woman in this portrait is wearing a coiffure similar to that represented on the Pwo mask in figure 2.

engage with people to bring forth aspects of Chokwe cosmology while demonstrating sociocultural values pertinent to the communities they entertain and protect.

The Art Institute's Pwo and Chihongo masks may originate in different Chokwe territories, perhaps even different countries; this aspect of their creation cannot be confirmed. It is equally impossible to situate them precisely in history, as they may have been manufactured years apart. Yet both masks are relatively close in carving style and as such they represent an ideal pair of *akishi* characters, two of the most prominent ones for the Chokwe. The iconic cultural value of the two characters is further reinforced by common references to Chihongo and Pwo in other art forms. Images of Chihongo, a spirit of wealth and power, may be included on Chokwe chief's chairs (see cat. 59), scepters, and other prestige items such as weapons, pipes, and snuff containers; it may even be carved in low relief to decorate royal musical instruments. Pwo is accessible to all (and broadly associated with fertility), so she shows up in a range of art forms, including figurative stools, staffs, flywhisks, and personal accessories such as combs and hairpins. Carved figures representing both characters are also found in divining, healing, and religious ancestral contexts. Part powerful spirit ancestors, part role models, Chihongo and Pwo—as embodied in these masks—continue to fulfill their roles throughout expansive areas in the Democratic Republic of the Congo, Angola, and Zambia, engaging and educating audiences in aspects of a rich cosmology while ensuring a propitious future for all Chokwe.

1 For Chokwe language see these dictionaries: Barbosa 1989; and MacJannet 1947.

2 For publications that illustrate the diversity of mask characters among Chokwe and the historically/culturally related Lunda, Lwena, Luchazi, Mbunda, and others in the Democratic Republic of the Congo, Angola, and Zambia, see Felix and Jordán, 1998. Marie-Louise Bastin dedicated various books to Chokwe art and culture, including masks, based on her research in Angola; she cites additional, earlier authors; see Bastin 1961; and Bastin 1982. Constantine Petridis provides a well-researched account on Chokwe masks in the Democratic Republic of the Congo, based on missionary archival materials; see Petridis 2001a.

3 See Jordán 2006 for mask character types and categories, based on fieldwork in Zambia.

4 For the sociopolitical contexts for masks, see Jordán 1993, 41–46.

5 Mask performers I interviewed while conducting fieldwork in Zambia (1991–93) explained wearing a mask (masquerade) as "losing themselves in the spirit" they were meant to perform. This resulted in them engaging in a redefined sense of identity. See Jordán 2006, 15–19.

6 Initiations nowadays may be significantly shorter and organized around boys being on vacation from school.

7 Graduation ceremonies normally last a couple of days and these may be attended by large numbers of people from the village hosting the *mukanda* and adjacent villages. During the last two days of initiation, all the *akishi* that have participated in the *mukanda* come out to perform, normally consecutively. This is one of few occasions where all *akishi* characters may be experienced throughout the day. During the length of initiations, a few characters may be employed to visit the village, dance, and promote the *mukanda*. Another context in which multiple *akishi* may be seen performing on the same day (or days) is during the confirmatory ceremonies of important chiefs when masks from different villages hosting *mukanda* may come to the palace and honor the chief.

8 As explained above, Chihongo is exclusively a Chokwe character, reflective of Chokwe identity and the attributes of their chiefs. Neighboring groups such as the Lwena, Mbunda, and Lunda create many *akishi* (called *makishi* in Zambia) but rather than Chihongo, they employ other male characters to impart the same principles in their own fashion. See Felix and Jordán 1998, 277–89.

9 In addition to wood carving, Chihongo may be constructed by creating a frame of tied twigs that shapes its facial contours. Pitch or resin is then added to model its facial features; the crown is constructed as an extension or attachment to the face. Strips of cloth or paper are applied to finish highlights such as scarification details. Carved wooden Chihongo masks are made with permanence in mind. Whereas many *akishi* made from ephemeral materials are burnt after *mukanda* initiations, those carved in wood are retained for future initiations or chiefs' ceremonies. Outside the villages of chiefs, most *akishi* are constructed and modeled rather than carved in wood. Wood carving is costly in part because a professional carver must be involved and paid for his work.

10 See Bastin 1961, vol. 1, for the identification of several Chokwe symbols and their definitions.

11 de Cerqueira 1947, 64.

12 For an essay discussing a Chokwe bird mask and related bird symbolism, see Jordán 2004. See A. Roberts 1995 for a publication dedicated to animals in African art.

13 Information regarding masks and initiation derives from personal communications with Bernard Mukuta Samukinji, my Zambian Chokwe (main) informant and friend. Most Chokwe-specific information I share in this article is from working with him from 1991–93 as well as from study of actual initiations thanks to the Chokwe Malikinya family in northwestern Zambia. While pursuing fieldwork in Zambia I resided with Chitofu Sampoko, a Lunda village headman, diviner, and healer who graciously shared his knowledge for the extended period of time.

14 Who performs a mask is insider's information, managed by *mukanda* initiation camp leaders and initiated men, and/or ritual experts at a chief's court. It is not acceptable to mention or publicly recognize a dancer; he is treated as Chihongo or the spirit represented. These are matters of secrecy for men and steep fines or penalties may be assigned if anyone were to break the rules and reveal a performer's name—even if it is the wife or a close relative of the performer who has that knowledge.

15 This is pertinent in divination rituals. A diviner's basket may include a miniature representation of a Chihongo mask; if it were to "come up" during a divination session alongside symbols that are perceived as negative, the diviner may decide that it is the spirit of a previous performer that is afflicting his client. For other explanations of the Chihongo divination symbol, see de Areia 1985; and Jordán 2003.

16 These rituals were described to me by Mr. Samukinji as very trying and cumbersome. They include a ritual bath (at midnight) by the client; the bathwater is also used to mix the substances/materials included in a bundle.

17 For a brief introduction to Chokwe initiations, including those pursued after *mukanda* by adults, see Bastin 1982, 49–52.

18 See Redinha 1956; and Bastin 1982, 90.

19 For focused discussions of Pwo masks, see Jordán 2000; and Jordán 2014.

20 Within the context of *mukanda* initiations, boys essentially stop being boys and transition into adulthood. There is a physical shift for them from residing with their mothers to their new after-graduation reality, when they move and live with their brothers. Mothers are thus "losing their sons" and Pwo, as a *mukishi* honoring women, may be said to help women in this transition. In fact, during the graduation dances performed by *tundanji* in the company of *akishi*, mothers symbolically throw themselves on the ground to lament the "death" of their sons. Soon they get up and join the dances to celebrate the new status gained by their children. Because female participation is critical to *mukanda* success, Pwo in many ways recognizes or acknowledges the female perspective—even if interpreted by men.

21 Jordán 1998, 72, plate 95.

22 Bastin 1982, 90–91.

23 Jorissen 2010, 250–53.

24 Most performance photos in these contexts are posed and include "by request" presences and arrangements of characters that are atypical for ritual and most ceremonial contexts. Bastin was fully aware of alternative settings. Indeed, there are a large number of photos of Chihongo masks interacting (dancing) with Pwo and others; see Fontinha 1997, 30–32.

25 The contributions sponsor initiation camps rather than individual mask performers.

52 Half-Length Figure (*Eyema Byeri*)

Fang: probably Betsi
Gabon
Late 19th to early 20th
century
Wood with pigment
50.2 × 14.6 × 14.9 cm
(19¾ × 5¾ × 5⅞ in.)

Gift of Mr. and Mrs. Raymond
Wielgus, 1958.302

Provenance: Ladislas Segy
(Ladislas Szecsi; died 1988),
Segy Art Gallery, New York,
by 1952; sold to Raymond
Wielgus (died 2010) and
Laura Wielgus (died 2003),
Chicago, 1955; given to the
Art Institute, 1958.

53 Head (*Angokh Nlo Byeri*)

Fang: Betsi
Gabon
Mid- to late 19th century
Wood, pigment, and copper
H. 39.4 cm (15½ in.)

Frederick W. Renshaw Acquisi-
tion Fund; Robert Allerton and
Ada Turnbull Hertle endow-
ments; Robert Allerton Income

Fund; Gladys N. Anderson
Endowment, 2006.127

Provenance: Pierre Vérité
(died 1993), Vérité Gallery,
Paris, from 1948; by descent to
his son, Claude Vérité, Paris,
1993; sold Hôtel Drouot, Paris,
June 17, 2006, lot 197, to the Art
Institute.

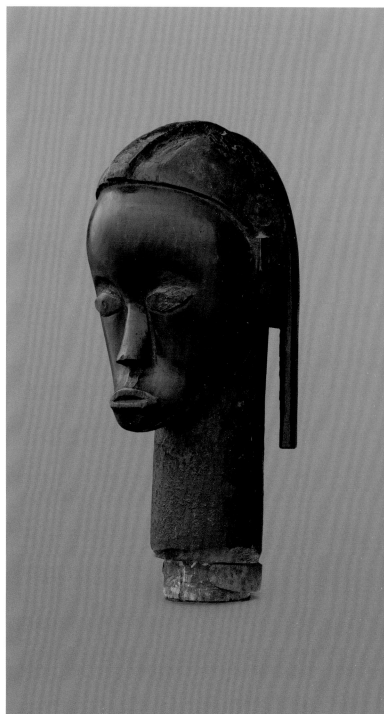

Figure sculptures from the Fang people of northern Gabon, southern Cameroon, and adjacent Equatorial Guinea have been highly sought-after by collectors of African art since their first appearance, in the landmark auction catalogue of the Georges de Miré collection in 1931.[1] The half-length figure shown here was among the very first works that was collected by the department of Primitive Art after it was established at the Art Institute in 1957.

Such figures were acquired and exported from Africa as early as the late nineteenth century. The practice of making and using them as part of ancestral veneration, through a cult known as *byeri*, seems to have ended in the 1930s. Functioning as reliquary guardians, the figures were inserted into the lid of a cylindrical container or box made of bark that preserved parts of the skull and skeletal remains of an honored, usually male, ancestor.[2] The full-length sculptures combine the wide-eyed stare and large head of a child with the muscular body of an adult (see cat. 52), and these visual oppositions reify the ancestors' enduring presence, infusing the object with an energy necessary for its ongoing role as an intermediary between the living and the dead. The figure and box were stored in the corner of a man's sleeping chamber and kept the ancestor's powers within reach of his descendants, who could call upon him to solve problems and deal with threats to the well-being and survival of the extended family or village. Light-reflecting copper-alloy inserts were sometimes added to the eyes, as was done with the head in the Art Institute's collection (cat. 53), and indicate the owner's wealth and prestige; they also would have startled any intruder to his sleeping chamber while enhancing the head's dramatic appearance and spiritual power.

The descendants encouraged the ancestor's support by bestowing libations, sacrifices, and gifts upon the reliquary guardians. Fang figures like these two examples typically received applications of a mixture of resin and plant oils that occasionally still exude from the wood when it is exposed to heat. The sculptures would also sometimes be removed from their boxes and used as puppets in ritual performances.

It has been suggested that the earliest Fang reliquary guardian figures were heads because that form was best suited to the nomadic lifestyle of their makers, who migrated seasonally. Stylistic variations within the diverse corpus of Fang sculpture have also been attributed to these migratory habits. But since few examples have been acquired with firsthand data about their places of origin or use, it is nearly impossible to attribute them to a specific region in the Fang territory with any certainty. Moreover, most of the Fang sculptures preserved in collections in the West—including those shown here—have been separated from the reliquary containers they once guarded and stripped of their accoutrements.

Constantine Petridis

1 Hôtel Drouot 1931. See especially Monroe 2019; see also Perrois 2007, 63–77. 2 The main primary sources on Fang art are the writings of French anthropologist Louis Perrois and American anthropologists James W. and Renate Fernandez. See especially Fernandez and Fernandez 1975; Perrois 1972; and Perrois 2006. For a comprehensive introduction to Fang sculpture from a broader perspective, see also Alisa LaGamma, "Eternal Ancestors: The Art of the Central African Reliquary," in LaGamma 2007, 3–31.

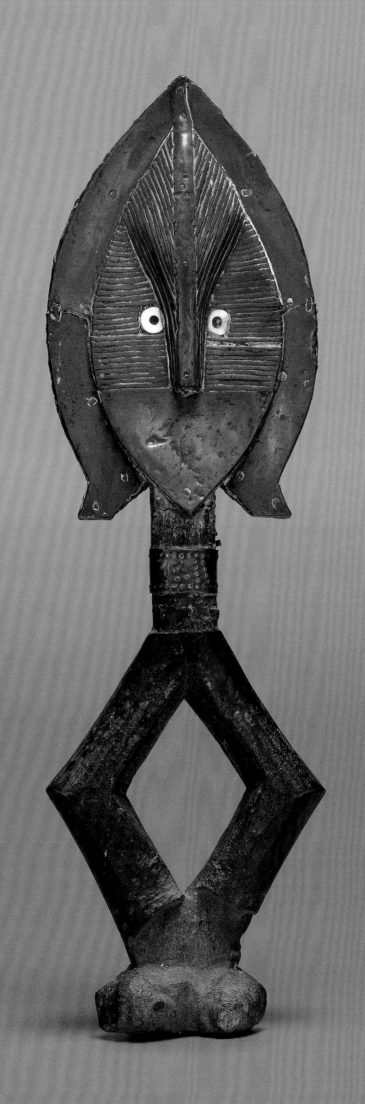

54 Figure (*Mbulu Ngulu*)

Kota: Shamaye
Gabon
Late 19th or early 20th century
Wood, brass, and ivory
H. 34.3 cm (13½ in.)

Restricted gift of the Alsdorf
Foundation, 1968.788

Provenance: Henri Kamer (died 1992)
and Hélène Kamer (later Hélène Leloup),
Henri A. Kamer Gallery, New York, by
1968; sold to the Art Institute, 1968.

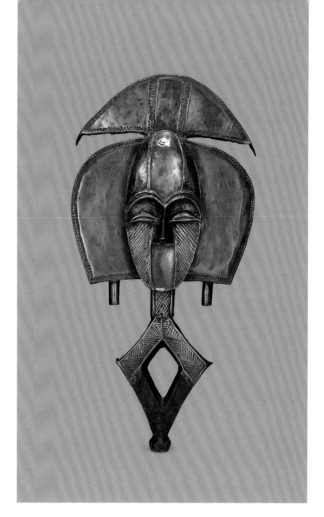

1 Figure (*Mbulu
Ngulu*), late 19th or
early 20th century.
Kota: Obamba;
Gabon. Wood, brass,
copper, and iron;
H. 54.6 cm (21 ½ in.).
The Art Institute
of Chicago, Charles
H. and Mary F.
Worcester Collec-
tion Fund, 2007.212.

The Art Institute's *mbulu ngulu* is a striking example of the two-dimensional, wooden, copper-and-brass-covered guardian figures attributed to the various Kota subgroups. The sculptural type was first documented in the 1880s in Gabon, where such figures were usually attached to reliquary ensembles.[1] They were set on top of packets or basketry containers holding parts of the skulls, certain bones, and other relics of the dead, where they served primarily as guardians as well as sites of ancestor veneration and continued dialogue with the divine. These ensembles belonged to a politico-religious institution, most often referred to as *bwete* (or *bwiti*), honoring the memory of exceptional individuals who had made important contributions during their lifetime. The combination of the relics and the guardian figure exuded a positive energy that passed to the surviving kin and assured their safety and prosperity. The brilliance and wealth signaled by the expensive metalwork—typically a combination of brass and copper, materials used as currency—would help sustain the interaction between the deceased and his descendants. However, the figures were routinely separated from their ensembles during the works' displacement from Africa to Europe. In the West, these abstract wooden renderings of the human body are among the most iconic genres of African art, having appealed to and influenced the work of European avant-garde artists including Pablo Picasso and Paul Klee in the early 1900s.

This figure with ivory eyes is part of a small group of similar works that have all been attributed to the Shamaye, a small Kota subgroup in northeastern Gabon whose style constitutes the linchpin between the northern and southern Kota styles. The Art Institute's figure was probably carved by the same artist that created two other such sculptures: one in the collection of Mitchell A. Harwood and Fran Janis in New York, the other formerly in the Vérité Collection.[2]

A larger figure also in the Art Institute's collection (fig. 1)—once owned by Ernst and Ruth Anspach, New York-based collectors who had purchased it from Klejman Gallery in 1962—is a classic example of a more common style that has been attributed to the Obamba subgroup located in the southern part of the Kota territory, in the upper valley of the Ogooué River.[3] Its silhouette represents an ancient hairstyle with a crescent-shaped crest and side buns. Some of the figures in this Obamba style are double-faced and have metal strips or plates covering both sides, but this example's back has no metal covering and instead shows a geometric design in high relief that may be interpreted as the abstract rendering of a face.

Constantine Petridis

1 Of the many publications by Louis Perrois, who remains the primary source of information on the subject of Kota reliquary guardian figures, I would like to single out Perrois 1986 and Perrois 2012. For valuable complementary perspectives and new angles on the historiography of reliquary sculpture, see LaGamma 2007. **2** Cloth 2017. Decades ago, Louis Perrois presented the Art Institute's figure as a transitional style between the Shamaye, Sango, and Obamba styles; see Perrois 1976, 33, fig. 19. **3** Alain and Françoise Chaffin describe the Art Institute's figure (2007.212) as an "ungroupable piece," a name they reserved for authentic sculptures that did not fit in any of the twenty-one style categories identified in their classification. See Chaffin and Chaffin 1979, 263, no. 159.

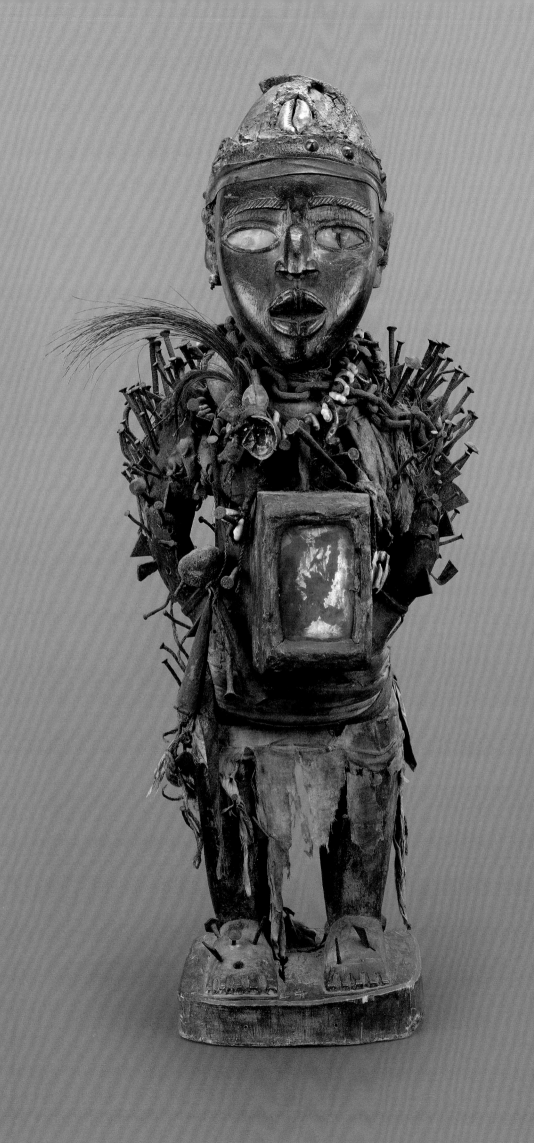

55 Male Figure (*Nkisi Nkondi*)

Vili
Republic of the Congo
Possibly early to mid-19th century
Wood, metal, glass, fabric, fiber,
cowrie shells, bone, leather, gourd,
and feathers
H. 72 cm (28⅜ in.)

Ada H. Turnbull Hertle Endowment,
1998.502

Mixed-media sculptures of this type were known locally as *minkisi* (sing. *nkisi*) and more widely as "power figures." They served as vessels for magico-medicinal ingredients called *bilongo*, which were enclosed within body parts of the carving—usually the head and the stomach.[1] Here, the ingredients are stored in a mirror-covered box that is attached to the belly. Inlaid mirrors and the figure's staring eyes signal its heightened perception and ability to see beyond the material world, while its upright pose—with hands on hips—signals alertness.

Perhaps the most striking features, however, are the nails and other metal studs that are hammered into the body (see also fig. 1). They denote that this is a type of power figure known as *nkisi nkondi*, a name that clarifies its most important task: hunting down evil and wrongdoers. Each nail or blade covering the sculpture was associated with a particular case or problem; hammering and driving nails and other blades into its body would arouse or entice the inhabiting spirit and compel it to act. The accumulation of a large number of such metal insertions testifies to the figure's successful and lengthy career.

The name *nkisi* actually refers to both the receptacle—whether made by human hands and figurative, or found in nature and nonrepresentational—and the spirit of the deceased person for which it provided a vehicle. This description has led to the identification of *minkisi* as portable altars. A man or woman named *nganga* (plur. *banganga*), a therapist or ritual expert, would care for the *nkisi* and use it in consultations with clients to answer questions, solve problems, ensure success, and offer protection. The *nganga* originally charged the wooden figurative container with *bilongo* and enhanced its dress and accessories. Their own outfit included a feathered headdress and white stripes painted onto the face and body—strikingly similar to that of some *minkisi* in collections in the West. Depending on their size and the richness of the accoutrements, *minkisi*

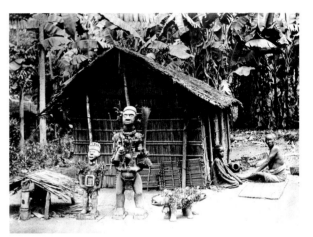

1 Postcard showing two *minkisi minkondi* and one zoomorphic power figure in the shape of a two-headed dog, in a village in what is now the Democratic Republic of the Congo, 1913–14. Photo possibly by Joseph Maes. Haeckel Collection, Berlin.

were either largely stationary, serving community and collective interests, or predominantly mobile, serving individual and personal interests.

Beginning in the early 1500s, European colonial officials and missionaries fostered the spread of Christianity in the region, and in the context of conversion, many power figures were identified as symbols of irrational superstition and publicly destroyed or discarded. *Minkisi minkondi* were not seen as art until the 1960s; they were seldom published in art books and rarely exhibited in art museums. The Art Institute's figure, however, has a provenance dating back to the 1950s, and was successively owned by three contemporary artists: Klaus Clausmeyer, Ulfert Wilke, and Arman (Armand Fernandez). The latter was especially famous for his own accumulative sculptures.

Constantine Petridis

1 Of the extensive literature on the Kongo and their arts, publications by Wyatt MacGaffey offer a good introduction to the complexity of the subject; see especially MacGaffey 1993, 19–103. See also the encyclopedic *Art & Kongos* (Felix, Meur, and Batulukisi 1995). Two more recent publications each offer a comprehensive view of Kongo historical arts and their diaspora: Cooksey, Poynor, and Vanhee 2013; and LaGamma 2015.

56 Helmet Mask (*Kholuka* or *Mbala*)

Yaka
Bandundu region, Democratic
Republic of the Congo
Probably late 19th or
early to mid-20th century
Wood, raffia, cloth, twigs, resin,
and pigment
H. 45.7 cm (18 in.)

Gift of Neal Ball, 2009.118

Provenance: Sulaiman Diane,
New York, by 1983; sold to
Neal Ball, Chicago, 1983; given to
the Art Institute, 2009.

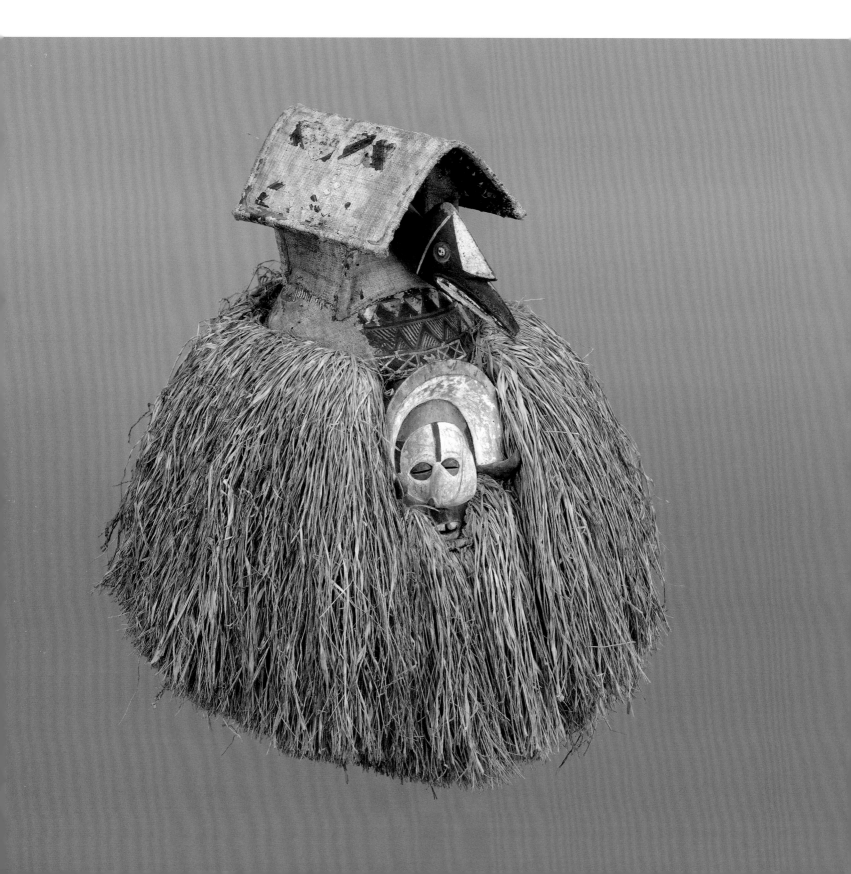

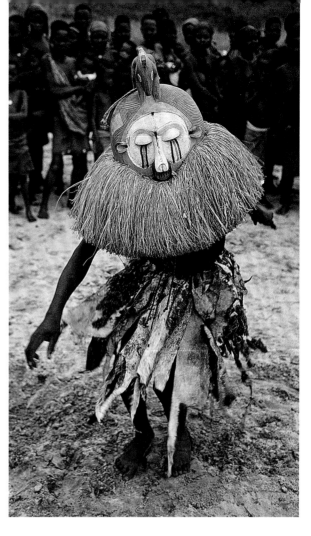

1 Eliot Elisofon (American, 1911–1973). A masquerader performing during an initiation ritual, near Kasongo Lunda, Belgian Congo (now Democratic Republic of the Congo), 1951. Eliot Elisofon Photographic Archives, National Museum of African Art, Smithsonian Institution, Washington, DC, EEPA EECL 4373.

Yaka masks like this example, consisting of a small, carved wooden face and a hairstyle constructed of twigs and painted cloth, were actively worn as part of initiation rituals until the very recent past—and there are indications that in some villages, the practice continues to this day. Initiation officials were the primary users, but initiated novices also wore such masks at the coming-out festivities that celebrated the transition of uncircumcised boys into adulthood. The events followed a prolonged seclusion, lasting from one to three years, in an initiation camp known as *n-khanda*. The initiation's main goal was to promote healthy offspring. As embodiments of the ancestors who founded the puberty ritual, the masks watched over the well-being and fertility of the pubescent youths while they were separated from their mothers and families on the outskirts of the village. The dancer who wore this mask probably would have been one of the *n-khanda* officials, a man bearing the title of *n-langala*, who assists the official charged with collecting and distributing food to the boys throughout their seclusion.

Among the northern Yaka—where the Art Institute's mask originated—a dance set would feature eight masks representing the genres known as *tsekedi*, *myondo*, and *ndeemba*, each typically appearing in pairs, with the single *kholuka* or *mbala* closing the masquerade. The imagery of the masks refers to sophisticated Yaka concepts of cosmogony and sexuality. It usually includes a face carved in the shape of a paddle or scoop, and a cylindrical handle—hidden under a thick raffia collar (see fig. 1)—used to hold the mask before the wearer's face. For the Yaka, the mask's upturned nose has explicit sexual connotations, as it refers to seduction and desire. The hallmark of such a mask is the puppet-like scene, often imbued with sexual overtones, set into its hairstyle superstructure.

These scenes are alluded to in the songs accompanying the masks' dances. In the example shown here, the superstructure of the mask comprises a dwelling with a bird's head and neck bouncing within its doorway. The depiction of a house on top of a *kholuka* (or *mbala*) mask typically refers to the union of a couple in matrimony. The masked dance was accompanied by sung verses with similar sexual references while the dancer himself displayed vigorous pelvic thrusts and occasionally revealed a large wooden phallus hidden under his raffia skirt. But despite the secular nature of the *kholuka/mbala* performance, the mask is charged with powerful ingredients, including the ashes of the nose of a mask that was burned following the previous *n-khanda*. Before the emergence of an art market in concert with the settlement of European and American colonists and missionaries in the Yaka region in the early twentieth century, such *n-khanda* masks would always have been destroyed, along with the initiation camp site, after the completion of the initiation cycle.[1]

Constantine Petridis

1 This discussion is mostly based on Bourgeois 2014, esp. 40–53 and 123, plate 36. For an alternative reading of *n-khanda*-related Yaka masks, see Devisch 2017.

57 Headrest (*Musawa* or *Musau*)

Yaka
Bandudu region,
Democratic Republic
of the Congo
Probably late 19th or
early 20th century
Wood and pigment
16.7 × 9.8 × 17.4 cm
(6⅝ × 3⅞ × 6⅞ in.)

Gift of George F. Harding,
1928.175

Provenance: Raoul Blondiau,
Brussels, by 1925 [reportedly
acquired between 1900 and
1925; see Locke 1927, n.p.];
sold to Theatre Arts, New
York, Nov. 1926; sold to the
Art Institute, 1928.

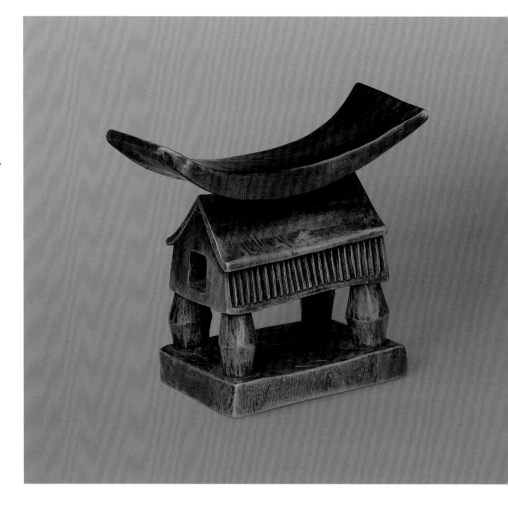

58 Drinking Horn

Kuba
Kasai region, Democratic
Republic of the Congo
Probably late 19th or
early 20th century
Wood, copper alloy, iron,
and pigment
39.4 × 44.5 × 11.4 cm
(15½ × 17½ × 4½ in.)

Gift of George F. Harding,
1928.173

Provenance: Raoul Blondiau,
Brussels, by 1925 [reportedly
acquired between 1900 and
1925; see Locke 1927, n.p.];
sold to Theatre Arts, New
York, Nov. 1926; sold to the
Art Institute, 1928.

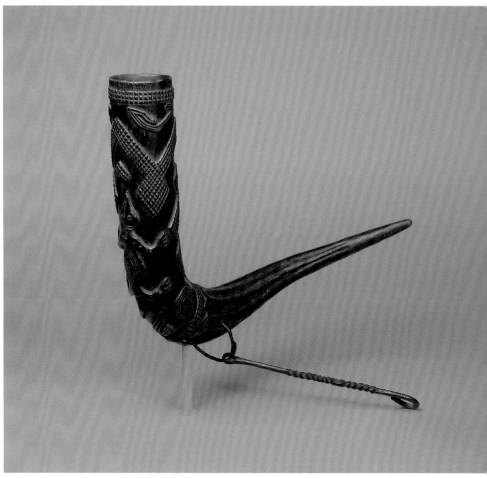

These objects were among the first African works to be accessioned by the Art Institute, in 1928. This playful headrest by an unidentified Yaka carver had been displayed at the museum in November 1927 in the context of a citywide event called *The Negro in Art Week*. Organized by the Chicago Woman's Club, that historical exhibition juxtaposed traditional African sculptures with paintings and sculptures by leading African American artists of the day, such as Aaron Douglas and Henry Ossawa Tanner.

Headrests had already fallen into disuse by the late 1970s, when art historian Arthur P. Bourgeois conducted field research and learned that such objects had been owned and used by Yaka chiefs and other male dignitaries to protect their elaborate hairdos.[1] Sometimes they were enhanced with charms providing metaphysical protection to their owners during sleep. The pitched-roof house, whether elevated on stilts or not, is a motif that also appears in the carved superstructures of initiation-related masks like the example in the Art Institute's collection (cat. 56); it could refer to a dwelling destined to contain protective charms. But when depicted on a headrest it probably would have served a merely decorative purpose.

The drinking container, skillfully carved to imitate the shape of a buffalo horn, was used for the consumption of palm wine. Such insignia were sometimes carved from horn itself instead of being copied in wood and were usually carried over the shoulder; the iron ring and hook-like element on the Art Institute's example may have allowed the wearer to attach it to a belt or strap. Although typically associated with the hierarchical Kuba society, similar drinking horns and their wooden imitations have also been documented among the neighboring Luluwa, who sometimes feature them on their power figures representing high-ranking chiefs, carved to appear hooked over a shoulder.[2]

The surface of this finely made sculpture is covered with designs in relief, exemplifying the *horror vacui* characteristic of Kuba royal arts. An array of geometric patterns, which probably mimic body scarifications, are enhanced with delicate copper inlay. Some of these designs are very similar to the scarification marks on the face of the Art Institute's Luluwa mother-and-child figure (cat. 60). The decoration also includes images of a hand and a lizard or crocodile. Without any field-based documentation it is impossible to be confident about the meanings of these designs. But the horn shape indicates that this likely belonged to a warrior whose prowess was likened to that of the wild buffalo and the untamed bush it inhabits.

Constantine Petridis

1 Arthur P. Bourgeois, cited in Dewey 1993, 55. See also Bourgeois 1984, 71, no. 49. 2 For more information on Kuba prestige arts, see Binkley and Darish 2009, esp. 14–30.

59 Chair (*Chitwamo* or *Njunga*)

Chokwe
Angola
Late 19th to early 20th century
Wood, brass tacks, and hide
H. 50.8 cm (20 in.)

Winter and Hirsch Fund, 1968.789

Provenance: Everett D. Rassiga (died 2003), New York, by 1968; sold to the Art Institute, 1968.

1 Detail of cat. 59 featuring the side on a sitter's left, with a maternity figure and her attendant.

This chair is an example of the wooden prestige chairs that were popular among Chokwe chiefs in the late nineteenth and early twentieth centuries. Starting with colonial European furniture models, Chokwe artists refined those designs to feature a wide array of carved symbols and motifs; the style is characterized by narrative scenes composed of miniature, three-dimensional representations of people, animals, and objects.[1] The Art Institute's chief's chair, for example, emphasizes the gender complementarity also embodied in the museum's Chihongo and Pwo masks (see cat. 51 and p. 132, fig. 2.). The choice sculptural element decorating the chair's back (top center) is a representation of Chihongo, the male spirit of wealth and power for the Chokwe, mirroring attributes and morals associated with the chief.[2] The abstract low-relief carvings on the chair's back, below its Chihongo, carry their own symbolic names and associations and may reference the designs woven or dyed into the bodysuits of Chihongo and other *akishi*.[3]

The chair's four rungs include scenes that emphasize male and female roles. The two figures represented on the front include *kalamba kuku wa lunga* and *kalamba kuku wa pwo*. These are male and female ancestral characters, respectively.[4] On a sitter's left side, a scene featuring a mother with her newly born child and an attendant honors women's endeavors: human fertility and, by extension, continuity for a chief's lineage (fig. 1). On the opposite side, a royal male (marked by his disk-shaped beard) gestures with open hands behind a figure that appears to hold a large antelope horn.[5] This scene evokes the world of men and the manipulation of the supernatural (represented by the horn) for the well-being of all people.

The figures on the chair's back rung include a stork—a traditionally regal bird—with what may be a ritual expert holding or presenting an offering or gift. The stork, discussed elsewhere in relation to Chihongo's feathers (see my essay in this volume,

p. 130), carries additional symbolic meaning as part of a chief's seat. It was described to me as one of the last birds to remain around water pools as they dry up long after the rainy season has ended. The stork catches insects and other food and knows how to survive through difficult times. This metaphor for endurance, survival, and sustenance is one of a number of motifs referencing a chief's qualities and ability to support the people.[6] Indeed, the deep dark patina on the Art Institute's chief's chair attests to its years of use in the context of a chief's palace. It was meant to complement and reflect—in a visual form—the values as well as the responsibilities of a Chokwe chief.[7]

Manuel Jordán

1 For publications dedicated to African and Central African seats, see Benitez-Johannot 2003; and Van Wassenhove 1996. Marie-Louise Bastin illustrates several figurative Chokwe stools and chairs; see Bastin 1961, vol. 2, plates 155–201. See also Kiangala 1989; and Masuka Maleka 1999. 2 The chair's miniature Chihongo representation features a crown that arches back, a different style/approach to Chihongo's headdress than the upright fan of feathers on the Art Institute's mask (cat. 51). 3 See Bastin 1961, vol. 1, for related symbolism. 4 Similar hand-on-chin figurines are found in divination and represent male and female ancestors; see de Areia 1985. The image of a seated male character with both hands on his chin has been popularized in Angola to represent "the Angolan thinker"; it is mass-produced in craft markets as an Angolan symbol. 5 The hand gestures are part of the formalities at a chief's court. Large antelope horns are used as receptacles for *vitumbo* (medicines) used to manipulate the supernatural. The scene reflects a chief's access to such powers. 6 My dissertation introduces chiefs' chairs and their symbolism to comment on aspects of Chokwe life and cosmology; see Jordán 1996. 7 Chokwe chiefs may own several chairs and stools in different sizes and with varying degrees of elaboration. Larger ones may be reserved for the chief and act as thrones whereas others may be used on more casual occasions or offered to important court officials and distinguished visitors. Seating follows conventional Chokwe norms: no one can sit higher than the chief.

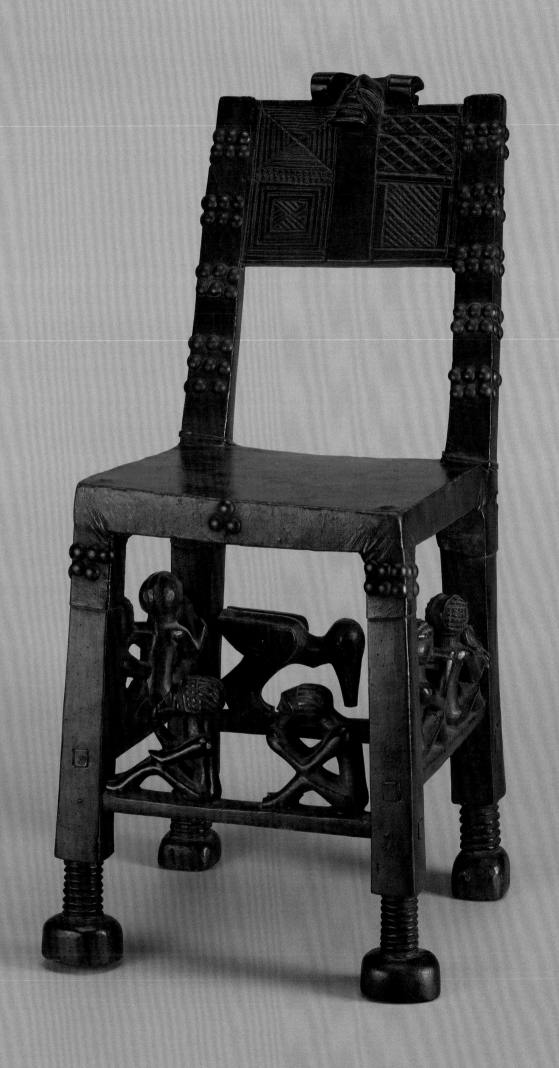

60 Mother-and-Child Figure (*Bwanga bwa Cibola*)

Luluwa: Bakwa Mushilu
Democratic Republic of the Congo
Probably mid- to late 19th century
Wood and pigment
28.9 × 8.6 × 8.2 cm (11⅜ × 3⅜ × 3¼ in.)

Wirt D. Walker Fund, 1993.354

Provenance: Jaap (Jacob) Wiegersma, Utrecht, Netherlands, 1937. A. F. C. A. van Heyst (died 1962), Rotterdam, by 1962; by descent to his son, J. van Heyst, Ottawa, Ontario, 1962; sold Sotheby's, New York, Nov. 14, 1980, lot 227. Stuart Hollander, Saint Louis, MO, by 1993; consigned to Thomas S. Alexander III, Alexander Gallery, Saint Louis, 1993; sold to the Art Institute, 1993.

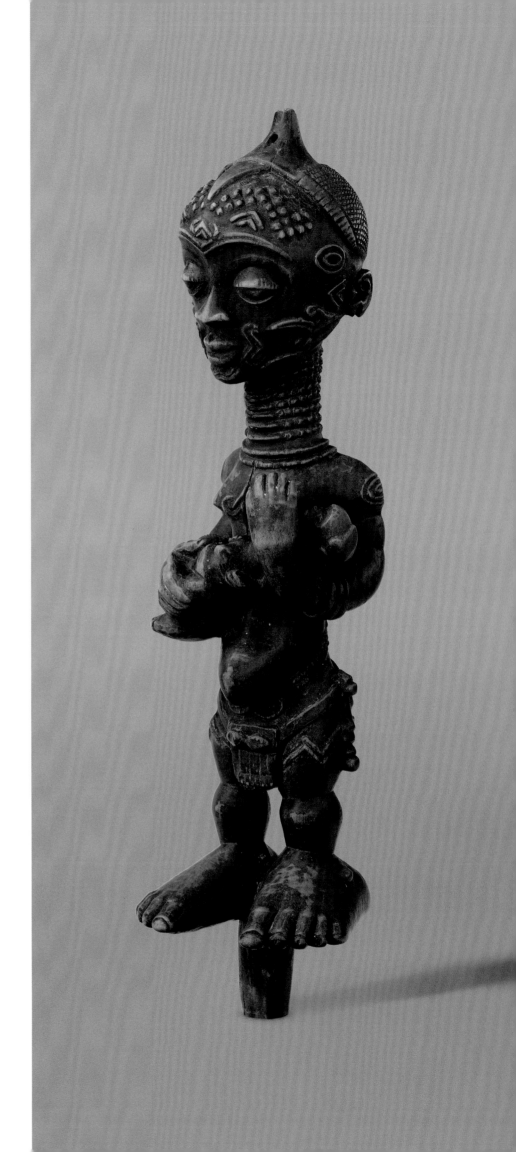

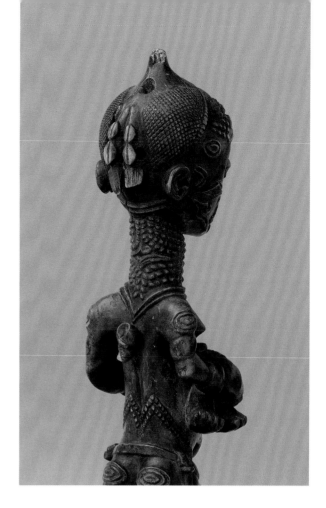

1 View of the
back of mother-
and-child-figure
(cat. 60).

This mother-and-child figure represents one
of the Luluwa people's best-known and most
classic substyles, named "Bakwa Mushilu" after
the subgroup in northern Luluwaland where
it originated.[1] The Art Institute's example is
distinguished from other such maternity sculp-
tures by the pointed extension underneath
its feet, which is usually cut or broken off. But it
is missing its original surface coating, which
would have consisted of a mixture of red cam-
wood or clay and oils similar to that used by
Luluwa men and women to beautify their own
skin. It seems to have been cleaned shortly
after it was accessioned by the museum in 1993.[2]
The figure's appearance marks it as a paragon
of the Luluwa concept of beauty known as
bwimpe, which unites Western notions of aes-
thetics and ethics. Her anatomy, elaborate
coiffure, jewelry, and cicatrizations conform to
standards of physical beauty (see fig. 1).

This object's idealization is pertinent to
its role in a fertility initiation ritual. *Bwanga
bwa cibola* is the name for both the power cult
that administers and oversees the initiation
ritual and the figure or other object that serves
as its focal point. *Bwanga* (plur. *manga*) is the
generic Luluwa term for what is more usually
labeled a "power object" (once pejoratively known
as a "fetish"); the word is thus the equivalent of
the term *nkisi* (plur. *minkisi*), used among the
Kongo-speaking peoples in the western part of
the Congo and adjacent countries. The *bwanga
bwa cibola* is called upon when a woman has
problems conceiving, suffers from miscarriages,
or repeatedly endures the death of a newborn.
If natural remedies cannot improve the situa-
tion, the woman will be encouraged to undergo
the lengthy and complicated initiation into
bwanga bwa cibola in order to withdraw her-
self from possession by *cibola*—the malevolent
metaphysical force at the root of her misfortune.

A mother-and-child power figure (like the Art
Institute's) would be placed in a basket or ceramic
vessel that is filled with dirt and a mixture of medic-
inal and magical ingredients. The object functions
as a mediator between the material and the spiritual
world, and also serves as a guardian of both the
mother and her new offspring. Its idealized render-
ing of *bwimpe* is designed to attract ancestral
spirits who may render assistance and invite them
to inhabit the figure, through which they will exert
their benevolent influence. Thus, the representation
of both outer and inner beauty is essential to over-
coming the affliction that has prevented the woman
from fulfilling her role as a mother.

Constantine Petridis

1 In fact, its style is so similar to that of two maternity figures
in the Royal Museum for Central Africa in Tervuren, Belgium,
that it seems justified to attribute all three to the same artist
or at least the same atelier. The Art Institute's provenance
history also connects it with the works in the Tervuren museum—
all were acquired in Central Africa before World War II. See
Petridis 1997, 198–200; see also Petridis 2018, esp. 67–93.
2 Barbara Hall, conservation treatment report, Nov. 22, 1994,
in the Art Institute of Chicago curatorial object file.

61 Helmet Mask (*Bwoom*)

Kuba
Kasai region, Democratic
Republic of the Congo
Possibly late 19th to
mid-20th century
Wood, metal, glass beads,
cowrie shells, fabric, pigment,
seeds, thread, and leather
63.5 × 49.9 × 67.3 cm
(25 × 18½ × 26½ in.)

Edward E. Ayer Endowment in memory of
Charles L. Hutchinson, 1982.1506

Provenance: Reportedly Chief Kemishanga
(died 1945), village of Mbelo, near Mweka,
now Democratic Republic of the Congo
[see Neyt 1981, 160, fig. VIII.8]. Peter Loebarth
(died 2015), Kinshasa and Hamelin,
Germany, by late 1970s; sold to Jacques
Hautelet (died 2014), Brussels and La Jolla,
CA, by 1981; sold to the Art Institute, 1982.

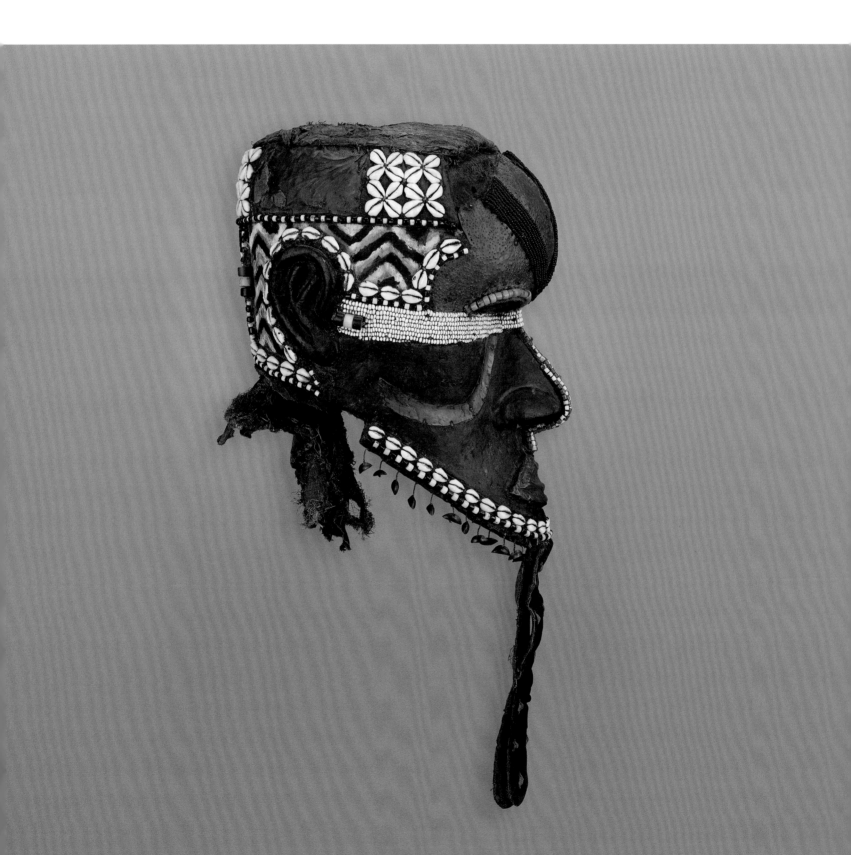

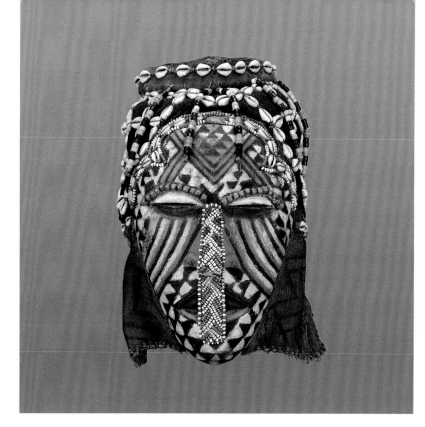

The literature on Kuba art—and specifically that on the art of the Bushoong, the central group of the Kuba people—typically focuses on a trio of royal masks related to reenactments of the mythical drama of the Kuba Kingdom's origins, which are staged at public ceremonies, initiations, and funerals.[1] In this context, a male mask known as *bwoom* and a female mask known as *ngady mwaash* (see fig. 1) are joined by another male mask called *mwaash ambooy*, which represents Woot, the culture hero and original ancestor of the Bushoong, and is similar in form to the *mukenga* mask of the northern Kuba (see cat. 62).[2] The wooden headpiece of each mask in the trio is complemented by an elaborate costume covered with beads and cowrie shells as well as multiple other accessories. During masquerades *bwoom* and *ngady mwaash* always appear as a pair, but they do so by taking turns rather than dancing together. The dance styles assigned to Kuba men and women are markedly different and underscore the tension between initiated men and uninitiated women. Male mask characters like *bwoom* display aggression and heaviness while female characters like *ngady mwaash* dance in a sensuous and graceful manner even though the mask is always worn by a man.

Different interpretations have been offered to characterize *bwoom*'s role within the cultural narrative associated with it in the central and southern Kuba regions: some sources identify him as a prince, others as a commoner, and still others as a Pygmy. *Bwoom* is the inventor of the *nkaan* initiation and thus danced with during initiation rites. But *bwoom* also appears during funerary masquerades honoring dead members of the *nkaan* initiation association. Comprising a wooden carving with a fabric headdress and a beard of animal hide, the mask's surface is richly embellished white cowrie shells, colorfully painted areas, and many glass beads, including a number of bead bands that

1 Face Mask (*Ngady Mwaash*), late 19th to mid-20th century. Kuba; Kasai region, Democratic Republic of the Congo. Wood, pigment, glass beads, cowrie shells, fabric, and thread; 31.8 × 20.6 × 20.5 cm (12 ½ × 8 ⅛ × 10 in.). The Art Institute of Chicago, restricted gift of the American Hospital Supply Corp., the Evanston Associates of the Woman's Board in honor of Wilbur Tuggle, Deborah Stokes and Jeffrey Hammer, William E. Hartmann, Charles A. Meyer, D. Daniel Michel, and Claire B. Zeisler; African and Amerindian Art Purchase Fund, 1982.1505.

run over the nose and eyes and, most notably, in a trident pattern over the forehead. The Art Institute's example is further distinguished by copper sheeting that bedecks most of the mask's wooden surface, with lighter-colored strips decorating the cheeks and covering the mouth.

An idealized representation of women, *ngady mwaash* is commonly identified as the sister and wife of the king.[3] Densely painted surfaces with busy geometric patterns are a typical feature of masks in the central and southern Kuba regions. As in the case of *bwoom*, colorful beads and white cowrie shells further enhance the decorated surface of *ngady mwaash*. Parallel lines running diagonally across the cheeks represent tears (*byoosh'dy*) and bespeak the mask's primary performance at funerals for deceased men of the *nkaan* association. Masquerades were meant both as celebrations of the life of the departed and as a time of mourning.

Constantine Petridis

1 Joseph Cornet has written extensively on this subject; a concise overview can be found in Cornet 1993. 2 Teachings about Woot were integral to the education of the boys undergoing their initiation. 3 Although *ngady mwaash* is often described as royal, David A. Binkley notes that the performances of this mask genre have only been documented in the southern Kuba region, where these connotations would not pertain. See Binkley 2004, 172–73. See also Binkley and Darish 2009 for a condensed, encyclopedic account of Kuba arts.

62 Helmet Mask (*Mukenga*)

Kuba
Kasai region, Democratic
Republic of the Congo
Possibly late 19th to
mid-20th century
Wood, glass beads, cowrie
shells, feathers, raffia, fur, fabric,
thread, monkey hair, and bells
57.5 × 24.1 × 20.3 cm
(22⅝ × 9½ × 8 in.)

Laura T. Magnuson Fund, 1982.1504

Provenance: Peter Loebarth (died 2015), Kinshasa and Hamelin, Germany, by late 1970s; sold to Jacques Hautelet (died 2014), Brussels and La Jolla, CA, by 1981; sold to the Art Institute, 1982.

The most characteristic trait of *mukenga*—a mask, also known as *mukyeeng or mukyeem*, that combines animal features with human ones—is the long curved projection from the top that represents an elephant trunk; two shorter parallel projections mimic tusks. Ivory hunting and its trade were critical elements in the Kuba Kingdom's establishment and expansion as a regional power, and the form of the *mukenga* mask reflects that material's cultural importance.[1] Embellished with a tuft of red parrot tail feathers attached to the end, the "trunk" also indicates that this mask's owner was an eagle-feathered chief called *kum aphoong*. Aside from these red feathers, the mask's value is underscored by the spotted fur, likely from a civet or other cat, and the beard of monkey hair. Its prestige is further defined by the number of beads and shells that make up its ostentatious decoration, together with the complexity of their design, which is time-consuming to create. The white cowrie shells represent mourning and purity while the blue beads signal high rank and wealth.

The eagle-feathered titleholder wears *mukenga* along with its costume on the day of his installation and dances before the community. The mask also appears in the context of the puberty initiation ritual for boys, called *babende* in the central and northern Kuba region, which takes place within the walled compound of the newly invested village headman. *Mukenga* is the highest-ranking mask of a triad that also includes two wooden sculptures: a helmet mask called *bongo* and a face mask called *ishyeen imaalu*. But its performance at the funeral rites of deceased titleholders who are members of the Kuba aristocracy is even more important. The masker's costume is similar to the funerary attire of the titleholders, in which they are displayed before their interment. The mask makes

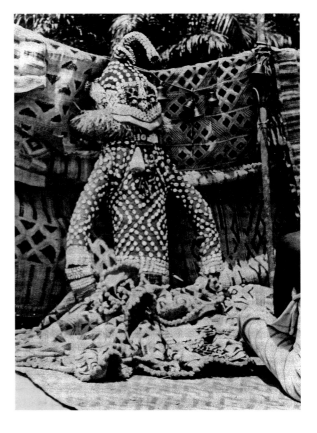

1 Funeral effigy with *mukenga* mask among the Ndengese people, Belgian Congo (now Democratic Republic of the Congo), c. 1955. Photo by Mr. Cremers.

its final appearance at the eagle-feathered chief's own funeral; before the individual's actual burial the mask is displayed for three days on a mannequin-like effigy dressed with a funerary costume and full regalia (see fig. 1). After the third day, the man succeeding the chief would be confined in a room with the effigy in order to receive the powers of his predecessor during a ritual of transference. In the past, however, the *mukenga* mask would always accompany its deceased owner in his grave.

Constantine Petridis

1 The relationship between the *mukenga* mask and the elephant is discussed in Binkley 1992. See also Binkley 2016, 170–71.

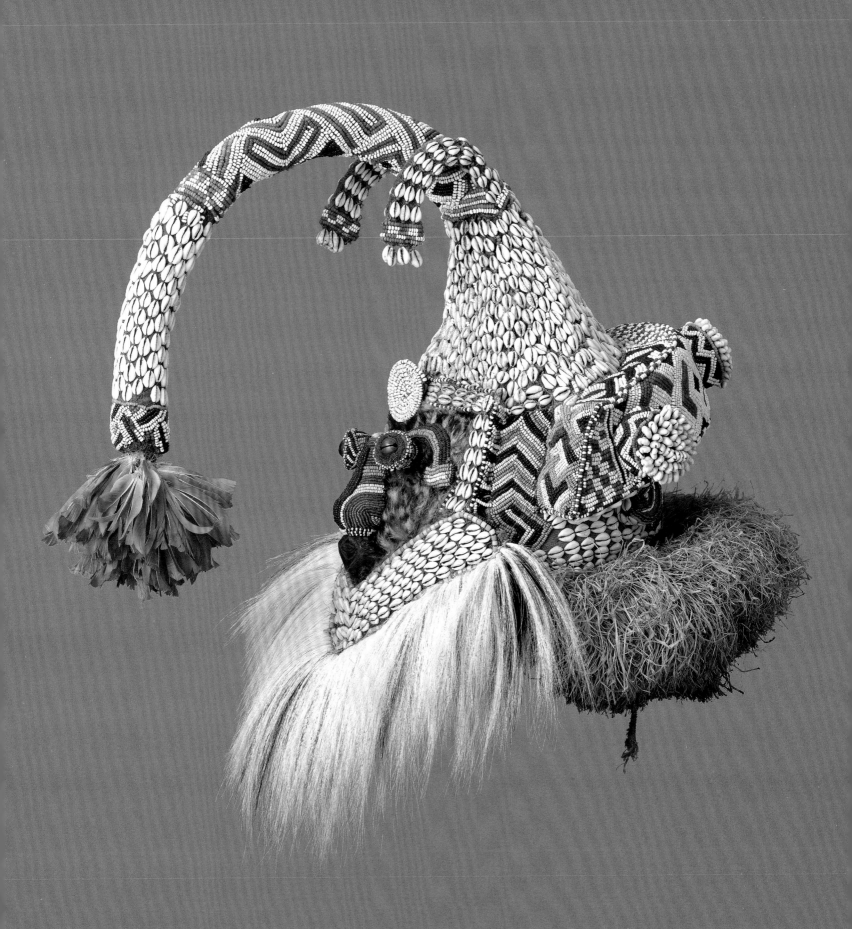

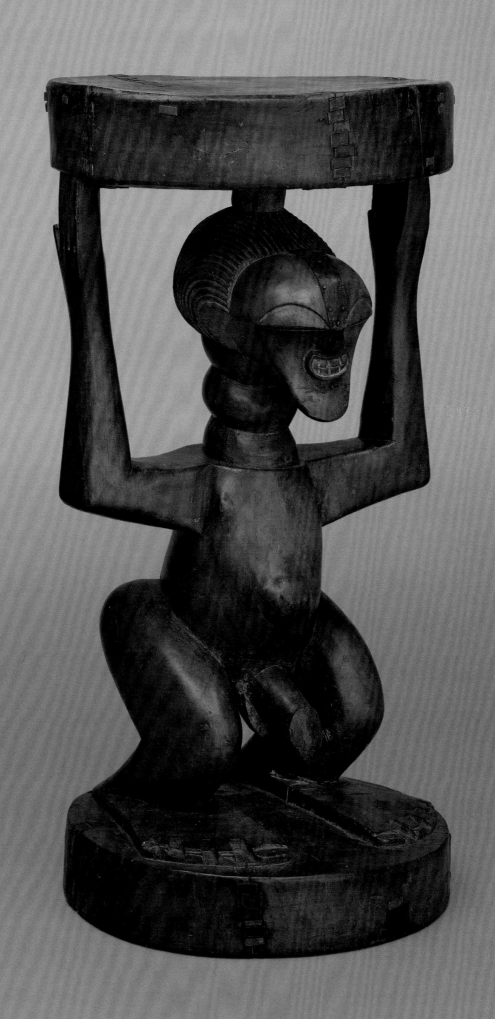

63 Male Caryatid Stool

Songye
Democratic Republic of the Congo
Probably late 19th to early 20th century
Wood, pigment, copper alloy, and iron
63.8 × 27.6 × 30.8 cm (25⅛ × 10⅞ × 12⅛ in.)

Major Acquisitions Centennial
Endowment, 1992.64

Provenance: Reportedly acquired in
the town of Lusambo, now Democratic
Republic of the Congo, by Mr. and Mrs.
Schepens, from 1924. Sold Christie's,
London, Dec. 3, 1991, lot 110, to the
Art Institute.

Art scholars and collectors readily associate the ethnic name "Songye" with arresting human-shaped power figures known as *mankishi* (sing. *nkishi*) and with striped anthropo-zoomorphic masks (see fig. 1) known locally as *bifwebe* (sing. *kifwebe*). The Art Institute's caryatid stool features a recognizable Songye style and belongs to a small corpus of such sculptures; about a dozen of these have been attributed to one artist or at least a single workshop. It combines refined details with stylized features to present a bold, expressive whole—collectively attesting to the skill and inspiration of a master carver. Some of these stools are carved as conjoined figures—male and female—standing back-to-back, and while most depict the caryatid with flexed knees, in a few examples the figure kneels. Featuring masklike faces and long, ringed necks, the female examples are also decorated with relief designs on their torsos in imitation of body scarification.

The genre of caryatid stools appears to be a rather rare occurrence among the Songye, but it has been extensively documented and collected among their eastern neighbors, the Luba people, and other related groups. Some scholars have argued that Songye carvers were inspired or influenced by the prestige arts of their Luba neighbors, for whom such stools served as status emblems of the ruling elite.[1] It is likely that Songye chiefs or other high-ranking dignitaries laid a similar claim to such stools. While some of them appear newly carved and pristine, the traces of wear on the Art Institute's example as well as some obvious locally made restorations leave no doubt that it has actually served its purpose over some period of time. The work's documented early collection history supports this claim: it was acquired in 1924 by Mr. and Mrs. Schepens in the town of Lusambo, the heart of Songye territory in what was then the Belgian Congo.[2]

Constantine Petridis

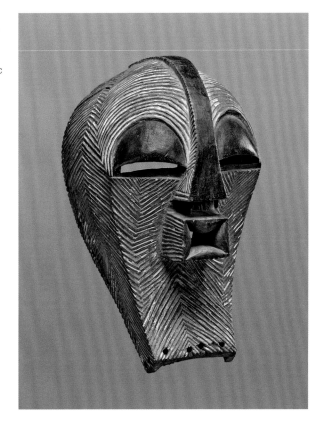

1 Face Mask
(*Kifwebe*), late 19th–
early 20th century.
Probably Songye;
Democratic Republic
of the Congo. Wood,
pigment, and hair;
H. 35 cm (13 ¾ in.).
Private collection,
United States.

1 Frans M. Olbrechts launched the idea of a mixed "Luba–Songye substyle," of which caryatid stools like this example would be the paradigmatic expression; see Olbrechts 1946, 65–66 and plate XXXIV; see also Bastin 1988, 303, cat. XXXVIII; Cornet 1988, 267, cat. no. 172; and M. Roberts 1995. 2 François Neyt specifically attributes these stools to two different Songye workshops: Kisengwa and Kabalo, both located north of Kabinda and east of Lusambo, albeit separated from one another by considerable distance; see Neyt 1993, 91 and 233.

64 Male Figure (*Singiti*)

Hemba
Democratic Republic
of the Congo
Probably mid-19th or
early 20th century
Wood and pigment
H. 70.9 cm (27⅞ in.)

Ada Turnbull Hertle Fund, 1972.453

Provenance: Reportedly acquired in
the village of Befeka, now Democratic
Republic of the Congo, by Pierre
Dartevelle, Brussels, by about 1970; sold
to Pierre Langlois, Galerie Nord, Lille,
France, by 1972. John J. Klejman (died
1995), Klejman Gallery, New York, 1972;
sold to the Art Institute, 1972.

Sensitively carved commemorative *lusingiti* (sing. *singiti*) figures were viewed by those who made them as purely spiritual creations that resided in the otherworld and lived a secret life hidden from human onlookers.[1] Such sculptures were infused with a life force or vital energy that allowed them to facilitate communication between the living and the dead. Indeed, *lusingiti*—like other spirit-invested objects among the Hemba people—served first and foremost as mediators between the ancestors and their descendants. Most of these sculptures would have been carved from the African teak or iroko tree (*Chlorophora excelsa*), called *muvela* by the Hemba. It was itself considered an abode for the spirits and thereby infused the figures with some of its inherent qualities.

The name "Hemba" was recognized by Western scholars as the term for an autonomous style in the 1970s, shortly after the massive extraction of figures from the country then called Zaire, against the background of the political and economic turmoil caused by the kleptocracy of the ruling dictator Mobutu Sese Seko. However, works in the newly identified Hemba style had been acquired sporadically from the late nineteenth century onward. Before the 1970s the style was seen as simply a substyle of Luba art, and the continuity between Luba and Hemba is generally accepted among art scholars. Despite stylistic affinities between the arts of both peoples, however, it is equally clear that this standing ancestor figure should be attributed to the Hemba rather than to the Luba. Although our knowledge of the contextual setting of such figures is rather limited, they belong to a rich and widespread tradition of grouping sets of related figures, from three to as many as twenty or more, in a special house or shrine where they were accompanied by fragments of skulls and bones from the same ancestors that the figures commemorated. All of these figures are believed to have represented important former chiefs. With their downcast eyes and closed mouths conveying calm, and elaborate

1 A chief seated on a caryatid stool and flanked by three ancestor figures, Zaire (now Democratic Republic of the Congo), c. 1975. From Petridis 2017b, 133, fig. 5.

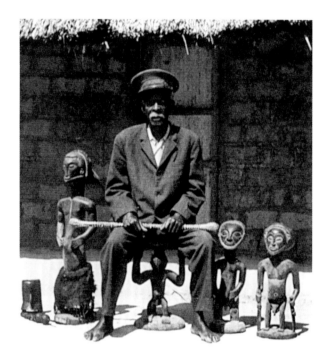

hairstyles and beards expressing authority and wisdom, *lusingiti* were considered predominantly benevolent and tender. The figures were typically preserved in the darkness of their shrine, which served as a mausoleum and had the spirits of the otherworld as its privileged audience; they were very rarely removed for display (see fig. 1). As idealized likenesses memorializing esteemed leaders of the past, the figures' power is rooted in the belief that, when treated appropriately through offerings and prayers, the ancestors will intervene in times of crisis and misfortune, and continue to positively influence the well-being and fertility of their surviving descendants.

Constantine Petridis

1 Neyt 1977 remains the most pertinent source of information on the subject of Hemba ancestral figures. Much of this discussion has previously appeared in Petridis 2017b.

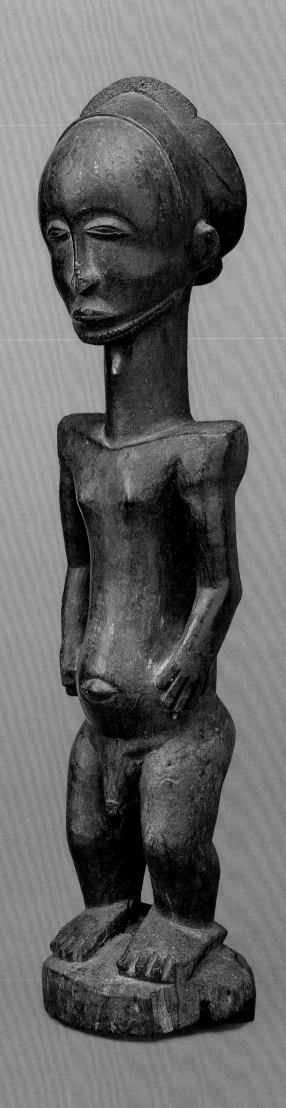

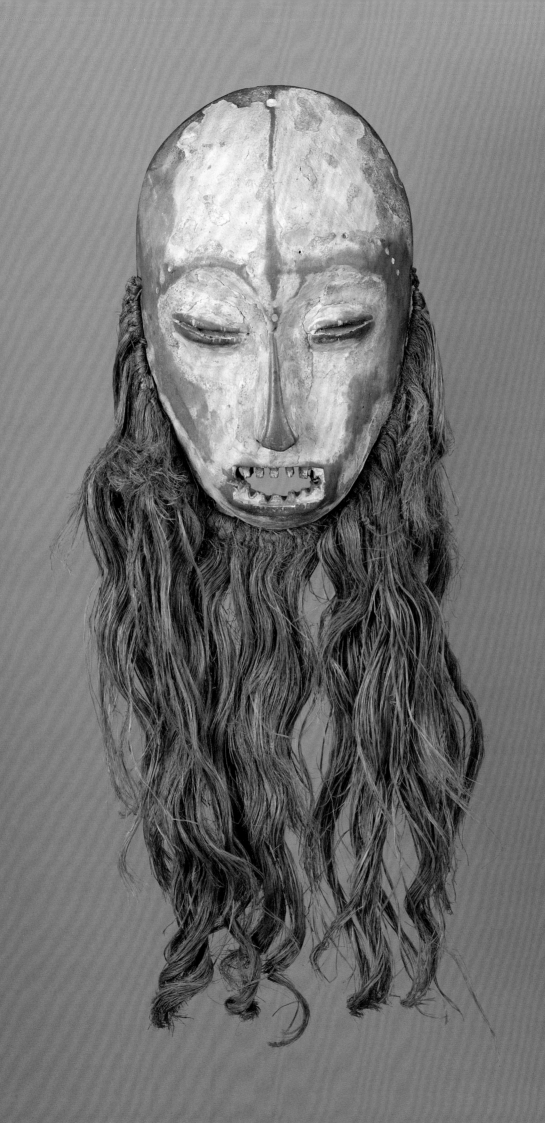

65 Mask (*Idimu*)

Lega
Kivu region, Democratic
Republic of the Congo
Probably late 19th or early 20th century
Wood, raffia, and chalk
64.8 × 30.5 × 7.7 cm (25½ × 12 × 3 in.)

Gift of Grace Hokin, 1991.387

Provenance: Edwin Hokin (died 1990)
and Grace E. Hokin (born Grace Cohen;
died 2009), Chicago, by 1963; by descent
to Grace E. Hokin, Chicago, by about
1990; given to the Art Institute, 1991.

Masks of different materials, shapes, and sizes were among the many objects the Lega people used in the initiations and performances of the Bwami association. This is a relatively well-preserved example of one of the most important wooden masks related those activities.[1] A hierarchically organized institution open to both male and female members, Bwami unified the different Lega groups dispersed in numerous small villages within the densely forested regions of eastern Congo. The men's association consisted of five levels while the women's counted three ranks. Combining social, political, religious, and economic purposes as well as artistic and aesthetic ones, its ultimate goal was to educate members in a complicated and all-encompassing moral philosophy that brought enlightenment and wisdom, thereby contributing to a harmonious society and solidarity among its members. The Lega word that encapsulates this high aspiration is *busoga*, the ideal union between moral perfection and physical beauty. The term also characterizes a great work of Lega art.

With the aim of boosting their prestige, Bwami members strived to accumulate large numbers of sculptures and other Bwami-related objects. These valuable items were carefully preserved and bequeathed by one generation to the next. In addition to indicating rank within the association, masks and a variety of other crafted objects were used alongside natural objects as didactic devices to convey the Bwami's teachings in the course of sequential and secret initiations. These items illustrated the proverbs or aphorisms that transmitted the association's philosophical precepts to initiates. Music, song, dance, gestures, and theater accompanied the presentation of objects and the recitation of proverbs. But masks were rarely worn in front of the face to disguise someone's identity; instead, they were "worn" on the arms or other body parts, held in the hands,

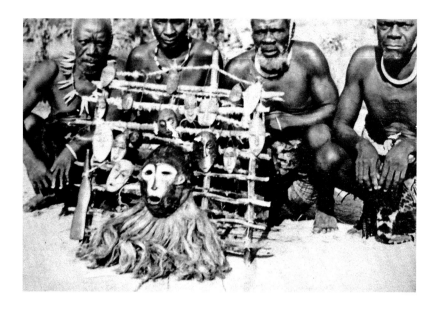

1 Daniel P. Biebuyck (Belgian, 1925–2019). Wooden framework with a display of ivory and wooden masks during an initiation into the Kindi grade of the Bwami association, Belgian Congo (now Democratic Republic of the Congo), 1952–54. Photographic print. Private collection.

piled in stacks, hung on fences and surrounded by other wooden and ivory masks, or even dragged on the ground by their long raffia beards (see fig. 1).

The Art Institute's large, white-faced mask represents one of five basic mask categories. Bearing the name *idimu*, which means "ancestor," it was the collective property of the Yananio or Kindi grade, the two highest levels of the men's Bwami association. As part of their role in recalling death and the ancestors, a mask was often displayed on the grave of its owner before being passed down to an heir. All Bwami-related objects were identified as "heavy things," or *masengo* in the Lega language—that is, objects infused with transcendental power that made them either beneficial or harmful.

Constantine Petridis

1 This discussion relies heavily on many writings by Lega art expert Daniel P. Biebuyck, particularly Biebuyck 2002. For a comprehensive summary of the literature on the subject and a useful survey of Lega art, see also Cameron 2001.

66 Lidded Box

**Mangbetu or Zande
Uele region, Democratic
Republic of the Congo
Probably early 20th century
Wood, bark, pigment, and raffia cord
H. 58.4 cm (23 in.)**

Bessie Bennett and Edward Johnson
endowments, 2001.411

Provenance: Jacques Blanckaert (died
1995), Brussels, by 1986; Carlo Monzino
(died 1996), Lugano, Switzerland,
from 1986 [see Vogel 1986, 181, cat. 130].
Lance Entwistle and Roberta Entwistle,
Entwistle Gallery, London, by 2000;
sold to Steven Morris, Donald Morris
Gallery, New York and Birmingham, MI,
by 2001; sold to the Art Institute, 2001.

Both Zande and Mangbetu sculptors are
renowned for the range of objects they have
decorated with elements drawn from human
anatomy. In addition to serving utilitarian
functions, these creations—including figural
harps, knives, pipes, and complex, cylindrical
wood-and-bark boxes like the Art Institute's—
express prestige and rank in a hierarchical
society.[1] In this example a female head with
finely carved facial features, round pierced
ears, and a typical halo-shaped hairstyle
adorns the lid of a cylindrical container; the
figure's "body" is made of wrapped and tightly
sewn layers of bark set atop a wooden pedes-
tal in the form of a woman's stool. Some parts
have been blackened by fire and then bur-
nished while others were painted with a light
yellow stain to create attractive contrast.

 None of the comparable examples now
preserved in collections around the world show
traces of either honey (a coveted delicacy in the
region) or red camwood powder (a popular body
cosmetic among the Mangbetu and Zande), as
has often been maintained in the scholarly liter-
ature. Rather, as the German explorer Georg
Schweinfürth first noted in his account of a visit
to the Mangbetu court in 1870, such lidded boxes
would have been used by nobles among both
populations to store personal valuables includ-
ing trinkets, jewelry, clothing, money, and even
protective charms.[2]

 The shapes of the coiffure and "stool" have
previously led scholars to attribute this work to
the Mangbetu (based on comparison with *in situ*
photographs of Mangbetu women; see fig. 1). But
subsequent research has revealed that these
features were shared by both groups and thus
cannot be used to distinguish them. Moreover,
it has been demonstrated that the production
of figural carving in the Uele region of north-
eastern Congo, where the Mangbetu and Zande

1 Herbert Lang
(German, 1879–
1957). Portrait of
a woman wearing
the popular halo
coiffure in a village
in Belgian Congo
(now Democratic
Republic of the
Congo), 1913.
Photographic print;
12.7 × 17.8 cm
(5 × 7 in.). American
Museum of Natural
History, New York,
Department of
Library Services,
111817.

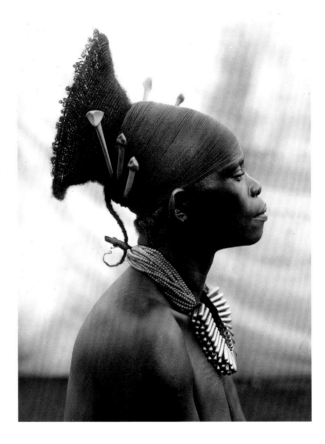

reside, was stimulated in the early twentieth cen-
tury by European travelers and residents seeking
souvenirs. Heads in the "typical" Mangbetu style
may have been created by carvers of the Zande
or any of the other cultures in the region in order
to meet this demand.[3] Whether a master carver
made this example for local use by a member of
the elite or for sale to a European visitor cannot
be determined.

Constantine Petridis

1 See Schildkrout and Keim 1990, esp. 119 and 232–57.
One can also find a useful overview of Mangbetu art in all
its variety and richness in Burssens and Guisson 1992.
2 Schweinfürth 1874. **3** Schildkrout and Keim 1990, 244–49.

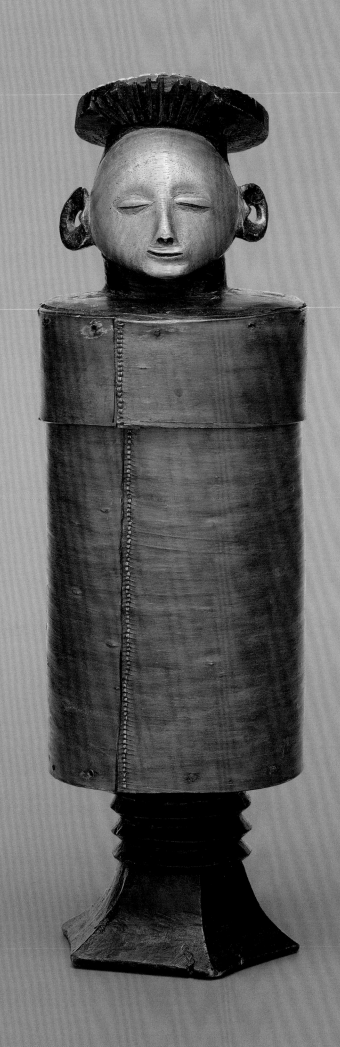

67 Face Mask

Possibly Bwa
Uele region, Democratic
Republic of the Congo
Probably late 19th
or early 20th century
Wood, kaolin, and pigment
H. 28.6 cm (11 ¼ in.)

Samuel A. Marx Restricted
Fund, 1961.915

Provenance: Jean Willy Mestach (died
2014), Brussels, by 1961. Allan Frumkin
Gallery, Chicago and New York, 1961; sold
to the Art Institute, 1961.

This striking face mask is part of a corpus of
about twenty similar sculptures that also feature
a black-and-white geometric design and wooden
inset teeth. Its separately carved, large, perforated
round ears imitate a type of ear ornamentation
that is no longer practiced. Such masks are typi-
cally identified with the Bwa people (whose name
is often still spelled "Boa"), also known as Ababua.

The descendants of these masks' creators
live in the Uele region, an area in what is today
northeastern Democratic Republic of the Congo,
which has been the focus of travel and exploration
since the mid-1800s.[1] Surprisingly, most of the
earliest observers of art and culture in the field
did not witness or describe any masks. Although
some examples of the genre were acquired *in situ*
as early as the 1890s—including masks that were
later in the collections of the Royal Museum for
Central Africa, Tervuren, Belgium, and the British
Museum, London—research on the subject has
been limited. Their fabrication ceased in the first
decade of the twentieth century.

Early sources offered the name *pongdudu*
to describe them and claimed that they were used
during warfare to instill fear in the enemy and to
render the courageous warriors who wore them
invulnerable during combat. However, field research
among the Bwa in 1978–79 by the American ethno-
linguist Mary McMaster revealed the mask genre's
original, proper name as *kpongadomba*, and
connected it with an association responsible for
the enculturation and initiation of young people.[2]
Further careful archival and literature research
has shown that these reports about war masks
among the Bwa are likely fictitious, and the origi-
nal meaning and purpose of masks like the Art
Institute's remain a mystery.

Constantine Petridis

1 This entry is based primarily on Ceyssens 2007. 2 Ceyssens
2007, 66–67; see also Burssens 1993. Most recently, in her
catalogue entry on one of the Royal Museum for Central
Africa's Bwa (Ababua) masks, Hannelore Vandenbergen refers
to preliminary field research conducted in August 2017 by
epidemiologist Anne Laudisoit that indicated that the large
ears identify a chief, who is expected to listen carefully before
reaching a decision and expressing an opinion; see
Vandenbergen 2018.

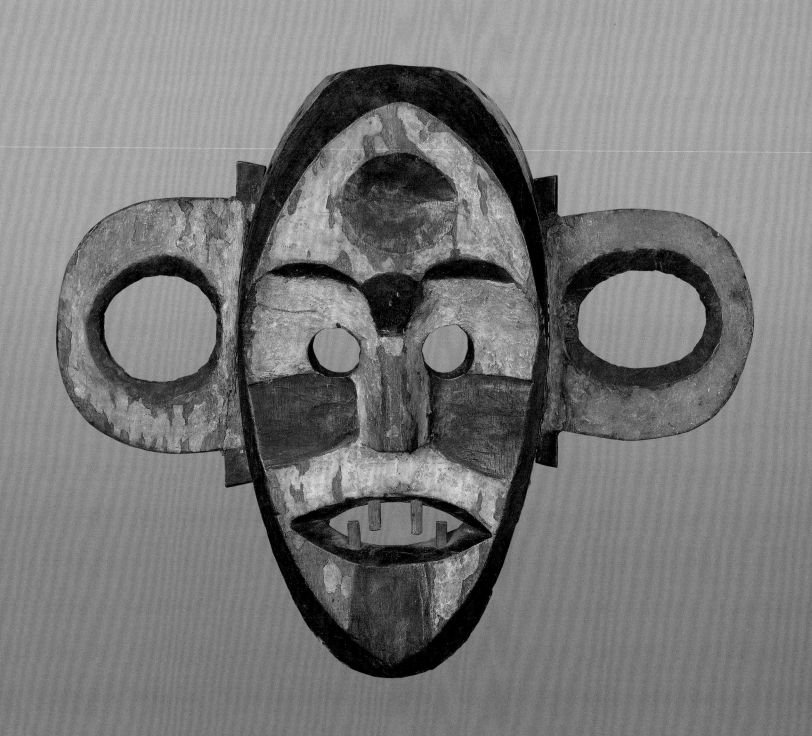

Eastern and
Southern Africa

68 **Headrest**
(*Isicamelo*
or *Isigqiki*)

Zulu
South Africa
19th century
Wood
17.8 × 44.5 × 16.1 cm (7 × 17¼ × 6⅜ in.)

Edward E. Ayer Endowment in memory
of Charles L. Hutchinson, 1996.434

Provenance: Private collection, England, by
1990; sold Christie's, London, Oct. 2, 1990, lot
266, to Kevin Conru, Brussels, then London;
sold to the Art Institute, 1996.

Anitra Nettleton

Of Pillows, Cattle, and Curios

People across Central, East, and southern Africa commonly used headrests to elevate sleepers' heads off the ground and protect their elaborate coiffures. By the nineteenth century, when Europeans started to collect these items as objects of curiosity, an enormous number of different forms of head- or neckrests existed, in styles and compositions that could be associated with particular regions. Two types were dominant in southeast Africa: horizontally oriented headrests like this one, associated particularly with the Nguni-speaking peoples and some Sotho-speakers; and lighter, more delicate, vertically oriented forms associated with Shona- and Tsonga-speaking peoples.[1]

Part of the Nguni-language group, the isiZulu-speaking peoples of the South African eastern littoral were never united into a single polity despite the strength of the Zulu state instituted by King Shaka Senzangakhona in the early 1800s. Yet cultural practices were shared by many isiZulu-speakers across the region, both within and neighboring the kingdom. Many were carried to and have survived in far-distant places in the subcontinent, such as southern Zimbabwe and the area around Lake Malawi, where the leaders Mzilikazi and Zwagendaba, respectively, moved away from

Shaka's depredations and started their own polities. The isiZulu-speakers of Natal and the Zulu Kingdom and these offshoots—which included the siSwati-speakers of the Swazi Kingdom—are grouped together as the Northern Nguni. All had specialist carvers who made wooden headrests on commission for patrons, following the same basic form, each variant in some way evoking the forms of cattle and their economic and symbolic significance to these communities. Similarly, the men of the Nguni language grouping continued the shared practice of wearing a headring (*isicoco*) sewn into the hair on the crown of the head; women's hairstyles were subject to greater change.[2]

The isiZulu-speakers of what is now the Republic of South Africa can be roughly divided into two larger groups: those who were subjected to colonial rule under the British in the Colony of Natal from the 1830 onwards and those who, as residents of the Zulu Kingdom, remained independent of the British until 1879.[3] After King Cetswayo's defeat in that year, the Zulu Kingdom fell under British colonial control, albeit via indirect rule, and remained a tribal trust area/homeland/Bantustan until 1994, when democracy was ushered in and the homeland policy was abandoned. It is still constitutionally under the control

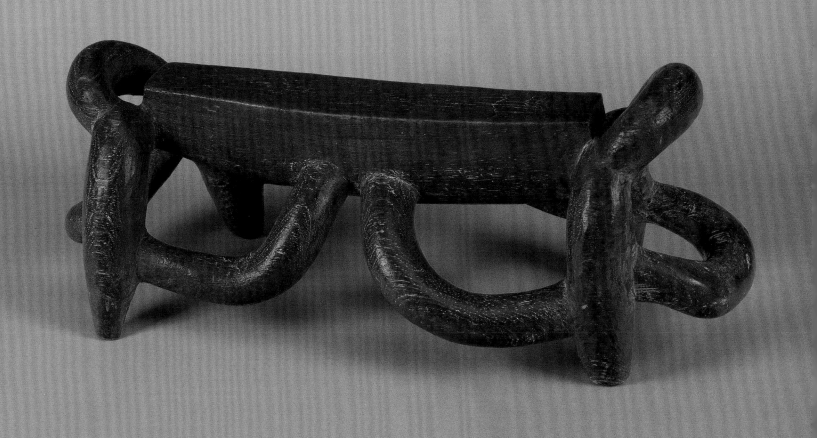

of the Zulu king. The impacts of colonial contact on both land tenure and traditional ways of life were therefore felt very strongly by isiZulu-speakers in Natal and over a more extended period than in the Zulu Kingdom. As a result of that closer contact, colonial officials and settlers were more likely to have obtained objects of ethnographic interest, such as wooden headrests, from peoples in Natal than from those in the Kingdom. These were taken back to Europe by the dozen, where many now sit unseen in museum storage. Others, of course, landed in South African museum vaults.

Zulu Headrest Styles

While most of the headrests made and used by isiZulu-speakers share the common characteristics of horizontal orientation and human-scaled length, they are nevertheless differentiated from one another by their structures, decoration, and degree of elaboration. Thus, the notion of a single "Zulu" headrest style is problematic, especially as the idea of a unified "Zulu" polity has always been contested by isiZulu-speakers themselves. Prior to the mid-twentieth century, within this

1 George French Angas (French, 1822–1886). *Umpanda: King of the Amazulus*. Color lithograph. In *The Kafirs Illustrated in a Series of Drawings Taken among the Amazulu, Amaponda and Amakosa Tribes* (London: J. Hogarth, 1849).

population marriage was traditionally exogamous and patrilocal. Upon her marriage to a man from a different lineage and locale, a woman would take headrests from her own district to her husband's home in another district. The brides' headrests often included those from two generations of marriages, which were likely to have been stylistically different from those made in the men's lineage and district. So untangling the stylistic regions from poorly documented museum collections presents a challenge.

Zulu headrests vary from minimalist tripod branches—similar to forms found in northern East Africa among diverse peoples including the Nuer, Dinka, and Karamojong—to examples like that seen in George French Angas's image *Umpanda: King of the Amazulus* (fig. 1). More elaborately designed headrests from the territory occupied by isiZulu-speakers are known from collections in Europe and South Africa, although collecting practices at the time seldom included names of makers or exact locations of acquisition. Some collections made in the twentieth century, however, allow for closer allocation of more recent styles to particular areas and even to individual carvers. Headrests elaborated with the design motif called *amasumpa* (warts) were particularly associated with Zulu royalty in the nineteenth century and thus would have been restricted to the areas around the heartland of the Kingdom.[4] Given that headrests with *amasumpa* have rectangular rather than horn-shaped legs, there is a strong possibility that Angas's image of a headrest in his portrait of Mpande (King Umpanda) is a piece of colonial intervention and cultural misrepresentation, as he uses headrests of a type made in the colony of Natal to represent cultural practices in the Kingdom.

The Art Institute's headrest corresponds, in part, to the type with the basic structure depicted in Angas's image. A long U- or V-shaped upper section, suggestive of the back and belly of an animal, forms the platform for the sleeper's head. This platform stands on four curved, horn-shaped legs placed at its corners; originally, these may have been given a different, darker patina than the "body." In the Angas image and in examples known from European collections, a design of black triangles or diamonds is marked on the sides of the platform by poker work. The museum's rest is differentiated not only by the absence of this design motif, but more particularly by the addition of two wooden tubular loops that extend from the center of the long sides to join the legs, with all of these elements carved from the same

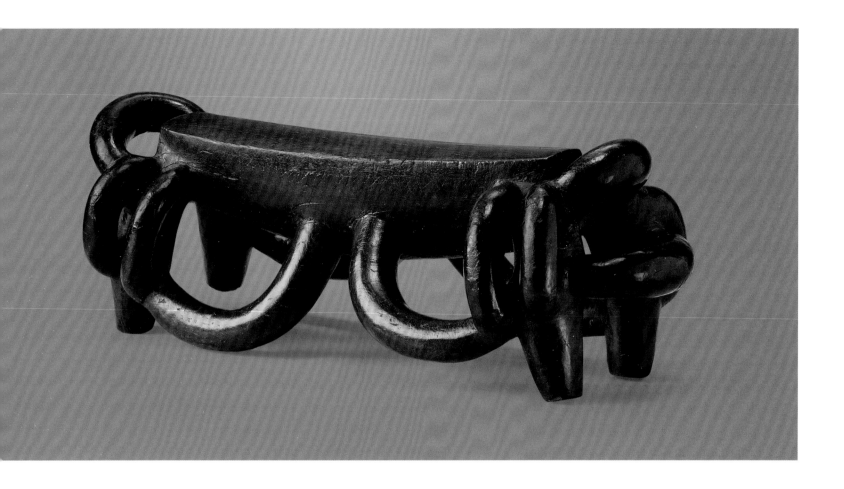

piece of wood. These loops do not have an obvious function and might even have impeded use of the object as a headrest, if it ever was meant for that. Because wooden headrests were used to support a person's head at the base of their skull while lying on their side, the distance between where the shoulder touched the ground and the top of the headrest platform had to be quite closely calculated. The outwardly projected loop extensions on this example increase this distance, which makes it unlikely that anyone could have slept on it unless the dimensions of the loops had been calculated exactly according to the individual's need. The two additional loops on the short ends could have been placed there for the purpose of carrying it. Some Zulu headrests were made long enough to accommodate a person sitting on them, and this example might also have doubled as a seat.

This headrest represents a basic type of some antiquity, albeit usually without the loops. The Ngoni peoples of Malawi and Tanzania mentioned above continued to make such headrests from the late eighteenth century, when they departed from the Zulu Kingdom's reach under Zwagendaba, until the middle of the twentieth. This suggests that the type predated their departure, possibly by centuries. A number of headrests of a type similar to this one were collected in the

2 Headrest (*Isicamelo*), 19th century. Zulu; South Africa. Wood; 21.5 × 55.5 cm (8 ½ × 21 ¾ in.). Private collection, Paris.

early and mid-nineteenth century in the region of Natal and possibly also the Zulu Kingdom or the border area near the Tugela River. Many of these examples show a number of other forms of elaboration on the basic shape, including multiple horn-shaped legs ranged down one side, sometimes carved with engraved lines or joined by axe-shapes or smaller horns.

There are very few known examples with looping extensions like this one. One is in a private collection in Paris (fig. 2). In 1954 the British Museum acquired a very similar headrest as part of a donation from the Wellcome Institute for the History of Medicine, but received little accompanying information about its creation and provenance.[5] Significantly, this donation included a lidded vessel similar to the one in cat. 72, which may have had its origins as a piece carved for display at the 1862 International Exhibition in London. Moreover, it is of the same type as another known to have been carved by an artist in Natal called Unobhadule, discussed further below. The British Museum headrest and the one at the Art Institute share a set of similar loops. However, the loops on the side of the British Museum headrest do not extend as far outward and those on the short ends are arranged differently; it also has a platform split lengthwise into two separate

the headrest had been destined for use as a seat—in which case, having an attached snuffbox or two could have come in handy. It is highly unlikely, however, that the headrest Hawkins depicted was ever used, for most of the objects in the 1862 exhibition were obtained by commissioners tasked with selecting pieces specifically for display. The example shown in figure 3 may have been made by Unobhadule, named as the maker of a number of items in a catalogue of the Natal contribution to the exhibition made by Robert Mann (see cat. 72).[7] Mann was a medical doctor who served as Superintendent of Education in the colonial administration in Natal from 1857 to 1866. He headed the commission for acquisition of material for the 1862 exhibition and apparently was acquainted with the carver, whom he photographed (p. 181, fig. 1). As an isiZulu-speaker, Unobhadule would have had indigenous iconographic and cultural conceptual patterns as his source. But he may also have had more liberty to express his own virtuosity while working for expatriate and settler clients.

Dreaming of the Ancestors

Among Bantu-speaking peoples in Southern Africa, headrests appear to have a shared significance, with different kinds of iconography coming to the fore as one moves from one group of people to another. Among the Nguni groups and some Sotho-Tswana peoples there is an emphasis on bovine images, while some possibly late nineteenth-century headrest forms focus on the homestead; in any case, both kinds of imagery are connected to ancestral shades. These seemingly disparate elements have all become embedded in isiZulu-speakers' ideas about individuals' relationships to homesteads and domestic animals, especially cattle.

IsiZulu-speakers consider sleep and dreams to be a link with the ancestral realm of *abaphansi* (under the earth).[8] One's dreams are sent by ancestral shades, referred to in Natal as *amathongo*, and known as *amadlozi* in the Zulu Kingdom. Ancestors are ever-present in the lives of their descendants and need to be propitiated and kept happy and content. To ignore one's ancestors is to invite trouble, and one of the ways to avoid this is to acknowledge their presence in many tacit ways. The ancestors' ubiquitous presence among the living links them to the dominant iconographic referent of these headrests: cattle. The cattle owned by a homestead belong to that homestead rather than to individuals, and they are thus regarded as belonging also to the ancestors of

parts and a different application of black patina. Like the Chicago example, it may have doubled as a seat, and the styles of the two are similar enough that they probably came from the same district, if not the same carver's hands. It is important to note here that dual functionality is not peculiar to these examples. Moreover, headrests of this type were made within the context of particular cultural thought-patterns and carried their iconographies within their design DNA, as it were, even when they were made for external consumption or featured particular stylistic deviations.

We have further evidence that headrests of this type were related to examples commissioned for, or in some way connected with, the 1862 International Exhibition: drawings made by Louisa Leila Hawkins in a manuscript for the English banker and collector Henry Christy, whose collection was donated to the British Museum in 1867.[6] Hawkins's drawings were framed as "gleanings" of design from "aboriginal" ornament on some of the objects from various parts of the British colonial empire that were displayed in the exhibition. She clearly admired the works and in some instances, her watercolor drawings can be matched with specific objects in the British Museum collections. One drawing represents a headrest of the same type as the examples discussed above, but with horn-shaped legs joined by round bars and two loops at each of the short ends (fig. 3). This example also had a lidded egg-shaped vessel on each end. These were decorated with the same ridged designs that can be seen in the freestanding lidded bowl already mentioned (cat. 72). The function of such vessels is rather mysterious unless

3 Louisa Leila Hawkins (British, 1841–1880), "*Isicamela* ('Zulu' Headrest)." Watercolor; 23.7 × 33.3 cm (9 ⁵⁄₁₆ × 13 in.). In Hawkins 1862, plate 14. Ethnography Department, British Museum, London, No. Am2006,Drg.72.

the homestead. One cow is singled out from the herd for its strength, beauty, fertility, and milk-yield, and is named the *inkomo yamadlozi* (cow of the ancestors). This animal cannot be slaughtered without the consent of its owners and thus can never be killed; upon its natural death, it is replaced by another specially chosen cow. An additional cow associated with the ancestors is the *isigodo*, an animal that traditionally accompanies a bride from her father's homestead to her husband's, where it provides milk for her consumption. Because it is associated with the bride's lineage, the *isigodo* also must be looked after until its natural death.

Nguni cattle have a very particular place in isiZulu-speakers' lives. Because isiZulu-speakers understand cattle to have a gestation period similar to that of humans, they draw a parallel between the two species: a herd is equated with a polygamous household. Similarly, Zulu men are credited with or claim a form of masculinity aligned with the characteristics of bulls, which is given expression in dance styles and praise-poems.[9] Cattle are judged to be beautiful on the basis of their coloring and relatively long, symmetrically curved horns of even length. Because beautiful cattle are thought to please the ancestors, they are the ones chosen for ancestral sacrifices. The horns of sacrificed cattle would be tied to the thatching of the traditional dwelling (*indlu*) above the crown of the doorway arch (*ikhothamo*). Ancestral shades are said to survey their descendants from this arch, and to communicate with them by means of a particular whistling. Cattle horns are commonly used by healers (*isangoma*) as containers for medicines and powerful substances, and may also be kept in the interior roof thatching of the healers' dwelling.[10]

It is thus understandable that there should be an emphatic reference to the bovine in so many Zulu headrests. While this particular example makes a relatively subtle allusion, it is nevertheless present, particularly in the horn-shaped legs. The inverted V shape created by these legs, when seen from the short end with the V shape of the platform between them, is reminiscent of the shape created by the skulls and horns of sacrificed beasts hung on the reed and wooden fencing of cattle byres in isiZulu-speakers' homesteads. Such praxis is said to act as a reminder—either to the living, of a particular event that required the sacrifice of an animal, or to the ancestors, of the requests involved in that sacrifice. The inverted V shape is also a visual echo of the arched doorway to the dwelling in which a person's ancestral

shades are said to reside, and from which they whistle. Finally, since dreams are said to come from ancestors, the person sleeping on a headrest that recalls the importance or the act of ancestral veneration would have a support that visually and metaphorically recalled this particular bond.

Ostentatious Coiffures and Enchanted Headrests

The addition of loops on this particular example appears to place it in a context in which the admiration of individuality and virtuosity is as important as the functionality of the object. It is an expression of an aesthetic impulse also evident in all but the most rudimentary of isiZulu-speakers' and others' headrests (and wider material culture), and in traditional isiZulu-speakers' customs of dressing their hair. Married men and women had prescribed hairstyles that followed different patterns in different regions and also changed over time. But Mann photographed people wearing a number of different hairstyles, some of which were displayed in the 1862 International Exhibition and were listed in the catalogue: men with headrings kept close to the skull, others with headrings

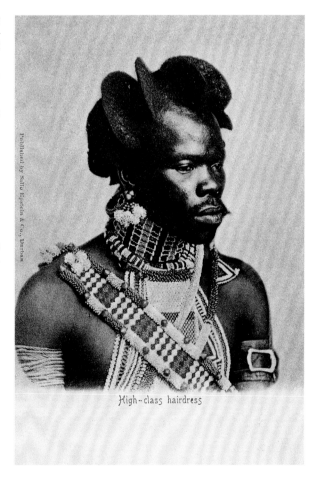

4 Aegidius Müller (South African, 1853–1921). Studio portrait of a Zulu man, Mariannhill Mission, KwaZulu-Natal, South Africa, 1890–1900. Albumen print; 22 × 15 cm (8 ¹¹⁄₁₆ × 5 ⅚ in.) Private collection. Both the hairstyle and the beadwork confirm that the subject of this portrait came from Natal. This essentialized image of a man identified as Zulu was reproduced in numerous forms including postcards.

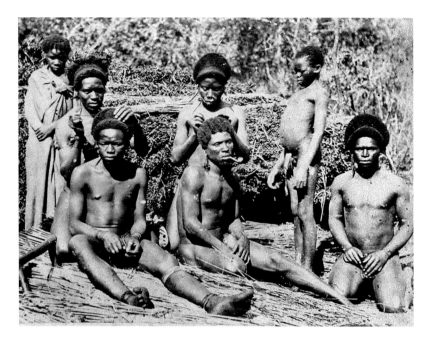

pages of *The Illustrated London News* in 1879; others were documented in photographs, the most famous of which is reproduced in figure 4.[13] These coiffures were sculptural creations of impressive dimensions, which indexed the need to keep hair under control, albeit through a form of ostentatious excess. They, too, would have needed some form of support during sleep. When an unknown photographer recorded a group of these young men dressing their hair, the image included a branch headrest, suggesting that the subjects did not have the resources for expertly crafted ones (fig. 5). Beautifully carved headrests constituted prestige items within isiZulu-speaking communities and would have had particular meaning for individuals.

The isiZulu word *isithunzi* describes a concept encompassing the personality and appearance of a person as determined by his or her lineage as well as his or her status as living or dead.[14] It is also very closely linked to a living person's shadow, reflection in a mirror, and, more recently, appearance in a photograph. A standing person will cast a shadow that moves with them and diminishes to almost nothing when she or he is recumbent on a sleeping mat. Ancestors communicate with the living via dreams, while in death the *isithunzi* departs to join the ancestors. Anthropologist and academic Harriet Ngubane argues that there is incipient danger in darkness, and that because "sleep is *ubuthongo*, and the ancestral spirit is *ithongo* ... Sleep is like a miniature death."[15] But a head resting on a headrest may cast a shadow that defuses the potential dangers associated with darkness, the absence of a shadow, and death.

The associations linking sleep with darkness, nighttime, and death may also find expression in the way that red and black are often combined on headrests. Sculptors have used a variety of woods, creating some headrests that are much heavier than others and clearly not meant to be moved around. Many headrests are patinated by the carver with poker work: parts of the headrest, most often the legs, are blackened by first burning them with a hot poker and then polishing them with some form of grease. Ngubane reports that black is associated with the realm of the ancestors, and that dark colors such as red belong within the same spectrum of relative danger.[16] When an object treated in this way has been used for some time, the black starts to wear away and expose the original color of the wood. In Hawkins's illustration of the example from the 1862 International Exhibition, the whole headrest and its two

allowed to grow upward to form a kind of crown.[11] The headring itself was fashioned from a vegetable wax placed on the crown of the head, with the hair stretched over it and sewn into place. In the Zulu Kingdom men were not allowed to wear a headring until they had completed their military service in the king's age-grade regiments, a practice probably common in earlier, smaller isiZulu-speaking polities. This was also the point at which men reached marriageable age. Married women were similarly required to manage their hair, either by arranging it in a knot on top of the head or, later in some areas, by stretching and sewing it over a basketlike frame. The shape and length of the topknot varied, as did the circumference and flaring of the basket-frame forms. The latter was eventually replaced by cloth-covered hats of the same shape.[12] While such coiffures remained affixed to the wearer's head, there was no possibility of sleeping with one's head nestled onto a pillow, or even on the ground. These hairstyles represented an investment of time and resources, and they would be damaged by such treatment. So a structure that fit at the nape of the neck, supporting the head at its base and allowing the hairstyle to remain elevated above the ground, was imperative.

Younger members of isiZulu-speaking communities had somewhat more freedom in dressing their hair, and this was carried to extremes by young men in the vicinity of settler towns in Natal, especially those who found employment as letter-carriers running between towns. These young men affected extraordinary hairstyles. Some appeared as illustrations of so-called "Zulu Dandies" in the

5 Unknown artist. "Young Zulu Men Dressing Their Hair," c. 1875. Albumen print. Private collection. Note the tripod branch headrest at the far left.

attached bowls were treated in this way and are matte black all over (fig. 3). But the black poker work appears to have been confined to the legs and part of the extended loops on the Art Institute and British Museum examples. The platforms of both retain the original color of the wood, suggesting that black was not used there because a living person's head would lie on the headrest during sleep. The parts of the headrest that have direct contact with the earth or ground and what lies below and around it (*abapansi*) are black, reinforcing their position as the connectors between the realm of the ancestors (*amadlozi*) and that of the living.

Thus, the Art Institute's headrest, whether or not it was actually ever used by someone to pillow his or her head, raising it above the ground in sleep to make a shadow, can be seen as a statement about indigenous isiZulu-speakers' relationships to the ancestors and to the wider world. The carver of this particular headrest based it upon traditional forms but also interpreted them creatively. Like many other extraordinarily intricate headrests, vessels, and staffs that made their way from Natal to European and, later, American international exhibitions in the nineteenth century, this one displays both virtuosity and an inventive approach. Knowing that this object is carved from a single piece of wood, using simple indigenous tools, enhances our appreciation of the maker's skill. In the words of anthropologist Alfred Gell, it results in an "enchantment."[17]

1 See Nettleton 2007, 246–73, for a discussion of the types of neck- and headrests common in the region.

2 For discussion of the complexities of cultural contexts in the region, see the essays in Hamilton and Leibhammer 2015; and Klopper 1992.

3 For some of this history see the essays in Carton, Laband, and Sithole 2008.

4 See Klopper 1991.

5 British Museum, London, AF1954,+23.1841. The object's elaborate loops can be viewed from multiple angles on the British Museum website; see britishmuseum.org/collection/object/E_Af1954-23-1841.

6 Hawkins 1862.

7 Mann 1862. See also cat. 72 in this volume.

8 Much of my information about the isiZulu understanding of the world is drawn from Berglund 1976; and Ngubane 1977. It has been augmented by reference to other ethnographic writing and my own interviews with a number of isiZulu-speakers over the past twenty years.

9 See Clegg 1981.

10 It must be noted that while many of these traditions continue into the present, living conditions have changed so that very few people now dwell in grass structures, or even in thatched ones. So the present placement of cattle horns in the homestead of even rural dwellers does not necessarily correspond to this description.

11 Mann 1862. Some of these images are discussed in more detail; see Guy 2014, 165–69.

12 Such hats are now often worn as fashion items by ethnically conscious isiZulu-speaking women, and informed the designs for some of the headgear seen in the 2018 film *Black Panther*.

13 See *The Illustrated London News*, June 7, 1879, 88. See also Klopper 2016.

14 Berglund 1976, 85–88.

15 Harriet Ngubane discusses this in the context of the use of dark and light medicines; see Ngubane 1977, 117.

16 Ngubane 1977, 115.

17 Gell 1992, 40–63.

69 Figure Posts

Kwere
Tanzania
Early to mid-20th century
Wood and chalk
H. 259.1 cm (102 in.)

Restricted gift of Terry E. and
Cynthia Perucca, 2006.128.1–2

Provenance: James Stephenson
African Art, Brooklyn, NY, from 2003;
sold to Gary van Wyk and Lisa
Brittan, Axis Gallery, New York, by
2005; sold to the Art Institute, 2006.

1 Full-length
view of figure
posts (cat. 69).

Wooden sculptures of this large scale by East African carvers are not widely represented in museum collections, and very few details are known about these tall posts in the Art Institute's collection (fig. 1). They are attributed to the Kwere of eastern Tanzania, who share overlapping characteristics with many neighboring matrilineal groups in the region but are especially aligned with the Zaramo and Luguru cultures. According to oral tradition, Kwere and Zaramo clans actually originate with the Luguru; their remarkably analogous social structures support this scenario.[1] Scholars also find comparable similarities in the clans' artistic and ancestral traditions. Artists from all three cultures carve wooden figures usually known as *mwana hiti*, which take various forms. Among the Zaramo, *mwana hiti* carvings are typically small (about four to six inches tall) with breasts and a bifurcated hairstyle. They function as ritual objects and teaching tools and are attached to musical instruments, furniture, or ancestral markers in the form of grave posts.[2] Although the Kwere posts seen here differ in significant formal aspects, it is logical to consider them within that broader category of post-like carved wooden forms scattered all over eastern Africa. They may well serve similar purposes. Primary examples from that corpus include posts of the Bongo (Sudan) and Sukuma (Great Lakes region, Tanzania); *vigango* markers by Mijikenda artists (Kenya); *waga* grave figures of the Konso (Ethiopia); and the *aloalo* stelae of the Mahafaly (Madagascar).[3]

Like those of many *mwana hiti* figures, the facial features on these posts are only lightly suggested, save the prominent square nose and the double-pointed, upward-curving hairstyle, both of which are typical of Kwere carving styles.[4] It is not clear whether the stacked circular disks and carved triangular patterns at the top of these posts are merely decorative or if they are meant to represent jewelry, clothing, or even folds of skin, or if the

number of rings on each post is symbolic. Such carvings may not be overtly personalized or individualized because, in addition to acting as grave markers, *mwana hiti* and similar sculptures could also stand as a monumental offering or act as a placeholder for unknown ancestors and spirits.

We should also consider the possibility that these posts were not intended as markers at all, but were designed as conventional objects of architectural adornment. In times of trouble, the Kwere built spirit structures at crossroads as offerings to ancestral spirits that had been angered in some way; for the same purpose the Luguru and the Zaramo built small spirit houses and larger structures with round roofs supported by a circle of wooden posts.[5] Although they are not figurative, center posts and doorframes carved by Swahili artists can be found throughout East Africa and are also worthy of comparison. Their ornamental and geometric surface designs were transmitted widely via exchange networks inland of the Indian Ocean, and regional carvers shared techniques and motifs across cultures and forms.[6] Finally, these posts may also be understood within the scope of meanings and uses attached to prestige staffs carved for diviners, rulers, and elders throughout eastern and southern Africa.[7]

Janet M. Purdy

1 Brain 1962; and Mshana 2013. **2** Felix 1990; and Mshana 2013, 140. **3** For references to many of these carving traditions, see Jahn 1994; and van Wyk 2013. **4** See especially the Kwere post in the collection of the Royal Ontario Museum, Toronto; van Wyk 2013, 141, fig. 4.5. **5** Brain 1962, 238–39. See also Pelrine 2014. **6** For similar considerations, see Sieber 1986. **7** Dewey 1994.

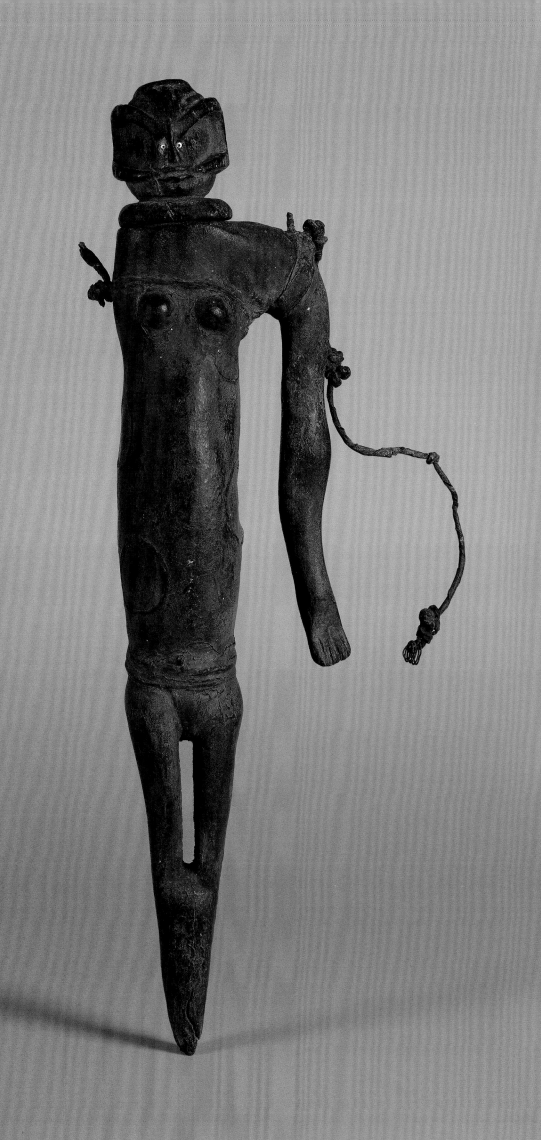

70 Figural Container

Zigua or Mbugu
Usambara Mountains region, Tanzania
Late 19th or early 20th century
Wood, leather, glass beads, and
sacrificial material
H. 52.1 cm (20 ½ in.)

Charles H. and Mary F. S. Worcester
Collection and Edward Johnson funds,
2007.347

Provenance: James Stephenson
African Art, Brooklyn, NY, from about
2004; sold to Gary van Wyk and Lisa
Brittan, Axis Gallery, New York, by 2007;
sold to the Art Institute, 2007.

1 Postcard show-
ing a woman wearing
a *saif malik* mask,
Muscat, Oman,
c. 1905. Photo by
A. R. Fernandez.
Private collection.

In northeastern Tanzania during the nineteenth and twentieth centuries, sculptures like this one were created primarily for divination, protection, and medicine practices, a tradition that registers in their forms. For example, standing figures were posted at crossroads or building entrances to ward off trespassers or to dispel maleficent spirits.[1] The legs of this carving join to form a point at the base so that it could be pounded into the earth, where it could tap terrestrial powers directly. As part of traditional healing arts, ritual specialists activate such containers and similar objects, harnessing ancestor and spirit forces in order to counteract individual or community maladies. This carving may represent Mphepo Mzuku, an ancient spirit and benevolent force linked to sacred spaces where ancestors rest.[2] The Zigua believe that Mphepo Mzuku and other woodland spirits with missing appendages also possess malevolent powers to cripple or deform victims.[3] The figure's distorted body elements, missing arm, unusual mask-like outline of the eyes, and circular mark-ings on the torso—possibly scarifications—might serve as evidence of negative external forces or disease at work. Kathleen Bickford Berzock sug-gests that the circles might represent open sores.[4] Materials poured over or attached to a container— here, the knotted cords tethered to the arm and upper chest as well as the leather wrapped tightly around the lower torso—define or embody ele-ments of the spirit or affliction represented.[5]

The wooden figures carved by the Zigua and other groups were not typically hollowed for use as vessels, like this one that doubles as a medicine container; healing experts would more commonly store herbal extracts and powders in calabashes or animal horns.[6] It is understood, however, that an object carved from the wood of a sacred tree or significant site is endowed with spiritual energy that elevates the efficacy of the materials it holds or touches—so a vessel used in this way makes

a certain metaphorical sense.[7] The carved head is a removable stopper for the container, with a longer coned portion hidden inside. Such stoppers are used throughout eastern Africa to dispense, extract, or apply substances, and their sculptural forms are often customized to reflect an individual patron or purpose.[8]

In earlier centuries, Zigua peoples were sig-nificant participants in coastal and inland trade networks. Imported white European glass beads inserted as eyes are thus another standard feature of such sculptures made in the region. Over time these cultures absorbed aspects of Christianity and Islam as part of their traditional belief systems.[9] Their artistic imagery reflects this intermixture, as do the rites employed to counteract religious, cul-tural, and political infringements. In this example, the frame-like lines around the eyes could represent the *saif malik* mask worn by some Swahili women or women from Oman, functioning as a visual ref-erence to regional slave traders (see fig. 1). Diviners among the Zigua and closely related Pare are still known throughout Tanzania to be extremely knowl-edgeable and powerful in spiritual traditions, and are often sought for help.[10]

Janet M. Purdy

1 Beidelman 1967, 72. **2** B. Thompson 2013, 161. **3** Beidelman, 1967, 71; B. Thompson 2013, 161; and Berzock 2008, 12–13, 94.
4 Berzock 2018, 12. **5** B. Thompson 2004, 29. **6** See, for example, Zigua/Pare medicine horns pictured in Jahn 1994, 196–97, figs. 103–5. **7** Personal communications with Tanzania elders, 2016– 19; and Studstill 1970, 119–37. **8** Dewey 2009, 232. **9** Beidelman 1967, 66; and Stuhlmann 1910, 270. **10** Personal communications with Tanzania elders, 2016–19; and Beidelman 1967, XIV.

71 Helmet Mask (*Lipiko*)

Carved by Diteka (active mid-20th century)
Makonde
Tanzania or Mozambique
Probably 1930s–1950s
Wood, human hair, and pigment
Inscribed "Wakugonga Diteka"
H. 26 cm (10¼ in.)

Through prior bequest of Florene May Schoenborn, 2017.106

Provenance: Arman (Armand Pierre Fernandez; died 2005), New York, by 1984 [see Rubin 1984, 1: 39]; by descent to Corice Canton Arman, New York, 2005; sold to Galerie Jacques Germain, Montreal, 2016; sold to the Art Institute, 2017.

This striking sculpture with its carved rendering of chipped teeth is distinguished by the engraved signature in Kiswahili behind the sculpture's proper right ear: *Wakugonga Diteka*, meaning "The Carver [literally, 'the Striker'] is Diteka." The boastful claim may indicate that it was carved at the time of labor immigration between 1930 and 1950, in the region then called the Tanganyika Territory (now part of Tanzania).[1] Although this helmet mask was likely made in Tanzania, it is in the style typical of the Mozambican Makonde, which differs substantially from that across the border despite the cultures' shared name.

The mask was probably carved from the soft, lightweight wood of the tree species *Swartzia madagascariensis*. Incisions evoke the scarification marks that, on real people, served as signs of both beauty and endurance, and were also seen as markers of cultural affiliation and belonging. The asymmetrical hair patches on the skull imitate the once popular practice in which young boys shave their hair at the end of their initiation seclusion. The black or dark brown color of the painted surface of the mask indicates this is a male character; female examples were typically painted yellow or pale orange. Repeated application of oils and resins contributed to the wood's shiny surface.

Due to the impact of Islam, the Tanzanian Makonde traditions largely belong to the past, while Makonde in Mozambique have preserved many of their cultural and artistic practices, including making and dancing with helmet masks (see fig. 1). They are known locally as *mapiko* (sing. *lipiko*) and represent ancestral spirits or so-called living dead, who temporarily return to earth and appear in dance choreographies that accompany the initiation rituals of adolescent boys and girls. More specifically, young men dance with them during the closing ceremonies that celebrate the end of a period of seclusion for the newly initiated.[2]

Constantine Petridis

1 A *lipalipanda* player and a *lipiko* masquerader entering the village of Matambalale, Mozambique, 2004. Photo by Alexander Bortolot.

1 I thank Paolo Israel from the University of the Western Cape, South Africa, for helping us transcribe and translate the inscription on the mask's cheek; email message to author, Apr. 6, 2017.
2 The information summarized in this entry stems primarily from Bortolot 2007. For more general information on Makonde art in Tanzania, see esp. Blesse 1992.

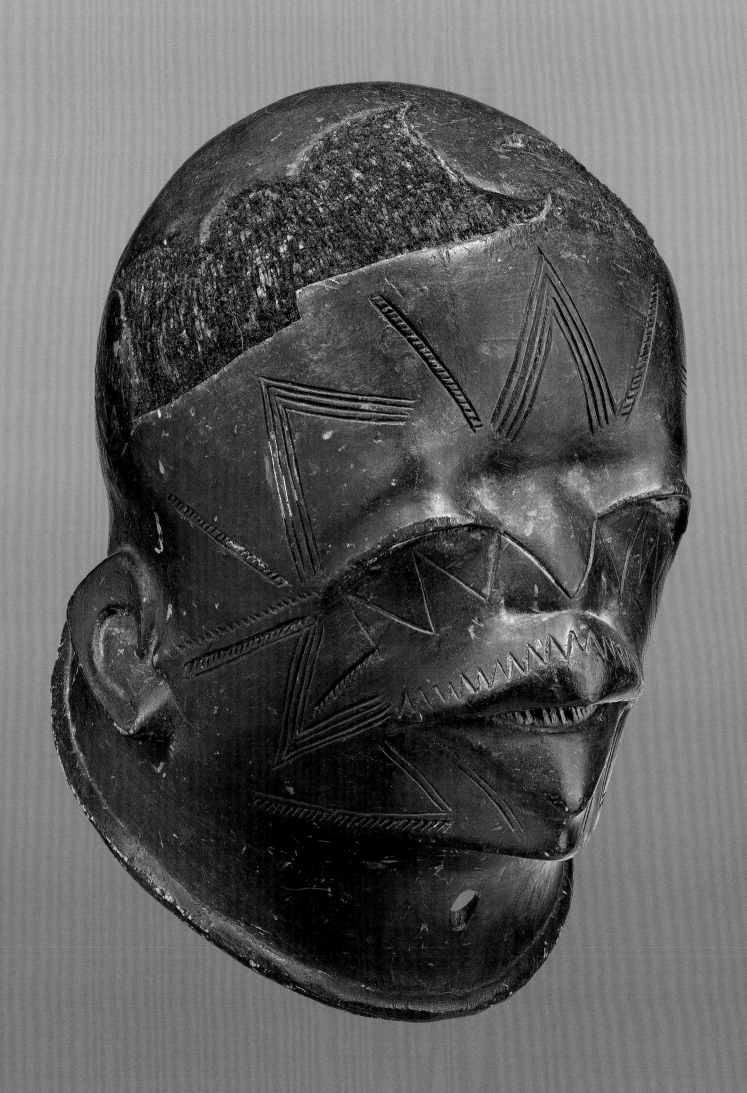

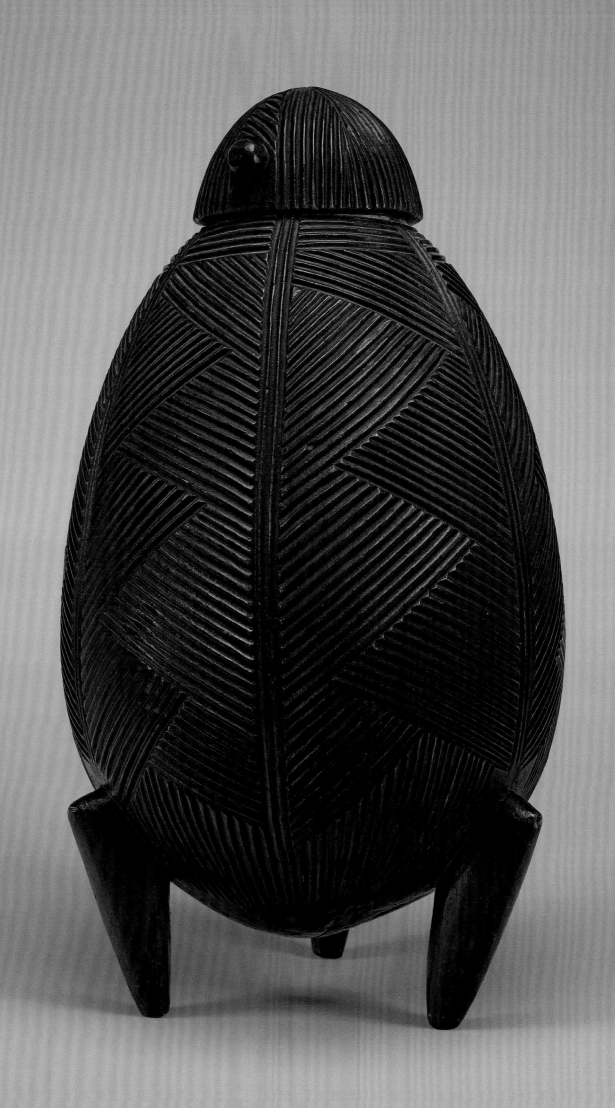

72 Lidded Container

Attributed to Unobhadule
(active mid- to late 19th century)
Northern Nguni
KwaZulu-Natal, South Africa
Mid- to late 19th century
Wood
46 × 27.9 cm (18⅛ × 11 in.)

Ada Turnbull Hertle Fund, 1979.539

Provenance: Merton Simpson (died 2013), Merton D. Simpson Gallery, New York, before 1979; sold to Linda Einfeld (later Linda Sigel), Linda Einfeld Sigel Primitive Art, Chicago; sold to the Art Institute, 1979.

1 Robert Mann (British, 1817–1886). "Unobadula (Unobhadule), the Wood Carver," c. 1862. Campbell Collections, University of KwaZulu-Natal, Durban, South Africa, a74-006, Album a74-001-036.

This vessel belongs to a set of carvings in a style that possibly originated with a single artist named Unobhadule (fig. 1; see also p. 170). He is said to have carved a number of objects displayed in the International Exhibition of 1862, which was held in London.[1] One of these, a vessel that Henry Christy, an English banker and collector, acquired and donated to the British Museum before 1867, is extremely similar to the Art Institute's example.[2] The two share egg-shaped bodies, each supported by a set of three small tapering legs, with finely gouged parallel grooves grouped in triangular sections covering both the body and the neatly fitting lid with a small knob on one side.

These vessels are part of an even larger set of objects including additional vessels, some headrests, and possibly a meat platter, all of which have similar fluted surfaces. The round vessels—ranging from globular to egg-shaped—are the most numerous but can be subdivided into groups according to the degree of elaboration of their legs and handles. One of the most elaborate vessels, with surface decoration very similar to the Art Institute's example but with multiple additional projecting loops, appears in a photograph of Unobhadule taken by British colonial administrator Robert Mann (fig. 1). This portrait was exhibited with others by Mann of isiZulu-speaking subjects at the International Exhibition of 1862, so the vessel he is shown holding must have been made earlier.[3]

The photograph of Unobhadule thus establishes not only a date before which this carver had been making his extraordinary works, but also that Unobhadule was an isiZulu-speaker, as evinced by his wearing an *isicoco* (headring) on his head.[4] It is possible that Unobhadule initiated the elaborate surface and sculptural design of such lidded vessels, but also that he was not its sole exponent, as there is a good deal of variation in the evident level of skill used to execute objects in this style. He is recorded by Mann as a "famous artist," possibly living within reasonably easy reach of the settler town of Pietermaritzburg in the Natal colony. While Unobhadule was famous enough among settler patrons for his name to be recorded, his status among his Indigenous community is not known.

Like all the others in the same style, this vessel shows no signs of use, although it has been surmised that they functioned as containers for milk or tobacco, and/or as vessels for water and washing.[5] Virtually all known examples have been recovered from collections in Europe; no direct record exists of their use among isiZulu peoples. They are feats of virtuoso carving: each was made from a single piece of wood and elaborated in a style that recalls the carving on small snuffboxes in horn and wood from the same region.[6] That so many survived is testament to the fact that they were highly prized by their European colonial collectors.

Anitra Nettleton

1 Mann 1862, 18. See also the discussion of Mann in this volume, p. 170. 2 See the British Museum, London, Af.1559.a. 3 Another example of this more elaborate vessel type is also in the British Museum, London, received from the Wellcome Institute for the History of Medicine (Af 1954,+23.570.a–b). 4 This was first noted in Weinberg 2015. 5 For a discussion of the functions of these sculptures, see Nettleton 2018. 6 See Nettleton 2012.

73 Snuff Container

Northern Nguni
KwaZulu-Natal, South Africa
Possibly mid- to late 19th century
Cattle horn, copper, brass, and iron
6 × 40 cm (2⅜ × 15¾ in.)

African Decorative Arts Fund, 2018.5

Provenance: Jean-Pierre Laprugne, Paris, by 1997; sold to David Petty, London, from 1997; sold to Kevin Conru and Anna Conru (born and later Anna Bennett), Brussels, by 2002; Anna Bennett (previously Anna Conru), Brussels, from 2009; consigned to Dori Rootenberg, Jacaranda Tribal, New York, 2017; sold to the Art Institute, 2017.

Cattle occupied a central place in the economic and symbolic universe of the Nguni-speaking peoples of southern Africa.[1] This snuff container references this universe in a number of ways: the materials used, its function as a container, and the arrangement of its constituent parts. First, it is made of cattle horn, thereby invoking the animal directly and the metaphysical potency of horns more generally. Horns from cattle and some antelopes were used by traditional healers as containers for powerful substances as well as for snuffboxes. Introduced into the southeast African region by European trade from the 1600s onward, snuff was used in a number of ways by most Indigenous peoples, including as offerings to ancestors or to guests and as interpersonal gifts. As snuff had particular physiological effects—clearing the head, or making one somewhat light-headed—it was often used, particularly by diviners, before communicating with the ancestors. In some instances snuff itself might be used as an offering. Snuff was also central in social exchanges, governed by etiquette in which the person who had snuff would share it with those who might ask for it, rather than actively offering it. In accepting snuff, as in all such interactions, the recipient had to exercise caution, guarding against the possibility that tobacco offered by another might have been "doctored" in some way. Nevertheless snuff was highly valued, placed in a variety of different kinds of containers whose aesthetic elaboration could take a number of different forms.

The fine ridges carved on the main central tube conform to a style used for horn and wood snuff containers across southern Africa in the nineteenth century (see, for example, fig. 1).[2] IsiZulu-speakers admired straight and even growth of the horns, and preferred it on the cattle they considered worthy of sacrificing to the ancestors; the two horn-like extensions to either side of the central

1 Snuff Container, 19th century. Southern Sotho; Lesotho. Horn and wood; 14 × 3.5 cm (5 ½ × 1 ⅜ in.). Private collection, Brussels. Snuff containers were often made to be worn as pendants; thus, this one has a loop carved at the wide end.

tube can be read as a reflection of this preference. Adult men in isiZulu-speaking communities identified themselves very strongly with the bulls that led their herds of cattle, and a man wearing a snuff container like this one, which could be suspended around the neck with a thong through the metal ring at the top, would have clearly signaled both his adult status and his manly prowess. This prowess, *ubunkuzi*, is particularly vaunted by younger men in both fighting and dancing—but a snuffbox like this one is likely to have been a prestige item owned by a man of means.[3] It is distinguished not only by its fine carving and use of horn, but also by the delicate decorative woven wirework marking the points where the horns meet the body of the container. This spiraling design of different-colored wires follows a pattern common on snuffboxes, staffs, and clubs used as markers of status, and would have acted here as an aesthetic embellishment as well as a means of joining the different parts.

Anitra Nettleton

1 See Berglund 1976, 199–208. 2 A number of these containers are discussed and illustrated in Wanless 1991. 3 For a discussion of this, see Clegg 1981.

74 **The Miracles of Mary (*Te'amive Maryam*): "The Story of Saint Ildephonsus of Toledo,"** 59 verso/60 recto

Gondar, Ethiopia
Late 17th century
Bound manuscript: parchment, ink, tempera, wood, leather, cotton, and string
36.8 × 31.8 × 9.5 cm (14½ × 12½ × 3¾ in.)

Ada Turnbull Hertle and Marian and Samuel Klasstorner endowments, 2002.4

Provenance: Walda Iyasus, Masih Hayla, Lesana Krestos, and Walatta Dengel, Ethiopia, 17th century [original family donors/owners as listed in the manuscript]. Kirubel and Kola Gannat, unknown date after 17th century [secondary owners, as listed in the manuscript]. Ginette Giordana (died 2013), Nimes, France, by mid-1980s; sold to Sam Fogg, Sam Fogg Rare Books and Manuscripts, London, by 1998; sold to the Art Institute, 2002.

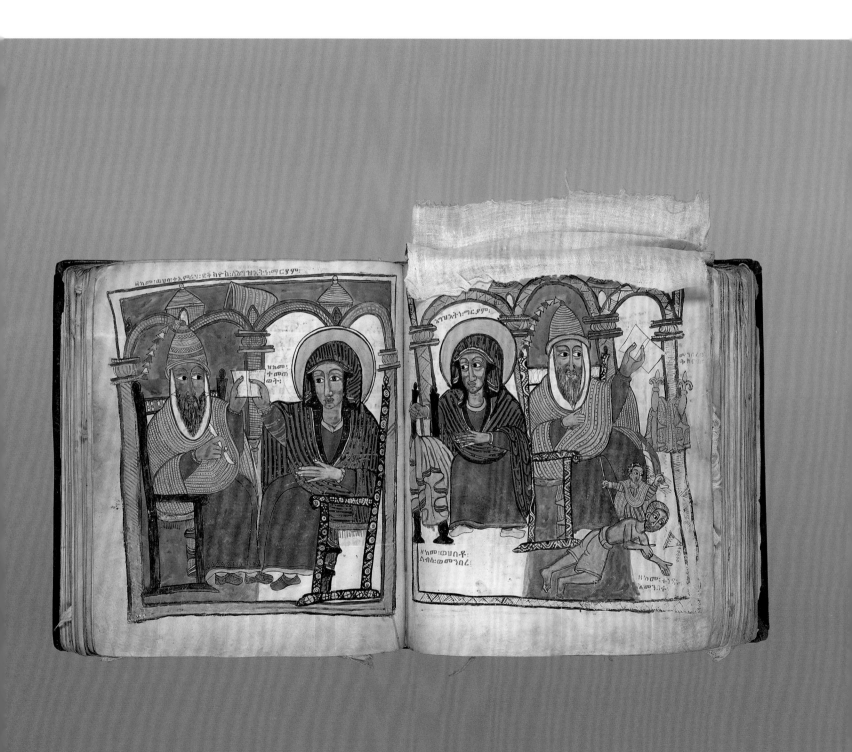

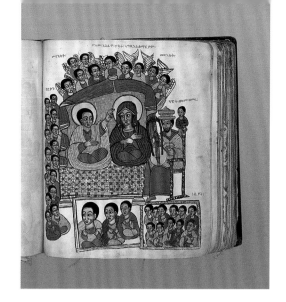

In the highlands of Ethiopia, the present-day practice of Orthodox Christianity can be traced back in an unbroken line to its roots in the fourth century. In the early seventeenth century Christian Ethiopia's first sedentary capital was established at Gondar, a town strategically located at the crossroads of important trade routes. The city quickly became a center for artistic innovation, with workshops producing commissioned artworks including lavishly illustrated books and portable icons for private devotion as well as for presentation to monasteries and churches. Two works in the Art Institute's collection are examples of this medieval production: a manuscript illustrating the Miracles of Mary (*Te'amire Maryam*) and a triptych icon of the Virgin and Child Enthroned. Both highlight the strong thematic focus on the Virgin Mary in the religious arts of Christian Ethiopia during this period. Mary's significance in the church intensified in the mid-fifteenth century, during the reign of Emperor Zara Yaqob, who instituted feast days in her honor throughout the yearly liturgical calendar and integrated readings about her into daily ritual.[1]

This luxurious copy of the Miracles of Mary includes 158 leaves and 72 paintings, all but three of which are full-page.[2] The volume comprises apocryphal tales and texts recounting miracles performed by the Virgin Mary for those who honored her or prayed in her name; these originated in the Levant in the fourth century and traveled from there to Europe.[3] They came to Ethiopia from Egypt in the thirteenth century, and were first translated from Arabic into the classical Ethiopic language of Ge'ez in the fourteenth century.[4] By the fifteenth century the Miracles of Mary had become one of the most popular themes for religious books produced in Ethiopia.[5] Over the centuries the number of miracles credited to Mary by devotees in the region has multiplied into the hundreds.

1 "Christ and Mary Enthroned," cat. 74, 48 recto.

2 "The Covenant of Mercy," cat. 74, 51 recto.

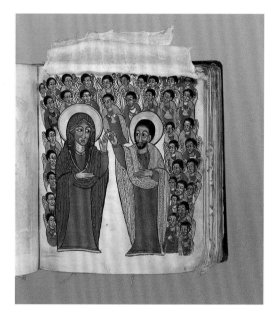

This book was commissioned by a wealthy family to guide and glorify their adherence to the yearly cycle of celebrations in Mary's honor. Its parchment pages, made from goat- or sheepskin, bear the effects of many years of use. The names of the book's original owner and his family were included throughout the text. These were later scratched out and replaced by the names of a subsequent owner in all but one location. The book is one of multiple versions of the Miracles of Mary that were produced in Ethiopia in the seventeenth century. Each shares a similar cycle of illustrated miracles and related texts, and it is likely that each was modeled on an archetype that was probably created at Gondar.[6] However, the versions are not merely copies. Each shows a personal approach to illustration that reflects the creativity of artists working in proximity and inspired by each other.

The principal text includes 32 miracle stories, each illustrated with a narrative painting in the First Gondarine style, which is distinguished

75 Triptych Icon

Central Ethiopia
Late 17th century
Tempera on linen, mounted on
wood and bound with cord
67 × 74 cm (26⅜ × 29⅛ in.)

Director's Fund, 2006.11

Provenance: Mr. Vesecchi and
Mrs. Mitrano (died 1997), Milan, Italy;
by descent to her son, Andrea Mitrano,
Varese, Italy, from 1997; sold to Sam
Fogg, Sam Fogg Rare Books and
Manuscripts, London, 2005; sold to
the Art Institute, 2006.

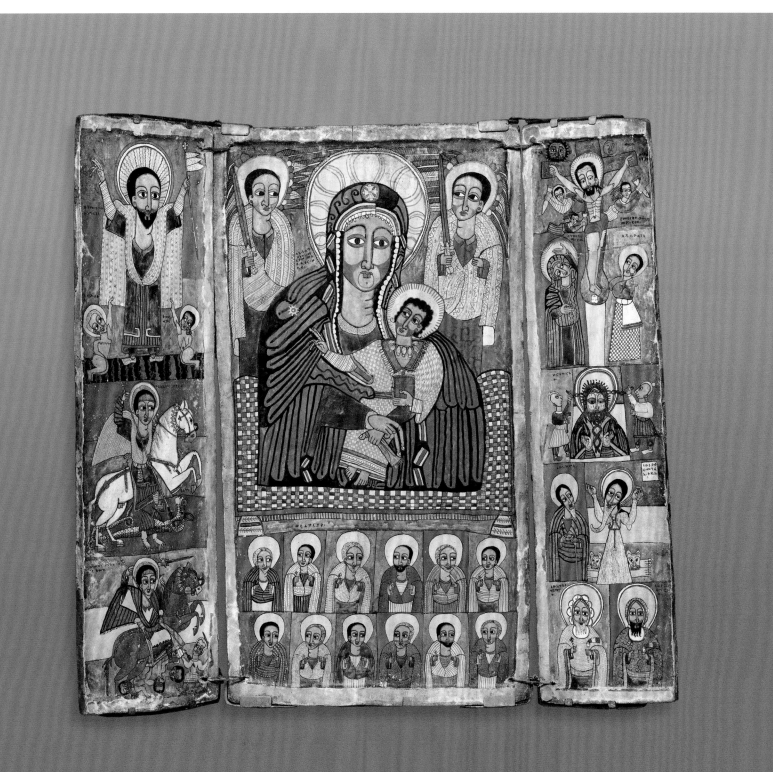

by elongated stylized faces and figures; schematic shadowing and rhythmic decorative patterns; a restrained palette of red, yellow, blue, and green; and undelineated backgrounds. Prayers, hymns, and three illustrated stories from the Life of the Virgin precede the miracle stories (see figs. 1–2); illustrations of events from the New Testament and scenes of martyrdom follow, filling the remaining pages. The first miracle recounts the story of Saint Ildephonsus of Toledo (see p. 184). Ildephonsus (died 667) is seen on the left writing a treatise in praise of the Virgin, who then appears before him and presents him with a divine robe and throne in honor of his great devotion to her.[7] On the lower right, the archangel Gabriel spears a bishop who tried to sit on Ildephonsus's throne after his death.

When the veneration of Mary became a formal part of church liturgy in the mid-fifteenth century, the production of painted icons honoring the Virgin increased alongside that of manuscripts recounting the Miracles of Mary. This triptych icon of the Virgin and Child (cat. 75) is one of a small group of paintings and manuscripts that may all be by the same artist, as they are painted in a distinct rendition of the courtly First Gondarine style.[8] The triptych's imagery includes several standard themes that reflect seventeenth-century Ethiopia's connections with the wider world. Its central panel features the Virgin and Child flanked by the archangels Gabriel and Michael. Their pose, with Mary holding a handkerchief and Christ blessing her with one hand while holding a book in the other, derives from a painting in Rome's Basilica of Santa Maria Maggiore. Reproduced as a print, it was disseminated throughout the Christian world by Jesuit missionaries beginning in the early seventeenth century.[9] The Jesuits set up a mission in Ethiopia in 1557, and images like this influenced the development of new fashions in religious art, some of which lasted well beyond the expulsion of the Jesuits in 1632.[10] Here the artist has portrayed Mary and Christ with details that situate the figures within an Ethiopian context. Stately Mary sits on an Ethiopian-style bed that is covered with a woven textile and Christ wears a type of cowrie-shell necklace worn by Ethiopian children to protect them from harm.[11] To the middle right of the central image is one called *Kwer'ata Re'esu* (Striking of His Head), which likewise developed in Ethiopia in the early seventeenth century with inspiration from a non-Ethiopian source[12]: it is based on a sixteenth-century Portuguese print depicting Christ Crowned with

3 View of the triptych icon (cat. 75) with side panels closed.

Thorns, which became the imperial icon of the Kings of Gondar.[13] In this Ethiopian rendition of the Passion, Christ's tormentors literally drive nails into his head.[14]

The outer faces of the triptych's side panels (fig. 3) reveal a painting of a hunter pursuing a lion into the forest. The hunter is dressed as a nobleman and bears a spear, sword, and shield. This painting appears to portray a purely secular event and its presence on a religious icon may be unique in Ethiopian art.[15] It is tempting to speculate that this scene of an aristocratic hunt may have been included because the icon was commissioned as an object of personal or family devotion rather than for a large church.

Kathleen Bickford Berzock

1 Haile 1992, 1–2. **2** For more on this manuscript, see Berzock 2002. **3** Belcher 2019, 31. **4** Belcher 2019, 32. **5** Heldman 1993, 73. **6** Heldman 1993, 98. **7** Heldman 1993, 36. **8** There is ongoing debate about whether this group of paintings originated in Gondar or in Lasta, a province to the east of Gondar. See Berzock 2009, 95n6. **9** Chojnacki 2000, 33. **10** This research appears in Kristen Windmuller-Luna's unpublished manuscript "Building Faith: Ethiopian Art and Architecture during the Jesuit Interlude, 1557–1632" (PhD diss., Princeton University, 2016). **11** Grierson 1993, 99. **12** Chojnacki 2000, 38. **13** The location of the icon was unknown, but it was rediscovered in 1983; see Art Newspaper 1983. **14** Chojnacki 1985, 38–39. **15** Fogg 2005, 63.

Babatunde Lawal

"One's Head Is One's Creator":

The Interconnectedness of Word and Image in Yòrùbá Art

Before the twentieth century, an emphasis on Eurocentric theories led many Western anthropologists and art historians to regard the stylized forms of indigenous African art as "primitive" and a failed attempt to imitate nature.[1] Since then, field research has revealed that the general disregard for naturalism in African art was a deliberate choice rather than the result of a technical deficiency.[2] The practice seems to derive from the need to use conceptual forms to encode cultural messages. The glaring misinterpretations in much of the previous scholarship on African art has led a number of Africanist scholars to call for a new approach that emphasizes methodologies derived "from within" the African culture being studied.[3] This is what Rowland Abiodun has done in his landmark book *Yoruba Art and Language: Seeking the African in African Art,* which sheds light not only on form and meaning but also on the interconnectedness of word and image in Yòrùbá culture.[4] For example, *àwòrán*, the Yòrùbá word for a pictorial representation, is a contraction of *à* (that which), *wò* (you look at), and *rántí* (recall—as in, "recall the subject"). In other words, *àwòrán* is mnemonic in nature, because it identifies a work of art as

"a visual construct specially crafted to appeal to the eyes, relate a representation to its subject, and, at the same time, convey messages that may have aesthetic, social, political or spiritual import."[5]

A similar phenomenon is evident in Yòrùbá music, which reflects the tonal nature of the Yòrùbá language. As a popular adage puts it:

> *Bí òwe, bi òwe ni a nlùlù Ògìdìgbó.*
> *Ológbón ni i jo; òmòràn ni imo.*

> The rhythm and lyrics of *Ògìdìgbó*
> wooden drums are proverbial.

> Only the wise can dance to them;
> only the knowledgeable ones can
> interpret them.[6]

Thus, a good knowledge of the language, history, culture, and worldview is bound to enrich one's understanding and interpretation of Yòrùbá art and aesthetics. Scholars should also consult with professional artists as well as the custodians of Yòrùbá oral traditions (such as priests and diviners) when conducting field, archival, and library research. In addition, they must be cognizant of

local epistemologies to understand linguistic nuances. That said, proficiency in the Yòrùbá language alone is not enough. Even Yòrùbá-born scholars need certain research tools and expertise in order to make original contributions to the subject, just as many non-Yòrùbá scholars with a good knowledge of the language now do. My research on word and image in Yòrùbá art has been enhanced not only by field and library research, but also by my role as a participant-observer during public festivals and ritual ceremonies. The fact that I usually conduct interviews in the Yòrùbá language has enabled me to follow up with relevant questions pertaining to the semiotics of form and spectatorship. My theoretical approach combines linguistic, visual, iconographic, contextual, and anthropological analyses, reinforced by the findings of other scholars.[7]

Yòrùbá Cosmology, Religion, and Art

Numbering more than thirty million people, the Yòrùbá inhabit present-day Nigeria, Ghana, the Republic of Benin, and Togo. Most of them live in southwestern Nigeria (see pp. 196–97). Like other African ethnic groups, the Yòrùbá trace the origin of the cosmos to a Supreme Being popularly addressed as Olódùmarè (Omnipresent One), but also called Olórun (Owner of the Sky) and Aláse, the generator of a mysterious power (àse) that sustains the cosmos.[8] They conceptualize the latter as a big calabash (see fig. 1) with two halves (Igbá nlá méjì s'ojú dé'ra won). The top half of the calabash (also called Ìgbá Ìwà, "Calabash of Existence") signifies the heavens and maleness (ako) and the bottom half, the primordial waters and femaleness (abo).[9] Because they consider the "Omnipresent One" too sublime to be approached directly, the Yòrùbá communicate with Olódùmarè through a number of deities (òrìsà), each personifying a natural or cultural phenomenon. Thus Yemoja (also called Ìyá Nlá, the Great Mother, Olókun, Sea Goddess, and other names) exemplifies the primordial waters and motherhood; Obàtálá, creativity; Èsù, communication; Ifá, divination, knowledge, and wisdom; and Odùduwà, divine kingship—to mention only a few.

According to Yòrùbá cosmology, the physical world came into being when Olódùmarè gave Odùduwà a bird and a bag of sand. Odùduwà then descended from the sky, poured the sand on the primeval waters (òkun), and released the sacred bird, which scattered the sand in all directions, eventually creating land and the rivers within it. Shortly afterward, Olódùmarè asked the creativity

deity, Obàtálá, to mold the first human images from clay. The final products turned into living humans after Olódùmarè infused their heads with àse, an enabling power popularly identified with the soul force (èmí) in an individual. The clay sculptures were then placed inside the womb of Mother Earth to be delivered into the physical world as babies. The decision to create humanity was allegedly influenced by Olódùmarè's desire to transform the wilderness below the sky into an orderly estate. Hence, ènìyàn, the Yòrùbá word for humanity, is regarded as an abbreviation of the phrase Àwon-tí-a-yàn láti lo tún'lé ayé se, that is, "those specially commissioned to convey goodness" to the physical world.[10] In effect, the word ènìyàn not only identifies the human body (ara) as a divinely inspired form, but it also implies that the capacity to create and appreciate art is an integral part of humanity, accounting for the aesthetic impulses in the visual and performing arts.

1 Calabash, 19th century. Yòrùbá: Oyo empire, Nigeria. Carved gourd; diam. 24.5 cm (9 ¾ in.). Museum Five Continents, Munich, 18-22-15.

Enlisting the Support of the Òrìsà

A close examination of Yòrùbá cosmology reveals two opposing forces. On the right (òtún) are the benevolent forces, consisting mainly of the òrìsà

and deified ancestors who watch over the interest of humankind by virtue of their human essence. On the left (*òsì*) are malevolent forces known as *ajogun* (warriors) and popularly associated with hardship, diseases, death, and other elements that threaten human existence and well-being.[11] As renowned Yòrùbá scholar and diviner Wande Abimbola puts it, "There is no peaceful coexistence between the two powers. They are always in conflict."[12] Yet they partake of one another's attributes, reflecting the Yòrùbá belief that nothing is so good that it does not have something bad in it, and vice versa. This binary opposition resounds in popular sayings such as *Tibi t'ire la dá'lé ayé* (The physical world evolved out of good and evil) and *Búburú ati rere ni ó nrìn pò* (Bad and good things work together).[13] In other words, the same Olódùmarè created both Babalúayé, the dreaded smallpox deity, and his opposite, Òsanyìn, the herbal deity that cures diseases.

The Yòrùbá dedicate altars to various *òrìsà* for support and guidance through environmental and other hazards. Called *ojúbo* (face of the worshipped), a typical altar contains the sacred symbol(s) of a deity, which may be buried in the ground or kept in a clay pot or carved receptacle (see fig. 2). The content and size of a given altar depend partly on its owner's status, and partly on whether it is for private or public use. Communal altars are usually the biggest. Some altars may include images (*erè ojúbo*) representing supplicants (see cat. 34) while others may include figurative bowls (*olúmèye*) for keeping ritual objects (see cat. 35).

The veneration of two *òrìsà*, Èsù and Ifá, looms large in Yòrùbá religion because of the myth that Olódùmarè gave them special powers (*àse*) with which to protect, guide, and help humanity to fulfill its mission on earth. In his role as the divine messenger, Èsù mediates between opposing forces in the cosmos, frequently using diplomacy to keep them under control. Some ritual staffs portray him as a figure blowing a whistle in order to underscore his role as an arbitrator, monitoring the goings-on in the cosmos.[14] Other staffs have two heads facing opposite directions, to reflect his ambivalent character (see also cat. 38).[15] Still others have four heads facing the cardinal directions to identify him as the guardian of the crossroads. His cognomen, Elégbára (literally, "One Body with Two Hundred Aspects"), refers to his metaphysical capacity to assume different guises (including those of other deities) in the course of performing his cosmic duties; hence his praise-name: *Okùnrin kúkúrú, okùnrin gogoro* (the short and tall one).[16]

2 William Buller Fagg (British, 1914–1992). Altar for Sàngó with different containers, including a rooster-shaped container for storing sacred objects, Ìdòfin, Ìgbàná, Western Nigeria, 1959. Royal Anthropological Institute of Great Britain and Ireland, 400_ WBF. 1959.057.03.

The divination deity Ifá, on the other hand, uses his divine intelligence and visionary powers not only to foretell the future and interpret omens but also to find solutions to various human problems. These powers are evident in his cognomen, Òrúnmìlà, which roughly translates as "Only Heaven Knows the Means of Salvation."[17] Although Yòrùbá diviners (*babaláwo*) use different ritual tools to liaise with the deity, the most popular is a carved wooden tray (*opón* Ifá).[18] It has four basic forms: circular, semicircular, square, and rectangular. The most popular, circular form (*opón ribiti*) (see fig. 3), evokes the Yòrùbá conception of the cosmos as Ìgbá Ìwà, the "Calabash of Existence" with two halves (see also fig. 1). The border of the tray is usually adorned with interlaced patterns as well as human, animal, and mythological motifs, all carved in low relief with a recessed open space in the middle of the tray (called *àárín opón*). The big face at the top represents Èsù, who is flanked by kneeling maternity figures with bowls for offering sacrifices (compare with cat. 34). Below the woman on the right is a hunter holding a crossbow and arrow. Under him is a seated male figure smoking a pipe, another reference to Èsù Elégbára's responsibility as a tracker—tradition requires those lost in the forest to use rising tobacco smoke as a signal for rescuers. Below the pipe-smoker,

directly opposite the prominent human face on the top, is a standing maternity figure. Above her, to the left, is another representation of Èsù as a pipe-smoker. On top of him—completing the circle around the rim—is a priest holding the staff of Òsanyìn (the medicine deity). Carved into the inner border of the tray is a string of cowrie shells (*owó eyo*), once used as currency. Most of the decorative motifs on the tray are expected to convey the human desire for agricultural abundance, divine protection, economic prosperity, fertility, and good health. Because it represents Èsù in his role as the divine messenger and mediator, the big face on the tray must be oriented to look at and interact with the diviner throughout the process (see p. 103, fig. 1).[19] Like the staffs mentioned above, some trays also have four faces alluding to the cardinal directions and to Èsù's role as the guardian of the crossroads.

Communication with Ifá begins when the diviner invokes the deity. He will hold sixteen sacred palm nuts (*ikín*) in one hand and throw them to the other hand four times, recording each throw with one or two dots on the wood-dust (*ìyèrosùn*) inside the recessed middle of the tray (*àárín opón*).[20] This space signifies the midsection of Ìgbá Ìwà and links the terrestrial realm to the celestial, as is implied in the popular saying *Àárín opón nita orun* (The middle of the tray connects with heaven).[21] After creating a set of four markings that corresponds with one of the 256 verses of the Ifá literary corpus (*odù* Ifá), the diviner will recite the relevant verse, which will mention a problem similar to that of the client, and he will then advise the client to follow the solution recommended in the verse. While reciting the *odù* Ifá, the diviner typically uses a carved wooden or ivory tapper/clapper (*ìróké* Ifá) to knock the tray intermittently, implicating Èsù in the process (see cats. 36–37). Since the latter is also known as *Sónsó òbe* (Sharp Tip of the Knife), the tapper is expected to pave the way for Ifá to find solutions to the client's problems, just as "the fish cuts through the deep [with its head]." The *ìróké* Ifá constitutes an important part of a diviner's attire, as the clapper is shaken to acknowledge greetings from friends, neighbors, clients, and fellow priests, and to wish them Ifá's blessings.

The King (Oba) as the Head of the Body Politic

The emphasis on the head (*orí*) in Yòrùbá art reflects the biological importance of the physical head as the seat of the brain (*opolo*), which

3 Attributed to Areogun of Òsì-Ìlorin (Nigerian, c. 1880–1954). Circular Divination Tray (*Opón* Ifá), mid-20th century, probably 1930s. Yòrùbá; Odò-Owà, Òsì-Ìlorin, Kwara State, Nigeria. Wood and pigment; 5 × 45 cm (2 × 17 ¾ in.). The Art Institute of Chicago, Laura T. Magnuson Endowment, 1999.289.

controls the rest of the body. It also hints at the anthropocentric nature of Yòrùbá cosmology and the identification of the Supreme Being, Olódùmarè, as the head of a constellation of deities (*òrìsà*) who act on his/her behalf. Simply put, the head is to the body what Olódùmarè is to the cosmos, and a king to his kingdom: a source of power. This phenomenon is apparent in some of the appellations of Olódùmarè, such as Oba Òrun (King of Heaven), Olú Ìwà (Lord/Head of Existence), and Orísè (Head-Source).[22] While the etymology of the term *òrìsà* is uncertain, there are speculations that it may be a contraction of *àwon tí orí sà*; that is, "beings specially selected by the head (God)."[23] The Yòrùbá perception of Olódùmarè as the "Ultimate Head" of the cosmos also resonates in the popular saying:

Orí ló dá ni, enìkan ò d'órí o;
Orí eni, l'Elédá eni

The Ultimate Head created us;
nobody created the Ultimate Head;
One's head is one's creator.[24]

The last sentence recalls the myth that the Supreme Being breathed the soul force (àse) into the head of the archetypal human image created by the artist deity Obàtálá. In other words, the physical head is no more than the outer shell (orí òde) of an inner head (orí inú) that localizes Olódùmarè's àse in an individual, determining their personality and destiny on earth. Hence the prayer Orí inú mi kó má ba ti òde jé (May my inner head not spoil the outer head).[25]

The primacy of the head in Yòrùbá art is also reflected in the tradition that requires every adult to dedicate an altar to the àse located inside his or her inner head. The tradition continues today in some areas. This altar (ìborí) is cone-shaped and stuffed with charms intended to attract good luck to an individual, if invoked regularly (see fig. 4). It is usually kept inside a crown-shaped container lavishly adorned with cowrie shells (owó eyo) and called ilé-orí (house of the head). The size and ornateness of a given ilé-orí depend on the social and economic status of its owner. Those belonging to chiefs (olóyè) and kings (oba) are understandably the most elaborate in the community and may be adorned with colorful coral beads (ilèkè sègi) as well as cowrie shells. Given his role as an embodiment of the kingdom, a king-elect is subject

4 Altar for the Inner Head (Ìborí) with Container (Ilé-Orí), 20th century. Yòrùbá; Nigeria. Cowrie shells, fiber, cloth, and leather; 35.6 × 22.9 × 22.9 cm (14 × 9 × 9 in.). High Museum of Art, Atlanta, Gift of Bernard and Patricia Wagner, 2008.282a-b.

to certain rituals intended to prepare him for the throne; these vary from one kingdom to another. In some cases, his head would be shaved clean and then rubbed with herbal preparations to increase its metaphysical powers (àse).[26] In others, tradition requires him to worship in the shrines of the principal deities in the kingdom, after which he is expected to choose from two identical closed calabashes placed side by side. One would be filled with beads and other treasures to symbolize peace and prosperity, and the other with broken pieces of swords, arrows, and similar articles associated with hardship, unrest, or warfare. The content of the calabash he chooses becomes an indication of what is likely to happen during his reign.[27] Underlying these rituals is the belief that the fate of a ruler (the head of the body politic) is bound to affect that of his subjects. The last ceremony usually takes place in the market square where, in some kingdoms, a priestess, regarded as the godmother of the king (ìyá oba), places the crown on the head of the new monarch (see cat. 33).[28] Below is an excerpt from one of the ceremonies:

Ìwo Oòduà, nítorí re
Ni èrìnlójó ilèkè se ti òde òrun
rò wá sáyé
Gbogbo Oba tí í dádé lo fún ún
láse láti máa lo adé…
Omo ò re yìí yóò dádé…
Omo ò re yìí yó te òpá ilèkè
Omo ò re yìí yó wo bàtà ilèkè sì esè
Bo si se pe lori Oodua
Béè ni kí adé pé lórí re

Your Highness, Oòduà, it was
because of you
That a variety of beads came
to the earth from the sky
You gave all kings the permission
to wear beaded crowns…
This child of yours will wear a crown…
This child of yours will
carry a beaded staff
This child of yours will
wear beaded shoes
Just as Oòduà wore the
crown for a long time
So too will the crown stay long
on your child's head[29]

According to a popular belief, as soon as it touches his head, the crown will change the persona of a new king. He will no longer be addressed in public by his pre-coronation name, but by the

title that identified his predecessor. Thereafter, custom forbids the king to appear in public bareheaded, but to wear a cone-shaped beaded crown (*adé*) that functions like an *ilé-orí* (see fig. 5). A typical crown has a veil that conceals his face from the general public (see cat. 42), thus transforming the regalia into a kind of mask that identifies the king as *Oba Aláse, Èkejì Òrìsà* (The All-Powerful One, Deputy of the *Òrìsà*)—that is, a surrogate of Odùduwà, the divine ancestor.[30] Costumes and crowns worn inside the palace are usually less elaborate, although still richly adorned (see cats. 43–44).[31] The iconic image of the king also echoes in his palace (*ààfin*), which, before the twentieth century, was the biggest and most decorated building in a given town. Carved wooden posts (*òpó*) and freestanding sculptures (*ère*) usually adorned the facade as well as porches and strategic places in the inner courtyards where the king received and entertained important guests (see cat. 33).[32]

The Significance of the Mask among the Yòrùbá

As in other parts of Africa, the Yòrùbá use the mask for a variety of purposes, ranging from the ritualistic, political, and militaristic to the recreational, satirical, and educational. It is a byproduct of the belief that the human body is a work of art animated by a vital force of soul.[33] Thus, earthly life has two aspects, body and soul. An individual is alive so long as the soul resides in their body. Death occurs when the soul leaves that body, which then becomes a corpse. For the Yòrùbá, however, death (*ikú*) is not the end of an individual's existence but, rather, a dislocation of *èmí* from the body (*ara*) and its relocation to the hereafter (*èhìn ìwà*) where it can stay forever or reincarnate as a baby and return to the physical world (*ilé ayé*) to begin another life in a new body.[34] Simply put, the belief that the body manifests the soul on earth led the Yòrùbá to create a mask (*agò*) to perform a similar function. Since wearing a mask is akin to spirit-mediumship, tradition requires the wearer to undergo a rite of passage to enable his body to perform the task. As Evan Zuesse has observed in his study of African religions, "The spatial universe of the body is absolutely crucial for ritual. Religious meaning is mediated through the spaces ritual establishes for the body."[35] And being a tangible, mobile, and expressive form, the lived body, when transformed into a mask, becomes one of the most effective media not only for dramatizing the African belief in the oneness of the visible

and invisible aspects of existence but also for involving the sublime in human affairs. At the same time, the masked body provides a unique opportunity for creating a multimedia spectacle in which the visual and performing arts combine to project values deemed vital to the social and spiritual well-being of a given community.[36] Consequently, not every Yòrùbá mask is involved in spirit-mediumship. Some may embody concepts and ideals such as courage, leadership, and selflessness in order to promote good citizenship. Others may emphasize satire purely to entertain or educate the public and, in the process, persuade antisocial community members to turn over a new leaf (see, e.g., cats. 39–41). By and large, such is the spiritual, cultural, political and aesthetic significance of art among the Yòrùbá that it is inseparable from life in the culture.

Envoi

Unfortunately, the mass conversion of many Africans to Islam and Christianity between the late nineteenth and early twentieth centuries precipitated the destruction of many shrines or the sale of their contents to local and foreign art collectors because of their association with paganism. European colonization of much of the continent during the period resulted in the establishment of new art schools by the colonial administration. These institutions emphasized European-type realism designed to replace the ancient African preference for conceptual forms then deemed "primitive" in Europe. Yet the new development did not totally eradicate indigenous African art and aesthetics, especially in villages far from urban areas. For the same colonial period, paradoxically, witnessed a paradigm shift in Europe. No longer content with mimetic representations, some radical European artists began to search for other forms of expression. In the process, they found new inspirations in the stylized or conceptual forms of the so-called "primitive" art of the non-Western world, especially African sculptures and masks. The formal experimentation that followed the encounter gave rise to Modernism in Europe, inspiring prominent artists like André Derain, Pablo Picasso, and Maurice de Vlaminck, among others, to abandon naturalism in favor of conceptual forms and abstraction.[37]

Thus, while traditionally trained Yòrùbá artists in the highly urbanized areas lost many of their local clients, they found new ones in the international market created by the influence

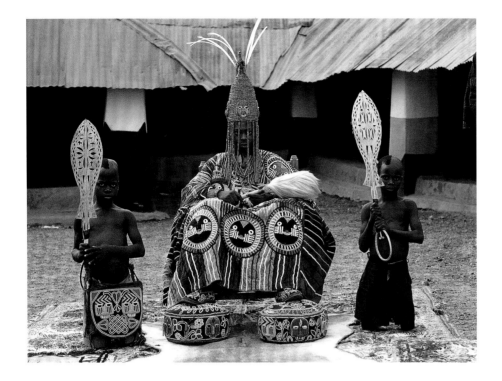

5 Eliot Elisofon (American, 1911–1973). The king (*deji*) of Àkúré in full regalia, Àkúré, Nigeria, 1959. Eliot Elisofon Photographic Archives, National Museum of African Art, Smithsonian Institution, Washington, DC, EEPA EECL 2071.

of African art on Western Modernism. Many of the works discussed in this publication left their original contexts during this period. But no sooner did Nigeria gain political independence from the United Kingdom in 1960 than the new government began to preserve different aspects of the country's cultural heritage in the visual and performing arts. Notwithstanding their conversion to Islam or Christianity, many Nigerians still consult with diviners and traditional healers in times of crisis or when neither the recently introduced religions nor modern technology can solve certain spiritual or health problems. Others synthesize ancient elements with ones introduced from different parts of the world.[38] A similar phenomenon obtains among the Yòrùbá of Ghana, the Republic of Benin, and Togo.[39] As William Bascom once observed, "no African group has had greater impact on the New World than the Yòrùbá."[40]

The large number of Yòrùbá captives exported to the Americas during the transatlantic slave trade helped them to preserve many aspects of their culture (albeit often in creolized forms). It also fostered the veneration of Yòrùbá *òrìsà* in the guise of Roman Catholic saints in African-influenced religions such as Vodou (in the Dominican Republic, Haiti, and the United States), Santeria (in Argentina, Cuba, Panama, Puerto Rico, and the US), Candomblé and Macumba (in Argentina and Brazil), Òrìsà (in the US) and the Òrìsà/Baptist Movement (in Trinidad and Tobago), among others.[41] To fill in some of the gaps in their ritual practices, some people in North America, Brazil, the Caribbean, and/or Hispanics now pay regular visits to Nigeria not only for ritual consultations, but also to participate in major festivals. Others invite Yòrùbá ritual specialists and diviners to the Americas to conduct seminars or supervise certain ritual procedures. Temples dedicated to major Yòrùbá deities now abound in Brazil, the Caribbean, and the United States. The *Egúngún* masquerade has since been revived at Òyótúnjí (African Village) in Sheldon, South Carolina, to memorialize the achievements of culture heroes in the African diaspora.[42] And, to come full circle, many African-diaspora artists now explore the aesthetics of *Egúngún* in their works.[43]

Museum holdings of Yòrùbá art have since become a source of inspiration for both artists and practitioners of Yòrùbá-influenced religions in their quest to relate the African past to the present. As a result, in addition to using methodologies derived from within a given African culture to study the nexus between its visual and verbal metaphors, there is an urgent need for fieldwork as well as an interdisciplinary approach that would relate ancient and contemporary arts of Africa to those of the African diasporas in the global village that our world has become.

This essay is dedicated to Marilyn Jensen Houlberg (1939–2012), former Professor of Art History, Theory, and Criticism at the School of the Art Institute of Chicago (1974–2008).

1 See Lawal 2004, 143–44.

2 See Biebuyck 1969; d'Azevedo 1973; and Cole 1989. For a review of the scholarship, see Adams 1989; Ben-Amos 1989; and Cole 1989.

3 Hountondji 1983; Mudimbe 1988; Ben-Amos 1989; Obiechina 1992; and Gates 1988, xix.

4 Abiodun 2014.

5 Lawal 2001, 498.

6 Olatunji 1984, 170; and Akindele 2005, 316.

7 See also Lawal 2001, 498.

8 Olódùmarè is also called Oba Òrun (King of Heaven) and Olú Ìwà (Lord of Existence). See Idowu 1995, 37–38; and Euba 1985, 3.

9 Lawal 2012a, 218–23; Wyndham 1921, 17; Idowu 1995, 19–22; Morton-Williams 1964, 243–610; Ojo 1966a; and Ojo 1996b, 196.

10 Ajanaku 1972, 10; Akiwowo 1983, 11.

11 Abimbola 1976, 152.

12 Abimbola 1997a, 3.

13 For *Tibi t'ire la dá'lé ayé*, see Akiwowo 1983, 23; for *Búburú ati rere ni ó nrìn pò*, see Hallen 2003, 57.

14 See R. Thompson 1971, X70-650 (ill.) and X70-651 (ill.).

15 Wescott 1962; dos Santos and dos Santos 1971; Pemberton 1975; Daramola and Jeje 1975, 296; and Lawal 2008, 30–31.

16 Adeoye 1979, 32.

17 Idowu 1995, 74.

18 For more information on Yòrùbá divination ritual tools, see Abiodun 1975, 421–69.

19 For another illustration of the ritual in process, see Bascom 1969b, plate 14.

20 If one nut remains in the other hand, he will make two dots on the wood dust; if two remain, he will make one dot in the wood dust.

21 Abimbola 2000, 177.

22 Idowu 1995, 57; and Euba 1985, 3.

23 Euba 1985, 7.

24 dos Santos and dos Santos 1971, 49; and Abiodun 1986, 18.

25 Drewal and Pemberton 1989, 26.

26 Euba 1985, 1–7.

27 Johnson 1921, 46.

28 The "godmother" is also called Yèyé Oba; "yèyé" is another Yòrùbá word for "mother." At Òyó, even though there is an *ìyá oba*, another equally powerful palace priestess, the *ìyá kéré*, performs the ritual of placing the crown on a new king's head. See Johnson 1921, 63. In some Yòrùbá kingdoms, the *ìyá oba* is a priestess of the Ògbóni/Òsùgbó society, an institution dedicated to the veneration of Mother Earth (Onílé/Onílè). For other implications of this tradition, see R. Thompson 1972; and Babayemi 1986, 13.

29 Ayelaagbe 1997, 52–54. Translation by the author.

30 Daramola and Jeje 1975, 128.

31 See also Drewal and Mason 1998, 70–77.

32 Ojo 1966b, 15–21, plates 2, 4.

33 Parrinder 1967, 19–54; Mbiti 1991, 45–86; and Hackett 1996, 23–77.

34 This explains why a baby boy may be named Babájídé (Father Reincarnates) if he is born shortly after the death of his father or grandfather, and a baby girl may be called Yéjídé (Mother Reincarnates) if she is born shortly after the death of a mother or grandmother. Another popular name is Babátúndé (Father Returns) or Yétúndé (Mother Returns). For the meanings of popular Yòrùbá names, see Adeoye 1972.

35 Zuesse 1979, 142.

36 For a review of the functions of the mask in Africa, see R. Thompson 1974; Huet 1978; Cole 1985; and Hahner-Herzog, Kecskési, and Vajda 1998. For details see Carroll 1956, 3; Carroll 1967; and R. Thompson 1971.

37 For a review of this period in art history, see Goldwater 1986; Torgovnick 1992; and Lawal 2004.

38 Hackett 1996; Müller and Ritz-Müller 1999; and Ray 2000.

39 Abimbola 1991, 51–58; and Dopamu 1979.

40 Bascom 1969b, 1.

41 R. Thompson 1993; Araújo and de Moura 1994; Lawal 1996a; Lindsay 1996; Galembo 1993; Cosentino 1996; Barnes 1997; Falola and Childs 2004; and Falola and Genova 2005.

42 Olupona and Rey 2008.

43 Examples of such work include Napoleon Jones-Henderson (American, born 1943), *Egungun for Duke* (2000; Kravets Wehby Gallery, New York) and Willis "Bing" Davis (American, born 1937), *Ancestral Spirit Dance* series, 1990s (Willis "Bing" Davis Studio and Ebonia Gallery, Dayton, Ohio).

Africa
Cultures and Locations

**Northern Africa
and the Sahel**

**Coastal
West Africa**

Central Africa

**Eastern and
Southern Africa**

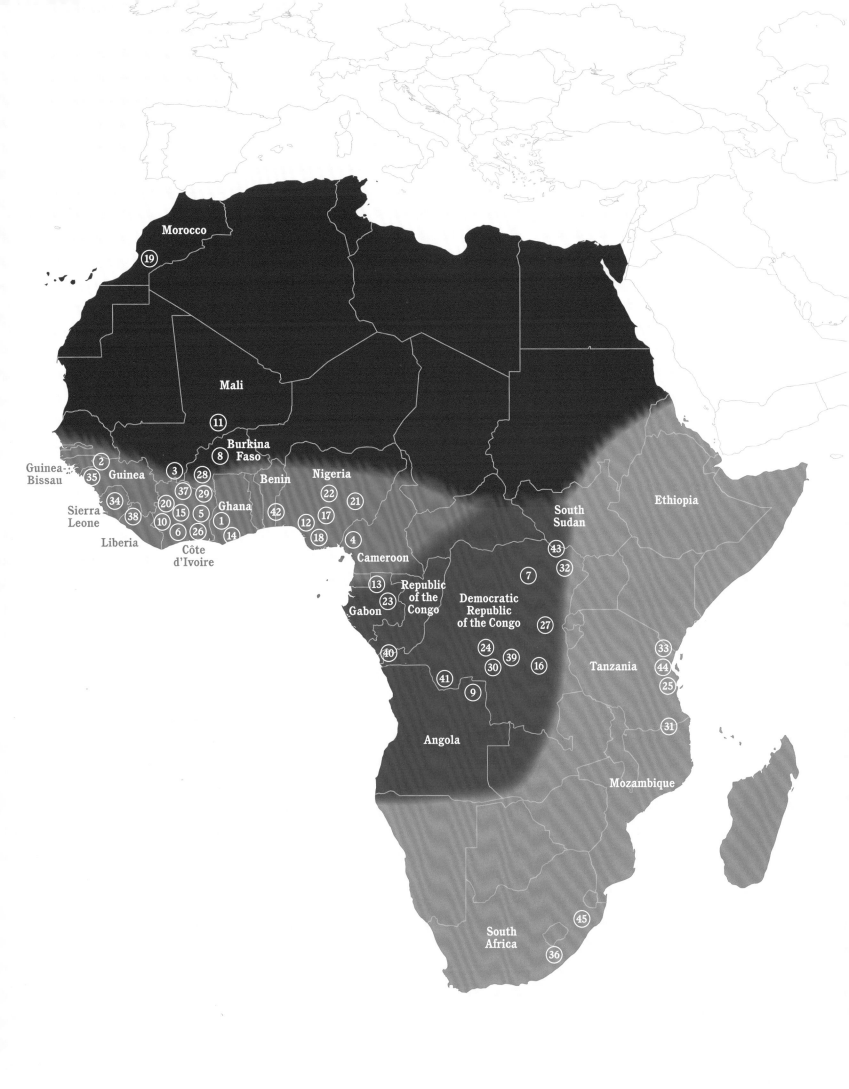

Works Cited

Abimbola, Wande. 1975. *Sixteen Great Poems of Ifá.* Zaria, Nigeria: UNESCO.

———. 1976. *Ifá: An Exposition of Ifá Literary Corpus.* Ibadan, Nigeria: Oxford University Press.

———. 1991. "The Place of Traditional African Religion in Contemporary Africa: The Yoruba Example." In *African Traditional Religions in Contemporary Societies*, edited by Jacob K. Olupona, 51–58. New York: Paragon House.

———. 1997a. *Ifá Will Mend Our Broken World: Thoughts on Yoruba Religion and Culture in Africa and the Diaspora.* Introduction by Ivor Miller. Roxbury, MA: Aim Books.

———. 1997b. "Images of Women in the Ifá Literary Corpus." In *Queens, Queen Mothers, Priestesses, and Power: Case Studies in African Gender*, edited by Flora E. S. Kaplan, 401–13. New York: New York Academy of Sciences.

———. 2000. "Continuity and Change in the Verbal, Artistic, Ritualistic, and Performance Tradition of Ifá Divination." In *Insight and Artistry in African Divination*, edited by John Pemberton III, 175–81. Washington, DC, and London: Smithsonian Institution Press.

Abiodun, Rowland. 1975. "Ifá Art Objects: An Interpretation Based on Oral Tradition." In *Yoruba Oral Tradition: Poetry in Music, Dance and Drama*, edited by Wande Abimbola, 421–69. Ilé-Ifè, Nigeria: University of Ifè Department of African Languages and Literatures.

———. 1986. "Visual and Verbal Metaphors in the Yoruba Ritualistic Art of the Ori." *Ifè: Annals of the Institute of African Studies* 1: 8–39.

———. 1987. "Verbal and Visual Metaphors: Mythical Allusions in Yoruba Ritualistic Art of *Orí*." *Word and Image* 3 (3): 252–70.

———. 2014. *Yoruba Art and Language: Seeking the African in African Art.* New York: Cambridge University Press.

Abraham, Roy Clive. 1958. *Dictionary of Modern Yoruba.* London: University of London Press.

Adams, Monni. 1989. "African Visual Arts from an Art Historical Perspective." *African Studies Review* 32 (2): 55–103.

———. 2009. "Both Sides of the Collecting Encounter: The George W. Harley Collection at the Peabody Museum of Archaeology and Ethnology, Harvard University." *Museum Anthropology* 32, no. 1 (Spring): 17–32.

Adejumo, Ademola. 2002. "Color Symbolism in Traditional Yoruba Culture." *Ifè: Annals of the Institute of African Studies* 8: 27–39.

Adeoye, C. Laogun. 1972. *Oruko Yoruba.* Ibadan, Nigeria: Oxford University Press.

———. 1979. *Àṣà àti iṣe Yorùbá.* Oxford: Oxford University Press.

———. 1989. *Ìgbàgbó àti èsìn Yoruba.* Ibadan, Nigeria: Evans Brothers.

African Art Studies. 1990. *African Art Studies: The State of the Discipline. Papers Presented at a Symposium Organized by the National Museum of African Art.* Washington, DC: Smithsonian Institution Press.

Ajanaku, Fagbemi. 1972. "Ori, Ipin ati Kadara. Apa Keji." *Olokun* 19: 11–13.

Akindele, Kayode J. Awon. 2005. *Owe Yoruba (Yoruba Proverbs).* Kearney, NE: Morris Publishing.

Akintoye, Samuel A. 2010. *A History of the Yoruba People.* Dakar, Senegal: Amalion Publishing.

Akiwowo, Akinsola. 1983. *Ajobi and Ajogbe: Variations on the Theme of Sociation.* Inaugural Lecture, ser. 46. Ilé-Ifè, Nigeria: University of Ifè Press.

Alldridge, Thomas J. 1901. *The Sherbro and Its Hinterland.* New York and London: Macmillan.

Aloudat, Nala, and Hanna Boghanim, eds. 2017. *Trésors de l'Islam en Afrique: de Tombouctou à Zanzibar.* Exh. cat. Paris: Institut du monde arabe.

Anderson, Martha G. 1987. "The Funeral of an Ijo Shrine Priest." *African Arts* 21 (1): 52–57, 88.

———. 2002a. "Bulletproof: Exploring the Warrior Ethos in Ijo Culture." In *Ways of the Rivers: Arts and Environment of the Niger Delta*, edited by Martha G. Anderson and Philip M. Peek, 91–119. Exh. cat. Los Angeles: UCLA Fowler Museum of Cultural History.

———. 2002b. "From River Horses to Dancing Sharks: Canoes and Fish in Ijo Art and Ritual." In *Ways of the Rivers: Art and Environment of the Niger Delta*, edited by Martha G. Anderson and Philip M. Peek, 132–61.

Exh. cat. Los Angeles: UCLA Fowler Museum of Cultural History.

———. 2003. "*Ikiyan aru*: Ijo Vessels of Sacrifice." *African Arts*, Memorial to Roy Sieber Part 1, 36, no. 1 (Spring): 24–39, 91–92.

Ansah, Joseph K. 1989. "The Ethics of African Religious Tradition." In *World Religions and Global Ethics*, edited by S. Cromwell Crawford, 245–57. New York: Paragon House.

Appiah, Kwame Anthony. 2006. *Cosmopolitanism: Ethics in a World of Strangers.* New York and London: W. W. Norton.

Araújo, Emanuel, and C. E. M. de Moura. 1994. *Art in Afro-Brazilian Religion/Arte e religiosidade Afro-Brasileira.* São Paulo: Câmara Brasileira do Livro.

Art Newspaper. 1998. "The Kwer'ata Re'usu Brought to Light: Ethiopia's Greatest Treasure Found." *The Art Newspaper* 9, no. 80: 1, 4–5.

Art of Primitive Peoples. 1946. *Art of Primitive Peoples.* Foreword by Frans M. Olbrechts. Exh. cat. London: Berkeley Galleries, William F. C. Ohly.

Awe, Bolanle. 1977. "The Iyalode in the Traditional Yoruba Political System." In *Sexual Stratification: A Cross-Cultural View*, edited by Alice Schlegel, 144–60. New York: Columbia University Press.

Awolalu, J. Omosade. 2001. *Yoruba Beliefs and Sacrificial Rites.* New York: Athelia Henrietta Press.

Ayelaagbe, Adebayo. 1997. *Ìwúre: ìjìnlè àdúà ẹnu àwọn Yorùbá.* Ibadan, Nigeria: Vantage Publishers.

Babalola, Adeboye. 1970. "Ounje Oju." *Olokun* 9: 39–40.

———. 1972–73. "Further Discussion on Ayo Bamgbose's Article, 'The Meaning of Olódùmarè: An Etymology of the Name of the Yoruba High God.'" *African Notes* 7 (2): 104–5.

Babayemi, Solomon O. 1986. "Oyo Palace Organization: Past and Present." *African Notes* 10 (1): 4–24.

Babayemi, Solomon O., and O. O. Adekola. 1988. *Isedale Awon Odu Ifa, Apa Keta.* Ibadan, Nigeria: Institute of African Studies, University of Ibadan.

Bamgbose, Ayo. 1971–72. "The Meaning of Olódùmarè: An Etymology of the Name of the Yoruba High God." *African Notes* 7 (1): 28–29.

Barbier-Mueller, Jean Paul, and Purissima Benitez-Johannot, eds. 2003. *Sièges d'Afrique noire du musée Barbier-Mueller.* Exh. cat. Geneva: Musée Barbier-Mueller; Milan: 5 Continents Editions.

Barbosa, Adriano. 1989. *Dicionário Cokwe-Português.* Coimbra, Portugal: Instituto de Antropologia, Universidade de Coimbra.

Barley, Nigel. 1988. *Foreheads of the Dead: An Anthropological View of Kalabari Ancestral Screens.* Exh. cat. Washington, DC: Smithsonian

Institution Press for the National Museum of African Art.

Barnes, Sandra T., ed. 1997. *Africa's Ogun: Old World and New*. 2nd ed. Bloomington and Indianapolis: Indiana University Press.

Bascom, William. 1969a. "Creativity and Style in African Art." In *Tradition and Creativity in Tribal Art,* edited by Daniel P. Biebuyck, 98–119. Berkeley and Los Angeles: University of California Press.

——. 1969b. *Ifa Divination: Communication between Gods and Men in West Africa*. Bloomington: Indiana University Press.

——. 1969c. *The Yoruba of Southwestern Nigeria*. New York: Holt, Rinehart and Winston.

Basden, G. T. 1938. *Niger Ibos: A Description of the Primitive Life, Customs and Animistic Beliefs, etc. of the Igbo People of Nigeria by One Who, for Thirty-Five Years, Enjoyed the Privilege of Their Intimate Confidence and Friendship*. London: Seeley, Service and Co.

Bassani, Ezio. 1978. "Una bottega di grandi artisti Bambara. 2." *Critica d'Arte* 43 (160–62): 181–200.

Bastin, Marie-Louise. 1961. *Art décoratif tshokwe*. 2 vols. Lisbon: Museu do Dundo.

——. 1988. "Songye, Zaïre, Lomami." In *Utotombo: Kunst uit Zwart-Afrika in Belgisch privé-bezit*, 303, cat. XXXVIII. Exh. cat. Brussels: Vereniging voor Tentoonstellingen van het Paleis voor Schone Kunsten.

Becker, Cynthia. 2010. "Deconstructing the History of Berber Arts: Tribalism, Matriarchy, and a Primitive Neolithic Past." In *Berbers and Others: Beyond Tribe and Nation in the Maghrib*, edited by Katherine E. Hoffman and Susan Gilson Miller, 195–220. Bloomington: Indiana University Press.

Bedaux, Rogier M. A. 1988. "Tellem and Dogon Material Culture." *African Arts* 21 (4): 38–45, 91.

Beidelman, Thomas O. 1967. *The Matrilineal Peoples of Eastern Tanzania: Zaramo, Luguru, Kaguru, Ngulu, Etc*. London: International African Institute.

Beier, Ulli H. 1955. "The Historical and Psychological Significance of Yoruba Myths." *Odù, Journal of Yoruba and Related Studies* 1: 19–22.

——. 1982. *Yoruba Beaded Crowns: Sacred Regalia of the Olokuku of Okuku*. London: Ethnographica; Lagos, Nigeria: National Museum.

Belcher, Wendy Laura. 2019. "Mary Saves the Man-Eater: Value in the Medieval Ethiopian Marian Miracle Tale of 'The Cannibal of Qemer.'" *Digital Philology: A Journal of Medieval Cultures* 8, no. 1 (Spring): 29–49.

Ben-Amos, Paula. 1989. "African Visual Arts from a Sociological Perspective." *African Studies Review* 32 (2): 1–54.

Berglund, Axel-Ivar. 1976. *Zulu Thought-Patterns and Symbolism*. Cape Town: David Phillip.

Berns, Marla R., Richard Fardon, and Sidney Littlefield Kasfir, eds. 2011. *Central Nigeria Unmasked: Arts of the Benue River Valley*. Exh. cat. Los Angeles: Fowler Museum at UCLA; Seattle: University of Washington Press.

Berzock, Kathleen Bickford. 2002. *The Miracles of Mary: A Seventeenth-Century Ethiopian Manuscript*. Chicago: Art Institute of Chicago.

——. 2005. *For Hearth and Altar: African Ceramics from the Keith Achepohl Collection*. Exh. cat. Chicago: Art Institute of Chicago; New Haven and London: Yale University Press.

——. 2008a. *Benin: Royal Arts of a West African Kingdom*. Exh. cat. Chicago: Art Institute of Chicago; New Haven: Yale University Press.

——. 2008b. "Notable Acquisitions at the Art Institute of Chicago: Figural Medicine Container." *Museum Studies* 34 (1): 12–13, 94.

——. 2009. "Triptych Icon with Central Image of the Virgin and Child." In *The Art Institute of Chicago: The Essential Guide*, 76–78, 95. Chicago: Art Institute of Chicago.

Bianchi, Ugo. 1978. *Selected Essays on Gnosticism, Dualism, and Mysteriology*. Leiden: Brill.

Bickford, Kathleen E. 1997. "Foreword." In *African Art at the Art Institute of Chicago*, special issue edited by Kathleen E. Bickford. *Museum Studies* 23 (2): 101–2.

Biebuyck, Daniel P., ed. 1969. *Tradition and Creativity in Tribal Art*. Berkeley and Los Angeles: University of California Press.

Biebuyck, Daniel P. 2002. *Lega. Éthique et beauté au coeur de l'Afrique*. Exh. cat. Brussels: KBC Banque et Assurance.

Binkley, David A. 1992. "The Teeth of the Nyim: The Elephant and Ivory in Kuba Art." In *Elephant: The Animal and Its Ivory in African Culture,* edited by Doran H. Ross, 276–91. Exh. cat. Los Angeles: Fowler Museum of Cultural History, University of California.

——. 2004. "Ideology of Male and Female Movement: A Kuba Mask (*Ngady Mwaash*)." In *See the Music, Hear the Dance: Rethinking African Art at the Baltimore Museum of Art*, edited by Frederick John Lamp, 172–73, cat. 41. Baltimore: Baltimore Museum of Art; Munich, London, and New York: Prestel.

——. 2016. "Helmet Mask (Mukenga)." In *Masks in Congo*, edited by Marc Leo Felix, 170–71, cat. 48. Exh. cat. Brussels: Tribal Arts; Hong Kong: Ethnic Art and Culture.

Binkley, David A., and Patricia Darish. 2009. *Kuba*. Visions of Africa. Milan: 5 Continents Editions.

Biobaku, Saburi O. 1949. "Ogboni: The Egba Senate." In *The Proceedings of the Third West African Conference, Ibadan, Dec. 12–21, 1949*, 257–63. Lagos: Nigerian Museum.

——. 1952. "An Historical Sketch of Ègbá Traditional Authorities." *Africa* 22 (1): 35–49.

Blackmun, Barbara Winston. 1997. "Icons and Emblems in Ivory: An Altar Tusk from the Palace of Old Benin." In *African Art at the Art Institute of Chicago*, special issue edited by Kathleen E. Bickford. *Museum Studies* 23 (2): 148–63.

Blesse, Giselher. 1992. "Kunst der Makonde. Masken und Skulpturen aus dem Museum für Völkerkunde Leipzig," *Mitteilungen aus dem Museum für Völkerkunde zu Leipzig* 54: 2–24.

Blier, Suzanne P. 1988. "Melville J. Herskovits and the Arts of Ancient Dahomey." *RES: Anthropology and Aesthetics* 16: 125–42.

——. 2015. *Art and Risk in Ancient Yoruba: Ife History, Power, and Identity, c. 1300*. New York: Cambridge University Press.

Bochet, Gilbert. 1993a. "Carved Doors." In *Art of Côte d'Ivoire from the Collections of the Barbier-Mueller Museum*, edited by Jean Paul Barbier, 2: 37–38, cats. 41–42. 2 vols. Geneva: Barbier-Mueller Museum.

——. 1993b. "Helmet Masks." In *Art of Côte d'Ivoire from the Collections of the Barbier-Mueller Museum*, edited by Jean Paul Barbier, 2: 19–20, cats. 13–15. 2 vols. Geneva: Barbier-Mueller Museum.

Bognolo, Daniela. 2007. "Sur la piste de l'animal: les rôles de la représentation zoomorphe au Burkina Faso." In *Animal*, edited by Christiane Falgayrettes-Leveau, 175–206. Exh. cat. Paris: Éditions Dapper.

Boone, Sylvia Ardyn. 1986. *Radiance from the Waters: Ideals of Feminine Beauty in Mende Art*. New Haven: Yale University Press.

Bortolot, Alexander Ives. 2007. *Revolutions: A Century of Makonde Masquerade in Mozambique*. Exh. cat. New York: Miriam and Ira D. Wallach Art Center, Columbia University.

Bouju, Jacky. 1994. "La statuaire dogon au regard de l'anthropologue." In *Dogon*, 221–37. Exh. cat. Paris: Éditions Dapper.

Bourgeois, Arthur P. 1984. *Art of the Yaka and Suku*. Meudon, France: Alain et Françoise Chaffin.

——. 2014. *Yaka*. Visions of Africa. Milan: 5 Continents Editions.

Bouttiaux, Anne-Marie. 2016. *Guro*. Visions of Africa. Milan: 5 Continents Editions.

Bowdich, T. Edward. 1870. *Mission from Cape Coast Castle to Ashantee: With a Descriptive Account of That Kingdom*. London: Griffith and Farran.

Brain, James L. 1962. "The Kwere of the Eastern Province." *Tanganyika Notes and Records* 58–59: 231–41.

Bravmann, René A. 1973. *Open Frontiers: The Mobility of Art in Black Africa.* Exh. cat. Seattle: University of Washington Press.

Brett-Smith, Sarah C. 1983. "The Poisonous Child." *RES: Anthropology and Aesthetics* 6: 47–64.

Burssens, Herman. 1993. "Mask Styles and Mask Use in the North of Zaire." In *Face of the Spirits: Masks from the Zaire Basin,* edited by Frank Herreman and Constantine Petridis, 217–33. Exh. cat. Antwerp: Ethnographic Museum; Ghent: Martial & Snoeck.

Burssens, Herman, and Alain Guisson. 1992. *Mangbetu. Art de cour africain de collections privées belges*. Exh. cat. Brussels: Kredietbank.

Cameron, Elisabeth L. 2001. *Art of the Lega*. Exh. cat. Los Angeles: UCLA Fowler Museum of Cultural History.

Campbell, Bolaji. 2008. *Painting for the Gods: Art and Aesthetics of Yoruba Religious Murals.* Trenton, NJ: African World Press.

Carroll, Kevin C. 1956. "Yoruba Masks: Notes on the Masks of Northeastern Yoruba Country." *Odù* 3: 3–15.

——. 1967. *Yoruba Religious Carving: Pagan and Christian Sculpture in Nigeria and Dahomey.* New York and Washington, DC: Frederick A. Praeger Publishers.

Carton, Benedict, John Laband, and Jabulani Sithole, eds. 2008. *Zulu Identities: Being Zulu, Past and Present*. Pietermaritzburg: University of KwaZulu-Natal Press.

Ceyssens, Rik. 2007. "The 'Bwa War Masks' of the Middle Uele Region: A Review." *African Arts* 40, no. 4 (Winter): 58–73.

Chaffin, Alain, and Françoise Chaffin. 1979. *L'Art kota: Les figures de reliquaire*. Meudon, France: Alain et Françoise Chaffin.

Chemeche, George. 2013. *Eshu: The Divine Trickster*. Woodbridge, Suffolk, England: Antique Collectors' Club.

Chojnacki, Stanislaw. 1985. *The "Kwer'ata Re'esu": Its Iconography and Significance. An Essay in Cultural History of Ethiopia*. Annali dell' Istituto Universitario Orientale, suppl. 42. Naples: Istituto Universitario Orientale.

——. 2000. *Ethiopian Icons: Catalogue of the Collection of the Institute of Ethiopian Studies, Addis Ababa University*. Milan: Skira Editore; London: Thames and Hudson.

Christie's New York. 1997. *Important Tribal Art*. Sale cat. New York: Christie's New York, Nov. 20.

Cissé, Youssouf Tata. 1996. "*Boli*: Statues et statuettes dans la religion Bambara." In *Magies,* 145–72. Paris: Éditions Dapper.

——. 2001. "Mythe fondateur du masque *Tyiwara*." In *Tyiwara,* 5–13. Exh. cat. Paris: Galerie Ratton-Hourdé.

Clark-Bekederemo, J. P. 1991. *The Ozidi Saga: Collected and Translated from the Oral Ijo Version of Okabou Ojobolo*. Washington, DC: Howard University Press. Originally published in 1977.

Clarke, J. D. 1944. "Three Fertility Ceremonies." *Journal of the Royal Anthropological Institute* 74 (1/2): 91–96.

Clegg, Johnny. 1981. "Towards an Understanding of African Dance: The Zulu *Isishimeni* Style." In *Papers Presented to the Symposium on Ethnomusicology at the International Library of African Music (ILAM)*, edited by Andrew Tracey, 165–81. Grahamstown, South Africa: Rhodes University, Grahamstown Institute of Social Research.

Cloth, Frederic. 2015. *Kota: Digital Excavations*. Exh. cat. Saint Louis: Pulitzer Arts Foundation.

——. 2017. "Figure de reliquaire Kota-Shamaye." In *Collection Vérité: Art d'Afrique, d'Océanie et d'Amérique du Nord*, lot. 91. Sale cat. Paris: Christie's Paris, Nov. 21.

Cole, Herbert M. 1989. *Icons: Ideals and Power in the Art of Africa.* Exh. cat. Washington, DC: Smithsonian Institution Press.

——. 2003. "A Crisis in Connoisseurship?" *African Arts* 36, no. 1 (Spring), 1, 4–5, 8, 86, 96.

Cole, Herbert M., ed. 1985. *I Am Not Myself: The Art of African Masquerade*. Monograph Series, 26. Exh. cat. Los Angeles: Museum of Cultural History, University of California.

Cole, Herbert M., and Chike C. Aniakor. 1984. *Igbo Arts: Community and Cosmos*. Foreword by Chinua Achebe. Exh. cat. Los Angeles: Museum of Cultural History, University of California.

Cole, Herbert M., and Doran Ross. 1977. *The Arts of Ghana*. Exh. cat. Los Angeles: University of California.

Colin-Noguès, Renée. 2006. *Sénoufo du Mali. Kènèdougou, Terre de Lumière. Photographies de Renée Colin-Noguès dans les années 1950*. Preface by Adame Ba Konaré and contributions by Roland Colin, Gail de Courcy-Ireland, and Moussa Sow. Exh. cat. Bamako: Musée National du Mali; Paris: Revue Noire Éditions.

Colleyn, Jean-Paul. 2009. *Boli*. Preface by Daniel Cordier. Exh. cat. Paris: Johann Levy; Montreuil, France: Gourcuff Gradenigo.

Colleyn, Jean-Paul, ed. 2001. *Bamana: The Art of Existence in Mali*. Exh. cat. New York: Museum for African Art; Zurich: Museum Rietberg; Ghent: Snoeck-Ducaju and Zoon.

Colleyn, Jean-Paul, and Lorenz Homberger. 2006. *Ciwara. Chimères africaines*. Exh. cat. Paris: Musée du Quai Branly; Milan: 5 Continents Editions.

Cosentino, Donald, ed. 1996. *Sacred Arts of Haitian Vodou.* Exh. cat. Los Angeles: Fowler Museum of Cultural History, UCLA.

Cooksey, Susan, Robin Poynor, and Hein Vanhee, eds. 2013. *Kongo across the Waters*. Exh. cat. Gainesville: University of Florida, Harn Museum of Art.

Cornet, Joseph. 1988. "Tabouret de chef." In *Arts de l'Afrique noire dans la collection Barbier-Mueller*, edited by Werner Schmalenbach, 267, cat. 172. Exh. cat. Paris: Éditions Fernand Nathan.

——. "Masks among the Kuba People." In *Face of the Spirits: Masks from the Zaire Basin*, edited by Frank Herreman and Constantine Petridis, 129–43. Exh. cat. Antwerp: Ethnographic Museum; Ghent: Martial & Snoeck.

Crowther, Samuel A. 1852. *A Vocabulary of the Yoruba Language*. London: Seeley's.

Curtis, Marie Yvonne. 2018. *Baga*. Visions of Africa. Milan: 5 Continents Editions.

Curtis, Marie Yvonne, and Ramon Sarró. 1997. "The *Nimba* Headdress: Art, History, and Ritual of the Baga and Nalu Peoples of Guinea." In *African Art at the Art Institute of Chicago*, special issue edited by Kathleen E. Bickford. *Museum Studies* 23 (2): 120–33, 196–97.

Daramola, Olu, and A. Jeje. 1975. *Awọn Àṣà ati Òrìṣà ilẹ Yorùbá*. Ibadan, Nigeria: Onibonoje Press.

d'Azevedo, Warren L., ed. 1973. *The Traditional Artist in African Societies*. Bloomington and London: Indiana University Press.

de Areia, Manuel L. Rodrigues. 1985. *Les Symboles divinatoires. Analyse socio-culturelle d'une technique de divination des Cokwe de l'Angola.* Coimbra, Portugal: Centro de Estudos Africanos.

de Cerqueira, Ivo. 1947. *Vida social indígena na colónia de Angola*. Lisbon: Agência Geral das Colónias.

de Grunne, Bernard. 1980. *Terres cuites anciennes de l'Ouest Africain/ Ancient Terracottas from West Africa*. Louvain-la-Neuve, Belgium: Institut Supérieur d'Archéologie et d'Histoire de l'Art.

———. 1981. *Ancient Treasures in Terra Cotta of Mali and Ghana*. New York: African American Institute.

———. 2014. *Djenné-Jeno: 1,000 years of Terracotta Statuary in Mali*. Brussels: Mercatorfonds.

de Grunne, Bernard, ed. 2001. *Mains de maîtres. À la découverte des sculpteurs d'Afrique*. Exh. cat. Brussels: BBL.

de la Burde, Roger. 1973. "The Ijebu Ekine Cult." *African Arts* 7, no. 1 (Autumn): 28–33.

Delano, Isaac O. 1979. *Òwe L'Esin Oro: Yoruba Proverbs: Their Meaning and Usage*. Ibadan, Nigeria: University Press Limited.

Dembélé, Mamadi. 2019. "Urbanization and Trade Networks in the Inland Niger Delta." In *Caravans of Gold, Fragments in Time: Art, Culture, and Exchange across Medieval Saharan Africa*, edited by Kathleen Bickford Berzock, 153–59. Exh. cat. Evanston, IL: Block Museum of Art; Princeton, NJ: Princeton University Press.

Devisch, René. 2017. "A Dancing Mask, Estranged in the Museum." In *Body and Affect in the Intercultural Encounter*, 119–29. Mankon and Bamenda, Cameroon: Langaa; Leiden, Netherlands: African Studies Center.

Dewey, William J. 1993. *Sleeping Beauties: The Jerome L. Joss Collection of African Headrests at UCLA*. Exh. cat. Los Angeles: Fowler Museum of Cultural History, University of California.

———. 1994. "Staffs from Eastern and Southern Africa." In *Staffs of Life: Rods, Staffs, Scepters and Wands from the Coudron Collection of African Art*, edited by Allen F. Roberts, 8–13. Exh. cat. Iowa City: University of Iowa Museum of Art.

———. 2009. "East Africa." In *Africa—Art and Culture: Masterpieces of African Art, Ethnological Museum, Berlin*, edited by Hans-Joachim Koloss, 181–97. Munich: Prestel.

Diamitani, Boureima T. 2011. "The Insider and the Ethnography of Secrecy: Challenges of Collecting Data on the Fearful Komo of the Tagwa-Senufo." *African Archaeological Review* 28: 55–70.

Dopamu, P. A. 1979. "Yoruba Magic and Medicine and Their Relevance for Today." *Journal of the Nigerian Association of Religious Studies* 4: 3–20.

Doris, David T. 2013. *Vigilant Things: On Thieves, Yoruba Anti-Aesthetics, and the Strange Faiths of Ordinary Objects in Nigeria*. Seattle and London: University of Washington Press.

dos Santos, Juana E., and Deoscoredes M. dos Santos. 1971. *Esu Bara Laaroye: A Comparative Study*. Ibadan, Nigeria: Institute of African Studies, University of Ibadan.

Drewal, Henry J. 1980. *African Artistry: Technique and Aesthetics in Yoruba Sculpture*. Exh. cat. Atlanta: High Museum of Art.

———. 1986. "Flaming Crowns, Cooling Waters: Masquerades of the Ijebu Yoruba." *African Arts* 20 (1): 32–41, 99–100.

———. 2002. "Celebrating Water Spirits: Influence, Confluence, and Difference in Ijebu-Yoruba and Delta Masquerades." In *Ways of the Rivers: Art and Environment of the Niger Delta*, edited by Martha G. Anderson and Philip M. Peek, 192–215. Exh. cat. Los Angeles: Fowler Museum of Cultural History, UCLA.

Drewal, Henry J., and Margaret T. Drewal. 1983. *Gèlèdé: Art and Female Power Among the Yoruba*. Bloomington: Indiana University Press.

Drewal, Henry J., and John Mason. 1998. *Art and Light in the Yoruba Universe*. Exh. cat. Los Angeles: UCLA Fowler Museum of Cultural History.

Drewal, Henry J., and John Pemberton III, with Rowland Abiodun. 1989. *Yoruba: Nine Centuries of African Art and Thought*. Exh. cat. New York: Center for African Art.

Drewal, Henry J., and Enid J. Schildkrout. 2009. *Dynasty and Divinity: Ife Art in Ancient Nigeria*. Exh. cat. New York and Santander, Spain: Museum for African Art.

Dreyfus, Camille. 1898. *À la Côte d'Ivoire. Six mois dans l'Attié (un Transvaal français)*. Paris: Société française d'Éditions d'Art, L. Henry May.

Ehrlich, Martha J. 1981. "A Catalogue of Ashanti Art Taken from Kumasi in the Anglo-Ashanti War." PhD diss., Indiana University.

———. 2018. "Asante Regalia." In *The Power of Gold: Asante Royal Regalia from Ghana*, edited by Roslyn A. Walker, 27–34. Exh. cat. Dallas: Dallas Museum of Art.

Elliott Weinberg, Catherine. 2015. "The Name Zulu Is Now Given: Provenancing Objects from Colonial Natal in the British Museum's Christy Collection." In *Tribing and Untribing the Archive: Identity and the Material Record in Southern Natal in the Late Independent and Colonial Periods*, edited by Carolyn Hamilton and Nessa Leibhammer, 477–501. Pietermaritzburg, South Africa: University of KwaZulu-Natal Press, 2015.

Elsner, Jaś. 2003. "Style." In *Critical Terms for Art History,* edited by Robert S. Nelson and Richard Shiff, 98–109. Chicago: University of Chicago Press.

Epega, D. Olarimiwa. 1971. *The Basis of Yoruba Religion*. Abeokuta, Nigeria: Ijamido Printers.

Euba, Titi.1985. "The Ooni of Ife's *Arè* Crown and the Concept of Divine Head." *Nigeria Magazine* 53 (1): 1–7.

Ezra, Kate. 2011. "Figure with Four Arms." In *Ancestors of Congo Square: African Art in the New Orleans Museum of Art*, edited by William A. Fagaly, 32, cat. 6. New Orleans: New Orleans Museum of Art; London: Scala Publishers.

Fabunmi, Michael A. 1972. *Ayajo Ijinle Ohun Enu Ife*. Ibadan, Nigeria: Onibonoje Press.

Fagg, William Buller. 1980a. *Masques d'Afrique dans les collections du Musée Barbier-Müller*. Paris: Fernand Nathan.

———. 1980b. *Yoruba Beadwork: Art of Nigeria*. Exh. cat. New York: Pace Gallery.

Fakinlede, Kayode J. 2003. *Yoruba Modern Practical Dictionary*. New York: Hippocrene Books.

Falola, Toyin, and Ann Genova, eds. 2005. *Orisa: Yoruba Gods and Spiritual Identity in Africa and the Diaspora*. Trenton, NJ: Africa World Press, Inc.

Falola, Toyin, and Matt T. Childs, eds. 2005. *The Yoruba in the Atlantic World*. Bloomington: Indiana University Press.

Féau, Etienne. 1989. "Akyé." In *Corps sculptés, corps parés, corps masqués—Chefs-d'oeuvre de Côte-d'Ivoire*, edited by Etienne Féau, 149, cat. 105. Exh. cat. Paris: Association Française d'Action Artistique.

Felix, Marc L. 1990. *Mwana Hiti: Life and Art of the Matrilineal Bantu of Tanzania*. Munich: Verlag Fred Jahn.

Felix, Marc L., and Manuel Jordán. 1998. *Makishi Lya Zambia: Mask Characters of the Upper Zambezi Peoples*. Munich: Fred Jahn Publications.

Felix, Marc L., Charles Meur, and Niangi Batulukisi. 1995. *Art & Kongos— Les peuples kongophones et leur sculpture*. Brussels: Zaïre Basin Art History Research Center.

Fernandez, James W., and Renate L. Fernandez. 1975. "Fang Reliquary Art: Its Quantities and Qualities." *Cahiers d'Études africaines* 60 (4): 723–46.

Fischer, Eberhard. 1978. "Dan Forest Spirits: Masks in Dan Villages." *African Arts* 11 (2): 16–23, 94.

Fischer, Eberhard, and Hans Himmelheber. 1984. *The Arts of the Dan in West Africa*. Translated by Anne Buddle. Zurich: Museum Rietberg. Originally published in German, 1976.

Fischer, Eberhard, and Lorenz Homberger. 1985. *Die Kunst der Guro, Elfenbeinküste*. Exh. cat. Zurich: Museum Rietberg.

Fischer, Eberhard, and Lorenz Homberger, eds. 2014. *Afrikanische*

Meister: Kunst der Elfenbeinküste. Exh. cat. Zurich: Museum Rietberg and Scheidegger and Spiess.

Fogg, Sam. 2005. *Art of Ethiopia.* Introduction by Griffith Mann. London: Paul Holberton Publishing.

Fontinha, Mário. 1997. *NGOMBO (adivin-hação): Tradições no Nordeste de Angola.* Oeiras, Portugal: Câmara Municipal de Oeiras.

Forni, Silvia. 2010. "Ambiguous Values and Incommensurable Claims: The Canon, the Market, and Entangled Histories of Collections and Exhibits." *Critical Interventions* 7: 150–59.

Forni, Silvia, and Christopher B. Steiner, eds. 2015. *Africa in the Market: Twentieth-Century Art from the Amrad African Art Collection.* Toronto: Royal Ontario Museum.

———. eds. 2018. *The African Art Market as Ego-System.* Critical Interventions 12, 1. London: Routledge.

Förster, Till. 1997. "The Bronze Works of the Senufo." In *Earth and Ore: 2500 Years of African Art in Terra-Cotta and Metal*, edited by Karl-Ferdinand Schaedler, 93–110. Exh. cat. Munich: Panterra Verlag; Eurasburg: Edition Minerva.

———. 2004. "Alienating the Living from the Dead: A Senufo Mask (Pònyugu)." In *See the Music, Hear the Dance: Rethinking African Art at the Baltimore Museum of Art*, edited by Frederick John Lamp, 200–1, cat. 48. Baltimore: Baltimore Museum of Art; Munich, London, and New York: Prestel.

Fowler, Caroline. 2019. "Technical Art History as Method." *The Art Bulletin*, special issue edited by Nina Athanassoglou-Kallmyer, 101 (4): 9–17.

Frank, Barbara E. 1998. *Mande Potters and Leatherworkers: Art and Heritage in West Africa.* Washington, DC: Smithsonian Institution Press.

———. 2002. "Thoughts on Who Made the Jenné Terra-Cottas: Gender, Craft Specialization, and Mande Art History." *Mande Studies* 4: 121–32.

Gagliardi, Susan Elizabeth. 2014. *Senufo Unbound: Dynamics of Art and Identity in West Africa.* Preface by Constantine Petridis. Exh. cat. Cleveland: Cleveland Museum of Art; Milan: 5 Continents Editions.

Galembo, Phyllis. 1993. *Divine Inspiration: From Benin to Bahia.* Albuquerque: University of New Mexico Press.

Garrard, Timothy F. 1989. *Gold of Africa: Jewellery and Ornaments from Ghana, Côte d'Ivoire, Mali and Senegal in the Collection of the Barbier-Mueller Museum.* Exh. cat. Munich: Prestel.

———. 1993. "The Arts of Metal in Côte d'Ivoire." In *Art of Côte d'Ivoire from the Collections of the Barbier-Mueller Museum*, edited by Jean Paul Barbier, 1: 384–401. 2 vols. Geneva: Barbier-Mueller Museum.

Gates, Henry Louis, Jr.. 1988. *The Signifying Monkey: A Theory of African-American Literary Criticism.* New York: Oxford University Press.

Gebauer, Paul. *Art of Cameroon.* 1979. Exh. cat. New York: Metropolitan Museum of Art; Portland, OR: Portland Art Museum.

Gell, Alfred. 1992. "The Technology of Enchantment and the Enchantment of Technology." In *Anthropology, Art, and Aesthetics*, edited by Jeremy Coote and Anthony Sheldon, 40–63. Oxford: Clarendon Press.

Glaze, Anita J. 1981a. *Art and Death in a Senufo Village.* Bloomington: Indiana University Press.

———. 1981b. "Door." In *For Spirits and Kings: African Art from the Tishman Collection*, edited by Susan Vogel, 50–51, cat. 24. Exh. cat. New York: Metropolitan Museum of Art.

———. 1993. "Call and Response: A Senufo Female Caryatid Drum." *Museum Studies* 19 (2): 118–33, 196–98.

Glaze, Anita J., with Ramona Austin. 1991. *Senufo Woman and Art: A Caryatid Drum.* Exh. pamphlet. Art Institute of Chicago, April 27–October 27, 1991.

Glaze, Anita J., and Alfred L. Scheinberg, eds. 1989. *Discoveries: African Art from the Smiley Collection.* Exh. cat. Urbana-Champaign: University of Illinois, Krannert Art Museum.

Goldwater, Robert. 1986. *Primitivism in Modern Art.* Cambridge, MA: Harvard University Press. Originally published New York and London: Harper and Brothers, 1938.

Gollmer, Charles A. 1885. "On African Symbolic Images." *Journal of the Anthropological Institute of Great Britain and Ireland* 14 (2): 169–82.

Grammet, Ivo. 1998. "Les bijoux." In *Splendeurs du Maroc*, edited by Ivo Grammet and Min De Meersman, 212–86. Exh. cat. Tervuren, Belgium: Royal Museum for Central Africa; Paris: Éditions Plume.

Granzotto, Clara, Ken Sutherland, Young Ah Goo, Amra Aksamija, and Constantine Petridis. 2020. "Surface Characterization of Accumulative African Sculptures: New Insights through Proteomic Analysis." Unpublished manuscript.

Grierson, Roderick, ed. 1993. *African Zion: The Sacred Art of Ethiopia.* Exh. cat. New Haven and London: Yale University Press.

Griaule, Marcel. 1938. *Masques dogons.* Paris: Institut d'ethnologie.

Guérin, Sarah M. 2019. "Gold, Ivory, and Copper: Materials and Arts of Trans-Saharan Trade." In *Caravans of Gold, Fragments in Time: Art, Culture, and Exchange across Medieval Saharan Africa*, edited by Kathleen Bickford Berzock, 175–201. Exh. cat. Evanston, IL: Block Museum of Art; Princeton, NJ: Princeton University Press.

Gunsch, Kathryn. 2018. *The Benin Plaques: A 16th Century Imperial Monument.* London: Routledge.

Guy, Jefferson John. 2014. "*Imifanekiso*: An Introduction to the Photographic Portraits of Dr. R. J. Mann." *Safundi: The Journal of South African and American Studies* 15 (2/3): 155–78.

Hackett, Rosalind. 1996. *Art and Religion in Africa.* London and New York: Cassell.

Hahner-Herzog, Iris, Maria Kecskési, and László Vajda. 1998. *African Masks from the Barbier-Mueller Collection.* Munich: Prestel Verlag.

Haile, Getatchew. 1992. *The Mariology of Emperor Zär'a Ya'eqob of Ethiopia.* Orientalia Christiana Analecta, 242. Rome: Pontificium Institutum Studiorum Orientalium.

Hallen, Barry. 2003. *The Good, the Bad, and the Beautiful: Discourse about Values in Yoruba Culture.* Bloomington: Indiana University Press.

Hamilton, Carolyn, and Nessa Leibhammer, eds. 2015. *Tribing and Untribing the Archive: Identity and the Material Record in Southern Natal in the Late Independent and Colonial Periods.* Pietermaritzburg, South Africa: University of KwaZulu-Natal Press.

Harley, George W. 1950. *Masks as Agents of Social Control in Northeast Liberia.* Papers of the Peabody Museum of American Archaeology and Ethnology at Harvard University, 32, no. 2. Cambridge, MA: Peabody Museum.

Harter, Pierre. 1986. *Arts anciens du Cameroun.* Arnouville, France: Arts d'Afrique noire.

Hawkins, Louisa Leila. 1862. "Aboriginal Ornament from the International Exhibition, 1862: Drawings and Handwritten Text for Henry Christy Esq." Unpublished manuscript, Ethnography Department, British Museum, London.

Heldman, Marilyn E. 1993. "Maryam Seyon: Mary of Zion." In *African Zion: The Sacred Art of Ethiopia*, edited by Roderick Grierson, 71–75. Exh. cat. New Haven: Yale University Press.

Henry, Frances. 2003. *Reclaiming African Religions in Trinidad.* Barbados: University of the West Indies Press.

Henry, Joseph. 1910. *L'Âme d'un peuple africain—Les Bambara: leur vie psychique, éthique, sociale, religieuse.* Münster: Aschendorffschen Buchhandlung.

Hirschoff, Paula M. 2002. "Ciwara: Hallmark of Hard Work Today as in the Past." *Anthropology News* 43 (2): 18.

Horton, Robin. n.d. "Ijo Ritual Sculpture." Lagos: Nigeria National Museum. Ms. Accession no. 194. Typescript.

———. 1965. *Kalabari Sculpture*. Lagos: Department of Antiquities, Federal Republic of Nigeria.

Hôtel Drouot. 1931. *Sculptures anciennes d'Afrique et d'Amérique. Collection G. de Miré.* Sale cat. Paris: Hôtel Drouot, Dec. 16.

Hountondji, Paulin J. 1983. *African Philosophy: Myth and Reality*. Bloomington: Indiana University Press.

Huet, Michel. 1978. *The Dance, Art and Ritual of Africa*. New York: Abrams.

Idowu, E. Bolaji. 1995. *Olódùmarè: God in Yoruba Belief*. Rev. ed. New York: Original Publications.

Imperato, Pascal James. 1970. "The Dance of the *Tyi Wara*." *African Arts* 4, no. 1 (Autumn): 8–13, 71–80.

———. 1972. "Contemporary Masked Dances and Masquerades of the Bamana Age Sets from the Cercle of Bamako, Mali." Paper presented at Conference on Manding Studies, School of Oriental and African Studies, London.

———. 1975. "Last Dances of the Bambara." *Natural History* 84 (4): cover, 62–71, 91.

———. 1977. *African Folk Medicine: Practices and Beliefs of the Bambara and Other Peoples*. Baltimore: York Press.

———. 1980. "Bambara and Malinke Ton Masquerades." *African Arts* 13 (4): 47–55, 82–85, 87.

———. 1981. "Sogoni Koun." *African Arts* 14 (2): 38–47, 72, 88.

Imperato, Pascal James, and Gavin H. Imperato. 2008. "Twins, Hermaphrodites, and an Androgynous Albino Deity: Twins and Sculpted Twin Figures among the Bamana and Maninka of Mali." *African Arts*, Representations of Twins in African Art, 41, no. 1 (Spring): 40–49.

Jahn, Jens, ed. 1994. *Tanzania: Meisterwerke Afrikanischer Skulptur/Sanaa Za Mabingwa Wa Kiafrika.* Exh. cat. Munich: Fred Jahn Verlag.

Johnson, Samuel. 1921. *The History of the Yorubas*. Lagos: Church Missionary Society Bookshops.

Jones, Erica P. 2016. "A Lending Museum: The Moving of Objects and the Impact of the Museum Space in the Grassfields (Cameroon)." *African Arts* 49, no. 2 (Summer): 6–19.

Jones, G. I. 1963. *The Trading States of the Oil Rivers: A Study of Political Development in Eastern Nigeria*. London: Oxford University Press.

———. 1984. *The Art of Eastern Nigeria*. Cambridge, UK: Cambridge University Press.

———. 1989. *Ibo Art*. Aylesbury, UK: Shire Ethnography.

Jordán, Manuel. 1993. "Le masque comme processus ironique: les makishi du nord-ouest de la Zambie." *Anthropologie et Sociétés* 17 (3): 41–46.

———. 1996. "Tossing Life in a Basket: Art and Divination among Chokwe, Lunda, Luvale and Related Peoples of Northwestern Zambia." PhD diss. University of Iowa.

———. 2000. "Revisiting *Pwo*." *African Arts* 33, no. 4 (Winter): 16–25.

———. 2003. "*Tupele:* Basket Divination Symbols of the Chokwe." *Tribal Art Magazine* 8 (1), no. 30 (Spring): 96–106.

———. 2004. "*Chikwekwe:* le masque calao des Tshokwe." *Arts & Cultures* 5: 127–33.

———. 2006. *Makishi: Mask Characters of Zambia*. Los Angeles: Fowler Museum at UCLA.

———. 2014. "Chokwe Pwo Masks: A Note on Style." *Tribal Art Magazine* 18 (2), no. 71 (Spring): 108–19.

Jordán, Manuel, ed. 1998. *Chokwe! Art and Initiation Among Chokwe and Related Peoples*. Exh. cat. Munich: Prestel for the Birmingham Museum of Art.

Jorissen, Tony. 2010. *De Lunda en de Tshokwe van Shaba*. Berg aan den Maas, Netherlands: Herman K. T. de Jonge.

Kart, Susan. 2020. "The Missing Women of Sande: A Necessary Exercise in Museum Decolonization." *African Arts* 53, no. 3 (Autumn): forthcoming.

Kasfir, Sidney Littlefield. 1984. "One Tribe, One Style? Paradigms in the Historiography of African Art." *History in Africa* 11: 163–93.

Kiangala, Manuel, ed. 1989. *A Evolução dos tronos Lunda-Cokwe*. Luanda, Angola: Museu Nacional de Antropologia.

Klopper, Sandra. 1991. "Zulu Headrests and Figurative Carvings: The Brenthurst Collection and the Art of South East Africa." In *Art and Ambiguity: Perspectives on the Brenthurst Collection*, edited by Patricia Davison, 80–98. Exh. cat. Johannesburg: Johannesburg Art Gallery.

———. 1992. "The Art of Zulu-Speakers in Northern Natal-Zululand: An Investigation of the History of Beadwork, Carving and Dress from Shaka to Inkatha." PhD diss., University of the Witwatersrand.

———. 2016. "Forging Identities in an Uncertain World: Changing Notions of Self and Other in Early Colonial Natal." In *Tribing and Untribing the Archive: Identity and the Material Record in Southern Natal in the Late Independent and Colonial Periods,* edited by Carolyn Hamilton and Nessa Leibhammer, 2: 335–55. 2 vols. Pietermaritzburg: University of KwaZulu-Natal Press, 2015–17.

Kreamer, Christine Mullen. 2003a. "A Tribute to Roy Sieber, Part 1." Memorial to Roy Sieber, Part 1, special issue edited by Christine Mullen Kreamer. *African Arts* 36, no. 1 (Spring): 12–23, 91.

———. 2003b. "A Tribute to Roy Sieber, Part 2." Memorial to Roy Sieber, Part 2, special issue edited by Christine Mullen Kreamer. *African Arts* 36, no. 2 (Summer): 10–29, 94.

LaGamma, Alisa. 2002. *Genesis: Ideas of Origin in African Sculpture*. Exh. cat. New York: Metropolitan Museum of Art; New Haven: Yale University Press.

LaGamma, Alisa, ed. 2007. *Eternal Ancestors: The Art of the Central African Reliquary*. Exh. cat. New York: Metropolitan Museum of Art.

———. 2015. *Kongo: Power and Majesty*. Exh. cat. New York: Metropolitan Museum of Art.

Lamp, Frederick John. 1985. "Cosmos, Cosmetics, and the Spirit of Bondo." *African Arts* 18 (3): 28–43, 98–99.

———. 1996. *The Art of the Baga: A Drama of Cultural Reinvention*. Exh. cat. New York: Museum for African Art; Munich: Prestel-Verlag.

———. 2004. "Sun, Fire, and Variations on Womanhood: A Baga/Buluñits Mask (*D'mba*)." In *See the Music, Hear the Dance: Rethinking African Art at the Baltimore Museum of Art*, edited by Frederick John Lamp, 222–25, cat. 53. Baltimore: Baltimore Museum of Art; Munich, London, and New York: Prestel Verlag.

LaViolette, Adria. 2000. *Ethno-Archaeology in Jenné, Mali: Craft and Status among Smiths, Potters and Masons*. BAR International Series, 838, Cambridge Monographs in African Archaeology, 49. Oxford: Archaeopress.

Lawal, Babatunde. 1974. "Some Aspects of Yoruba Aesthetics." *British Journal of Aesthetics* 14, no. 3 (Summer): 239–49.

———. 1977. "The Living Dead: Art and Immortality among the Yoruba of Nigeria." *Africa* 47 (1): 50–61.

———. 1995. "*À Yà Gbó, À Yà Tó*: New Perspectives on Edan Ògbóni." *African Arts* 28, no. 1 (Winter): 37–49, 98–100.

———. 1996a. "From Africa to the New World: Art in Yoruba Religion." In *Santeria Aesthetics in Contemporary Latin American*

Art, edited by Arturo Lindsay, 3–39. Washington, DC: Smithsonian Institution Press.

———. 1996b. *The Gelede Spectacle: Art, Gender, and Social Harmony in an African Culture.* Seattle and London: University of Washington Press.

———. 2000. "Orilonise: The Hermeneutics of the Head and Hairstyles among the Yoruba." In *Hair in African Art and Culture*, edited by Roy Sieber and Frank Herreman, 93–109. Exh. cat. New York: Museum for African Art; Munich: Prestel.

———. 2001. "Àwòrán: Representing the Self and Its Metaphysical Other in Yoruba Art." *The Art Bulletin* 83 (3): 489–526.

———. 2004. "Arts: Africa." In *New Dictionary of the History of Ideas*, vol. 6, edited by Maryanne C. Horowitz, 143–44. 6 vols. New York: Charles Scribner's Sons.

———. 2007. *Embodying the Sacred in Yoruba Art.* Exh. cat. Atlanta: High Museum of Art; Newark: Newark Museum.

———. 2008. "Èjìwàpò: The Dialectics of Twoness in Yoruba Art and Culture." *African Arts*, Representations of Twins in African Art, 41, no. 1 (Spring): 24–39.

———. 2012a. "*Ayeloja, Orunn'ile*: Imaging and Performing Yoruba Cosmology." In *African Cosmos: Stellar Arts*, edited by Christine Mullen Kreamer, 217–43. Exh. cat. New York: Monacelli Press in collaboration with the Smithsonian National Museum of African Art.

———. 2012b. *Yoruba.* Visions of Africa. Milan: 5 Continents Editions.

Le Fur, Yves, ed. 2009. *Musée du Quai Branly. The Collection. Art from Africa, Asia, Oceania, and the Americas.* Paris: Flammarion and Musée du quai Branly.

Lecoq, Raymond. 1953. *Les Bamiléké. Une civilisation africaine*. Paris: Éditions africaines.

Leiris, Michel. 1934. *L'Afrique fantôme. De Dakar à Djibouti (1931–1933)*. Paris: Gallimard.

Leloup, Hélène. 1994. *Dogon Statuary*. Translated by Brunhilde Biebuyck. Strasbourg: Éditions Danièle Amez.

Leonard, Arthur Glyn. 1906. *The Lower Niger and Its Tribes*. New York: Macmillan.

Lindsay, Arturo, ed. 1996. *Santeria Aesthetics in Contemporary Latin American Art*. Washington, DC: Smithsonian Institution Press.

Locke, Alain. 1927. *Blondiau-Theatre Arts Collection of Primitive African Art.* Exh. cat. New York: Theatre Arts Monthly.

Lovejoy, Arthur O. 1996. *The Revolt Against Dualism: An Inquiry Concerning the Existence of Ideas*. New Brunswick, NJ: Transaction Publishers.

Lucas, Jonathan Olumide. 1948. *The Religion of the Yorubas*. Lagos: Church Missionary Society Bookshop.

MacGaffey, Wyatt. 1993. "The Eyes of Understanding: Kongo Minkisi." In *Astonishment and Power: Kongo Minkisi & the Art of Renée Stout*, 19–103. Exh. cat. Washington, DC: Smithsonian Institution.

MacJannet, Malcolm Brooks. 1947. *Chokwe-English, English-Chokwe Dictionary and Grammar Lessons*. Vila Luso, Angola: Missâo da Biulu.

Mann, Robert. 1862. *London: The International Exhibition: A Descriptive Catalogue of the Natal Contribution to the International Exhibition.* London: Jarrold and Sons.

Masuka Maleka, Jean Claude. 1999. "Chaises Tshokwe d'avant 1960: Étude symbolique des figurines animales." MA thesis, Institut Supérieur Pédagogique, Lubumbashi, Democratic Republic of the Congo.

Matthys, Kaat. 1996. "Bete Sculpture: Unduly Unknown." *Gentse Bijdragen tot de Kunstgeschiedenis en Oudheidkunde* 31: 279–89.

Mazel, Vincent, Pascale Richardin, Delphine Debois, David Touboul, Marine Cotte, Alain Brunelle, Philippe Walter, and Olivier Laprévote. 2007. "Identification of Ritual Blood in African Artifacts Using TOF-SIMS and Synchrotron Radiation Microspectroscopies." *Analytical Chemistry* 79: 9253–60.

Mbiti, John. 1991. *African Religions and Philosophy.* 2nd ed. London: Heineman.

McIntosh, Roderick J. 2000. "Clustered Cities of the Middle Niger: Alternative Routes to Authority in Prehistory." In *Africa's Urban Past*, edited by David M. Anderson and Richard Rathbone, 19–35. Oxford: Oxford University Press.

McIntosh, Roderick J., and Susan Keech McIntosh. 1979. "Terracotta Statuettes from Mali." *African Arts* 12 (2): 51–53, 91.

Meillassoux, Claude. 1968. *Urbanization of an African Community: Voluntary Associations in Bamako*. Seattle and London: University of Washington Press.

Meyer, Piet. 1981. *Kunst und Religion der Lobi*. Exh. cat. Zurich: Museum Rietberg.

Monroe, John Warne. 2019. "Charles Ratton, Louis Carré, and the Landmark Auctions of 1931." *Tribal Art Magazine* 23 (4), no. 93 (Autumn): 94–117.

Morton-Williams, Peter. 1964. "An Outline of the Cosmology and Cult Organization of the Oyo Yoruba." *Africa* 34 (3): 243–61.

Mshana, Fadhili. 2013. "Art for Life among Coastal Peoples of Tanzania." In *Shangaa: Art of Tanzania,* edited by Gary van Wyk, 134–59. Exh. cat. New York: QCC Art Gallery of CUNY.

Mudimbe, Valentin-Yves. 1988. *The Invention of Africa: Gnosis, Philosophy and the Order of Knowledge.* Bloomington: Indiana University Press.

Müller, Klaus, and Ute Ritz-Müller. 2000. *Soul of Africa: Magical Rites and Traditions*. Cologne: Könemann.

Narayan, Kirin. 1993. "How 'Native' Is a Native Anthropologist?" *American Anthropologist* 95 (3): 671–86.

Nelson, Robert S., and Richard Schiff, eds. 2003. *Critical Terms for Art History*. Chicago: University of Chicago Press.

Nettleton, Anitra. 2007. *African Dream Machines: Style, Identity and Meaning of African Headrests.* Johannesburg: Wits University Press.

———. 2012. "In Pursuit of Virtuosity: Gendering 'Master' Pieces of Nineteenth-Century South African Indigenous Arts." *Visual Studies* 27 (3): 221–36.

———. 2018. "Zulu Vessels: The Archive and the History of a Genre." *Southern African Humanities* 31: 93–115.

Neyt, François. 1977. *La grande statuaire hemba du Zaïre*. Louvain-la-Neuve, Belgium: Institut supérieur d'archéologie et d'histoire de l'art de l'Université catholique de Louvain.

———. 1981. *Arts traditionnels et histoire au Zaïre—Cultures forestières et royaumes de la savane*. Brussels: Société d'arts primitifs.

———. 1993. *Luba—Aux sources du Zaïre*. Exh. cat. Paris: Éditions Dapper.

Ngubane, Harriet. 1977. *Body and Mind in Zulu Medicine: An Ethnography of Health and Disease in Nyuswa-Zulu Thought and Practice.* London: Academic Press.

Nooter, Mary H., ed. 1993. *Secrecy: African Art That Conceals and Reveals*. Exh. cat. New York: Museum for African Art; Munich: Prestel.

Notué, Jean-Paul, and Bianca Triaca. 2005a. *Baham. Arts, mémoire et pouvoir dans le Royaume de Baham.* Milan: 5 Continents Editions.

———. 2005b. *Bandjoun. Trésors royaux au Cameroun.* Milan: 5 Continents Editions.

———. 2005c. *Mankon. Arts, Heritage and Culture from the Mankon Kingdom.* Milan: 5 Continents Editions.

———. 2006. *Babungo. Treasures of the Sculptor Kings in Cameroon.* Milan: 5 Continents Editions.

Obiechina, Emmanuel. 1992. "Multiple Perspectives: The Dilemma of the African Intellectual in the Modern World." *Liberal Education* 78 (2): 16–21.

Odebunmi, E. O., O. O. Oluwaniyi, G. V. Awolola, and O. D. Adediji. 2009. "Proximate and Nutritional Composition of Kola Nut (*Cola nitida*), Bitter Cola (*Garcinia cola*) and Alligator Pepper (*Afromomum melegueta*)." *African Journal of Biotechnology* 8 (2): 308–10.

Oelmann, Albin. 1979. "Nduen Fobara." *African Arts* 12 (2): 36–43, 90.

O'Hern, Robin, Ellen Pearlstein, and Susan Elizabeth Gagliardi. 2016. "Beyond the Surface: Where Cultural Contexts and Scientific Analyses Meet in Museum Conservation of West African Power Association Helmet Masks." *Museum Anthropology* 39, no. 1 (Spring): 70–86.

Ojo, G. J. Afolabi. 1966a. *Yoruba Culture: A Geographical Analysis*. London: University of London Press.

———. 1966b. *Yoruba Palaces: A Study of Afins of Yorubaland*. London: University of London Press.

Okediji, Moyo. 1997. "Art of the Yoruba: African Art at the Art Institute of Chicago." In *African Art at the Art Institute of Chicago*, special issue edited by Kathleen E. Bickford. *Museum Studies* 23 (2): 168–69.

Ola, Yomi. 2013. *Satires of Power in Yoruba Visual Culture*. Durham, NC: Carolina Academic Press.

Olajubu, Oyeronke. 2003. *Women in the Yoruba Religious Sphere*. New York: State University of New York Press.

Olatunji, Olatunde O. 1984. *Features of Yoruba Oral Poetry*. Ibadan, Nigeria: Ibadan University Press.

Olbrechts, Frans M. 1940. "Stijl en sub-stijl in de plastiek der Ba-Luba (Belg. Kongo): de 'Kabila'-stijl." *Wetenschappelijke Tijdingen* 5 (1): 22–30.

———. 1941. "Centre pour l'étude de l'art africain à l'Université de Gand." *Bulletin de l'Institut royal colonial belge* 12 (1): 257–59.

———. 1943. "Contribution to the Chronology of African Plastic Art." *Africa* 14 (4): 183–93.

———. 1946. *Plastiek van Kongo*. Antwerp: Standaard-Boekhandel.

———. 1951. "Découverte de deux statuettes d'un grand sous-style ba-luba." *Bulletin de l'Institut royal colonial belge* 22 (1): 130–40.

Olbrechts, Frans M., and Adriaan G. Claerhout. 1956. *Het masker: alle volken, alle tijden / Le masque: de tous peuples, de tous temps / The Mask: All Peoples, All Times*. Exh. cat. Antwerp: Royal Museum of Fine Arts.

Olupona, Jacob K., and Terry Rey. 2008. *Orisa Devotion as World Religion: The Globalization of Yoruba Religious Culture*. Madison: University of Wisconsin Press.

Opadotun, Olatunji. 1986. *Arokò: àwọn àmì àti iró ibánisòrò ilè Yorùbá l'áyé ìjelòó*. Ibadan, Nigeria: Vantage Publishers.

Parrinder, Geoffrey. 1949. *West African Religion*. London: Epworth Press.

———. 1967. *African Mythology*. London: Paul Hamlyn.

———. 1969. *Religion in Africa*. Baltimore: Penguin.

Parsons, Sarah Watson. 1999. "Interpreting Projections, Projecting Interpretations: A Reconsideration of the 'Phallus' in Esu Iconography." *African Arts* 32, no. 2 (Summer): 36–45, 90–91.

Pelrine, Diane M. 1996. *Affinities of Form: Arts of Africa, Oceania, and the Americas from the Raymond and Laura Wielgus Collection*. Introduction by Roy Sieber. Exh. cat. Munich and New York: Prestel.

Pelrine, Diane M. 2014. "Art and Life among the Zaramo of Tanzania." In *Art and Life in Africa*, edited by Christopher D. Roy. Iowa City: University of Iowa Stanley Museum of Art. https://africa.uima.uiowa.edu/topic-essays/show/7. Accessed Apr. 15, 2020.

Pemberton, John, III. 1975. "Eshu-Elegba, the Yoruba Trickster God." *African Arts* 9 (1): 20–27, 66–70, 90–91.

———. 1989a. "Art and Rituals for Yoruba Sacred Kings." *Museum Studies* 15 (2): 96–111.

———. 1989b. "The Carvers of the Northeast." In *Yoruba: Nine Centuries of African Art and Thought*, by Henry J. Drewal and John Pemberton III, with Rowland O. Abiodun, 189–211. Exh. cat. New York: Center for African Art.

Pemberton, John, III, and Funso S. Afolayan. 1996. *Yoruba Sacred Kingship: "A Power Like That of the Gods."* Washington, DC, and London: Smithsonian Institution Press.

Pereira, Duarte Pacheco. 1937. *Esmeraldo de Situ Orbis*. Translated by G. H. T. Kimble. London: Hakluyt Society.

Perrois, Louis. 1972. *La Statuaire fan, Gabon*. Mémoires ORSTOM, 59. Paris: O.R.S.T.O.M.

———. 1976. "L'art Kota-Mahongwe." *Arts d'Afrique noire* 20 (Winter): 15–37.

———. 1986. *Ancestral Art of Gabon from the Collections of the Barbier-Mueller Museum*. Exh. cat. Geneva: Musée Barbier-Mueller.

———. 2006. *Fang*. Visions of Africa. Milan: 5 Continents Editions.

———. 2007. "The Western Historiography of African Reliquary Sculpture." In *Eternal Ancestors: The Art of the Central African Reliquary*, edited by Alisa LaGamma, 63–77. Exh. cat. New York: Metropolitan Museum of Art.

———. 2012. *Kota*. Visions of Africa. Milan: 5 Continents Editions.

Petridis, Constantine. 1997. "Of Mothers and Sorcerers: A Luluwa Maternity Figure." In *African Art at the Art Institute of Chicago*, special issue edited by Kathleen E. Bickford. *Museum Studies* 23 (2): 182–95.

———. 2001a. "Chokwe Masks and Franciscan Missionaries in Sandoa, Belgian Congo, ca. 1948." *Anthropos* 96: 3–28

———. ed. 2001b. *Frans M. Olbrechts (1899–1958): In Search of Art in Africa*. Exh. cat. Antwerp: Ethnographic Museum.

———. 2001c. "Olbrechts and the Morphological Approach to African Sculptural Art." In *Frans M. Olbrechts (1899–1958): In Search of Art in Africa*, edited by Constantine Petridis, 118–40. Exh. cat. Antwerp: Ethnographic Museum.

———. 2012. "A 'Harley Mask' at the Cleveland Museum of Art: More on Masks among the Mano and Dan Peoples (Liberia/Côte d'Ivoire)." *African Arts* 45, no. 1 (Spring): 16–31.

———. 2017a. "Inscriptions: Establishing a Pre-1937 Acquisition Date for 1,525 Central African Sculptures." *Tribal Art Magazine* 21 (4), no. 85 (Autumn): 106–21.

———. 2017b. "Meditations on Hemba Ancestral Figures." In Luigi Spina, *Hemba*, 124–37. Milan: 5 Continents Editions.

———. 2018. *Luluwa: Central African Art Between Heaven and Earth*. Brussels: Mercatorfonds.

Petridis, Constantine, with Kirstin Krause Gotway. 2018. "Art of Central Africa at the Indianapolis Museum of Art." *African Arts* 51, no. 4 (Winter): 34–47.

Phillips, Ruth B. 1994. "Fielding Culture: Dialogues between Art History and Anthropology." *Museum Anthropology* 18 (1): 39–46.

———. 1995. *Representing Women: Sande Masquerades of the Mende of Sierra Leone*. Los Angeles: UCLA Fowler Museum of Cultural History.

Plankensteiner, Barbara. 2007a. "The 'Benin Affair' and its Consequences." In *Benin, Kings and Rituals: Court Arts from Nigeria*, edited by Barbara Plankensteiner, 199–211. Exh. cat. Ghent: Snoeck Publishers.

———. 2007b. "Introduction." In *Benin, Kings and Rituals: Court Arts from Nigeria*, edited by Barbara Plankensteiner, 21–39. Exh. cat. Ghent: Snoeck Publishers.

Poynor, Robin. 1984. *Nigerian Sculpture: Bridges to Power*. Exh. cat. Birmingham, AL: Birmingham Museum of Art.

Preston, George Nelson. 1975. *African Sculpture: Rare and Familiar Forms from the Anspach Collection.* Exh. cat. Potsdam, NY: Brainerd Hall Art Gallery, State University College.

Prince, Raymond. 1961. "The Yoruba Image of the Witch." *Journal of Mental Science* 107: 795–805.

Prouteaux, M. 1929. "Premiers essais de théâtre chez les indigènes de la haute Côte d'Ivoire." *Bulletin du Comité d'études historiques et scientifiques de l'A.O.F* 12: 448–75.

Puccinelli, Lydia. 1999. "Crest Mask." In *Selected Works from the Collection of the National Museum of African Art*, edited by Roslyn Adele Walker, 97, cat. 66. Washington, DC: National Museum of African Art, Smithsonian Institution.

Rattray, R. S. 1927. *Religion and Art in Ashanti.* London: Oxford University Press.

Ray, Benjamin C. 2000. *African Religions: Symbol, Ritual, and Community.* 2nd ed. Upper Saddle River, NJ: Prentice Hall.

Redinha, José. 1956. *Máscaras de madeira da Lunda e Alto Zambeze.* Lisbon: Museu do Dundo.

Richter, Dolores. 1981. "Helmet Mask (*Kponyugu*)." In *For Spirits and Kings: African Art from the Tishman Collection,* ed. Susan Vogel, 42, cat. 20. Exh. cat. New York: Metropolitan Museum of Art.

Roberts, Allen F. 1995. *Animals in African Art: From the Familiar to the Marvelous.* Exh. cat. Munich and New York: Prestel for the Museum for African Art.

———. 1988. "Of Dogon Crooks and Thieves." *African Arts* 21 (4): 70–75, 91–92.

Roberts, Mary Nooter. 1995. "Caryatid Stool." In *African Masterworks in the Detroit Institute of Arts*, edited by Michael Kan and Roy Sieber, 152–53, cat. 78. Detroit: Detroit Institute of Arts; Washington, DC, and London: Smithsonian Institution Press.

———. 1998. "The Naming Game: Ideologies of Luba Artistic Identity." *African Arts*, Authorship in African Art, Part 1, 31, no. 4 (Autumn): 56–73, 90–92.

———. 2005. "New Directions in African Art(s)." *African Arts* 38, no. 4 (Winter): 1, 4, 6, 91.

Roberts, Mary Nooter, and Allen F. Roberts. 1997. *A Sense of Wonder: African Art from the Faletti Family Collection.* Exh. cat. Phoenix, AZ: Phoenix Art Museum.

Roy, Christopher D. 1987. *Art of the Upper Volta.* Meudon, France: Alain et Françoise Chaffin.

———. 1992. *Art and Life in Africa: Selections from the Stanley Collection, Exhibitions of 1985 and 1992.* Exh. cat. Iowa City: University of Iowa Museum of Art.

Rubin, William, ed. 1984. *"Primitivism" in 20th Century Art: Affinities of the Tribal and the Modern.* Exh. cat. 2 vols. New York: Museum of Modern Art.

Scheinberg, Alfred L. 1989. "Dance Crest." In *Discoveries: African Art from the Smiley Collection,* edited by Anita J. Glaze and Alfred L. Scheinberg, 55, cat. 32. Exh. cat. Urbana-Champaign: University of Illinois, Krannert Art Museum.

Schildkrout, Enid, and Curtis A. Keim, eds. 1990. *African Reflections: Art from Northeastern Zaire.* Exh. cat. New York: American Museum of Natural History.

Schweinfürth, Georg. 1874. *Im Herzen von Afrika: Reisen und Entdeckungen im Zentralafrika, während der Jahre 1868 bis 1871.* 2 vols. Leipzig: F. A. Brockhaus.

Schmalenbach, Werner, ed. 1988. *Arts de l'Afrique noire dans la collection Barbier-Mueller.* Exh. cat. Paris: Éditions Fernand Nathan.

Shaw, Thurstan, and S. G. H. Daniels. 1984. "Excavations at Iwo Eleru, Ondo State, Nigeria." *West African Journal of Archaeology* 14: 1–269.

Sieber, Roy. 1962. "Masks as Agents of Social Control in Northeast Liberia." *African Studies Review* 5 (2): 8–13.

———. 1969. *The Sculpture of Northern Nigeria.* Exh. cat. New York: Museum of Primitive Art.

———. 1986. "A Note on History and Style." In *Vigango: Commemorative Sculpture of the Mijikenda of Kenya*, edited by Ernie Wolfe III, 25–32. Williamstown, MA: Williams College Museum of Art.

Sieber, Roy, and Arnold Rubin. 1968. *Sculpture of Black Africa: The Paul Tishman Collection.* Exh. cat. Los Angeles: Los Angeles County Museum of Art.

Siegmann, William C. 1980. *African Sculpture from the Collection of the Society of African Missions.* Exh. cat. Tenafly, NJ: Society of African Missions.

———. 2009. *African Art: A Century at the Brooklyn Museum.* New York: Brooklyn Museum; Munich, Berlin, London, and New York: DelMonico Books and Prestel.

Silverman, Raymond. 2019. "Red Gold: Things Made of Copper, Bronze, and Brass." In *Caravans of Gold, Fragments in Time: Art, Culture, and Exchange across Medieval Saharan Africa*, edited by Kathleen Bickford Berzock, 257–67. Exh. cat. Evanston, IL: Block Museum of Art; Princeton, NJ: Princeton University Press.

Smith, Robert S. 1988. *Kingdoms of the Yoruba.* Madison: University of Wisconsin Press.

Sotheby's Paris. 2012. *Arts d'Afrique et d'Océanie.* Sale cat. Paris: Sotheby's Paris, June 12.

———. 2015a. *Arts d'Afrique et d'Océanie.* Sale cat. Paris: Sotheby's Paris, June 24.

———. 2015b. *Arts d'Afrique et d'Océanie.* Sale cat. Paris: Sotheby's Paris, Dec. 2.

———. 2017. *Arts d'Afrique et d'Océanie.* Sale cat. Paris: Sotheby's Paris, June 21.

Steiner, Christopher B. 2018. "The Missionary as Collector and Dealer: Dr. George W. Harley in Liberia, 1925–1960." *Critical Interventions* 12 (1): 36–51.

Strother, Z. S. 1998. *Inventing Masks: Agency and History in the Art of the Central Pende.* Chicago: University of Chicago Press.

Studstill, John. 1970. "L'Arbre ancestral." In *Le Thème de l'arbre dans les contes africains,* edited by Geneviève Calame-Griaule, 2: 119–37. 3 vols. Paris: Selaf.

Stuhlmann, Franz. 1910. *Handwerk und Industrie in Ostafrika: Kulturgeschichtliche Betrachtungen.* Abhandlungen des Hamburgischen Kolonialinstituts, 1. Hamburg: L. Friederichsen.

Szumowski, George. 1957. "Pseudo-tumulus des environs de Bamako." *Notes Africaines* 75: 66–73.

Talbot, P. A. 1967. *The Tribes of the Niger Delta.* London: Frank Cass. Originally published London: Sheldon Press; New York and Toronto: Macmillan, 1932.

Tauxier, Louis. 1927. *La religion bambara.* Paris: Librairie Orientaliste Paul Geuthner.

Thompson, Barbara. 2004. "The African Collection at the Hood Museum of Art." *African Arts* 37, no. 2 (Summer): 14–33, 93.

———. 2013. "Transformation in the Sacred Arts of Healing in Northeastern Tanzania." In *Shangaa: Art of Tanzania,* edited by Gary van Wyk, 161–85. Exh. cat. New York: QCC Art Gallery of CUNY.

Thompson, Robert Farris. 1970. "The Signs of the Divine King: An Essay on Yoruba Bead-Embroidered Crowns with Veil and Bird Decorations." *African Arts* 3, no. 3 (Spring): 8–17, 74–80.

———. 1971. *Black Gods and Kings: Yoruba Art at UCLA.* Exh. cat. Los Angeles: University of California Press.

———. 1972. "The Sign of the Divine King: Yoruba Bead-Embroidered Crowns with Veil and Bird Decorations." In *African Art and Leadership,* edited by Douglas Fraser and Herbert M. Cole, 227–60. Madison: University of Wisconsin Press.

———. 1974. *African Art in Motion: Icon and Act.* Exh. cat. Los Angeles and Berkeley: University of California Press.

———. 1993. *Face of the Gods: Art and Altars of Africa and the African Americas.* Exh. cat. New York:

Museum for African Art; Munich: Prestel.

Torgovnick, Marianne. 1992. *Gone Primitive: Savage Intellects, Modern Lives.* Chicago: University of Chicago Press.

van Beek, Walter E. A. 1988. "Functions of Sculpture in Dogon Religion." *African Arts* 21 (4): 58–65, 91.

———. 1991. "Dogon Restudied: A Field Evaluation of the Work of Marcel Griaule." *Current Anthropology* 32 (2): 139–67.

van Damme, Wilfried. 1996. *Beauty in Context: Towards an Anthropological Approach to Aesthetics.* Philosophy of History and Culture, 17. Leiden and New York: E. J. Brill.

Van Wassenhove, Donatienne. 1996. *Sièges de l'Afrique centrale.* Tervuren, Belgium: Royal Museum of Central Africa.

van Wyk, Gary, ed. 2013. *Shangaa: Art of Tanzania.* Exh. cat. New York: QCC Art Gallery of CUNY.

Vandenbergen, Hannelore. 2018. "*Pongdudu* Mask." In *Unrivalled Art: Spellbinding Artefacts at the Royal Museum for Central Africa*, edited by Julien Volper, 142–43. Exh. cat. Tervuren, Belgium: Royal Museum for Central Africa; Kontich, Belgium: BAI Publishers.

Vandenhoute, Pieter J. L. 1948. *Classification stylistique du masque Dan et Guéré de la Côte d'Ivoire occidentale (A.O.F.).* Mededelingen van het Rijksmuseum voor Volkenkunde, 4. Leiden: E. J. Brill.

Verger, Pierre. 1957. *Notes sur le culte des Orisa et Vodun.* Dakar: IFAN.

———. 1965. "Grandeur et décadence du culte de Iyami Osoronga: ma mère la sorcière chez la Yoruba." *Journal de la Société des Africanistes* 35 (1): 141–24.

Visonà, Monica Blackmun. 1983. "Art and Authority among the Akye of the Ivory Coast." PhD diss., University of California, Santa Barbara.

———. 1993. "The Lagoons Peoples." In *Art of Côte d'Ivoire from the Collections of the Barbier-Mueller Museum*, edited by Jean Paul Barbier, 1: 368–83. 2 vols. Geneva: Barbier-Mueller Museum.

Vogel, Susan Mullin. 1986. *African Aesthetics: The Carlo Monzino Collection.* Exh. cat. New York: Center for African Art.

———. 1997. *Baule: African Art/Western Eyes.* Exh. cat. New Haven: Yale University Press and Yale University Art Gallery.

———. 1999. "Known Artists but Anonymous Works: Fieldwork and Art History." *African Arts*, Authorship in African Art, Part 1, 32, no. 1 (Spring): 40–55, 93–94.

———. 2005. "Whither African Art? Emerging Scholarship at the End of an Age." *African Arts* 38, no. 4 (Winter): 12–17, 91.

———. 2017. "Ancestral Shrine Staff." In *Arts of Global Africa: The Newark Museum Collection*, edited by Christa Clarke, 104–5, cat. 23. Seattle: Lucia | Marquand.

Walker, Roslyn Adele. 1998. *Olowe of Ise: A Yoruba Sculptor to Kings.* Exh. cat. Washington, DC: National Museum of African Art, Smithsonian Institution.

Wanless, Ann. 1991. "Public Pleasures: Smoking and Snuff-Taking in Southern Africa." In *Art and Ambiguity: Perspectives on the Brenthurst Collection of Southern African Art*, edited by Patricia Davison, 126–43. Exh. cat. Johannesburg: Johannesburg Art Gallery.

Wardwell, Allen. 1966. "Some Notes on a Substyle of the Bambara." *Museum Studies* 1: 112–28.

———. 1970. "New Acquisitions of African Art at the Art Institute of Chicago." *African Arts* 4, no. 1 (Autumn): 14–19.

Webb, James L. A., Jr. 1995. *Desert Frontier: Ecological and Economic Change along the Western Sahel, 1600–1850.* Madison: University of Wisconsin Press.

Wescott, Joan. 1962. "The Sculpture and Myths of Eshu-Elegba." *Africa* 32: 337–54.

Willett, Frank. 1967. *Ife in the History of West African Sculpture.* London: Thames and Hudson.

Windmuller-Luna, Kristen. 2016. "Building Faith: Ethiopian Art and Architecture during the Jesuit Interlude, 1557–1632." PhD diss., Princeton University.

Wingert, Paul S. 1962. *Primitive Art: Its Traditions and Styles.* New York: Oxford University Press.

Wolff, Norma H. 2004. "African Artisans and the Global Market: The Case of Ghanaian 'Fertility Dolls.'" *African Economic History* 32: 123–41.

Wooten, Stephen R. 2000. "Antelope Headdresses and Champion Farmers: Negotiating Meaning and Identity through the Bamana *Ciwara* Complex." *African Arts* 33, no. 2 (Summer): 18–33, 89–90.

———. 2009. *The Art of Livelihood: Creating Expressive Agriculture in Rural Mali.* Durham, NC: Carolina Academic Press.

Wyndham, John. 1921. *Myths of Ife.* London: Erskine Macdonald.

Zahan, Dominique. 1974. *The Bambara.* Leiden: E. J. Brill.

———. 1960. *Sociétés d'initiation bambara. Le N'domo. Le Korè.* Paris: Mouton.

———. 1980. *Antilopes du soleil. Arts et rites agraires d'Afrique noire.* Vienna: Édition A. Schendl.

Zahan, Dominique. 2000. "The Two Worlds of *Ciwara*." Translated by Allen F. Roberts. *African Arts* 33, no. 2 (Summer): 34–45, 90.

Zuesse, Evan. 1979. *Ritual Cosmos: The Sanctification of Life in African Religion.* Athens: Ohio University Press.

Contributors

Martha G. Anderson is professor emeritus of the School of Art and Design at Alfred University, New York. Her publications include *African Photographer J. A. Green: Reimagining the Indigenous and the Colonial* (co-edited with Lisa Aronson; 2017) and *Ways of the River: Arts and Environment of the Niger Delta* (co-edited with Philip M. Peek; 2002).

Kathleen Bickford Berzock is Associate Director of Curatorial Affairs at the Block Museum of Art, Northwestern University, Evanston, Illinois. She served as curator of African art at the Art Institute of Chicago from 1995 to 2013. Her recent projects include the exhibition and accompanying catalogue *Caravans of Gold, Fragments in Time: Art, Culture, and Exchange across Medieval Saharan Africa* (2019).

Pascal James Imperato, a physician and former professor of tropical medicine and public health, is Founding Dean and Dean Emeritus of the School of Public Health at the State University of New York Downstate Medical Center, Brooklyn. His most recent publications are *Mali: A Search for Direction* (2019) and *Quest for the Jade Sea: Colonial Competition around an East African Lake* (2018).

Manuel Jordán is Deputy Director and Chief Curator at the Musical Instrument Museum, Phoenix, Arizona. He previously served as curator of African art at the Iris & B. Gerald Cantor Center for Visual Arts at Stanford University, California, and at the Birmingham Museum of Art, Alabama. His publications include *Embodiments: Masterworks of African Figurative Sculpture* (co-edited with Christina Hellmich; 2014) and *Makishi: Mask Characters of Zambia* (2007).

Babatunde Lawal is professor of art history at Virginia Commonwealth University, Richmond, Virginia. His recent publications include *Yoruba* (2012), in the Visions of Africa series by 5 Continents Editions, Milan, and *Embodying the Sacred in Yoruba Art: Featuring the Bernard and Patricia Wagner Collection* (2007), in conjunction with an exhibition of the same name co-organized by the High Museum of Art, Atlanta, and the Newark Museum.

Anitra Nettleton is professor emeritus of the division of the History of Art and Chair and Director of the Centre for Creative Arts of Africa at the Wits Art Museum, University of the Witwatersrand, Johannesburg, South Africa. Her publications include *Beadwork, Art and the Body:* Dilo Tše Dintshi/*Abundance* (2016) and *African Dream Machines: Style, Identity and Meaning of African Headrests* (2007).

Constantine Petridis is Chair and Curator, Arts of Africa, at the Art Institute of Chicago. He previously served as curator of African art at the Cleveland Museum of Art and assistant professor of art history at Case Western Reserve University. His publications include *Luluwa: Central African Art Between Heaven and Earth* (2018) and *Art and Power in the Central African Savanna* (2008).

Janet M. Purdy recently completed her doctorate in art history at Penn State University with a dissertation focused on Swahili carving. She pursued research in Tanzania as a Fulbright Scholar (2018–19) and was awarded the Daniel F. and Ada L. Rice Postdoctoral Curatorial Fellowship in African Art at the Art Institute of Chicago (2020–23).

This book was made possible by a grant from **The Andrew W. Mellon Foundation**.

Index

Page numbers in *italics*
indicate illustrations.

figure screen (*duein fubara*), Ijo; Nigeria (cat. 46), 118, *119*

figures: *akua'ba/akua'maa*, 88, *89*; *angokh nlo byeri*, *136*, 137; *a-tshol/ tshol*, *72–73*, 73; Bankoni-style terracotta, 13, *32*, 33; *bateba phuwe*, *38*, 39; *boli/boliw*, 44, *46–47*, 47; Dogon or Tellem, *37*; encrusted surfaces, 13, 37, 39, 44, 47, 73, 88, 123, 149; *eyema byeri*, *136*, 137; Kantana, *122*, 123; forest spirits, 60–67, *61*; *lumbr*, *38*, 39; *mbëlëkët*, *72–73*, 73; *mbulu ngulu*, *2*, *138–39*, 139; *nkisi nkondi/minkisi minkondi*, *140–41*, 141; portrait figures of Metang (10th king of Batufam) and Queen Nana, by Mbeudjang (cat. 50), 124, *124–25*; *singiti*, 156, *156–67*. *See also* kneeling figures; maternal/ mother-and-child figures

First Gondarine style, 187

Fischer, Eberhard, 74

forest and water spirits, Ijo; Nigeria, 60–67, *61*, *64–66*, 117

Forni, Silvia, 19n24

Fortier, François-Edmond, 24, *24*

funerary ceremonies, objects, and associations, 51, 55, 56, 66, 79, 118, 137, 139, 151, 152, 156, 159, 175, 193

furniture: chief's chair (*chitwamo* or *njunga*), Chokwe; Angola (cat. 59), 146, *146–47*; male caryatid stool, Songye; Democratic Republic of the Congo (cat. 63), *154*, 155, *156*; title stool, Igbo; Nigeria, *121*. *See also* headrests

G

Ga girl, Addah, *88*

Gagliardi, Susan Elizabeth, 19n10, 19n23, 19n28

Gbagba performance, *85*

Gèlèdé headdress, 108, *109*

Gèlèdé society, 108

Gell, Alfred, 173

Glaze, Anita J., 19n22, 52, 55, 123

Goemai, 123

goldwork, 31, *90*, 91

Griaule, Marcel, 19n27, 37

Gu, Guro; Côte d'Ivoire, *79*

Guillaume, Paul, 24

guinea fowl, 130–31

Gunsch, Kathryn, 94n1

Guro, *78–81*, *79–80*

Gwomba, 27, *27*

H

hair and hairdressing: halo coiffure, 160, *160–61*; *isicoco*, 166, 171–72, 181; in Zulu culture, *171*, 171–72, *172*

Ham people, 123, *123*

Harley, George W., 74

Harwood, Mitchell A., 139

Hawkins, Louisa Leila, 170, *170*, 172

head, in Yòrùbá art and culture, 191–93, *192*

head figure (*angokh nlo byeri*), Fang; Gabon (cat. 53), *136*, 137

headband, Imazighen; Morocco (cat. 2), *30*, 30–31

headdresses: Ègúngún masquerade, *106–7*, 107, 193; *Epa* headdress, *110*, 111, 193; *igi Gèlèdé*, 108, *109*, 193; *ngambak* crest mask, 122; *nimba*, *d'mba*, or *yamban*, *68–69*, 69; *töngköngba* headdress, 73; *Tyi Wara kunw*, 22–28, *23*, *24*, *26*, *27*, 43. *See also* masks *and under* royal accoutrements

headrests: *isicamelo* or *isigqiki*, Zulu; South Africa, 166–73, *167*, *168*, *169*, *170*; *musawa* or *musau*, Yaka; Democratic Republic of the Congo (cat. 57), *144*, 145

headring. *See isicoco*

head-shaving, 83, 178, 192

helmet (*Sigi kun*), Bamana; Mali (cat. 12), 48, *49*

helmet masks: *banda* or *kumbaruba*, *13*, 70, *70–71*, 73; *bongo*, 152; *bwoom*, *150*, 151; *kholuka* or *mbala*, *4*, *142–43*, 143, 145; *Kono kunw*, 13, 44, *44–45*, 47; *kponyungo*, *50–51*, 51; *lipiko*, by Diteka (cat. 71), 178, *178–79*; *mukenga*, 151, 152, *152–53*; *ndoli jowei*, *76–77*, 77. *See also specific masks*

Hemba, 156, *156–57*

Henry, Joseph, 24, 44, *47*

Herskovits, Melville, 19n27

Himmelheber, Hans, 19n27, 74

"historical African art," as term, 10–11

hornbills, 25–26, 74

Horton, Robin, 66, *66*, 67

Huet, Michel, *40*, *51*

hyena, 51

I

Ibibio puppets, 118

ibori, 192, *192*

Ida Ou Nadif, *30*, 30–31, *31*

Saint Ildephonsus of Toledo, *184*, 187

idimu, Lega; Democratic Republic of the Congo (cat. 65), *158–59*, 159

Ifá, 103, 115, 189, 190–91, *191*

Igbo, 17, *120*, 121

Ìgbómìnà Yòrùbá, 111

igi Gèlèdé headdress/mask, by Fágbìté Àsàmú or Fálolá Edun, Yòrùbá; Benin (cat. 40), 108, *109*, 193

Ìjèsà Yòrùbá, 111

Ijo, *64–66*, 60–67, *61*, 117, 118, *119*

ikúnlè, 98, 101

ilé-orí, 192

The Illustrated London News, 172, 173n13

Imazighen (Berber), *30*, 30–31, *31*

impelo/yimpelo, 131

initiation ceremonies: *babende* initiation, 152; in Baga/Nalu cultures, 70, 73; Bamana N'Tomo society, 43; in Bwa culture, 40, 162; Bwami association, 159; *bwanga bwa cibola* fertility initiation ritual, 149; circumcision or clitoridectomy, 40, 43, 77n3, 143; helmet masks used in, 44, 51, 77, 143, 145, 152, 178; Kono initiation society, 44, 47; in Kuba kingdom, 151; *mukanda* initiation of boys, 128, 130, 131, 133, 134nn6–7, 135n9, 135n14, 135n20; *nkaan* initiation, 151; *n-khanda* initiation, 143; Poro

association and, 51, 55; scarification and, 130; Tyekpa/Sandogo associations and, 55; *Tyi Wara* as, 24, 27

inkomo yamadlozi, 171

inner head, 191–92, *192*

International Exhibition (1862; London), 170, 171, 172, 181

iróké Ifá: divination session with, *103*, 191; with maternity figure (cat. 37), *102*, 103; with supplicant and hunter (cat. 36), *102*, 103

iroko, 121, 156

ishyeen imaalu, 152

isicamelo or *isigqiki*, Zulu; South Africa (cat. 68), 166–73, *167*, *168*, *169*, *170*

isicoco, 166, 171–72, 181

isigodo, 171

isithunzi, 172

isiZulu-speakers, 166–73, 181, 183

Islam: conversions to, 43, 69, 115, 177, 178, 193, 194; culture and influence of, 56, 178; Sarakolé adherence to, 43; *Tyi Wara* and decline of, 28; Yòrùbá royal crowns and, 115. *See also* Jula; Qur'an boxes

Islamic Revolution (1954–57), 69

Isobowei, *64*

Isoko, 65

Israel, Paolo, 178n1

ivory, 93–94, *95*, *102*, *139*, 139, 152

Ìyá Nlá, 108

iyá oba, 97, 192, 195n28

J

Jaba, 123

jagúnjagún, 97, *110*, 111

Janis, Fran, 139

Jenné-Jeno, 33, 34, *35*

Jesuits, 187

jewelry: bracelets, Ida Ou Nadif, Morocco (cat. 2), *31*; clasps, Imazighen; Morocco, *30*, 31 (cat. 2); earrings, Imazighen; Morocco, *30*, 31 (cat. 2); headband, Imazighen, Morocco (cat. 2), *30*, 31. *See also* pectoral disks

Jones, G. I., 117, 117n1

Jones-Henderson, Napoleon, 195n43

Jorissen, Tony, 133

Jula, 56, *56*, 57

K

kacenefolo, 52

Kagoro, 123

Kalabari, 118, *119*

kalamba kuku wa lunga and *kalamba kuku wa pwo*, 146

Kamantan, 123

Kamer, Henri, 43

kangongo, 132

Kantana, *122*, 123

Karamojong, 168

Kasembele, 55

Kasfir, Sidney Littlefield, 13

Kemepara, 62

Kétu (kingdom), 108

Kétu (master sculptor), 104,

kholuka or *mbala*, Yaka; Democratic

First edition
Printed in Florence, Italy
ISBN: 9780300254327 (HARDCOVER)
LCCN: 2020940576

Published by
The Art Institute of Chicago
111 South Michigan Avenue
Chicago, IL 60603-6404
artic.edu

Distributed by
Yale University Press
302 Temple Street
P. O. Box 209040
New Haven, CT 06520-9040
yalebooks.com/art

This book was made using paper and
materials certified by the Forest
Stewardship Council, which ensures
responsible forest management.

FRONT COVER: Helmet Mask, cat. 62
FRONTISPIECE: Figure, cat. 54 (detail)
P. 4: Helmet Mask, cat. 56 (detail)
P. 7: Plank Mask, cat. 8. (detail)
PP. 20–21: Door, cat. 14 (detail)
PP. 58–59: Royal Tunic, cat. 43 (detail)
PP. 126–27: Face Mask, cat. 67 (detail)
PP. 164–65: Lidded Container,
 cat. 72 (detail)
BACK COVER: Crest Mask, cat. 48

Produced by the
Department of Publishing
The Art Institute of Chicago

Greg Nosan, *Executive Director*
Lisa Meyerowitz, *Editorial Director*
Joseph Mohan, *Director of Production*
Edited by A. Robin Hoffman
Production by Lauren Makholm
 and Ben Bertin
Photography research by Kylie Escudero

Unless otherwise noted, photography
of works of art is by Aidan Fitzpatrick,
Chris Gallagher, Bob Hashimoto,
Jonathan Mathias, Craig Stillwell, Joe
Tallarico, and Greg Williams, Depart-
ment of Imaging, Art Institute of Chicago;
and Jamie Stukenberg, ProGraphics Inc;
and is copyrighted by the Art Institute
of Chicago. Postproduction is by Aidan
Fitzpatrick, Jonathan Mathias, Shelby
Silvernell, and P. D. Young, Department
of Imaging, the Art Institute of Chicago;
and ProGraphics Inc.

Indexing by Kate Mertes
Proofreading by David B. Olsen
Design by Practise
 (James Goggin & Shan James)
Typeset in LL Catalogue (Nazareno Crea,
 Lineto, 2008–2017)
Separations by Professional Graphics,
 Rockford, Illinois
Printing and binding by Conti Tipocolor,
 Florence, Italy

Photography Credits

Every effort has been made to identify,
contact, and acknowledge copyright
holders for all reproductions; additional
rights holders are encouraged to contact
the Art Institute of Chicago Department
of Publishing. The following credits apply
to all images that appear in this cata-
logue for which acknowledgment is due.

P. 12, fig. 2; **P. 103**, fig. 1: Courtesy of the
University of Iowa Stanley Museum of
Art. **P. 24**, fig. 2: Image copyright © The
Metropolitan Museum of Art. Image
source: Art Resource, NY. **P. 26**, fig. 4:
Courtesy of The Cleveland Museum of
Art. **P. 27**, fig. 5: Courtesy of Roland Colin,
Paris. **P. 39**, fig. 1: © Huib Blom of www.
dogon-lobi.ch. **P. 40**, fig. 1; **P. 51**, fig. 1: ©
Michel HUET/GAMMA RAPHO. **P. 69**, fig. 1;
P. 80, fig. 1: © musée du quai Branly–
Jacques Chirac, Dist. RMN-Grand Palais /
Art Resource, NY. **P. 83**, fig. 1: Photograph
by Franko Khoury, National Museum of
African Art, Smithsonian Institution. **P. 91**,
fig. 1: Courtesy Northwestern University
Library. **P. 93**, fig. 1; **P. 107**, fig. 1; **P. 143**, fig.
1; **P. 194**, fig. 5: Eliot Elisofon Photographic
Archives, National Museum of African
Art, Smithsonian Institution. **P. 97**, fig. 1;
P. 123, fig. 1; **P. 190**, fig. 2: © RAI. **P. 113**, fig. 1:
© Charles Partridge Collection, Trustees
of the British Museum. **P. 130**, fig. 1;
P. 133, fig. 3: Courtesy of Pierre Loos.
P. 141, fig. 1: Photo by Haeckel collection/
ullstein bild via Getty Images. **P. 152**,
fig. 1: Photo by Mr. Cremers, courtesy
David A. Binkley. **P. 155**, fig. 1: Photo by
Tim Thayer. Courtesy Donald Morris
Gallery, New York and Michigan. **P. 159**,
fig. 1: Courtesy Dr. Brunhilde Biebuyck.
P. 168, fig. 1: © British Library Board /
Robana / Art Resource, NY. **P. 169**, fig. 2;
P. 183, fig. 1: Photo by Heini Schneebeli.
Courtesy of Jacaranda Tribal, New York.
P. 170, fig. 3: © Trustees of the British
Museum. **P. 171**, fig. 4: Courtesy of
Jacaranda Tribal, New York. **P. 172**, fig. 5:
Courtesy of Sandra Klopper. **P. 189**,
fig. 1: Museum Fünf Kontinente, Munich.